AHMANSON · MURPHY
FINE ARTS IMPRINT

The publisher gratefully acknowledges the generous contribution to this book provided by the Art Endowment Fund of the University of California Press Foundation, which is supported by a major gift from the Ahmanson Foundation.

THE ART MUSEUM FROM BOULLÉE TO BILBAO

THE ART MUSEUM FROM BOULLÉE TO BILBAO

Andrew McClellan

University of California Press Berkeley Los Angeles London

All photographs are by the author unless otherwise credited.

University of California Press, one of the most distinguished university presses in the United States, enriches lives around the world by advancing scholarship in the humanities, social sciences, and natural sciences. Its activities are supported by the UC Press Foundation and by philanthropic contributions from individuals and institutions. For more information, visit www.ucpress.edu.

University of California Press
Berkeley and Los Angeles, California

University of California Press, Ltd.
London, England

Library of Congress Cataloging-in-Publication Data
McClellan, Andrew.
 The art museum from Boullée to Bilbao / Andrew McClellan.
 p. cm.
 Includes bibliographical references and index.
 ISBN 978-0-520-24767-3 (cloth : alk. paper)
 ISBN 978-0-520-25126-7 (pbk. : alk. paper)
 1. Art museums. 2. Art museums—Philosophy.
 I. Title.
N410.M35 2008
708—dc22 2006037642

Manufactured in Canada

17 16 15 14 13 12 11 10 09
10 9 8 7 6 5 4 3 2

The paper used in this publication meets the minimum requirements of ANSI/NISO Z39.48–1992 (R 1997) *(Permanence of Paper).*

TO CONNIE, OLIVER, AND JAMES

CONTENTS

ACKNOWLEDGMENTS

A book that takes so many years to write accumulates debts of gratitude that can never be adequately acknowledged. But let me start with my students. This book grew out of a course on museum history and theory I have been teaching for a long time. I would like to thank all those students who have helped me refine my thinking about art museums over the years. Of those students, one deserves special mention: Sally Anne Duncan, who wrote her doctoral thesis on Paul Sachs under my supervision. It is a cliché to say students give their teachers as much as they get, but in Sally's case it is true. As an academic, I have learned most of what I know about museums from being an informed visitor who on rare occasions was also granted access to storage facilities, print rooms, conservation labs, and curatorial offices that the general public rarely sees. I count many (past and present) museum professionals among my friends, and they have helped me better understand the culture of the institution in which they work. They may take issue with some of what I say in this book, but I hope not to offend any of them. Those I would like to thank by name are Malcolm Baker, Christa Clarke, Michael Conforti, Stephen Deuchar, Adrian Ellis, Peter Funnell, Ivan Gaskell, Sarah Kianovsky, Asja Mandic, Danielle Rice, Laura Roberts, and Giles Waterfield. I have benefited enormously from the generous encouragement and brilliant work of my colleagues, fellow conference-goers, and friends in academe, particularly Jeffrey Abt, Bruce Altshuler, Stephen Bann, Tony Bennett, Chloe Chard, Fintan Cullen, Carol Duncan, Anne Higonnet, Anne Nellis, Carole Paul, Dominique Poulot, Rosamond Purcell, Katie Scott, Harriet Senie, Daniel Sherman, Alan Wallach, Martha Ward, and Richard Wrigley. At Tufts, my colleagues in the art history department were always supportive, especially Eric Rosenberg, Madeline Caviness, and Daniel Abramson, with whom I taught a most stimulating seminar on

museum architecture. I would also like to remember Father Harrie Vanderstappen, an early guide to the wonders of art. The constant support of my parents has been invaluable to me. It is a pleasure to acknowledge the important financial support I received at various stages of this project from the Faculty Research Awards Committee and Tisch Faculty Fellows program at Tufts University, and the fellowship program of the Clark Art Institute, where I spent a pleasant and productive term in the company of Michael Ann Holly and the other fellows. My sincere thanks also to Stephanie Fay and the staff at UC Press for their help in the editing and production of the book. Last, I would like to thank my family, Connie, Oliver, and Jamie, for their love, company, humor, and support. Perhaps I should thank them most of all for their patience, for during our travels over the past decade I came across scarcely any museums that I did not feel compelled to visit.

INTRODUCTION

Art museums have never been more popular, but at the same time their direction and values have never been more contested. Extensive press coverage has been in turn celebratory and critical, trumpeting new exhibitions, acquisitions, and buildings one day and probing unseemly transactions with tomb robbers, art dealers, and corporate sponsors the next. Within the art world, opinion is divided over the relative importance of traditional functions—collecting and scholarship—and the expansion of the museum through new programming, amenities (shops, restaurants, etc.), and outreach initiatives. It would seem to be both the best of times and the worst of times for an institution that over the past two centuries has worked its way to the center of, and come to epitomize, civilized society. This book offers a historical, theoretical, and critical perspective on both the continuing vitality of museums as social institutions and the challenges they face today. Separate chapters, each working backward from a recent dispute or controversy, offer focused histories of key aspects of museum theory and practice—ideals and mission; museum architecture; collecting, classification, and display; the public; commercialism; and restitution and repatriation—from the Enlightenment to the present, from the visionary museums of Boullée to the new Guggenheim in Bilbao and beyond. Because these issues are rooted in the history and evolution of museums, we must come to terms with that history to understand where museums are now and what their future might hold. This book aims to give readers—students, academics, present and future museum professionals—the background and range of views to engage in debate about the art museum's purpose and direction.

■ ■ ■

1

Art museums have emerged in recent decades as the most vibrant and popular of all cultural institutions in the West. As audiences for classical music, theater, and historical sites and museums stagnate or decline, attendance at art museums has steadily grown, from twenty-two million visitors in 1962 to over one hundred million in 2000. Long lines at blockbuster exhibitions have become commonplace, and it is said that art museums now rival professional sporting events in their drawing power.[1] New buildings are ubiquitous. The 1990s witnessed what the *New York Times* described as "the broadest, grandest, most ambitious museum boom" in history, and that boom has carried into the new century.[2] Despite a slump in the world economy and tourism after 9/11, museum construction and renovation continue at a remarkable pace in Europe, the Americas, and elsewhere. Cities without new or renovated museums would seem to be the exception rather than the norm. China has announced a target of one thousand new museums, and there is talk of new branches of the Guggenheim, and even the Louvre, in far-flung parts of the world (Abu Dhabi, Mexico, Singapore, Argentina).[3] Cutting-edge buildings designed by a cadre of globe-trotting architects have energized their host cities. Urban planners now speak of the "Bilbao effect," referring to the remarkable success of Frank Gehry's new Guggenheim Museum in northern Spain as an engine of urban renewal, economic expansion, and local pride. Where art and museums go, gentrification follows. The expansion and popularity of museums have fueled an increase in university-based museum studies programs and in the literature on museums. Museology is now a recognized branch of study in art history departments on both sides of the Atlantic.

What accounts for the art museum's recent success? Beyond education and the preservation of treasured objects for future generations—the standard justifications for all museums—the most compelling argument for art museums presents them as platforms for international dialogue and oases of beauty and calm in a hectic and rapidly changing world. In times of global anxiety, turmoil, and mounting differences, museums extend hope for mutual understanding grounded in the common traits of world art traditions. And as the pace of life and technology accelerates and society sinks beneath a rising tide of disposable products, ephemeral celebrity, and simulated images, art museums serve as repositories of the real, housing beautifully crafted artifacts that embody lasting values and collective memory. The allure of the genuine masterpiece offered for quiet contemplation in a soothing environment removed from the complexities and pressures of contemporary society has never been greater.

This argument was recently put forward by James Cuno, director of the Art Institute of Chicago, in a collection of essays by leading art museum directors that reads like a mainstream museum manifesto for the twenty-first century. For Cuno, art museums, by staging encounters with wondrous objects made by different peoples across many

centuries, encourage a process of "unselfing," through which we learn to see ourselves in a larger flow of human experience and to empathize with others through a shared appreciation of beauty. Following a museum visit, we return to our everyday existence at a "different angle," "changed somewhat from who we were . . . re-sourced, re-oriented, and renewed."[4] In a world of rising tensions and uncertainty, Cuno concludes, art museums offer "places of refuge and spiritual and cultural nourishment" where people may be "led from beauty to justice by a lateral distribution of caring."[5] Along similar lines, the philosopher Kwame Anthony Appiah has defended museums as a welcome space for imaginary and potentially healing conversations across the divisive boundaries of nationality, ethnicity, and religion.[6] Besides contributing to personal enrichment and global understanding, museums are places to shop, eat, socialize, and take in a film or concert, activities that have increased their profile in the civic and commercial landscape.

With success and celebration, however, come scrutiny and criticism. Precisely because the museum matters in our society, we argue about its purpose, what it should exhibit, and whom it should serve. From the late 1960s, activists and academics have critiqued the main spheres of the museum's activity: the contents, display, and interpretation of its collections; the nature of its public; the search for secure funding; and the ethical consequences of collecting practices past and present. When Cuno speaks of the museum's contribution to "justice" in the world, critics ask: What does he mean by justice, and justice for whom? Which cultures and heritages are included in the "cultural nourishment" museums provide? If "nourishment" involves education, how, and whom, does the museum educate? Who is invited to participate in the global conversations Appiah envisages, and how are different voices—or the voices of difference—registered? We now understand that the building and presentation of collections, the allocation of resources for exhibitions, and the content of public programming all involve choices and priorities that reflect the interests and biases of those in charge. Indeed, all museum work, from collecting and display to education and marketing, involves selection and interpretation. Museum critique has sought to understand the museum's operations as a historically specific and culturally mediated set of practices that may shift over time and vary from one institution to another but are never simply "natural." At a conference on museums held at Harvard in 1988, a prominent art museum director made himself an easy target for the critics by declaring that he espoused no particular philosophy, agenda, or point of view.[7] It is a mark of how thoroughly theory has been assimilated into the field that today no director would be so naive or unguarded.

In a remarkably short time, practices once taken for granted have been questioned and curatorial attitudes have evolved. Art museums now are arguably more "diverse" than they were thirty years ago: the canon includes previously overlooked cultures and populations, including women, and contemporary art is now recognized as a truly global phe-

nomenon. Curators are more sensitive to how they treat objects from different cultures and where things in their collection come from. Responsibility for objects in their care may go beyond the traditional concerns of preservation and exhibition to include respect for the viewing expectations of different constituencies and the meanings and purposes the objects once had, especially sacred objects from indigenous cultures. Public outreach initiatives, popular programming, and internship opportunities have perhaps never been greater. Critics would say that much work still needs to be done. Collections and exhibitions could be more heterogeneous, as could the museum's public and staff. The latter is still mostly white and, at the top, male. Rising admission charges at many institutions will surely work against broadening access. The much-publicized success of recent restitution claims still leaves many questions about provenance unanswered.

Criticism of the museum has generated a countercritique from factions in the art world. If critique gained momentum as a progressive, liberal assault on a conservative, elitist institution, it now includes a conservative backlash from establishment journalists and museum professionals who defend the museum's traditional commitments to collecting, preservation, and scholarship and resist the move to populist programming, building expansion, and market-driven initiatives. The critics' critics argue, moreover, that museums are no more elitist than universities, sports franchises, or any other institution that relies on judgments of quality and merit and charges for admission. Why expect art museums, any more than opera or bowling, to appeal to everyone? Critics argue against postcolonial demands to repatriate cultural artifacts by pointing out that a mass return of world treasures would limit our knowledge of other cultures at a time when we need to expand it.

Museums find themselves attempting to placate patrons and critics of different stripes while keeping an eye on rising costs and competing forms of recreation. The search for comfortable ground between elitism and populism, high standards and dumbing down, challenges all but the most insular, financially secure institutions. The present moment, one of critical exchange, global consciousness, institutional expansion, press coverage, broad public support, and shifting leisure patterns, is a compelling time to reconsider the art museum—its ideals, ethics, and practices—from a historical perspective. We stand to learn much about recent disputes if we see them historically, as the product of forces and tensions deep in the museum's structure.

Following chapter 1, in which I explore the recent evolution of the rationale for the museum as a place of refuge and dialogue, chapters 2 through 6 focus on continuing controversy in five areas: architecture; collecting, classification, and display; the public; commercialism; and restitution. Chapter 2 examines Frank Gehry's new Guggenheim Museum in Bilbao in light of tensions between architecture's symbolic function and its functional responsibilities that date back to the eighteenth century and the visionary

designs of Etienne-Louis Boullée. Why is opinion on this extraordinary building in north-ern Spain so sharply divided? Working backward from provocative recent installations by the contemporary artist Fred Wilson, chapter 3 considers the principles of collect-ing, classification, and display that have governed art museums since their inception. Extended asides look at the history of lighting, period rooms, and the emergence of the "white cube" gallery. Chapter 4 takes on the issue of the art museum public, or publics, in theory and actuality. Are art museums bound by their collections and their past to be less than all things to all people? Left-leaning critics and conservative museum staff agree on the corrosive potential of creeping commercialism and corporate involvement in museums, the subject of chapter 5. But why are funding and commerce viewed as such threats to art museums? Chapter 6 looks at restitution and repatriation, which have emerged lately to challenge the integrity of the mainstream art museum in the West. Can museums remain platforms for global dialogue *and* accede to the demands of other nations and indigenous peoples to retrieve their cultural artifacts and control their artis-tic heritage?

As I mentioned above, this book aims, not to chronicle the art museum comprehen-sively, but to chart the major themes and moments of engagement between museum theory and practice. While certain institutions, personalities, and developmental phases of the art museum figure prominently, others worth considering do not appear at all. I hope that such omissions will be viewed as opportunities for further research and fu-ture publication. I focus on major art museums (including survey museums, like the British Museum, which feature more than art), primarily those in the Euro-American orbit. And within that orbit, the traditions I know best—France, Britain, the United States, and, to a lesser extent, Germany—predominate.

By way of justifying a limited geographic scope, I would argue that art museums are a Western invention and that wherever they have taken root they conform essentially to the Western model in their core ideals, taxonomic principles, and administrative struc-ture. Whether at the turn of the twentieth century in Japan, where the new national mu-seums (fig. 1) demonstrated assimilation of modern Western values, or a century later in Zimbabwe, where a newly independent nation has aimed to redress colonial wrongs and foster a new self-identity through reworked museum displays, the blueprint has been recognizably Western.[8] Over the past two centuries museums have emerged as a universal sign of civilization that no nation-state or self-respecting municipal govern-ment can afford to ignore. Conformity is part of what has been on display. When Pak-istan gained its independence in 1947, for example, it built museums in the belief that "the number of museums in a country is taken as indication of the cultural level that country has reached."[9] To learn the principles of museology, Pakistan turned to the West and the famous museum studies program at Harvard. China has embarked on an am-

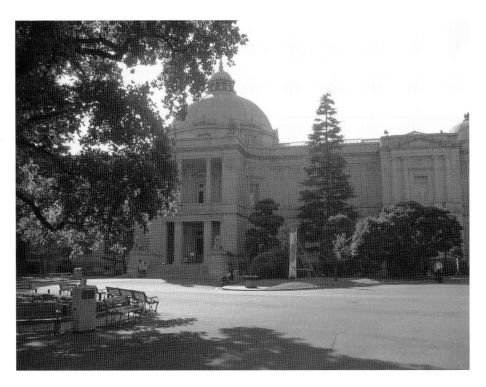

1. Katayuma Tokuma, Hyokeikan Museum, Tokyo, 1908.

bitious course of museum building for the same reason. So widely shared are museum values today that when a guard at the National Museum of Iraq exclaimed at its devastation during the invasion of Baghdad in 2003, "It was beautiful. . . . The museum is civilization," people all over the world recognized his pain and despair.[10] By the same token, efforts to rebuild the museum and reclaim Iraq's cultural heritage have elicited remarkable international sympathy and cooperation. And where museums evidence nonconformity—recent Native American museums come to mind—the mainstream Western museum and "the hegemony of the management regimes of Eurocentric museology," as a recent critic put it, are the forces from which their directors hope to liberate them.[11]

The Culture of Critique

In a recent essay, the distinguished American museum educator Danielle Rice tells an amusing and familiar anecdote of a fresh-faced college grad who, after interning for a summer at a large art museum, learned to look past "the evil political side of museums"

that the university had drummed into her.[12] For the past generation academic discourse on museums has generated what Rice calls a "one-dimensional representation of art museums," a critique evidently at odds with the public success those museums currently enjoy. The negative cast of much recent museum discourse has overlooked the power of attraction that keeps people coming back to museums in record numbers; has obscured what may be construed as the ultimately positive goals of critics who are motivated by the desire for institutional reform; and, as an essentially oppositional practice, has failed to acknowledge whatever reforms it may have helped bring about.

The familiar tropes of museum critique, likening museums to tombs, ritualized religious structures, and theme parks, fail to account for museums' burgeoning success across time, space, and cultural divides. Such comparisons also fall short on their own terms. For example, the metaphor, long popular with the avant-garde, of the museum as tomb, the place where art goes to die after serving a useful life elsewhere, willfully ignores the multiple lives and identities objects may have as they shed the uses and meanings gained in one time and place and acquire new relevance in another.[13] As Philip Fisher has remarked, "[N]ew characteristics come into existence [and] earlier features are effaced" as objects pass from one social and cultural context to another.[14] Museums offer a new life to many objects that have lost their raison d'être over time. Many modern works of art, meanwhile, were made for museums and depend on them for their meaning. Objects new and old, once in a museum, can and do serve a variety of purposes for different publics. The idea that modern museums are tomblike is also belied by the great surge in their popularity over the past half-century. Crowds flock to new exhibitions and buildings as a market-driven blurring of high and low culture, art and entertainment opens the museum to life and interests beyond its walls.[15] At the same time, however, disparaging references to the museum as a theme park or shopping mall underestimate the public's capacity to identify the distinct benefits and pleasures museums offer. To say that museums, movies, and malls now compete as alternative forms of recreation is not to say they are the same thing.

The frequent comparisons of the art museum to ritualized religious structures call for some refinement. The historical account of museums as sites of moral improvement, ideological acculturation, and social distinction, richly articulated by Pierre Bourdieu, Tony Bennett, Carol Duncan, and Alan Wallach, among others, is incontestably important. But are museums still the engines of bourgeois assimilation they once were? Rising costs, which have necessitated increased admission fees, have reinforced the status of museums as self-selecting preserves of the educated middle class, and even where museums are free, if you take away obligatory school groups, they are not ostensibly popular with the poor and uneducated. In any case, political parties and corporations now have more effective means—not least the media, sporting events, public education,

and organized religion—of inculcating patriotism and bourgeois capitalist values in the public. At the same time, in a society where wealth matters more than breeding, taste, or education as the criterion of status, conspicuous consumption—of property, designer couture, or sports franchises—carries more weight than patronage of art and museums. Does anyone care if Bill Gates or Richard Branson owns art or goes to the opera? Or if Ralph Lauren collects racing cars rather than art? Buying art is but one outlet for the superfluous wealth of the postmodern plutocracy, just as going to museums is only one of many recreational alternatives for today's middle classes. As Andreas Huyssen has suggested, the top-down "power-knowledge-ideological" model reduces audiences to "manipulated and reified culture cattle" and needs to be "complemented by a bottom-up perspective that investigates spectator desire . . . and the segmentation of overlapping public spheres addressed by a large variety of museums and exhibition practices today."[16]

As I mentioned above, the critique of museums by academic outsiders has been supplemented by a tradition of debate over ideals among museum insiders. Indeed, museum professionals have at times been their own sharpest critics. In the United States between the world wars, Benjamin Ives Gilman, a noted author and longtime secretary at Boston's Museum of Fine Arts, and John Cotton Dana, director of the Newark Museum, led opposing camps in a heated dispute over the soul of the museum. In the late 1960s Thomas Hoving, of the Metropolitan Museum of Art, sided with liberal social critics in a bid to change the course of the art museum; Hoving's biggest critics were conservative museum men, led by Sherman Lee, director of the Cleveland Museum of Art. The collection of essays assembled by James Cuno represents a polemical affirmation of traditional ideals in response to both external critique and what the authors see as the wayward paths of certain colleagues. Adopting a broad view of what constitutes critique underscores the wish of the great majority of critics, whatever their profession or persuasion, not for the museum's demise but rather for a different and better museum.

We need a framework for analysis that accommodates the reasons for popular support as well as criticism, the aspirations as well as the disillusionment that museums have inspired. To that end another metaphor recommends itself: the museum as a utopian space. Museums are utopian in the simple sense that they have often been imagined as contributing to the building of a better world. Set apart from the flow of normal life, art museums of our time, like classic utopias, offer a seductive vision of harmonious existence and communal values in a parallel realm of order and beauty. Free from the divisive tensions of the everyday world, we may entertain utopian thoughts about "what man is" and has as his "inner aim."[17] Or as Georges Bataille exclaimed, "The museum is the colossal mirror in which man finally contemplates himself in every aspect, finds

himself literally admirable, and abandons himself to the ecstasy expressed in all the art reviews."[18] It is a staple of museum rhetoric today that the transcendent art of distant ages and cultures speaks to us all about where we come from and what we have in common. Museums are emboldened by the belief that evidently shared ideals bodied forth in world art and experienced in the neutral zone of museums will foster cooperation and help overcome obstacles in the real world. As globalization draws the world closer together, the art museum prepares the way for a deeper understanding of our differences and commonalities. Museums are inherently "cosmopolitan" institutions, in the sense articulated by Kwame Appiah, and as such can work toward resolving conflicts born of ignorance and prejudice.[19] That museums actually have this power is safely beyond our ability to confirm or deny, for how could their success or failure be measured? Without a metric of success for such sweeping ambitions, museums remain places of hope and aspiration, and are no less important for that.

The concept of the museum as a utopian space not only accommodates the social aims and future-driven ameliorative dimension of our museums but also has powerful historical reach. As we shall see in chapter 1, museum ideals and utopian thinking overlap from a point of common origin in early modern Europe through the Enlightenment and Industrial Revolution to the present. The social good that museums could be made to serve evolved over time in response to historical circumstances and changing visions of what constituted a better world. At the dawn of the museum age after the French Revolution, newly created public museums helped to shape the body politic and cultural identity of emerging nation-states through shared access to nationalized art treasures. In the nineteenth century, museums aimed to provide training in design, uplifting recreation, and improved taste among the masses in the industrialized cities of Europe and the Americas. Following World War I and the Great Depression, museums acquired new life as spaces of redemptive retreat from war and socioeconomic strife, functions that intensified with further cataclysms and deepening Orwellian gloom later in the twentieth century. After 9/11 the rhetoric of hope and the power of art to mend a divided world have been revived. And museums have also become refuges of authenticity and affect in a society dominated by mass reproduction, media saturation, "reality" television, scripted photo shoots, and sound bites.[20] Nostalgia for the authentic is projected into the future as hope that the real will survive Jean Baudrillard's dystopian view of the world as simulacrum. Though museums have embraced computer technology and boast "virtual" Web tours and sophisticated collection databases, people still go to museums to see the real thing.[21] Virtual visits will not supplant real ones.

Insofar as museums are dedicated to improving the world, their idealism makes them vulnerable to critique. The goal of the modern museum critic is to penetrate the mu-

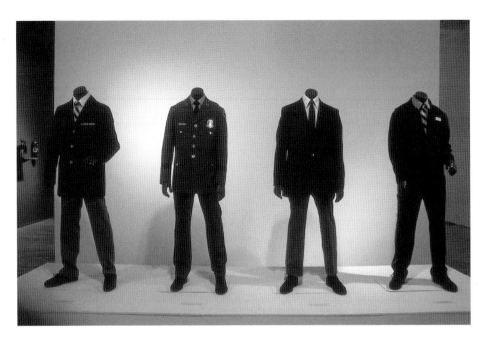

2. Fred Wilson, *Guarded View,* 1991. Mixed media. Installation view from the exhibition Primitivism: High and Low, Metro Pictures, March 1991. Mannequins, 75" × 48" × 166"; base, 9" × 144". © Fred Wilson. Photo courtesy of Pace/Wildenstein, New York.

seum's rhetoric of benevolence and disinterested service to society, pinpointing slippage between ideals and practice and identifying new or unfulfilled aspirations. According to Michel Foucault (who inspired much recent museum critique, though he did not write about museums themselves), the critic's aim is to "criticize the workings of institutions which appear to be both neutral and independent; to criticize them in such a manner that the political violence which has always exercised itself obscurely through them will be unmasked, so that one can fight them."[22] By *fight* Foucault meant identifying "the points where change is possible and desirable" and determining "the precise form this change should take."[23] When, for example, critics point to the pernicious influence of corporate sponsorship on museum programming, are they not defending the integrity of museums in the name of democracy, public enlightenment, and access? When the artist Fred Wilson invades the museum with an installation of faceless brown-toned guard mannequins (fig. 2) or juxtaposes slave shackles and repoussé silver vessels in a display case he ironically titles nineteenth-century American "metalwork" (see chapter 3), is he not inviting the public to reflect on how museums perpetuate—but might also alleviate—problems of race and class in the United States?[24] The desired outcome of criticizing

museums as mechanisms of Western colonial dominance is the liberation and empowerment of oppressed and marginalized peoples to pursue and celebrate their own cultural identity. The rhetoric of universality that museums happily embrace invites constant scrutiny for sins of omission; as Tony Bennett has observed, "The space of representation associated with the museum rests on a principle of general universality which renders it inherently volatile, opening it up to a constant discourse of reform as hitherto excluded constituencies seek inclusion—and inclusion on equal terms—within that space."[25] Since no collection can ever be complete, a function of criticism—Bennett's "constant discourse of reform"—is to revisit the canon and nominate overlooked artists and peoples for inclusion. Museums inch toward an elusive plenitude in response to evolving ideals and external pressure.

Criticism, by serving as the museum's conscience and engine of reform, is itself utopian. When asked why museums are willing to host his trenchant installations, Fred Wilson replied: "I think there are many curators and, interestingly, more and more directors, who on one level or another want things to change. . . . They want their museums to be more sensitive and inclusive. I'm brought in because there's a genuine desire to self-reflect and even change attitudes and policies. . . . They want something positive and dynamic to happen."[26]

Wilson's work is "outcome driven," we might say. Similarly, Andreas Huyssen observes that Baudrillard's dark account of the simulated environment in which we live reveals "nothing so much as the desire for the real after the end of television"[27]—an endorsement of museums that makes what and whose "reality" they represent more important than ever. The stated purpose of James Clifford's important book *The Predicament of Culture* is to offer a "critique of deep-seated Western habits of mind and systems of value" in order to "open space" for the "cultural futures" of marginalized peoples. Clifford admits to a "utopian hope" for the survival of "difference" against the "homogenizing effects of global economic and cultural centralization."[28] Museums are, and will continue to be, subjected to analysis and critique across a broad ideological spectrum because they matter and because they are susceptible to change. Criticism is integral to museums, as it is to any important social institution, and should be viewed as the legitimate prerogative of all who care about their future.

Museums unquestionably belong to the dream houses of the collective.
Walter Benjamin (ca. 1927–40)

1 IDEALS AND MISSION

Art museums, like most institutions, are guided by ideals laid out in a statement of mission. Institutional goals vary in detail from one museum to the next, but generally art museums share a commitment to preserving the objects in their care for posterity and to making those objects available to the public. The British Museum "exists to illuminate the histories of cultures, for the benefit of present and future generations," according to its Web site.[1] Similarly, the mission of Washington's National Gallery of Art "is to serve the United States of America . . . by preserving, collecting, exhibiting, and fostering the understanding of works of art."[2] Halfway around the world, the National Palace Museum in Taiwan is dedicated to "protecting and preserving the 7000-year cultural legacy of China" and "bringing the Museum's collection to the global community."[3] Because of their role in protecting cultural memory and spreading public enlightenment, museums are viewed as important and socially benevolent institutions, worthy of community support and a charitable (tax-exempt) status.

What mission statements rarely articulate, however, is what is meant by *benefit* and whose artistic heritage is, or is not, collected and displayed. Who decides, and on what grounds, what qualifies as "art"? Social benefit is customarily defined in terms of education, but what constitutes the educational value of art? What do visitors learn on an outing to the local museum? For what purpose do art museums preserve and educate? In a recent interview, the director of the British Museum, Neil MacGregor, stated that museums today should embrace a vision of civic humanism in which the knowledge they generate "is to have a civic outcome." What might that "civic outcome" look like?

As forward-looking institutions, museums have always been dedicated to building a better society, but visions of what constitutes it are always shifting. Consequently, mu-

seum priorities are not fixed in stone like their monolithic facades but subject to debate and modification as social needs change. Vaguely worded mission statements allow for change with no diminution of purpose. Change may appear subtle because it does not necessarily entail discarding past ideals and parts of the collection; instead, new or modified ideals are added to old, yielding a complex set of goals that aspires to serve a widening set of constituencies. For example, although multiculturalism is now broadly embraced by museums and has led to collecting initiatives in formerly marginalized visual traditions, European art has hardly been ignored. In times past, museums were considered vital to the formation of artists and were therefore built alongside art schools; those affiliations are still largely intact even though ambitious young artists no longer copy the Old Masters as their predecessors once did. Today museums are more likely to tout their role in the cognitive development of children or their economic contribution to the local community. Art museums owe their survival and success to their ability to promote new, and not-so-new, "missions," depending on current needs.

Lately, with rising strife around the world, mainstream art museums have stepped forward with a powerful new raison d'être: to foster global cooperation and understanding through a heightened awareness of shared interests and common values bodied forth in works of art. This message is at the core of the "Declaration on the Importance and Value of Universal Museums" (see Appendix), issued jointly in 2002 by nineteen leading museums "to stress the vital role they play in cultivating a better comprehension of different civilizations and in promoting respect between them," according to Peter-Klaus Schuster, director of the State Museums of Berlin.[4] Schuster and others argue that museums, because of the trust and respect they enjoy and their disinterested stance toward ideological contention in today's public sphere, are uniquely placed to promote cross-cultural exchange and smooth the path to social harmony and world peace—no small ambition.

Today the art museum's core functions—conservation, acquisition, scholarship, education—are increasingly directed toward, and justified by, this encompassing humanist purpose. This chapter charts the emergence of this museological ideal in the context of the utopian currents that have sustained art museums since their inception over two centuries ago. Apart from whatever historical interest a survey of museum ideals may have, it is vital to reckon with them if we are to comprehend the controversies and challenges museums face today. Ideals drive museums; they inspire the public to come, donors to give, and busy trustees and underpaid staff to serve. The chapters that make up the rest of this book examine aspects of museum policy and operation that are either means or obstacles to fulfilling a core mission. To understand art museums we must grasp the evolving relationships between ideals and mission, theory and practice, and perceived social commitments and overlapping constituencies.

Utopian Ideals and Real Politics

Before museums began appearing in the eighteenth century, they existed as notional spaces embodying ideals of collective learning and progress considered essential to a perfect society. Overlooked in the extensive literature on the origins of collecting and museums in early modern Europe is the appearance of museumlike structures in three famous utopian texts: Johann Valentin Andreae's *Christianopolis* (1619), Tomasso Campanella's *City of the Sun* (1623), and Sir Francis Bacon's *New Atlantis* (1627). Written by men of different nationalities, professions, and religions, the three texts signal the spread of a utopian museum ideal across Europe in step with the culture of collecting and curiosity. Andreae's model community of Christianopolis (fig. 3) is dominated by a college whose institutions represent universal knowledge: a library containing "the offspring of infinite minds," a pharmacy amounting to "a compendium of all nature," a natural history museum whose walls depict "the whole of natural history," and so on.[5] In Campanella's City of the Sun, knowledge is found, not in dedicated buildings, but in inscriptions on the city's seven concentric walls, integrating learning into everyday activity. Bacon's ideal city on the island of Bensalem is built around a college, Salomon's House, "dedicated to the study of the . . . true nature of all things," "[the] enlarging of the bounds of human empire," and "the effecting of all things possible."[6] Much of the *New Atlantis* is given over to a detailed description of the college, its facilities, collections, and goals, as if it were the true subject of the text. That Bacon's utopian model was designed to inspire real-world parallels is suggested by one of his earlier texts, *Gesta*

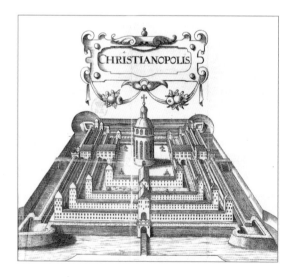

Grayorum (1594), in which a fictional counselor advises his prince on the contents of an ideal museum. To achieve "in small compass a model of universal nature," the prince should assemble, together with a "most perfect and general library," a "spacious, wonderful garden," a zoo with "all rare beasts and . . . all rare birds," and "a goodly huge cabinet, wherein whatsoever the hand of man by exquisite art or engine hath made rare in stuff, form, or motion; whatsoever singularity chance and the shuffle of things hath produced; whatsoever Nature hath wrought in things that want life and may be kept; shall be sorted and included."[7]

3. Johann Valentin Andreae, *Christianopolis*. Engraving from his *Reipublicae Christianopolitanae descriptio*, 1619. Bibliothèque nationale de France, Réserve des Livres rare.

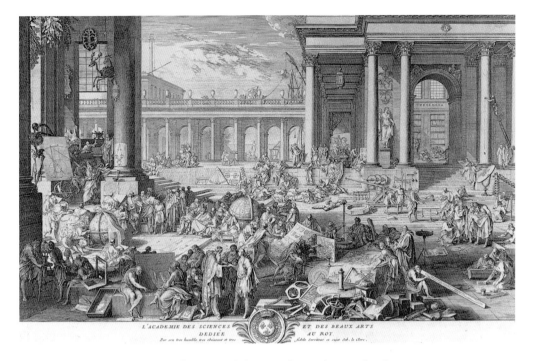

4. Sébastien Le Clerc, *The Academy of Sciences and Fine Arts*, 1699. Etching, 24.8 × 38.4 cm. Metropolitan Museum of Art, Elisha Whittelsey Collection, The Elisha Whittelsey Fund, 1962 (62.598.300). Photo: Metropolitan Museum of Art, New York.

Bacon and Andreae were both adapting descriptions of ideal collections that had begun to circulate in the late sixteenth century, beginning with Samuel Quicchelberg's "universal theater" of 1565.[8] What matters is the assumption that an elaborate institution for the collection, production, and dissemination of knowledge belonged at the heart of a perfect society. Inspired by the spread of collecting, museums and academies bodied forth in theoretical texts and images (fig. 4) became models for real-world institutions dedicated to serving the common good.[9]

From the Renaissance onward, the museum has been envisioned as a compendium of the world, a microcosm of the macrocosm, and a symbol of a harmonious, well-ordered society. But even as early imaginary museums provided a conceptual model for future academies and museums, they looked back to a common classical source of inspiration in the fabled *mouseion* at Alexandria (destroyed ca. AD 400) and the academies of Plato and Aristotle. Memories of those institutions haunted the early modern imagination, and the dream of recuperating and even surpassing lost knowledge underpinned all collecting and related study. Witness Andreae's traveler in the library at Christianopolis,

5. Raphael, *The School of Athens*, ca. 1510–12. Fresco. Vatican Palace, Vatican State. Photo: Scala/Art Resource, New York.

"dumbfounded to find there very nearly everything that is by us believed to have been lost."[10] Ptolemy's "museum" at Alexandria, known only through scattered literary references hailing its vast collection of books and knowledge ("all the books in the inhabited world," "the writings of all men," and so on),[11] established for later museums an ideal of universality all the more powerful because the collection itself no longer survived to reveal inevitable shortcomings.

Though knowledge progressed in the Renaissance beyond the written legacy of the ancients to encompass objects as well as books, antiquity nevertheless provided the visual means to represent the noble quest for knowledge. In paper projects and texts, museums and libraries took the form of ideal buildings modeled on classical temples, often lined with allegorical statues and busts of ancient philosophers. In Raphael's *School of Athens* (fig. 5) those philosophers are brought to life in a fittingly impressive space. One of four paintings decorating the Vatican library of Julius II (a collection that his contemporaries likened to the *mouseion* of Alexandria), it shows Plato and Aristotle engaged in metaphysical conversation at an imaginary gathering of history's great minds.[12] The

two men point, respectively, to heaven and to earth, which represent speculative and empirical philosophy, the combined source of *causarum cognito* (the knowledge of things), a phrase inscribed in the library's vault above. Though Julius's collection numbered only about five hundred books, the fresco illustrates the path to true understanding through the cumulative efforts of past, present, and future genius.

These early modern representations prepared the way for the full flowering of the utopian museum during the eighteenth century, when Enlightenment attempts to reduce the distance between an imaginary utopia and the actual world through philosophy and pragmatic reform lent urban planning and civic institutions a special prominence. In the words of Bronislaw Baczko, the Enlightenment propelled a shift from "cities in utopia to the utopia of the city, from power and government in the utopia to the power and government envisaged as the agent of the utopia and the executor of social dreams."[13] In the realm of utopian fiction, Sébastien Mercier's famous novel *The Year 2440*, published in 1771, is significant. Traveling into the future, Mercier's protagonist finds himself standing at the center of Paris, before a vast temple of knowledge that contains every specimen of nature and human culture, laid out with judgment and wisdom.[14] Everywhere he turns he finds students and members of the public studying in an atmosphere of cooperation and freedom. Like earlier utopias, Mercier's fable contained recommendations for political and social reform. His futuristic museum was easily recognizable as the Louvre Palace, abandoned by the royal family for Versailles in the late seventeenth century and in need of a new purpose, and his fictional account read as a blueprint for government action.[15] The French Revolution gave further impetus to utopian thinking about the Louvre. For Armand-Guy Kersaint, writing in 1792, the Louvre would "speak to all nations, transcend space, and triumph over time" by becoming a center of scholarship for the whole world that would accommodate "the reunion of all that nature and art have produced."[16] Revolutionary euphoria prompted the philosopher Condorcet, the great champion of human progress, to revive Bacon's vision of Atlantis, with its "vast edifices" consecrated to knowledge and its "crowd of researchers" working together for the good of mankind.[17] What had been a dream in Bacon's day was, in Condorcet's view, close to being realized, thanks to the "rapid progress" made by the Enlightenment.

With the opening of the Louvre in 1793 the Revolution's particular sociopolitical ambitions superseded the general aspirations to universal knowledge found in earlier utopian tracts. The Revolution, in other words, appropriated the utopian potential of the museum and specified how it could be socially useful. Though the Louvre initially occupied only one wing of the palace, which was devoted solely to art (fig. 6), the museum was nonetheless infused with revolutionary optimism and purpose. It was inaugurated on August 10, 1793, the first anniversary of the founding of the republic, during a day-

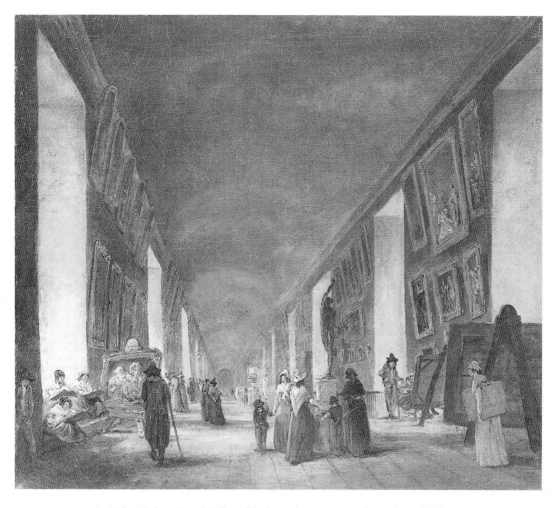

6. Hubert Robert, *Grand Gallery of the Louvre between 1794–96,* ca. 1794–96. Oil on canvas, 37 × 41 cm. Louvre Museum, Paris. Photo: Réunion des Musées Nationaux/Art Resource, New York.

long Festival of Unity celebrating the republican ideals of liberty, equality, and fraternity. The key event planned for the festival was an elaborate parade though the streets of Paris that amounted to a symbolic mass appropriation of the French capital. "All individuals useful to society will be joined as one," wrote the festival's mastermind, Jacques-Louis David. "[Y]ou will see the president of the executive committee in step with the blacksmith; the mayor with his sash beside the butcher and mason; the black African, who differs only in color, next to the white European."[18] Allegorical statues of liberty and national unity along the route replaced deposed monuments of former kings; on

the site of Louis XVI's execution delegates from the eighty-six regional departments set fire to a symbolic pyre made of the "debris of feudalism." The spirit of the festival continued inside the museum, where newly baptized citizens of the republic enjoyed free and equal access to treasures confiscated for the nation from the crown, the church, and émigré aristocrats in a royal palace turned palace of the people. Labels informed viewers who had owned the paintings prior to the Revolution, underscoring the power of liberation in the name of public instruction.

At the same time, an orderly display of acknowledged masterpieces countered disturbing images of public executions and social turmoil by demonstrating the nation's commitment to universal cultural values. As a leading politician put it, the opening of the museum would quiet "political storms" and prove "to both the enemies as well as the friends of our Republic that the liberty we seek, founded on philosophic principles and a belief in progress, is not that of savages and barbarians."[19] The chronological sequence of pictures culminating in the French school affirmed the principle of progress on which the Revolution was founded and made clear that the future of art belonged to France. Finally, the Louvre served as a training ground for young artists following the dissolution of the Royal Academy of Painting and Sculpture in 1793. No longer constrained by a formal system of instruction, students were now free to choose their own masters from the canon of great art. Artists copying in the Grand Gallery became a common sight for more than a century beginning in the 1790s.

In the first decades of the nineteenth century, the multifaceted success of the Louvre—as a symbol of democratic access and responsible government, source of national and civic pride, and school for young artists and historians—proved irresistible to emerging nation-states in post-Napoleonic Europe. Newly formed nations shaped their cultural identity around their national patrimony, embodied in historical artifacts and works of art openly displayed in public museums.[20] A nation exhibiting "classical" (Greco-Roman and Renaissance) art declared its adherence to civilized values and, by integrating homegrown artists, argued for including native traditions in the canon. Other countries followed the French example by using museums to instruct artists, artisans, scholars, and the public at large. Between 1800 and 1860, important museums modeled on the Louvre opened in Brussels (Royal Museum, 1803), Amsterdam (Rijksmuseum, 1808), Rome (Vatican Pinacotheca, 1816), Venice (Accademia, 1817), Milan (Brera, 1818), Munich (Glyptothek, 1815; Pinakothek, 1836), Madrid (Prado, 1819), London (National Gallery, 1824; British Museum, rebuilt 1823–47), Berlin (Altes Museum, 1830), and St. Petersburg (Hermitage, 1852). By the end of the century the museum movement had spread from Europe to North and South America, Asia, and Australia, so that virtually every capital and major city in the advanced world (and its colonies) could boast a public art museum of its own.

Useful Recreation

The belief, emanating from German philosophy, in the uplifting and harmonizing power of art further informed the spread of museum culture in the early nineteenth century. Art had long served to inspire religious devotion and loyalty to earthly rulers, but the new aesthetics of Kant and Schiller insisted that the beauty and autonomy of art could nourish the spirit of the individual subject by lifting consciousness above the contingent realities of the material world without letting it become lost in abstractions. "Through Beauty," wrote Schiller in *On the Aesthetic Education of Man* (1795), "the sensuous man is led to form and to thought; through Beauty, the spiritual man is brought back to matter and restored to the world of sense."[21] By appealing to the sensibility of individual viewers, art exhibited in public museums could improve and harmonize society as a whole.

Though the belief in art's restorative powers dates back to antiquity, when paintings and sculptures decorated country retreats outside Rome and constituted an appropriate subject of leisurely conversation, it took on new urgency during the Industrial Revolution, when the pace of modern life quickened. Witness William Hazlitt's reflections on a visit to the London collection of John Julius Angerstein (fig. 7) in the early 1820s:

> Art, lovely Art! "Balm of hurt minds, chief nourisher in life's feast, great Nature's second course!" Time's treasurer, the unsullied mirror of the mind of man! . . . A Collection of this sort . . . is a cure . . . for low thoughted cares and uneasy passions. We are transported to another sphere. . . . We breathe the empyrean air . . . and seem identified with the permanent form of things. The business of the world at large, and of its pleasures, appear[s] like a vanity and an impertinence. What signify the hubbub, the shifting scenery, the folly, the idle fashions without, when compared to the solitude, the silence of speaking looks, the unfading forms within.[22]

Facing mass immigration and unrest in newly industrialized cities, governments across Europe embarked on a course of museum building in the hope that the benefits described by Hazlitt could be extended to the population at large. Soon after Hazlitt's visit, the Angerstein collection in London became the nucleus of the new National Gallery (founded 1824).

Urban riots in the early 1830s prompted Sir Robert Peel, a leading politician and the founder of the London police, to recommend the expansion and rebuilding of the gallery: "In the present times of political excitement, the exacerbation of angry and unsocial feelings might be softened by the effects which the fine arts had ever produced on the minds of man. . . . The rich might have their own pictures, but those who had to obtain their bread by their labour, could not hope for much enjoyment. . . . The erection of [the new National Gallery] would not only contribute to the cultivation of the arts, but also to the cementing of the bonds of union between the richer and poorer orders of state."[23]

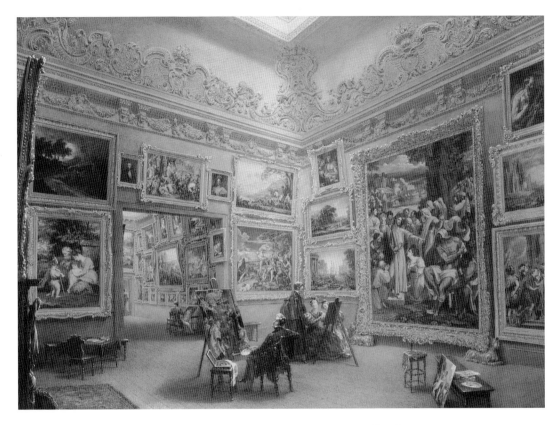

7. Frederick Mackenzie, *The Original National Gallery at J. J. Angerstein's House, Pall Mall, London,* ca. 1834. Watercolor, 46.7 × 62.2 cm. Photo: Victoria and Albert Museum, London/Art Resource, New York.

Government inquiries in the 1830s, 1840s, and 1850s confirmed the popularity of the new gallery (its attendance ran as high at ten thousand visitors a day) among a broad public. The satirical magazine *Punch* (fig. 8), however, was not convinced that Old Master paintings were what the people needed. It noted that the government seemed to have decided that since it "cannot afford to give hungry nakedness the *substance* which it covets, at least it shall have the *shadow.* The poor ask for bread, and the philanthropy of the state accords them—an exhibition."[24] But London's museum boosters were undeterred, insisting on the palliative effects of museum-going on the working multitudes. In the late 1840s, Dickens's friend Charles Kingsley had this to say in favor of art museums: "Picture-galleries should be the townsman's paradise of refreshment. . . . There, in the space of a single room, the townsman may take his country walk—a walk beneath mountain peaks, blushing sunsets, with broad woodlands spreading out below it . . . and his hard-worn heart wanders out free, beyond the grim city-world of stone and iron, smoky

chimneys, and roaring wheels, into the world of beautiful things."[25] Museum men like Sir Henry Cole, founder of the South Kensington Museum, joined forces with temperance leaders to have museums open on Sundays and weekday evenings in order to give the working classes a wholesome recreational alternative to procreation and the pub (fig. 9). "Let the working man get his refreshment there in company with his wife and children," Cole told an audience in 1875; "don't leave him to find his recreation in bed first, and in the public house afterwards."[26]

Museum historians and critics, inspired by the institutional critique of Michel Foucault, have argued that museums in the Victorian period, besides offering innocent diversion for the masses, contributed to what Foucault termed the "disciplinary technology" of the modern state, whose purpose was to produce "docile," ordered, and patriotic citizens.[27] This was clearly the case. For John Ruskin museums offered "an example of perfect order and perfect elegance . . . to the disorderly and rude populace."[28] Henry Cole believed they would "teach the young child to respect property and behave gently."[29] The chairman of the Art Union of London viewed museum visits by the workingman as productive on both social and economic levels: "Once refreshed he can return to work a productive member of society."[30] The first president of New York's Metropolitan Museum, Luigi di Cesnola, listed museums, with "the college, the seminary, the hospital, and the asylum," as "blessings" that "benefit the community at large."[31] But museums, unlike asylums and prisons, Foucault's chief examples of disciplinary institutions, made

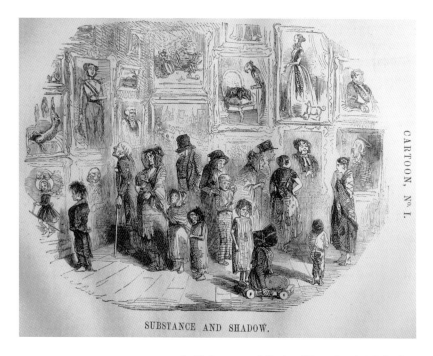

SUBSTANCE AND SHADOW.

8. "Substance and Shadow." From *Punch*, July 8, 1843.

9. Sir John Tenniel, "The Sunday Question: The Public-House, or,
the House for the Public?" From *Punch*, April 17, 1869.

art accessible to those whose lives were otherwise constrained by menial labor, poverty,
and crowded tenements. What they offered was more "shadow" than "substance," to be
sure, but within modern capitalist society they were as much a source of release and
respite as a source of discipline. Surviving the failure of his antimodern utopian com-
munity, the Guild of St. George, Ruskin created a museum (1875; fig. 10) that aspired to
counter the relentless and dehumanizing forces of modern industry. Giving thought
to where it could do most good, he sited his museum on a hilltop above the steel mills
of Sheffield, a city portrayed by a journalist as "the black heart of the grimy kingdom
of industry" and as a hotbed of "trades-union terrorism."[32] Visitors easily grasped Ruskin's
purpose, describing his museum as a "refreshing and useful respite from daily toil" and
"an ever-fresh oasis of art and culture amidst the barrenness and gloom of an English
manufacturing district."[33] Housed in a modest cottage and run by Henry Swan, a work-
ingman made good, Ruskin's museum was planned as a model for other industrial towns.
Equally concerned about the effects of the new industrial order, Ruskin's contemporary
Matthew Arnold advocated the softening effects of culture, which he famously defined
as "the best that has been thought and said." In his much-read book *Culture and Anar-
chy* (1869), Arnold stressed the value of embracing "all our fellow men"—not least the
"the raw and unkindled masses"—in the "sweetness and light" of high culture in order

to unify society and prevent anarchy. The purpose of culture and its broad dissemination was to bring about the "general expansion of the human family" and to "leave the world better and happier than we found it."[34] Arnold never mentioned museums specifically, but his theories greatly influenced museum culture on both sides of the Atlantic in the late nineteenth and early twentieth centuries.

Meanwhile the direct needs of industry and manufacturing led to the creation of a new type of museum devoted to the applied and decorative arts. The South Kensington Museum (fig. 11) opened in London in 1857 near the site of the immensely popular Great Exhibition of 1851 with the intention of making permanent the exhibition's benefits to the British economy and the general public.[35] By displaying domestic goods (metalwork, pottery, textiles, glass, and so on) rather than rare and costly paintings, South Kensington appealed to the everyday tastes of the public at large even as it provided study samples for manufacturers and aspiring students of design. In other words, the museum was intended to be both popular respite and industrial resource; and in keeping with the positivist spirit of nineteenth-century capitalism, its "profits" would be both concrete and quantifiable. Improved industrial design could be measured in increased sales and exports of British goods, while improved morality among the laboring classes, a by-product of innocent recreation, would be reflected in decreasing rates of childbirth, drunkenness, and crime.

Exterior of the St. George's Museum, Walkley

Interior of St. George's Museum, Walkley

(Bunney's picture of St. Mark's at the far end; Ruskin's drawing of "St. Mary of the Thorn," Pisa, on the stand)

South Kensington's blend of popular appeal, economic relevance, and social reform made it a quintessentially utilitarian product of the Victorian era. Encouraged by the museum's success, founder Henry Cole took his message on the road in the hope that "every centre of 10,000 people will have its museum" and that thereby "the taste of England will revive [among] all classes of the people."[36] Just as medieval England once "had its churches far and wide," so the modern world would have its engines of progress and social uplift in the form of museums.[37] Surveying Britain in the late 1880s, Thomas Greenwood found

10. St. George's Museum, Sheffield, Yorkshire. From *The Works of John Ruskin*, ed. E. T. Cook and A. Wedderburn, vol. 30 (London: George Allen, 1907).

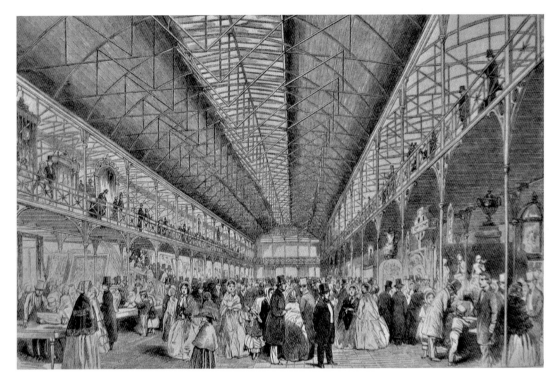

11. South Kensington Museum, original "Brompton Boilers" building.
Engraving from *Illustrated Times*, June 27, 1857.

that Cole's example had been widely imitated. Greenwood's book *Museums and Art Galleries* (1888), among the first texts devoted to the subject, documented the extraordinary spread of museum culture across Britain's industrial heartland. New museums in Sheffield, Preston, Liverpool, Manchester, and Birmingham, the fruit of civic enlightenment and private philanthropy, gave particular cause for optimism. "Unmistakably useful as are a large number of Museums and Art Galleries," Greenwood remarked, "we have, as yet, only touched on the fringe of their possible usefulness."[38]

Despite its great promise and influence on both sides of the Atlantic, the philosophy of the South Kensington Museum fell into disfavor toward the end of the century owing to its evident failure to inspire better-designed products or alleviate the demeaning nature of mechanized labor.[39] Over the years few manufacturers had sent their designers to study at the museum, prompting the painter Hubert von Herkomer to declare that "William Morris had done more in a few years to promote true decorative art than had been done by South Kensington during the whole of its existence."[40] The design school attached to the museum had similarly fallen short of its goals, devolving into a con-

ventional but second-rate art academy for aspiring artists not good enough to be admitted elsewhere. At the same time, the museum's West End location had deterred visits from the artisan class it was designed to serve; in his survey, Thomas Greenwood observed that the museum was patronized mostly by the residents of the well-to-do borough.[41] In 1899 South Kensington was renamed the Victoria and Albert Museum and acquired a new direction, shifting its focus to collecting fine and rare objects and serving an antiquarian public. When the new Musée des Arts Décoratifs opened in Paris in 1905, contemporaries viewed it as an institution forty years too late in coming. "Are we to suppose, as we did in 1865," wrote Paul Vitry, "that such collections of old and new objects will lift the imagination of artists and in themselves produce more bountiful and varied creations? We no longer believe that to be so."[42]

The collapse of utilitarian ideals was felt across a broad spectrum of museum types in the late nineteenth century. Just as the applied arts museum was ill suited to the practical needs of industry, so, as Steven Conn has argued, the static, object-based epistemology of early science and anthropology museums proved incapable of evolving in step with the shift in the natural and human sciences toward theory, experimentation, and contextual analysis.[43] The focus of knowledge production in those disciplines shifted to universities. The sudden obsolescence of the utilitarian Victorian museum even figures in the era's famous dystopian novel, H. G. Wells's *Time Machine* (1895), in which the time traveler stumbles across the abandoned, object-filled ruins of the once magnificent Palace of the Green Porcelain (a reference to South Kensington?) in a postapocalyptic London landscape.[44]

On the eve of the Great Exhibition, Prince Albert had declared that the display of manufactured goods from around the world would bring about the "union of the human race" through improved manufacturing, consumption, and international trade.[45] A half-century later, the expansion of industry and trade was instead blamed for the rise of materialism, international competition, and strife. In *Culture and Anarchy* Matthew Arnold had warned against a creeping materialism that threatened society from within. The "unfettered pursuit" of wealth had produced both "masses of sunken people" that society could ill afford to leave behind and a crass new middle class blinkered by a love of money and material goods. Arnold believed that "the temptation to get quickly rich and to cut a figure in the world" had become a corrosive force in advanced industrial society. The purpose of high culture, therefore, was to reduce the materialism of the bourgeoisie even as it civilized the poor.[46] Arnold's insistence that culture was as important to the middle classes as it was to the poor would have enormous implications for art museums in the twentieth century.

South Kensington's explicit encouragement of industry and consumption ran counter to antimaterial aspirations, but at the same time the world of high art itself was show-

ing disturbing signs of overproduction and conspicuous consumption. Congested exhibitions (like the Salon in Paris), thriving art dealerships, and record prices for Old Master paintings at turn-of-the-century auctions signaled that high art had become a market commodity and source of social distinction. For the German critic and historian Julius Meier-Graefe, writing in 1904, the art exhibition, "an institution of a thoroughly bourgeois nature, due to the senseless immensity of the artistic output . . . may be considered the most important artistic medium of our age," feeding the "mania for hoarding" that afflicts "the famous collectors of Paris, London, and America" like a "disease."[47] Meier-Graefe argued that art had long ago lost its purpose, becoming no more than a bourgeois trifle to "distract tired people after a day's work."[48] Commenting on New York's beau monde in the same year, Henry James famously remarked: "[T]here was money in the air, ever so much money. . . . And the money was to be all for the most exquisite things."[49] Five years earlier, Thorstein Veblen had published *The Theory of the Leisure Class* (1899), a blistering analysis of the indulgence of the rich.

The Social Utility of High Art

The challenge for art museums and collectors entering the twentieth century, then, was to chart a course that simultaneously eschewed claims to practical relevance and avoided the taint of materialism and bourgeois superficiality. Collectors did this by making well-publicized and seemingly selfless donations to local museums or by creating museums of their own. The astronomical sums paid for works of art in the early 1900s by the likes of Isabella Stewart Gardner, Henry Clay Frick, Henry Huntington, and J. P. Morgan were justified by the promise that those objects would soon be returned to the public realm and made accessible to all (the "house" museums of all four collectors date from that time).[50] And museums in turn attempted to forestall complaints of useless excess by rededicating themselves to aesthetic idealism and insisting on the social value of providing nonmaterial nourishment to rich and poor alike.

In Europe, well-established public art galleries needed only to refine their operation (principally culling overstocked collections, as we shall see in chapter 3), but in the United States the situation required a more significant redefinition of purpose. In a country looking to expand economically and eager to prove itself civilized, both European museum models—the utilitarian and the aesthetic—had enjoyed great appeal.[51] The pioneering museums of Boston (founded 1870), New York (1870), Philadelphia (1876), and Cincinnati (1881), together with the great exhibitions at Philadelphia (1876), Chicago (1893), and St. Louis (1904), attempted to fuse the practical impetus of South Kensington with the aesthetic idealism of the Louvre, London's National Gallery, and the Berlin Museum. For example, a visitor to Philadelphia's Centennial Exposition in 1876 noted its

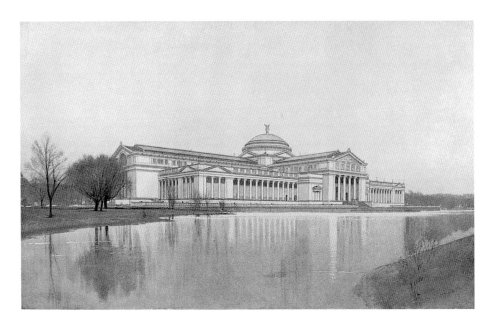

12. Charles B. Atwood, Fine Arts Palace, Chicago Columbian Exposition, 1893.
From Ripley Hitchcock, *The Art of the World* (New York: D. Appleton, 1895).

"union of two great elements of civilization—Industry, the mere mechanical, manual labor, and Art, the expression of something not taught by nature, the mere conception of which raises man above the level of savagery."[52] Cesnola's *Address on the Practical Value of the American Museum* stresses the dual mission of museums, to serve as "a resource whence artisanship and handicraft . . . may beautify our dwellings" and as an exhibition of "the riper fruits of civilization."[53] By the time of Chicago's Columbian Exposition, however, we begin to sense a new role for art in the emerging socioeconomic order.[54] Removed from the din and bustle of new machines and myriad consumer products at the "White City" fairgrounds stood a classical temple dedicated to the fine arts (fig. 12). In the exposition's utopian vision of a prosperous, technology-driven future, the temple by the lake offered respite and the stabilizing comfort of transcendent values.

In the years on either side of 1900, a renewed commitment to aesthetic idealism banished the remains of Victorian utilitarianism and set art museums on a path they still follow. The Metropolitan closed its technical school in 1894, and a decade later J. P. Morgan took over as head of the trustees and imported the English artist and critic Roger Fry to steer the museum toward the fine arts.[55] Fry determined to collect only "exceptional and spectacular pieces," a guideline that has described the Met's buying policy ever since.[56] At Boston's Museum of Fine Arts, like-minded aesthetes Matthew Prichard

and Benjamin Gilman fought to rid the museum of its utilitarian ethos and replace it with a doctrine of high aestheticism. Plaster casts, copies, and the applied arts gave way to original high art representing what Gilman, quoting Arnold, described as the visual equivalent of "the best that has been thought and said in the world."[57] Gilman insisted that "neither in scope nor in value is the purpose of an art museum a pedagogic one,"[58] by which he meant that the worth of an art museum was to be measured not in terms of practical efficiency, as it had been at South Kensington, but in terms of the salutary effects of beauty and human perfection on each and every visitor multiplied across society. Museums "are not now asking how they may aid technical workers," he wrote, but "how they may help to give all men a share in the life of the imagination."[59] The Boston museum was rebuilt at a healthy remove from the city center to signal the shift in purpose (see chapter 2), and a new program of popular instruction stressing aesthetic appreciation was put into operation. When the industrialist Andrew Carnegie created the Carnegie Institute in North America's equivalent to Sheffield, respite, not practical instruction, was uppermost in his mind. "Mine be it to have contributed to the enlightenment and the joys of the mind, to the things of the spirit, to all that tends to bring into the lives of the toilers of Pittsburgh sweetness and light," he said (quoting Arnold) in his dedication speech in 1895.[60] Philanthropic support of high art museums had particular appeal for captains of trade and industry like Carnegie and Morgan, who saw the gift of art as transforming their wealth into aesthetic and spiritual uplift for the people.

Utilitarianism did not vanish altogether, however. It retained a forceful advocate in the person of John Cotton Dana, director of the Newark Museum. Through the first decades of the twentieth century, Dana and Benjamin Gilman sparred over the direction of the museum, with Dana shaping his own institution in opposition to what he termed "gazing museums" like the Met and MFA, whose main function, as he saw it, was to satisfy the "culture fetishes" of the privileged classes.[61] Influenced by Veblen's *Theory of the Leisure Class,* Dana saw the collecting of art and patronage of art museums as exemplifying the "conspicuous waste of the rich" and providing "another obvious method of distinguishing their life from that of the common people."[62] The air of wealth and hushed reverence, combined with the "splendid isolation of a distant park," made the new art museums (such as those in Boston, New York, and Philadelphia, all built in new parks) the antithesis of the useful, community-based institution Dana had dedicated his life to creating. Where Gilman advocated silence and separation as necessary conditions for contemplation and "respite" from which museum-goers emerged "strengthened for that from which it has brought relief,"[63] Dana insisted that museums serve their constituents through active involvement in their everyday lives. Instead of acquiring costly European works of art, whose "utility [was] vastly over-rated" and whose cost was "out of proportion to their value,"[64] Dana thought the modern museum should

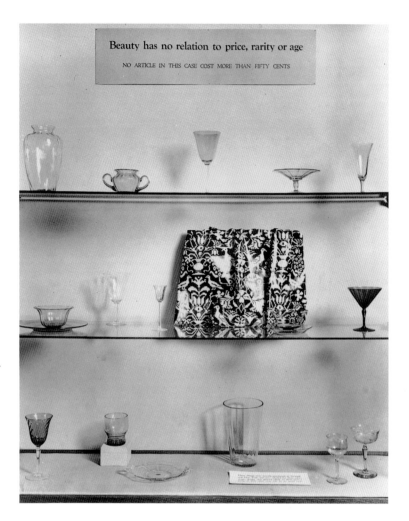

Beauty has no relation to price, rarity or age

NO ARTICLE IN THIS CASE COST MORE THAN FIFTY CENTS

13. Inexpensive Objects exhibition, Newark Museum, 1929. Photo courtesy of the Newark Museum.

be grounded in the community and should respond to its specific needs. In place of "undue reverence for oil paint," museums should showcase "objects which have quite a direct bearing on the daily life of those who support it . . . from shoes to sign posts and from table knives to hat pins."[65] Dana argued that department stores were as useful as museums, and he staged provocative displays of "beautiful" everyday objects available for less than fifty cents at the local dime store (fig. 13).

Dana's writings are being rediscovered and recirculated today by both latter-day disciples in the museum and outside critics, but his impact on art museum practice in his own time was limited.[66] Though Gilman's name has also been largely forgotten, his advocacy of respite and the restorative power of beauty proved far more influential. Gilman answered Dana's rejection of art's limited utility by insisting on the usefulness of the

Benjamin Gilman.

useless: though art might not "bring anything else worth while to pass," it had the power to provide pleasure, virtue, and knowledge.[67] Gilman's model proved more influential in part because it provided a social justification for the collecting and philanthropy of the rich, but it also satisfied middle-class desires in a way Dana's utilitarianism did not. While Dana spoke to everyday material needs, Gilman preached transcendence of the mundane, an aspiration that the leisured classes could more easily afford to pursue. Gilman cared greatly about extending the art museum's franchise to the poor, and designed education programs to that end, but he knew it would not happen overnight; in the meantime his sermons on beauty and transcendence found an eager audience among the already educated, who have ever since provided the art museum's loyal base of support. The eager participation of the bourgeois public in search of spiritual uplift and escape overtook the top-down social engineering ideals of the museum's early sponsors.

Art Museums and War

The art museum's standing as an oasis of high culture in a brutalized, materialistic world increased greatly during and after World War I. Many blamed the war on rising economic competition and its catastrophic death toll on improved technological efficiency. Addressing students at Yale University in the first year of the Great War, the architect Ralph Adams Cram insisted that because art was "the revelation of the human soul, not a product of industrialism," it stood above "the economic and industrial Armageddon that surges over the stricken field of contemporary life."[68] Charles Hutchinson, president of the Art Institute of Chicago, inaugurated the Cleveland Art Museum in 1916 with a speech that hailed art as an antidote to the materialism that had fueled the war and as the means to "increase the happiness of future generations." Fiercely rejecting the doctrine of "art for art's sake," he insisted that art's utility had never been more apparent: "Art for art's sake is a selfish and erroneous doctrine, unworthy of those who present it. Art for humanity and service of art for those who live and work and strive in a humdrum world is the true doctrine and one that every art museum should cherish."[69] A year later, the critic Mariana van Rensselaer wrote that the horrors of war raised the need "to cultivate the idealistic side of human nature" and "to combat the ambitious materialism, the self-seeking worship of 'practical efficiency' which is so largely to blame for the agony of Europe and which threatens the happiness of America also."[70] She held out hope that museums could demonstrate that "material things are not all in all" and "that art, that beauty is not a mere ornament of existence but a prime necessity of the eye and the soul."[71]

Following the war the art museum's emerging humanitarian charge broadened to include greater international cooperation and understanding. Colonial expansion across

the globe, coupled with world's fairs and avant-garde initiatives in the arts (for example, *Japonisme* and the influence of African masks), encouraged growing interest in world art traditions, which reached the public through museums and exhibitions. Roger Fry, an early enthusiast of African and modern art, had insisted in his influential book *Vision and Design* (1920) that an essential part of what was experienced by beholders of a work of art was "sympathy with the man" who brought it into being: "[W]e feel that he has expressed something which was latent in us all the time, but which we never realized, that he has revealed us to ourselves in revealing himself."[72] Ernest Fenollosa, the distinguished scholar of Asian art, wrote: "We are approaching the time when the art work of all the world of man may be looked upon as one, as infinite variations of a single kind of mental and social effort. . . . A universal scheme or logic of art unfolds, which as easily subsumes all forms of Asiatic and of savage art . . . as it does accepted European schools."[73] Our ability and desire to feel in works of art an immediate and profound connectedness with people and communities separated by time and cultural difference made art uniquely suited to act as a bridge between peoples. Art is "a kind of universal solvent, a final common denominator," wrote Cram, "and before our eyes the baffling chaos of chronicles, records, and historic facts open[s] out into order and simplicity."[74] While art constituted a unique record of a people and its beliefs, it was also a vehicle for mutual understanding, and on both scores it had to be safeguarded for the good of humanity. Writing at the end of the war, Benjamin Gilman said that "a penetration of the spirit of other peoples, a recognition of their ideals, and as far as may be a sharing of them" had become "the duty of an international culture" that art museums could help to fulfill.[75]

Just as art museums were assuming a new diplomatic responsibility, forty-one nations ratified the Hague Convention, which included (article 27) the first international accord on the protection of art during war: "In sieges and bombardments all necessary steps must be taken to spare, as far as possible, buildings dedicated to religion, art, science, or charitable purposes, historic monuments."[76] The preservation of artistic heritage took on great importance during World War I as a result of the Hague agreement. For the first time efforts were made to spare cultural sites, including museums, and at the same time to document for propaganda purposes damage inflicted by the enemy. Amid the carnage of a horrific war, both sides claimed a love of art as if seeking absolution for their sins against humanity. As the aggressors, the Germans tried especially hard to trumpet their respect and responsibility for art. Despite inflicting terrible damage on French and Belgian monuments, including Reims Cathedral, they insisted that the "culture of art and war" were "the most extreme opponents conceivable, like two poles which flee from one another just as the principles of preservation and destruction."[77] Puncturing German rhetoric, the French mounted an exhibition in Paris in 1916

of battle-scarred works of art for all to see. The inspector general of French museums, Arsène Alexandre, published a catalog of lost monuments—"many of which were cherished by the whole world"—to demonstrate to posterity that the Germans were "the enemies of humanity."[78] But looking to the future, Alexandre also hoped his book would inspire a greater respect for civilization and "association among all the human races."[79] Alexandre declared that even greater cooperation and a deeper appeal to civilized values were needed in view of the failure of the Hague Convention to prevent the devastation of modern war: "It was not in the name of the Hague Convention, nor the Geneva Convention, that the scholars and artists of France and the civilized world cried in protest [against the destruction of art]. . . . The laws in whose name one protested have no date. . . . [T]he laws of beauty, goodness, and justice are not written in perishable words but in the hearts of individuals and the consciences of nations."[80]

With such sentiments in mind, the League of Nations was formed in the decade following the war. In 1926 the League's International Committee on Intellectual Cooperation created the International Museums Office (forerunner of the International Council on Museums, or ICOM) and two years later sponsored an international congress of popular arts in Prague. Because the popular arts manifested "the deepest currents of civilization,"[81] as the art historian and International Committee member Henri Focillon put it, they could "characterize in a direct and immediate manner a people, region, and locality" and thus, when exhibited together, could demonstrate "the similitude and analogies that link the members of the large human family."[82] One of the organizers of the Prague exhibition wrote: "From the assembly of these documents emerges a human aesthetic—one might even say a 'human ethic'—that rises above the specificity of national aesthetics. Right there, at the tip of one's fingers, one has a common ground for all peoples and all times."[83] Conceived by Focillon, the event was organized by Jules Destrée, first director of the International Museums Office, who fervently believed that art was the "most universal instrument of reciprocal understanding among peoples" and "one of the most effective means of establishing a solidarity of heart and mind in a world dislocated by the war."[84] The League of Nations attempted to institutionalize global understanding a year after the Prague exhibition through the Mundaneum project, which was conceived as a "[c]enter for intellectual union, liaison, cooperation and coordination[;] . . . [a] synthetic expression of universal life and comparative civilization; a symbol of the intellectual Unity of the World and Humanity; [a]n image of the Community of Nations[;] . . . [a] means of making different peoples known to each other and leading them into collaboration; [a]n Emporium of works of the spirit. . . . The desire is: That at one point on the Globe, the image and total signification of the World may be seen and understood."[85] The symbolic heart of the unrealized Mundaneum complex was Le Corbusier's "World Museum" (fig. 14), designed as a square ziggurat, ancient

and fundamental in form, to house "all the world's civilizations" laid out chronologically from prehistoric times to the present. (The simultaneous discovery of prehistoric painted caves in France and Spain gave art added weight as a transcendent human document.) Against the backdrop of recent turmoil, the World Museum would allow visitors to behold "the unchanging soul of humanity in the form of artworks which are, for us, immortal . . . , unadulterated witnesses."[86] Across the Atlantic at the same time, DeWitt Parker expressed similar ideas in a lecture at the Metropolitan Museum:

> Art is the best instrument of culture. For art is man's considered dream; experience remodeled into an image of desire and prepared for communication. . . . Art puts us into touch with the desires of other classes, races, nations. Through art we not only know what these desires are, but we are compelled to sympathize with them; for the dream is embodied in such a way as to make us dream it as if it were our own. The barrier between one dream and the dream of another is overcome. The understanding of other nations, which by any other path would be long and difficult, is immediate through art. . . . Even as love creates an instant bond between diverse man and woman, so does art between alien cultures.[87]

Though art and culture had failed to prevent the Second World War, they were called upon to soften its effects and remind people of what was worth fighting for. During the darkest days of the war, London's National Gallery symbolized the endurance of a people—and of civilization—by hosting daily lunchtime concerts under the leadership of Dame Myra Hess (fig. 15).[88] "This was what we had all been waiting for—an assertion of eternal values," the gallery's director, Kenneth Clark, later recalled.[89] The evacuation of London's museums as a precaution against German bombing only prompted a heightened sense of art's soothing power. "Art is one of the simplest and most effective ways of taking a man 'out of himself' and making him forget the trials and troubles of ordinary life, and especially life in war-time," wrote J. B. Manson, a former director of the Tate Gallery in 1940, regretting the sudden termination of normal museum functions.[90] Two years later a letter to the London *Times* pleaded for access to the nation's treasures notwithstanding terrible bomb damage to the capital: "Because London's face is scarred and bruised these days, we need more than ever to see beautiful things. . . . Music lovers are not denied their Beethoven, but picture lovers are denied their Rembrandts just at a time when such beauty is most potent for good."[91] Soon thereafter the National Gallery initiated its highly popular "Picture of the Month" exhibitions, featuring a masterpiece brought back from safekeeping in the mines of Wales. The gallery invited public input on the selection of pictures and duly received a large number of suggestions. "These make it perfectly clear," wrote Kenneth Clark, "that people do not want to see Dutch painting or realistic painting of any kind: no doubt at the present time they are anxious

14. Le Corbusier, plan of the Musée Mondial, 1929. Drawing.
© 2006 Artists Rights Society (ARS), New York/ADAGP, Paris/FLC.

15. Dame Myra Hess in concert at the National Gallery, London, 1939. From *Museums Journal*, October 1939.

to contemplate a nobler order of humanity."[92] The first three shows featured Titian's *Noli Me Tangere*, El Greco's *Purification of the Temple*, and Botticelli's *Mystic Nativity*. Thereafter the selection became more eclectic and included some of the gallery's most beloved works, including Constable's *Hay Wain*, Velázquez's *Rokeby Venus*, Bellini's *The Doge*, and a Rembrandt self-portrait.

During the war years Frank Lloyd Wright began designing his Guggenheim Museum (1943–59; fig. 16) as a monument to the transfiguring power of art in the modern world. The museum's founder, Solomon Guggenheim, guided by his adviser Hilla Rebay, believed that his collection of "nonobjective" (abstract) art embodied a universal language that could lead to a "brotherhood of mankind" and a "more rhythmic creative life and . . . peace."[93] As Rebay put it to Wright, the new art would usher in a "bright millennium of cooperation and spirituality, . . . understanding and consideration of others. . . . Educating humanity to respect and appreciate spiritual worth will unite nations more firmly than any league of nations." "Educating everyone . . . may seem to be Utopia, but Utopias come true."[94] As Neil Levine has written, Wright responded to Rebay's and Guggenheim's belief that "art's utopian social values were primary" by creating what he called an "optimistic ziggurat" designed to foster communication and community under a magnificent dome of light.

After the war, museums and exhibitions were asked to help rebuild the human spirit. A 1946 article in *Museum News* declared: "The champion of man turns out to be man, and it is in the arts that we find the mirror of human dignity, a microcosm both of order and serenity, of vitality and valor."[95] At the first meeting of the American Association of Museums after the war, the poet and Librarian of Congress Archibald MacLeish delivered a paean to the power of museums to create a better world. Rapid advances in destructive technology made ineffectual any "physical defenses against the weapons of warfare," he wrote. "There are only the defenses of the human spirit."

> The work to be done is the work of building *in men's minds* the image of the world which now exists in fact *outside* their minds—the whole and single world of which all men are citizens together. . . . What is required now is . . . communication between mankind and man; an agreement that we are, and must conduct ourselves as though we were, one

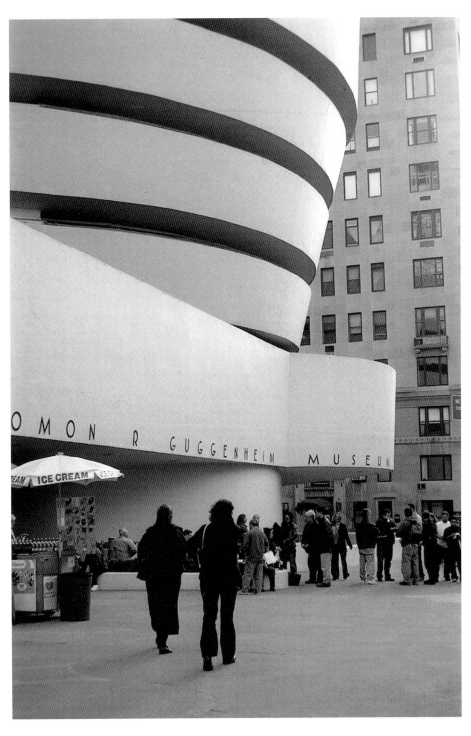

16. Frank Lloyd Wright, Guggenheim Museum, New York, 1959.

kind, one people, dwellers on one earth. . . . The world is not an archipelago of islands of humanity divided from each other by distance and by language and by habit, but one land, one whole, one earth. . . . It is precisely to their power to communicate such recognitions that the great cultural institutions of our civilization owe their influence. . . . The great libraries and the great galleries . . . demonstrate to anyone with ears to pierce their silence that the extraordinary characteristic of human cultures is their human likeness.[96]

MacLeish understood that "the conception of the gallery or the museum as the glass in which the total community of the human spirit can best be seen" could too easily become a "banal slogan of rhetorical idealism," but he insisted that "there never was a time in human history when it was more essential to take [the] simple meaning [of that idea] and to understand it and to act."[97]

Research is still needed to discover in what ways art museums responded to MacLeish's call to action. How typical was the "Wings around the World" program initiated in 1948 by the Minneapolis Institute of Art to teach high school students "the background, ideas, and cultures of the many peoples who have contributed to contemporary civilization" and "illustrate through works of art, the sociological, economic, political, and aesthetic ideals which constitute the heritage of all religious and racial groups"?[98] The most famous exhibition of postwar humanism was The Family of Man, which opened at the Museum of Modern Art in New York in 1955 and subsequently toured the world in various formats for a decade (fig. 17). When the tour came to an end, it had been seen by some eight million people in thirty-seven countries; the book accompanying the exhibition is still in print and has sold over three million copies.[99] The Family of Man used contemporary photographs, many by unknown photographers, to enhance its immediacy and relevance and featured images of ordinary people from around the globe engaged in universal human activities: working and at play, laughing and crying, giving birth and dying. The wall panel at the entrance read:

> There is only one man in the world / and his name is All Men.
> There is only one woman in the world / and her name is All Women.
> There is only one child in the world / and the child's name is All Children.
> A camera testament, a drama of the grand canyon of humanity, and epic woven of
> fun, mystery and holiness—here is the Family of Man![100]

The Family of Man was the last of a series of photomontage exhibitions curated at MoMA by Edward Steichen and dating back to World War II (Road to Victory, Power in the Pacific, Airways to Peace), but here seductive display strategies honed in the service of war were mobilized to support the common cause of life and peace. For Steichen, the exhibition was conceived "as a mirror of the universal elements and emotions in the everydayness of life—as a mirror of the essential oneness of mankind throughout the

17. Installation view of The Family of Man exhibition, Museum of Modern Art, New York, 1955. Photo: Digital Image © The Museum of Modern Art/Art Resource, New York.

world"[101] and thus represented "an antidote to the horror we have been fed from day to day for a number of years."[102] As a widely circulated photo exhibition and illustrated book, *The Family of Man* realized André Malraux's dream that museums and photography would advance the communication of universal values. In his famous postwar book *Museum without Walls* (1951, translated into English 1953), Malraux hailed the ability of the photograph and the museum to minimize differences of scale, media, and culture in the interests of expressing instead "the mysterious unity of works of art" and their essential value as symbols of "a fundamental relationship between man and the cosmos."[103]

During the Cold War decade of the 1950s, art museums in the West supplemented the rhetoric of universal humanism by promoting art as the embodiment of freedom and creativity. When the Guggenheim opened in 1959, it was described by President Eisenhower (in a letter read aloud at the opening) as "a symbol of our free society, which welcomes new expressions of the creative spirit of man."[104] During that decade, the ab-

stract tradition celebrated by the Guggenheim gained legitimacy as the expression of bold individualism and the antithesis of the censorship and social-realist propaganda of fascist and communist regimes.[105] Moreover, Western museums countered the heavy-handed ideological use of text and interpretation in Soviet and Nazi museums and art exhibitions before the war (notably the 1937 Degenerate Art show in Munich, see chapter 3) by minimizing wall labels and interpretation and allowing works of art to "speak for themselves." A yearning for freedom from all ideological systems became the prevailing ideology of the postwar generation in the West, as we see, for example, in a passage from Walter Pach's 1948 book *The Art Museum in America:* "Today we must leave every person free to form his own convictions, and the way to do that is to concentrate on the collections themselves, allowing the masters and the schools to say their say, independent of interpretations by educators."[106] Privileging aesthetics over ideology or contextual analysis had long been the policy of MoMA under Alfred Barr, whose tenure at the museum stretched from 1929 to 1967 (and who served as director from 1929 to 1943). From the 1930s, MoMA's pioneering exhibitions and catalogs on modern art "relieved formal analysis of any interpretive responsibility by conveying . . . only what could be seen," in the words of Barr's recent biographer.[107] Barr's successor at MoMA, William Rubin, was equally committed to a "wordless history of art" that allowed "the esthetic values of the pictures, their analogies, cross-relationships and historical filiations . . . to tell [their] own story."[108] In the 1950s and 1960s MoMA emerged as both the showcase for advanced Western art and, as we shall see in subsequent chapters, the model for modern museology.

The Return of Social Relevance

Nevertheless, the easy spread of humanist rhetoric in the West, carried along by postwar optimism and Cold War anxiety, did not go uncontested. Seeds of resistance may be found in reactions to its public manifestations. In a 1953 review of Malraux's *Museum without Walls,* for example, Francis Henry Taylor, director of the Met, rejected the author's argument as a misguided form of escapism born of war-inspired fatalism about the human condition: "[Malraux] finds mankind wanting and seeks refuge from the tragic inadequacy of our society in the artifacts which man has left behind him." "Maybe we can find comfort in the contemplation of a work of art but not necessarily a solution," Taylor continued, "for the emptiness is of our own creation and cannot be filled with fragments of stone and canvas from exotic lands."[109] Tired and evidently disillusioned by the rhetoric of "gazing museums," Taylor resigned from the Met soon after writing his review. No less wary of art's beguiling potential, Roland Barthes attacked the Family of Man exhibit when it came to Paris in the mid-1950s for its sentimental portrayal

of a generalized humanity shorn of diversity. For Barthes, a superficial assurance that we are at bottom all the same obscured recognition of real differences that stood in the way of true understanding and justice: "Everything here, the content and appeal of the pictures, the discourse which justifies them, aims to suppress the determining weight of History: we are held back at the surface of an identity, prevented precisely by senti- mentality from penetrating into this ulterior zone of human behavior where historical alienation introduces some 'differences' which we shall here quite simply call 'injus- tices.'"[110] The Family of Man relied on, and bolstered, a "myth of the human 'condi- tion,'" a myth dangerous in its failure to reveal the impact of what Barthes meant by History—the realities of race, politics, gender, creed, and class—on people's lives:

> Any classic humanism postulates that in scratching the history of men a little, the rela- tivity of their institutions or the superficial diversity of their skins (but why not ask the parents of Emmet Till, the young Negro assassinated by the Whites [lynched in Missis- sippi in 1955 for whistling at a white woman] what *they* think of *The Great Family of Man?*), one very quickly reaches the solid rock of a universal human nature. Progressive hu- manism, on the contrary, must always remember to reverse the terms of this very old imposture, constantly to scour nature, its "laws" and its "limits" in order to discover His- tory there, and at last to establish Nature itself as historical.[111]

In the 1960s exposing the "imposture" of humanism and redressing the injustices of "History" became in effect the motivating purpose of social activism and critique, which included the civil rights and feminist movements, student protests on both sides of the Atlantic, and development of critical theory in academe. In that politically charged en- vironment, the proclaimed autonomy of art and disengaged stance of art museums struck social activists and avant-garde artists as unacceptable establishment complacency and elitism. All of a sudden the postwar tranquillity of art museums was rudely disturbed by new calls for social relevance, community outreach, and heightened self-awareness. Bourgeois assumptions about public access to high culture were exploded by the French sociologist Pierre Bourdieu, whose important book *The Love of Art* (1966) demonstrated that aesthetic taste and judgment were the product of class and education (see chapter 4).[112] Backed by Bourdieu's empirical research, activists behind the Paris riots of 1968 called for a greater democratization of culture. A year later, President Pompidou an- nounced plans for the creation of a new multipurpose cultural institution at the heart of Paris, realized as the Pompidou Center in 1977 (see chapter 2). Also motivated by the radicalized political environment, revisionist art history began to challenge the de- politicized, formalist orthodoxy of Barr, Clement Greenberg, and their followers. Art entered a "postmodern" phase by renouncing formal purity, engaging with politics and mass culture, and "erupting" with language to make its politics perfectly clear.[113] In the late 1960s art museums became the target of activist artists who used the visual arts as

18. Hans Haacke, *MoMA-Poll*, 1970. © 2006 ARS, New York/ VG Bild-Kunst, Bonn.

a vital medium of popular and political communication. In 1969 various radical groups—the Art Workers' Coalition (AWC), Women Artists in Revolution (WAR), and the Black Emergency Cultural Coalition (BECC)—led protests in front of New York museums against the Vietnam War and the underrepresentation of minority artists.[114] Visitors to MoMA's Information show the following year were greeted by Hans Haacke's *MoMA-Poll* (fig. 18), which linked the museum and its administration, through trustee Nelson Rockefeller, to President Nixon's controversial policy in Indochina. Rockefeller, a four-term Republican governor of New York, was running for reelection that year. The poll asked: "Would the fact that Governor Rockefeller has not denounced President's Nixon's Indochina policy be a reason for you not to vote for him in November?"[115] Hilton Kramer, chief spokesman for the cultural right, singled out Haacke's work as a sign of the dangerous and lamentable "politicization of art."[116]

In New York calls for action and "relevance" found a powerful voice within the museum world in Thomas Hoving, the maverick young director of the Met. In an address to the American Association of Museums in 1968, Hoving called on his colleagues to "get involved and become far more relevant," to "re-examine what we are, continually ask ourselves how we can make ourselves indispensable and relevant."[117] Hoving then set an example of social relevance by staging the provocative exhibition Harlem on My Mind: Cultural Capital of Black America, 1900–1968. Hoving prepared the museum faithful for what was to come through the pages of the Met's monthly bulletin: "On the eighteenth of this month [January 1969] The Metropolitan Museum of Art will open an exhibition that has nothing to do with art in the narrow sense—but everything to do with this Museum, its evolving role and purpose, what we hope is its emerging position as a positive, relevant, and regenerative force in modern society."[118] Justifying the exhibition in advance, he resurrected the commitment to "practical life" advocated earlier by Dana and Henry Cole, only now practicality was concerned, not with industry or commerce, but with politics and activism. "'Practical life' in this day," he wrote, "can mean nothing less than involvement, an active and thoughtful participation in the events of our time."[119] Though Harlem on My Mind borrowed Steichen's familiar mass media format and though the show was dedicated to buttressing, in Hoving's words, "the deep and abiding importance of humanism,"[120] it made the mistake of coming down from an abstract plane of global humanity to the racially tense streets of New York City in the late 1960s. Some critics complained about the presence of photography in a high art museum, but what most disturbed the museum's loyal constituents, surely, was the introduction of race and social issues where they didn't belong. Instead of respite, Hoving offered a dose of social reality; in place of outright hope and celebration, he prompted reflection on social inequity, black-white relations, and an uncertain future.

For the majority of Hoving's professional peers, not to mention local critics and museum-goers, what Barthes meant by History was unwelcome in an art museum. In an essay prompted by the exhibition, entitled "What's an Art Museum For?" Katharine Kuh answered her own question by rejecting Hoving's social justification and suggesting instead that museums "offer us islands of relief where we can study, enjoy, contemplate, and experience emotional rapport with man's finest man-made products." As for the Harlem show, she concluded: "The exhibition shows us the pain, but where are the fantasies?"[121] A survey commissioned by ICOM in the same year as Harlem on My Mind revealed a museum-going public hostile to an overlap of art and "everyday" issues. By a clear margin, "images overtly or otherwise suggestive of catastrophe, human or social decay or other negative aspects of life" were held to be "offensive" and "out of place" in art and museums.[122] There was plenty to celebrate in Harlem's history but also plenty to generate feelings of anxiety and guilt in a predominantly white, middle-class audience.

Hoving knew Harlem on My Mind would be controversial—indeed, he wanted it to be "an unusual event," "a confrontation" that would change the "lives and minds" of its viewers "for the better."[123] According to the show's organizer, Allon Schoener, he and Hoving "saw the exhibition as an opportunity to change museums,"[124] "the first step toward rethinking and expanding our concepts of what exhibitions should do."[125] Even the *Bulletin* announcing the show broke with precedent by featuring on its cover not a precious new acquisition but a young African American boy face turned upward (fig. 19), as if looking forward to a better tomorrow. Intoxicated by the radical air of the late 1960s, Hoving had a vision of museums on the move: "An art museum today can neither afford to be, nor will it be, tolerated as silent repository of great treasures. . . . We are deeply committed by conscience to getting involved . . . in the ferment of the times. . . . We intend to shake off the passivity that renders too many museums unresponsive and by default almost irresponsible."[126]

With his "modishly-longer hair"[127] and knowing references to "happenings," zonked-out hippies, and SDS (Students for a Democratic Society), Hoving might have been in touch with the latest on the streets of New York, but he was out of step with the conservatism of his fellow museum directors elsewhere in the country. The Harlem exhibition sparked a swift and decisive backlash in the form of a redoubled affirmation of the value of the art museum as a haven of nonpolitical aesthetic contemplation. In the view of Hoving's antagonists (there were few supporters among his peers, it would seem), recent social turmoil, political instability, and war had made the art museum's function as respite from the world more relevant than ever. The chief spokesman for the disengaged museum was Sherman Lee, director of the Cleveland Museum of Art. In a speech delivered while the Harlem exhibition was still open, Lee insisted that "[t]he art museum is not fundamentally concerned with therapy, illustrating history, social action, entertainment or scientific research. . . . The museum is . . . a *primary source* of wonder and delight for mind and heart."[128] From the marble halls of Washington's National Gallery, John Walker concurred: "I am indifferent to [the art mu-

19. Cover of the *Metropolitan Museum of Art Bulletin* announcing the show Harlem on My Mind (January 1969).

seum's] function in community relations, in solving racial problems, in propaganda for any cause."[129] In 1971 the Guggenheim Museum canceled an exhibition by Hans Haacke (including a piece attacking a New York "slumlord") because of policies that "exclude active engagement toward social and political ends."[130] Leaders of the art world convened a few years later—with Lee but without Hoving—for a summit on the future of the museum and concluded: "Art museums should not become political or social advocates except on matters directly affecting the interests of the arts."[131] As the dust from the Harlem controversy settled, museum directors rallied around the position concisely put by George Heard Hamilton, director of the Clark Art Institute, that art museums were "most psychologically useful" to society by being *irrelevant* to the world outside; it was precisely in art's removal from daily life and the "effacement" of its social meanings that its "life-enhancing difference" could be felt.[132] Once it was clear that art museums were not about to follow Hoving's lead, the soothing "irrelevance" of timeless art reasserted itself in museum discourse. Witness a talk given in 1974 by Otto Wittmann, director of the Toledo Art Museum, entitled "Art Values in a Changing Society":

> In these precarious and unsettled times in which we all live, there is a great hunger for a sense of lasting significance. . . . The very nature of art and of the museums which preserve and present works of art reassures people of the continuity of human vision and thought and of the importance of their place in the vast stream of significant developments over centuries of time. A Mayan figure in Manhattan, a T'ang figure in Toledo[,] even though seemingly irrelevant to our culture today, can tell us much about humanity and human relationships. . . . These silent witnesses of the past can bridge the gap of time and place if we will let them. . . . The universal truths of all art should be shared.[133]

Activism of the 1960s produced the multiculturalism and outreach initiatives that have become the norm in museums in the decades since, and in terms of programming and audience museums are now more broadly representative than they were in 1970, but a reluctance to engage in potentially polemical political discourse remains in place. A number of prominent exhibitions in recent decades illustrate the broad turn in museum policy toward what can be called a depoliticized global humanism. A notable example was Jean-Hubert Martin's Magiciens de la Terre (Magicians of the Earth), held at the Pompidou Center in 1989. In that sprawling global survey, works by hundreds of contemporary artists from around the world, floating free of their original contexts and significations and endowed alike with what Martin called an "aura" and "magic" that set true art apart, were brought together on equal terms to further "a culture of dialogue."[134] Building on Malraux, Martin designed the exhibition to substantiate the maxim that the "multiplication of images around the world is one of the symptoms of the tightening of communication and connections . . . among the people of the planet." Martin

had also read his Barthes and was aware of the postcolonial politics of difference, so he understood that his selection and display of objects necessarily reflected his own European perspective and obscured "the complexity of certain local situations." His intention was not to speak for other cultures, for he realized no one could do that; rather, it was to celebrate "the diversity of creation and its multiple directions." Inevitably Magicians of the Earth revealed a problematic tension at the heart of much postmodern museology: although, as Martin confessed, it is "difficult, if not impossible to understand the cultural reality of . . . other cultures," it is asserted that exposure to what we can never fully understand will nevertheless foster appreciation, respect, and eventually dialogue. The tentative solution offered to this dilemma of otherness is the possibility—the hope— that the strange may be made familiar through contact mediated by the museum.

Cultural dialogue was likewise the goal of two high-profile blockbusters organized by the late J. Carter Brown in the 1990s: Circa 1492, staged at the National Gallery, Washington, D.C., in 1992 (on the five-hundredth anniversary of Columbus's "discovery" of America), and Rings, Five Passions in World Art, organized in conjunction with the 1996 Olympic Games in Atlanta. As we might expect of such establishment events, both were uncomplicated by Martin's postmodern anxiety, and both were criticized for their presumptuous (Euro-American) visions of kindred art forms and suppression of "History." In a review of Circa 1492, Homi Bhabha, a leading postcolonial critic, exposed the hubris of Carter Brown's visual parallels between European and non-European traditions. The exhibition's staged cross-cultural comparisons, though celebratory and well intentioned, omitted reference to the historical processes at work in 1492 that transformed, for example, Inca and Aztec ritual objects from "signs in a powerful cultural system to . . . symbols of a destroyed culture" fit only for museum collection and display.[135] Bhabha further lamented that the museological maneuvers characteristic of such exhibitions reduced museum visitors to "connoisseurs of the survival of Art" and unwitting "conspirators in the death of History." But for Carter Brown such concerns, had he been aware of them, would surely have seemed insignificant next to art's potential to heal a tense and divided world. "What kind of a world can we look forward to?" he asked in the introduction to the Rings catalog.[136] "What vision, what idealism, what aspects of our nature can we look to for a world of harmony and interconnectedness?" The answer, of course, lay in shared emotional experience revealed in, and communicated by, the world's art traditions: "We must strive to integrate cultural values into a concept of the whole person and explore, with openness and sensitivity, the importance—I would say the centrality—of our emotional lives and the riches that await us in receiving, through art, affective transmissions from across great gulfs of space and time."[137] Bhabha and others have argued that such museum displays perpetuate Euro-American values and foreclose the possibility of seeing the objects and cultures of others through a different

lens. Carter Brown's critics call for an alternative museology that, if not openly critical of Western ideology and practice, at least employs other, more culturally sensitive and specific ways of displaying and interpreting objects. But universal humanism remains the steady establishment response to the fracturing potential of postcolonial critique. Where the new museology calls for alternative voices, mainstream art museums insist all the more vehemently on the healing, conciliatory power of a transcultural dialogue that they are so well suited to facilitate.

The trope of dialogue has even penetrated the building programs of recent museums. An early vision statement for the new de Young Museum in San Francisco (by then-director Harry S. Parker III, Hoving's director of education at the Met in the late 1960s) described the museum in Golden Gate Park as a "common ground where—through art—the usual boundaries that separate us from each other: culture, creed, race and all the others, become bridges that connect us. . . . This uncompromising dedication to access will be integrated into the very structure of the building itself."[138] We learn that Zaha Hadid, the Iraqi-born, London-based architect, designs her buildings, including museums, "for a culture without national boundaries."[139] New museum buildings and cultural complexes, in addition to revitalizing moribund urban centers and local

20. Daniel Libeskind, Jewish Museum, Berlin, 1998.

economies, are now vested with the power to invoke a transcendent culture—"an al-
most musical sense of harmony with city life around the world"—that will ease the process
of globalization.[140] Hope is inscribed even in the architecture of museums commem-
orating the most dystopian of modern events, the Holocaust in World War II. In attempting
to communicate traumatic experience through the manipulation of built form, space,
and light, the Jewish Museum in Berlin (fig. 20) and the Holocaust Museum in Wash-
ington, D.C., aspire to keep memory alive and prevent history from repeating itself.

Meanwhile the debate about social relevance continues. Carrying on the activism that
began in the 1960s, museum critics call for a new museum paradigm that is "people-
centered and action oriented" and dedicated to "promoting social change."[141] From within,
museum educators have espoused social engagement through published tracts such as
Excellence and Equity (1992), which boldly asserts (echoing Hoving) that museums can
"no longer confine themselves to preservation, scholarship, and exhibition independent
of the social context in which they exist."[142] Through education and creative program-
ming, they must instead foster "the ability to live productively in a pluralistic society
and to contribute to the resolution of the challenges we face as global citizens." Philippe
de Montebello at the Met has responded in turn that such rhetoric, with its "misplaced
emphasis . . . on social activism," has no place in an art museum.[143] At the same time,
however, Montebello and others insist that museums play a vital social role by preserv-
ing and displaying transcendent masterpieces for quiet contemplation in a space set
apart from mundane concerns. Montebello writes: "I know it has become popular to
suggest that museums should not be removed from everyday experience, indeed that
they should blend in as much as possible. . . . I view our role quite differently; in fact,
as the very opposite. In our largely prosaic and materialistic world, where the factitious
holds sway, it is the mystery, the wonder of art, that is our singular distinction and that
our visitor seeks. So, it is precisely by distancing the visitor from what Sartre called 'the
monotonous disorder of daily life' that we best serve that visitor."[144]

9/11 and Beyond

Heightened world tensions after 9/11 have reenergized the discourse of disengaged global
humanism—the idea that museums serve society by offering space apart for the con-
templation and celebration of essential human qualities manifested in works of art. Im-
mediately following September 11, museum-goers demonstrated a strong desire for tran-
scendence. "In the days following the terrorist attacks two weeks ago, there were reports
of people flocking to museums," announced the radio broadcast *Here and Now* in late
September 2001.[145] When the Metropolitan Museum reopened uptown two days after
the attack on the World Trade Center, eight thousand people showed up, a record for a

day without a blockbuster exhibition. Asked to explain the sudden surge in attendance, museum visitors and staff stated it had to do with the power of art to uplift and soothe in times of darkness, the power of museums to offer a consoling "big" picture of human survival and creativity in a space free from geopolitical strife. Questioned by the same reporters, random visitors to Boston's Museum of Fine Arts replied: "I felt very strongly that art . . . is very important to my healing process. . . . [It is] a calm center in the midst of this chaos and real uncertainty and fear; . . . there's peace in it," and "I felt it was my aesthetic obligation to validate the culture we live in, and to get a little aesthetics, a little uplifting. . . . I want to be inspired and art is the best thing there is." Others said the museum was an "escape from everything that's been going on," where "things are permanent . . . stable, no matter what's going on in the outside world."[146]

In an open letter from "The Metropolitan Museum of Art Family to Your Family" shortly after 9/11, Director Philippe de Montebello wrote: "At a time of loss and profound dislocation, art museums offer a powerful antidote to hopelessness: their collections testify to the permanence of creative aspiration and achievement, and offer solace, affirmation, and a spirit of renewal so essential to our recovery. It remains the Met's responsibility—indeed, the very essence of its 131-year-old mission—to provide the public the opportunity to nourish the human spirit. For great art from all parts of the world can enlighten, inspire, awe, and ultimately, help heal."[147] Similarly, the Boston MFA offered free admission for the month of September. Echoing visitors to his museum, director Malcolm Rogers issued the following press statement: "Great works of art remind us of the enduring value of all that is best in the human spirit. We open the MFA's doors in hopes that these works of art . . . can provide solace and comfort at this time."[148] A year later, on the first anniversary of the terrorist attacks, the Met created a self-guided tour of selected works chosen to reveal "humankind's indomitable spirit." "Located throughout the museum, the works represent every culture and every time in history, and communicate the universal emotions of despair and hope, mourning and recovery, loss and renewal."[149]

In the years since 9/11 multicultural dialogue has become a leitmotif of art museum discourse. Witness the following pronouncement from James Cuno, an influential voice on the international museum scene: "The museum is about the world. I feel very, very strongly that the social purpose museums have is to breed greater familiarity with the rich diversity of the world's cultures. With greater familiarity comes greater understanding."[150] The philosopher Kwame Anthony Appiah has lent his support to the cause. In *Cosmopolitanism: Ethics in a World of Strangers* (2006) he encourages us to adopt a "cosmopolitan perspective," arguing that "we need to develop habits of coexistence," to "learn about people in other places, take an interest in their civilizations . . . because it will help us get used to one another."[151] Museums play an important role, he says, be-

cause "[c]onversations across the boundaries of identity—whether national, religious, or something else—begin with the sort of imaginative engagement you get when you read a novel or watch a movie or attend to a work of art that speaks from some place other than your own."[152]

Not surprisingly, the art of the Middle East and Asia in particular has taken on added significance in recent years. Milo Beach, former director of the Smithsonian's Sackler and Freer Galleries in Washington, had this to say in an appraisal of two East-West cultural events (the exhibition The Legacy of Genghis Khan and the Silk Road Project, led by Yo-Yo Ma): "Over the past decades, museums have come to play multiple roles in our lives, but surely none is more important than their ability—in the current period of international turmoil and political realignments—to connect each of us with what other people value culturally and artistically. . . . Given the internationalism of the world today, Americans deserve a rich, more balanced picture of other countries and peoples. . . . It seems clear, therefore, that the relevance and potential of museums has never been greater than it is today."[153]

Beach was writing in a U.S. newspaper for a North American audience, but the perceived need for international understanding and exchange in our increasingly interconnected world is now broadly shared. In 2005 a Saudi prince donated $20 million to create a new Islamic wing at the Louvre in the belief that "after 9/11, an increased appreciation of Islamic art can help bridge a cultural divide." In accepting the gift, the French culture minister said the Louvre was not simply a passive collection of objects: "It is by now an essential instrument for the dialogue of cultures and the preservation of their diversities. In a world where violence expresses itself individually and collectively, where hate erupts and imposes its expression of terror, you dare to affirm the conviction that is yours—that is ours—that the dialogue of peoples and cultures, the richness of patrimonies, the values of sharing are the responses of intelligence to the bitter experience of conflicts."[154] In August 2005, the Louvre took out a full-page color advertisement in the New York Times announcing the new wing. At the top of the page appeared a Quranic verse: "And we have made you into nations and tribes that you may know one another."[155] At the same moment across the channel in Britain, on the heels of deadly terrorist attacks in London, the Commission on African and Asian Heritage delivered a report calling on museums and school textbooks to reflect the nation's cultural diversity in the interests of greater unity. When minority culture is overlooked, it warned, "the outcome can be debilitating, leading to disaffection and disillusionment, a sense of disenfranchisement." Endorsing a more active role for museums in civic life, London's mayor said Britain's minorities must "see their achievements, contributions and historical presence reflected in our museums, archives, galleries and school textbooks."[156] Back in France a year later, French President Jacques Chirac sounded a sim-

ilar note at the opening of the Musée du Quai Branly, devoted to non-European art: "It aims to promote among the public at large a different, more open and respectful view, dispelling the clouds of ignorance, condescension and arrogance which in the past have often nourished distrust, contempt and rejection." In short, the new museum offered "an indispensable lesson in humanity for our times."[157] In 2007 the Louvre took another bold step by entering into a long-term partnership with the United Arab Emirates to create the Louvre Abu Dhabi, envisaged as a universal museum with exhibits encompassing all historical periods and cultures. In the words of His Highness Sheikh Mohammed Bin Zayed Al Nahyan, "The Louvre Abu Dhabi will empower a new era of international cultural cooperation." The minister leading the French delegation stated that the museum resulting from the collaboration would "foster cultural dialogue between East and West."[158]

Can art museums really foster global understanding and help bring about world peace, or is this merely rhetoric designed to soothe visitors and donors and fend off the critics? Since the outcomes of such ambitions are not measurable, we shall never know. But what cannot be measured also cannot be rejected, which leaves hope alive and the ideal compelling. Museums need ideals, and global humanism has served as one for a good century. Instrumentalists argue that high-minded ideals obscure more pressing issues of access and social value. The proper goal of museum policy, they say, should be to increase the number and diversity of people who visit. But this raises the question of why it matters that people go to art museums in the first place. What is it that people get from a visit to their local art museum? What value does access to high culture have? These have proved difficult questions to answer; we lack adequate language to justify the social importance of art. At the same time, the challenge for the universal humanists will be to think through how museums can deliver on their cosmopolitan promise. Museums have shown little enthusiasm for what Hoving meant by "active and thoughtful participation in the events of our times," so the question remains as to what cosmopolitanism will amount to and who will get to define its terms of reference. Politics compromise the quality of disengaged aesthetic contemplation that the public has come to value and that the museum's sponsors are content to pay for. Even if art museums do nothing more than offer us spaces of tranquil beauty in which to be moved by the creativity and humanity of peoples far removed in time and place, should we be disappointed? For better or worse, a celebratory but depoliticized global humanism may be as much as we can expect from our art museums in the years to come.

First delight, then instruct. **Karl Friedrich Schinkel and Gustav Waagen (1828)**

Architects in some way are always looking for their Atlantis. A good
architect is utopian, and as an architect you cannot escape from the duty to try
to change the world . . . the attitude of people in social life and public life.
Renzo Piano (2002)

2 ARCHITECTURE

Depending on your point of view, the opening of Frank Gehry's new Guggenheim Museum in Bilbao in 1997 (figs. 21–22) was either the best or the worst thing that had happened in the art world in many years. Many architects and architectural critics hailed the museum as one of the greatest buildings, if not *the* greatest building, of the twentieth century. Reviews resorted to hyperbole—spectacular! breathtaking! brilliant!—in an effort to convey the sublime scale, soaring internal spaces, and undulating titanium facades glinting in the sun.[1] Herbert Muschamp, in the *New York Times*, declared: "Architecture will never be the same. Cities will never be the same."[2] No less miraculous than the building itself was its effect on the forlorn city of Bilbao, a faded industrial center suddenly reborn as a cultural destination. The number of visitors exceeded all expectations. Instead of the 450,000 visitors projected for the first year, over 1.3 million came, generating an estimated $219 million in local revenue. Hotels, boutiques, and restaurants opened in the avenues nearby, and once-skeptical residents had cause to celebrate.[3]

So successful was the Guggenheim that dozens of other cities across the globe subsequently approached Gehry in the hope of reproducing the "Bilbao effect." But Gehry's Bilbao is part of a much larger worldwide museum boom that has made household names of many architects, including Richard Meier, Norman Foster, Renzo Piano, Tadeo Ando, Zaha Hadid, Daniel Libeskind, Santiago Calatrava, Rafael Moneo, Arato Isozaki, Jean Nouvel, James Polshek, Steven Holl, and Herzog & de Meuron. "It is a multibillion-dollar effort, a sustained growth spurt the likes of which the art world has never seen," declared *ARTnews* in 2001.[4] In recent years, museums have arguably become the most exciting building type of our time; they are where people go not only to see art but to encounter the latest currents in architecture.

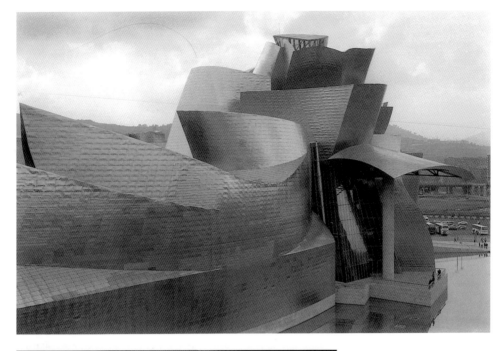

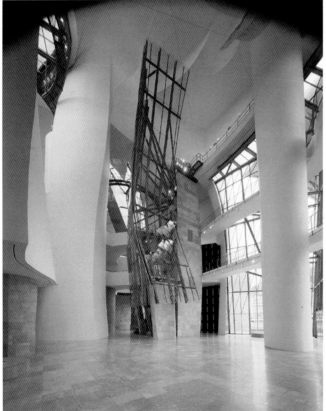

21. Frank Gehry, Guggenheim Museum, Bilbao, 1997.

22. Frank Gehry, Guggenheim Museum, Bilbao, 1997, interior view.

But some art world insiders—a vocal minority of critics, academics, and museum professionals—have viewed the media hype and wild popularity of the new museums with alarm and dismay. It is not so much that they dislike the Guggenheim as a piece of architecture; rather, they take it as a sign of a disturbing trend toward the "Disney-fication" or spectacularization of the museum at the expense of traditional commitments to high art, aesthetic contemplation, and scholarship. They would agree with Roberta Smith: "Buildings don't make museums; art and only art does."[5] Insofar as the new architecture stands for, and often houses, a new museum culture that promotes popular (often profit-driven) blockbuster exhibitions, shops, and restaurants over the serious consumption of art, it contributes heavily to "the annihilation of the museum as we know it," in the words of Jed Perl.[6] "You do not go to the [new] museum to look at things," Perl ruefully observes, "you go to be enveloped by a mood, an ambiance, a scene." When the museum itself becomes the event, Christopher Knight declared, art gets lost in the shuffle and the true purpose of the museum is betrayed.[7]

By way of contrast and in defense of traditional museum values, critics of the new architecture champion a small number of recent museum buildings that in their opinion get it right by deferring to their contents. At the top of the list are the late masterpieces of Louis Kahn (the Center for British Art at Yale and the Kimbell in Fort Worth) and new museums by Renzo Piano and a group of Japanese architects: Tadeo Ando, Yoshio Taniguchi, and the Sanaa team of Kazuyo Sejima and Ryue Nishizawa. According to Michael Kimmelman, writing in the *New York Times,* Piano's buildings remind us "that museums continue to have a basic function: that is, to display art well. For nearly two centuries, museum architects didn't seem to find this difficult. Suddenly, it has become a problem."[8]

Given the professional interests at stake, tensions between insiders' and outsiders' points of view are both inevitable and irresolvable. What is missing from the debate, and what this chapter aims to provide, is historical perspective. When and why did these opinions become entrenched? Kimmelman is wrong, for example, both in suggesting that displaying art well has only recently become problematic and in implying that it has always been the top concern of museum architects, yet he is far from alone in these beliefs. If we look back over the past two hundred years of museum design, we find competing priorities that have never been easy to reconcile. On the one hand are the priorities of displaying art well and providing a space that will best facilitate visitors' aesthetic experience. These needs have been championed by a small elite of critics, collectors, and cognoscenti who gained their authority and collective identity in the private galleries of early modern Europe. Their ideal has been the gallery as a setting for attentive viewing and refined conversation, secluded from the world and governed by

conventions elaborated over time by noted theorists (e.g., Bellori, Félibien, de Piles). On the other hand are the priorities of public utility and civic pride, promoted by philosophers, architects, and politicians. Here the ideal is that of the socially engaged museum, embodying civic values in an impressive building that combines symbolism and accessibility. The history of museum architecture is one of attempts to accommodate both viewpoints and the pressures that tip the balance one way or the other. While critics see in the new Guggenheim and its like a violation of the museum's basic purpose to "display art well," their desire for a display space that defers to the art it holds subverts the aspirations of those who want the museum to embody civic ideals. A curatorial prerogative informed by elite viewing habits privileged art over architecture for much of the twentieth century. Many recent museums appear to tilt the scale in the other direction, but we should see this trend, not as a betrayal of some a priori principles, but as a renewal of the struggle of conflicting ideals that are both deeply embedded in the history of the building type.

Boullée, Schinkel, and the Origins of the Public Museum

Modern museum design incorporates both Enlightenment commitments to public instruction and useful social institutions and the commitment to a museum ideal inherited from early modern utopian thinking. Before the spread of actual museums, the ideal museum took shape in paper projects and utopian texts that gave architectural expression to the desire to attain universal knowledge. Marcin Fabianski has shown that the ideal museum was modeled on the Temple of Solomon, and classical sources like the Pantheon and the temples of Apollo and the Muses, which often had a domed rotunda or octagon decorated with allegories of the intellectual virtues and arts.[9] As notional architectural spaces symmetrical in plan and perfect in form, the ideal museum and temple reflected the abstract harmony of the heavens above. In this the ideal museum had an affinity with imaginary ideal cities of the Renaissance, whose symmetry and regularity constituted, in the words of Lewis Mumford, "a symbolic representation of the universe itself . . . lowered down from heaven and cut to a heavenly pattern."[10] The museum, which, according to Mumford, became "the most typical institution of the metropolis, . . . of its ideal life,"[11] bears dual allegiance to polis and cosmos through its rational arrangement and timeless form. In the three utopias discussed in chapter 1, spaces of knowledge are located at the "very heart" (Andreae) or "very eye" (Bacon) of the ideal community or, in Campanella's *citta del sol,* are mapped onto circular city walls that enclose a domed temple.

Significantly, real objects and specimens are typically absent from imaginary representations, as if their flawed contingency would compromise the expression of the ideal.

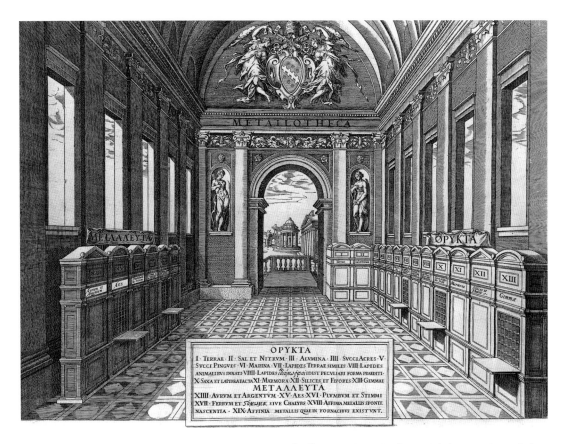

23. Vatican mineral collections. Engraving from Michele Mercati, *Metallotheca* (Rome, 1717). By permission of the Houghton Library, Harvard University.

In the frontispiece to Michele Mercati's 1580 catalog of the Vatican minerals collection (fig. 23), for example, a perspective view leads the eye past well-ordered cabinets to a temple that seems to symbolize the state of complete knowledge. The path to knowledge is lined by neatly labeled compartments showcasing the system of order and classification through which the phenomena of the world can be known and put to use. In the Vatican itself, the painted architecture in Raphael's *School of Athens* (fig. 5) functions in a similarly symbolic manner, depicting a majestic centrally planned, domed space that offers a setting worthy of its scholarly purpose.[12]

From the first, then, the museum idea, as represented in paper projects and utopian texts, exceeded or transcended its realization as a functioning institution. An important moment occurred in the late eighteenth century, when Enlightenment architects and philosophers came together to imagine the ideal city and its constituent parts, including museums. The museum described by Mercier in his futuristic novel *The Year 2440:*

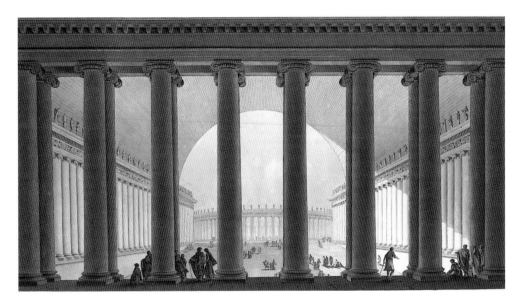

24. Etienne-Louis Boullée, *Interior View of a Museum*, 1783. Drawing with watercolor, 38" × 20". Photo: Bibliothèque nationale de France, Paris.

A Dream If Ever There Was One (1771), discussed in the preceding chapter, is especially important because it relied on architecture to signify its progressive mission. The protagonist of Mercier's utopia, finding himself at the heart of Paris in the twenty-fifth century, enters the building inscribed "Microcosm of the Universe" to discover "four wings of immense proportions . . . surmounted by the largest dome I had ever seen" and on display every conceivable specimen of nature and human culture laid out with judgment and wisdom. He confesses to feeling overwhelmed by the spectacle: "I felt oppressed by the weight of so many miracles. My eye embraced nature in all its bounty. How at that moment I felt compelled to admire her author!"[13] In addition to bountiful collections, he witnesses students engaged in study and open conversation. Just seven years after his book was published, in 1778, Mercier's description would seem to have inspired the winning entries in a competition to design an ideal museum, sponsored by the Royal Academy of Architecture. As in Mercier's text, the student designs were characterized by symmetrical plans, vast domed spaces, and axial galleries housing myriad objects. Perhaps also inspired by Mercier and certainly inspiring the students' efforts were the visionary schemes of Etienne-Louis Boullée, published in the 1780s (figs. 24–25).[14] Transcending practical considerations, Boullée's museum designs reached for the imaginary sublime, overwhelming contents and visitors alike with massive staircases, barrel-vaulted galleries, and glowing rotundas. Grand vistas bathed in radiant light, dizzying rows of

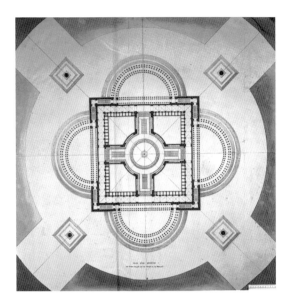

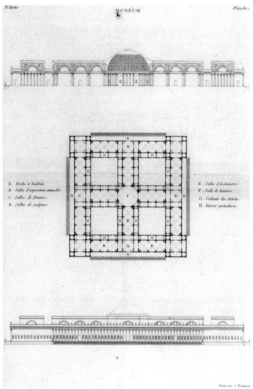

25. Etienne-Louis Boullée, *Plan of a Museum*, 1783. Drawing with watercolor, 43⅜" × 43⅝". Photo: Bibliothèque nationale de France, Paris.

26. Jean-Nicolas-Louis Durand, *Museum Design*. Engraving from *Précis des leçons d'architecture données à l'Ecole Royale Polytechnique* (Paris: Author, 1802–5).

columns, and radical shifts in elevation and perspective gave his museum and related building types a sublime and transcendent aura. The internal space was all the more impressive at first sight because masked on the exterior.

Mediating the grandiose schemes of Mercier and Boullée and the mundane constraints of building practice was the work of Jean-Nicolas-Louis Durand. In his widely disseminated treatise on building types of 1802–5, Durand offered a concise museum plan (fig. 26) with workable proportions, clearly defined room functions, and multiple points of entry.[15] In place of Boullée's colossal forum that dwarfs its occupants, Durand proposed a central "reunion room" fit for intimate dialogue. Functional in conception and clear in its articulation, Durand's design served as a useful template for various types of collection and constituencies.

Durand's rational and flexible modular approach to design proved useful to later architects, but Boullée's ideas were no less influential because they encouraged builders and their clients to go beyond functional concerns in pursuit of the museum's "character." "Character" was at the heart of what Boullée and many late-eighteenth-century

architects designed. Indebted to the sensationalist philosophy of Locke and Condillac, the theory of "character" held that buildings must express their purpose clearly to all who passed by: "To give character to one's work, it is necessary to study the subject in depth, to rise to the level of the ideas it is destined to put into effect and to imbue oneself with them to such an extent that they are . . . one's sole inspiration and guide."[16] An architect designing buildings useful to public life—temples of knowledge, tombs of great men, and the palace of a benign sovereign, for example—must strive for magnificence and grandeur. As one of Boullée's contemporaries put it: "Grand monuments must make a grand impression; the walls must speak; through multiplied sentences our buildings must become books of morality."[17]

Interrelated in purpose, grand public buildings shared much in design and visual effect. The *architecture parlante* of Boullée and his colleagues relied on certain forms, spatial relations, and effects of light and shade to trigger predictable and consistent responses in the beholder. Drawing on Edmund Burke's theory of the sublime, Boullée was much interested in the psychological effect of immensity, or "artificial infinity." Beyond the initial feelings of fear and vulnerability it aroused, immensity evoked a sense of profound wonder at the bounty of the universe and man's ability to conceive and harness it. Boullée, like Burke, points to effects of nature to explain the sublime but also translates our awe at the sight of boundless oceans and mighty mountains into architectural terms. Immensity in the built environment elevates the mind to a plane of abstract concepts, such as eternity, genius, and space, readily apparent in Boullée's most famous design, the Cenotaph of Newton, in whose vast sphere, decorated with stars and planets, the beholder experiences the "immensity of the sky" and senses Newton's "sublime mind" and "profound genius."[18] Similar effects are present in Boullée's designs for palaces, libraries, and museums, which rely on a common vocabulary of dizzying perspectives, unfathomable spaces, and mysterious parabolas of light.

Boullée came closest to realizing one of his schemes in the mid-1780s, when he drew up plans to convert the Palais Mazarin into a royal library (fig. 27). The dominant feature of his design is the luminous barrel-vaulted reading room, given a thrilling and awesome aspect in the architect's perspective drawing. The combination of spatial recession, suffused light, and figures dwarfed by knowledge justifies his description of the project as "sublime." Boulleé's designs are generally reminiscent of Piranesi, but here he acknowledged another inspiration: "Profoundly impressed by Raphael's sublime image of the School of Athens, I have sought to bring it to life."[19] Though his design was never executed, engravings were published and his scale model was publicly displayed, and together they had decisive impact on a royal project that reached fruition during his life, namely, the museum project in the Grand Gallery of the Louvre.

Boullée was among the architects chosen in 1785 (the year his library designs were published) to transform the tunnel-like gallery alongside the Seine into a museum. The nature of his involvement cannot be determined with any precision, but the mark of his approach to space, light, and the experiential dimension of architecture can be felt in the architects' report to the government of 1787, which also revealed evidence of an unusual, even utopian, spirit of cooperation among the architects. Recognizing the significance of the project, they worked together despite differences of age, rank, and personal preference to realize "the most magnificent monument to the arts that could be built."[20] The "noble simplicity" and "grand character of the place" persuaded the committee to avoid excess decoration and to focus on dividing the vast (1,300-foot) unbroken space of the gallery and on lighting it:

> When we first saw the gallery plans at the Academy, we were virtually all agreed that some division of the space would be necessary. We differed only on the number of divisions that would be needed to create compartments comparable in size to existing picture galleries. . . . But once we set foot inside the monument and saw it with our own eyes, we were unanimously against altering in any way the *spectacle of immensity that first meets the eye*. None of us doubted that the gallery should be left alone despite its seemingly disproportionate length; reason might fault this finding, yet the senses, which must judge such matters, find the proportions sublime. It is possible that theory could justify this impression, but its cause may remain obscure; in any event it would be impossible for any sensible man to remain unmoved by the effect.[21]

Immense spectacles, obscure causes, and the senses as supreme arbiters of judgment are the hallmarks of the architectural sublime derived from Burke by way of Boullée.

Their decisions on lighting similarly relied on the eye. After visiting other top-lighted public spaces in Paris, including Jacques Gondoin's magnificent Pantheon-like anatomy theater, the architects were convinced that "all those in the habit of using their eyes . . . will decide in favor of lighting [the gallery] from the summit of the vault." They also specified that the glass in the skylights should be left unpolished to create a "magical" diffused light within. And they agreed that "the size and placement of the openings, taken together with the extent and proportion of the gallery and the riches on view, will create an extraordinary and unique effect."[22] From the outset the architects resolved to create a monument wondrous in its own right.

Hubert Robert's famous paintings of the Grand Gallery capture perfectly the effects anticipated by the panel. Robert was no stranger to the Louvre project, as he had been named one of the museum's curators in 1784. The first of his imaginary views, dating from the mid-1780s (fig. 28), shows a diffused light penetrating from above and the "spectacle of immensity" caused by a deep recession of space to a distant point on the

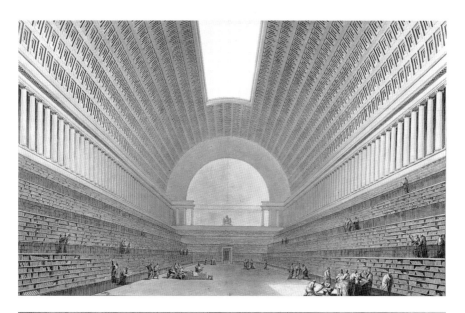

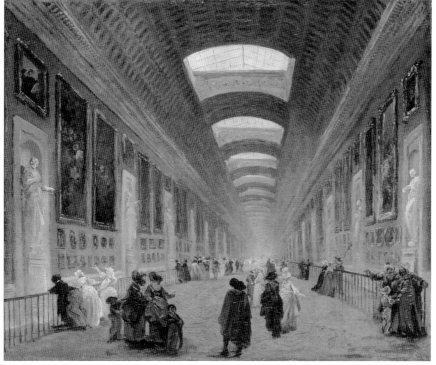

27. Etienne-Louis Boullée, *Design for the Royal Library,* 1785. Drawing with watercolor, 42¼" × 28". Photo: Bibliothèque nationale de France, Paris.

28. Hubert Robert, *Project for the Grand Gallery of the Louvre,* ca. 1785. Oil on canvas, 46.5 × 57.5 cm. Louvre Museum, Paris. Photo: Réunion des Musées Nationaux/Art Resource, New York.

horizon. While this painting captures the spirit of the architects' report, it also resembles Boullée's contemporary project drawing for the royal library, right down to the coffered vault (which the Louvre gallery never had) and shape of the skylights. The marked similarities speak to a pervasive fascination with the sublimely evocative potential of space and light and the importance of spectacle in grand public monuments.

When the Louvre museum opened in 1793, British travelers, seemingly familiar with Burke, evinced an almost visceral reaction to the space. One Thomas Jessop of Yorkshire wrote: "I cannot express my feelings when traversing these immense halls. . . . Nothing can exceed the elegant grandeur of this vast apartment. . . . [T]he effect upon a stranger's mind when he 1st enters this magnificent museum is better conceived than described. The eye is lost in the vast and original perspective; the sense is bewildered amid the vast combinations of art."[23]

The descriptive terms *bewildered, dazzled,* and *astonished* recur in other tourists' accounts, but so do complaints that the source of astonishment—the space and architecture of the gallery—worked against appreciation of the art on view. Though the idea of seeing Europe's masterpieces united under one roof was every art lover's dream, the reality left something to be desired. A critic writing for the *Edinburgh Review* in 1814 remarked:

> The immensity of the banquet served up all at once [prevented] enjoyment of any of the individual luxuries. All persons who have frequented those rich collections, whether in Italy or France, feel the desire strongly grow upon them, of singling out a few prime specimens of art, and poring over them separated from the rest. Every one who has travelled, must have felt how much more exquisitely he relished a visit to some place, where a single first-rate picture was to be seen,—some church, or convent, or chateau, remarkable only for this solitary jewel, than a surfeiting morning spent in devouring the richer wonders of a collection.[24]

As this author makes clear, dissatisfaction was particularly acute for those who had known the Louvre's recently acquired treasures prior to their removal to Paris. For John Scott, writing in 1815, the desire to "excite the wonder of the crowds" came at the expense of the "sensibility of the few" who previously had had the luxury to see those works of art *in situ;* the political goals of mass access and national pride frustrated the aesthetic expectations of the experienced amateur: "To please the vanity of the multitudes of Paris, who flock in to view their pillage, a long avenue with pictures forming its sides, like so many regularly planted trees, may be best adapted; but the person of taste and feeling would be most touched and gratified by a distribution into different rooms where a sort of precedency might be observed, by means of which natural distinctions might assist the judgment and prevent the bewildering of the senses which is produced by a vast

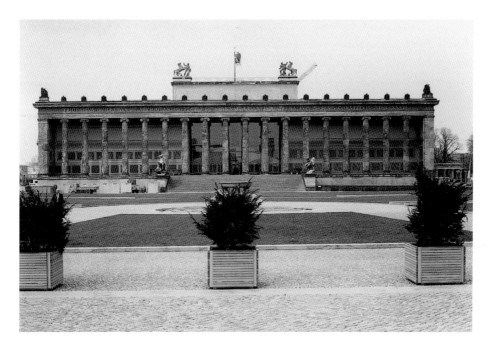

29. Karl Friedrich Schinkel, Altes Museum, Berlin, 1830.

promiscuous assemblage."[25] In similar mode, François-Xavier de Burtin contrasted the superficial allure of the space with the needs of the discerning art lover: "However imposing at first sight the spectacle . . . the true connoisseur soon realizes that this theatrical perspective, whose terminus may scarcely be perceived, greatly militates against proper enjoyment; and the art lover can only regret that this immense gallery has not been divided, at appropriate intervals, by separating walls, which would have contributed greatly to the viewer's pleasure, and considerably increased exhibition space for pictures."[26] The tensions manifested in these early reactions to the Louvre between an alluring architectural spectacle and informed viewing, a mass public and the educated elite, are with us still and continue to complicate art museum design.

The force of the Louvre's example, both negative and positive, may be felt in the architecture of several galleries built in the early nineteenth century. Small-scale attempts to echo the architectural effect of the Grand Gallery without sacrificing the comforts of the private cabinet may be seen in Sir John Soane's Dulwich College Picture Gallery (1811–14) and Raffaelo Stern's Braccio Nuovo at the Vatican (1806), but the first major purpose-built museum to absorb the lessons of the Louvre was Karl Friedrich Schinkel's Altes Museum in Berlin (1830; figs. 29–32).

The brilliance of Schinkel's design may be said to lie in its reconciliation of the functionalism of Durand and the symbolism of Boullée. Schinkel had visited the Louvre and

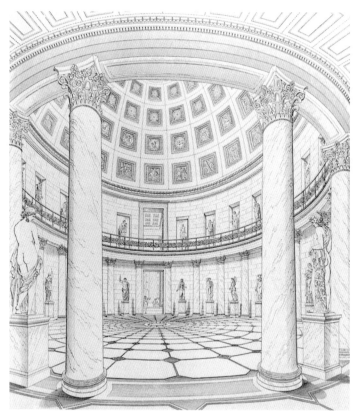

30. Karl Friedrich Schinkel, Altes Museum, Berlin, plan. Engraving from K.-F. Schinkel, *Sammlung architektonischer Entwurfe* (Berlin, 1831).

31. Karl Friedrich Schinkel, Altes Museum, Berlin, rotunda. Engraving from Schinkel, *Sammlung architektonischer Entwurfe* (Berlin, 1831).

32. Karl Friedrich Schinkel, Altes Museum, Berlin, terrace with view of the Lustgarten. Engraving from Schinkel, *Sammlung architektonischer Entwurfe* (Berlin, 1831).

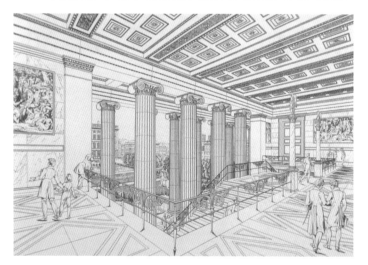

was familiar with Durand; he was the product of high Enlightenment culture, but he also grasped the sociopolitical realities of postrevolutionary Europe. Though respectful of precedent and the needs of art, Schinkel equally understood the importance of public institutions within the emerging political structure of the modern world. Following Durand, Schinkel housed the collection (statues on the ground floor, paintings on the floor above) in four wings that embrace a central domed rotunda. Galleries are subdivided into smaller units by pairs of columns placed at regular intervals (fig. 30); offices for staff and professors are included, as are storerooms. But unlike Durand, whose central rotunda served as a point of reunion and scholarly discussion *following* a visit, Schinkel gave his domed space a primarily symbolic and welcoming, or "liminal," function (fig. 31). Masked on the outside, the rotunda acts as a thrilling space of inspiration and transition from exterior to interior. As Schinkel wrote: "So mighty a building as the Museum will certainly be must have *[sic]* a worthy center. This must be a sanctuary, where the most precious objects are located. One first enters this place . . . and the sight of a beautiful and sublime room must make the visitor receptive and create the proper mood for the enjoyment and acknowledgment of what the building contains."[27] By contracting Durand's square plan into a rectangle and offering only one point of entry, Schinkel obliged the visitor to pass directly into the rotunda and experience its majesty. Schinkel's reworking of the plan and domed space was motivated by his conception of the visiting public. Durand's ideal public, polite and academic, required a space of discourse, not inspiration; it knew the collection's worth and needed no enticement. The broader lay public that Schinkel hoped to attract, on the other hand, needed to be enticed, impressed, and put in the right frame of mind for what followed. He further catered to this expanded public through the siting of the museum and the inclusion of an innovative terraced, wrought-iron staircase behind the porch (fig. 32). Whereas the abstract designs of Durand and Boullée lacked a specific site and main facade, Schinkel oriented his regal stoa (fig. 29) toward an open public space, the Lustgarten, which was framed on its other sides by the royal palace, the arsenal, and the cathedral. Spatially and architecturally, the museum was connected to other key institutions of the state. The museum and its contents were presented as the king's gift to his people, evidence of enlightened rule and stewardship of a unifying artistic heritage. On a practical level, the staircase connected one floor to another, yet it also linked the inside to the outside, the museum to the city. Anticipating the city views afforded by many new museums (the Pompidou, Tate Modern, MoMA), Schinkel's terrace is a place of refreshment and conversation, a platform from which the integrated fabric of city life may be apprehended. Whereas Durand's *salle de réunion* entails hermetic discourse internally focused on the collection, Schinkel moved conversation to the threshold between collection and city, implying an enlarged civic role for the museum within the body politic.

Embracing Durand's narrower view of the museum's function and public, the art historian Alois Hirt criticized the rotunda, facade, and staircase as useless extravagances. Using words that foreshadow recent controversies over museum architecture, Hirt complained that "the art objects are not there for the museum; rather the museum is built for the objects," and he offered a counterproposal that was notably lacking in architectural flourish.[28] But Schinkel stood behind the joint integrity of the building and the collection and, in defense of the museum's centerpiece, the magnificent domed rotunda, argued that the first *coup d'oeil* of the space was necessary to separate visitors from the outside world and prepare them for the experience of art in the surrounding galleries. Thinking more of novices than of seasoned connoisseurs, Schinkel insisted that a museum must "first delight, then instruct."[29] Schinkel's view prevailed, but Hirt's objections have lost none of their currency among the enemies of expressive architecture.

The Beaux Arts Temple Museum

The successful adaptation of Durand's model by Schinkel in Berlin, and by Leo von Klenze at the Glyptothek in Munich (1816–34), established the dominant formula for public museums through the nineteenth century and beyond. Clarity of plan, site adaptation, and an easy balance of function and symbolism became the hallmarks of Beaux Arts museum design. In the mid–nineteenth century the classical ideal was briefly challenged on two fronts. Historicist revivals tied to emerging nationalism led to the adoption of "native" medieval or Renaissance styles, displayed, for example, in the Rijksmuseum in Amsterdam (P. J. H. Cuypers, 1876–85) and the two splendid gothic revival museums by Thomas Deane and Benjamin Woodward in Dublin (Trinity College Museum, 1853) and Oxford (Oxford Museum, 1860).[30] At the same time, applied arts museums, with their focus on artisanal training and commercial application, sought to distinguish themselves architecturally from the fine arts temple. The first incarnation of the South Kensington Museum in London, known as the "Brompton Boilers" (1855–57; fig. 11), took as its model Sir Joseph Paxton's Crystal Palace, the glass and steel structure built for the Great Exhibition of 1851. Quickly constructed using new building materials, the Crystal Palace was sublimely modern in effect and was well designed, practically and conceptually, for the temporary exhibition of new commercial products for a mass public. But what worked for the Great Exhibition was not well suited to the permanent presentation, preservation, and intimate study of the often small, finely crafted objects that the South Kensington Museum hoped would inspire improved industrial design. Confused goals at South Kensington—the entertainment of the masses and the training of craftsmen; a commitment to contemporary design and technology but also to exemplary art from the past—fueled a programmatic incoherence and a marked instability in the

museum's architecture during its first decades. Before the 1891 competition to redesign the entire museum, a succession of lesser architects and engineers added new buildings in eclectic styles and materials; on the exterior, for example, classicizing bas reliefs made of modern terra-cotta symbolized the tensions between old and new, art and mass production.[31] South Kensington's gradual reincarnation, toward century's end, as a historical museum of high-quality decorative arts is properly reflected in Aston Webb's conventional Beaux Arts design, which won the competition of 1891. Applied ornament outside and an abundance of mosaic, ceramics, ironwork, stained glass, and wallpaper within declare the museum's allegiance to the decorative arts, but it is all brought under control by Webb's conventional plan and vaulted galleries, domes, and staircases. Webb's initial design even included a grand central staircase and barrel-vaulted space reminiscent of Boullée.

As discussed in chapter 1, the failure of the applied arts museum to improve industrial design or solve the spiritual and material problems of the urban population gave a renewed sense of purpose to the fine arts museum as a compensatory refuge in the modern metropolis. As a result, the inspirational spaces and classical style of the Beaux Arts palace gained added symbolic authority as the counterweight to the deadening routines of modern manufacturing and the inequities of capitalism. An important revalidation of the classical Beaux Arts model in a modern industrial context was Charles Atwood's Fine Arts Palace (fig. 12), built for Chicago's Columbian Exposition of 1893. Set apart as an oasis of high culture in the glimmering White City of progress, Atwood's palace symbolized the complementary civilizing role of the art museum in a modern society. It was the only building left standing when the exposition closed, as if to underline its lasting utility to the metropolis in the making (ironically, it now houses the famous Museum of Science and Industry). A second, permanent Beaux Arts palace opened downtown in the same year: the Art Institute of Chicago (designed by Shepley, Rutan, and Coolidge). In Boston, where in 1909 a new museum of fine arts replaced an earlier Ruskinian Gothic museum modeled on South Kensington, a Grecian facade signaled the museum's adherence to a redemptive vision of high culture inspired by Matthew Arnold (figs. 33–34). As the museum's bulletin put it: "The exterior should convey the positive assurance that that which is to be seen within shall be the best that men have imagined and have wrought with their hands. For such a conception the architectural style at once suggested is the classical."[32] The museums of Boston and Chicago both lent clarity and importance to their contents through a standard Beaux Arts plan and spaces of symbolic inspiration—porticoes, staircases, and domed rotundas. The integrity of the building enhanced the uplift of its contents and contrasted with the architectural and moral dilapidation of overpopulated urban areas.

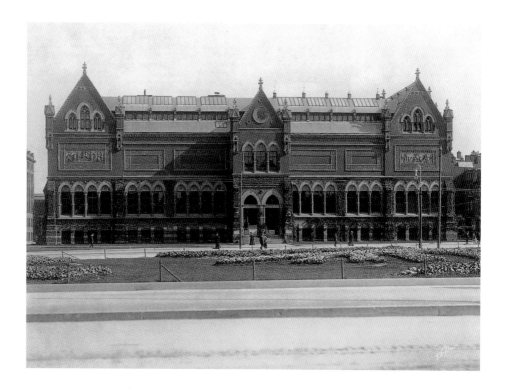

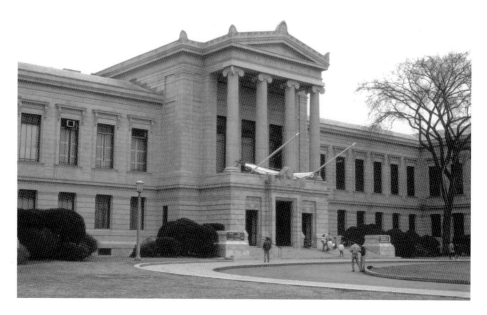

33. John Sturgis and Charles Brigham, Museum of Fine Arts, Boston, ca. 1876. Photograph © T. E. Marr, Courtesy of Museum of Fine Arts, Boston.

34. Guy Lowell, Museum of Fine Arts, Boston, 1909.

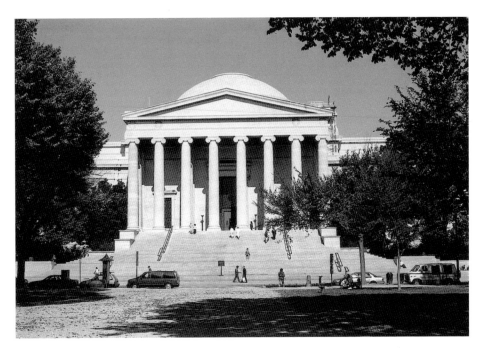

35. John Russell Pope, National Gallery of Art, Washington, D.C., 1941.

Across Europe and the United States in the late nineteenth and early twentieth centuries, both large and small cities built classical art museums to declare their civic pride and cultural standing. In Europe, art museums followed the Berlin example and tended to be built in town centers. For example, London's Tate Gallery (Sidney Smith, 1897), paid for by a sugar magnate, was built on the site of a prison adjacent to a working-class housing estate. In America, as part of the "City Beautiful" movement, the trend was to build museums in landscaped parkland on the outskirts of town in order to offer a twofold respite—art and nature—from urban toil. In their building, location, and contents, art museums were to be the antithesis of what William Cullen Bryant described as inner-city "labyrinths" that bred crime and vice.[33] Examples of City Beautiful park museum schemes may be found throughout the country. On the steps of Buffalo's Albright Gallery (Green & Wicks, 1900–1905), an immaculate temple with a fine view of the city across an Olmstead park, one can still grasp the intended effect as described by the museum's director in 1916: "Surely such a perfect building should hold one's attention for a while and lift one out of the busy life in which one lives. It should be capable of preparing one's mind for the glorious art within its walls, and place one in something of the attitude of mind and spirit in which that art was wrought."[34] The last of the classical temples, John Russell Pope's National Gallery in Washington (1941; fig. 35), deploys the stan-

dard elements of the Beaux Arts museum on the most symbolically charged landscape in the United States. As at the Altes Museum and other national galleries, function and symbolism are combined: strategically sited on Washington's Mall, the National Gallery is linked architecturally and spatially to structures of power and national identity. Visitors ascend from the mall through a grand portico and up the stairs to the central rotunda, an empty marble-clad space of inspiration. On either side, top-lighted, barrel-vaulted corridors reminiscent of Boullée and the Vatican lead to domestically scaled galleries offering serenity and ideal viewing conditions. A hundred years after Schinkel, the Beaux Arts formula was still adequate to the overlapping civic, political, and aesthetic demands of a public art museum.

The Museum as Machine

Pope's adherence to Beaux Arts planning and classical style, though well suited to Washington's Mall, nevertheless made the National Gallery an anachronism in the context of the progressive museology of the 1930s. The early decades of the twentieth century witnessed the rise of professional curators, and as their authority increased so did their involvement in matters of museum design. Dedicated primarily to the objects and visitors in their care, curators denounced the stately grandeur of traditional museum buildings in favor of a new environment that privileged flexibility, display conditions, access, and comfort. If Boullée had envisaged his museum unencumbered by objects and practical worries, newly empowered curators in their turn criticized building features that hindered the everyday priorities of museum work: visitor circulation, object display, public education, storage, and so forth. In keeping with the ideology of the machine age, museum professionals insisted that the functional efficiency of the museum take precedence over other considerations. The Beaux Arts formula needed revision.

Early rumblings of what would develop into the central dispute between art and architecture were felt in Boston during the construction of the new Museum of Fine Arts. In the course of an exhaustive study of what constituted criteria for the ideal art museum, which included a world tour of more than a hundred museums, consultations with leading experts, and full-scale mock-up installations, conflicting opinions emerged between different parties. The curatorial staff, led by Matthew Prichard and Benjamin Gilman (fortified by the recommendations of a German expert, Alfred Lichtwark, who advocated shattering "the idol of the monumental façade"), concentrated on the internal environment, arguing for an interior "absolutely without architectural adornment" so that "nothing may attract the eye of the visitor from the objects therein displayed."[35] But the museum's governing board insisted that the civic profile of the museum could not be ignored and pushed for an imposing architectural presence. The museum's pres-

ident confessed that "the new building was not de-
liberately planned as an architectural monument,
but inevitably became one from the dignity of its pur-
pose."[36] In the end, both sides could claim victory,
since the monumental structure that was built housed
prototypically functional, unadorned galleries.
Prichard conceded that apart from the "grand slice of
'architecture'" running from the entrance up the cer-
emonial staircase to the grand rotunda decorated
with John Singer Sargent's allegorical murals, the mu-
seum's design corresponded with his and Gilman's
principles.[37] One could say that Gilman devoted much
of his career to countering the effects of monumen-
tal architecture, devising various strategies and dis-
play modifications to overcome the "museum fa-
tigue" and viewing discomforts it caused. He even
designed a portable tool—the "skiascope" (fig. 36)—

THE SKIASCOPE

THE SKIASCOPE IN USE

36. Benjamin Ives Gilman's "skia-
scope." From Benjamin Ives Gilman,
Museum Ideals of Purpose and Method
(Boston: Boston Museum of Fine
Arts, 1923).

that compensated for oversized and overcrowded galleries by restricting vision to one
object at a time and shielding the eyes from glare. It can be said that the chief achieve-
ment of twentieth-century museology was the refinement of viewing conditions and
museum interiors so that the skiascope would no longer be necessary. The culmination
of this trend was the ubiquitous "white cube" (see chapter 3); the main casualty was
monumental museum architecture.

During the 1920s and 1930s opposition to palatial museum architecture became a
curatorial mantra. In a 1924 review of the new Beaux Arts Field Museum of Natural
History in Chicago, Richard Bach of the Metropolitan Museum attacked the temple type
as outdated and detrimental to both the objects on view and the public obliged to traipse
through its cavernous halls. Paraphrasing Le Corbusier's description of a house as "a
machine for living," Bach said museums must become "educational machines of ser-
vice."[38] "It is obvious," he wrote, "that museums . . . should be admired more within,
as to their contents, than without, as to their appearance," and he predicted that within
a generation "the last thought that could be associated with [museums] will be that of
'monument.'" Bach's sentiments were echoed in museum discourse across the decade.

Charles Coolidge's Fogg Museum at Harvard (fig. 37), opened in 1927 as a model lab-
oratory for the new museology, was praised by Bach and others for its modesty and util-
ity. On the outside, the Fogg had no pretensions to monumental grandeur and instead
blended in with the Colonial style of the Harvard campus. Inside, unadorned galleries
ringed a courtyard issuing from the entrance; behind the scenes, separated from the

37. Charles Coolidge, Fogg Art Museum, Harvard University, 1927.

public spaces but connected to them, was what Bach termed "the new functional machinery" appropriate to its purpose, namely, offices, classrooms, and storage space.[39] "The building is not an end in itself," wrote Bach, "it is the embodiment of a special kind of work." The Fogg exemplified a new way of thinking about museum design based on *internal* considerations: "The whole theory of museum design is being rewritten; the fundamental museum plan is taking shape. However museum needs may seem to the worker in museums, the architect's hand needs guidance, for he still sees the problem chiefly from the outside."[40] The Fogg Museum was home to Paul Sachs's influential Museum Course, which sent forth generations of museum workers inculcated with the new "theory of museum design" and ready to guide the architect's hand.

At a 1934 conference on museums held in Madrid, the transatlantic museum community spoke as one in calling for a new "nonarchitectural" museum affording maximum flexibility of walls and lighting and the suppression of unnecessary decoration.

Philip Youtz, director of the Brooklyn Museum and himself an architect by training, opened the conference with a lecture criticizing the "infatuated architect" who builds costly monuments "borrowed from various palaces of the renaissance according to the Beaux-arts tradition" without regard to use. He all but confessed that if he had his way he would tear down his own palatial museum and start again.[41] He settled for removing Brooklyn's imposing staircase, in his eyes a deterrent to the ordinary visitor. (Ironically, in the hope of making the Brooklyn Museum *more* visitor friendly, James Polshek has recently [in 2004] replaced the original staircase with a glowing new pavilion.) In other articles across the decade Youtz elaborated his vision of a modern, democratic art museum. Though the Beaux Arts palace might have been suited to the "amateur," "aristocratic," "feudal system" of America's first museums, that architecture was a "well-nigh insuperable handicap for a modern social institution attempting to serve a democratic public."[42] In a 1936 address to the Association of Art Museum Directors, Youtz told his colleagues that a museum "must be considered not as an example of art for art's sake but as the material form of a social institution."[43] Since the function of a museum is to display objects to a broad public, access, flexibility, and internal display conditions must take priority. Museums should be located on main traffic arteries rather than distant parks and should have "show windows" to "excite the curiosity of those who pass and tempt them to enter." Entrance halls should offer visitors a full array of amenities—cloakrooms, benches, telephones, elevators, information and sales desks, an auditorium, and a temporary exhibition gallery—and exude "an air of hospitality"; movable walls and lighting would give curators maximum flexibility; all effort should be made to reduce visitor fatigue. What he called "stale archaeological themes"—niches, pilasters, and vaulted ceilings, colonnades, rotundas, and domes, "all useless architectural liabilities which . . . make effective installation impossible and thwart the purpose of the museum"— should be done away with. "The interior of a museum needs no ornamentation, for the purpose of the building is to display highly decorative objects."[44]

A century after Hirt's dispute with Schinkel, the interests of the collection and its custodians had gained the upper hand. In the year of the Madrid conference, with architecture clearly in retreat, the architect Paul Cret defended his profession by arguing that it was the very "effacement of architecture" that was responsible for museum fatigue. This "terror of architecture, all too common among curators," he insisted, is "the principal cause of the ennui which spreads over the majority of modern museum rooms with their dingy aquarium lighting, their hectares of waxed parquet, their empty surfaces which no one knows what to do with but which no one dares decorate. . . . No wonder museums are called cemeteries of art."[45] As Cret saw it, a fundamental part of the museum's function was to inspire the visitor, and architecture was central to the task. Returning to the machine metaphor, he declared that museums are more than "ma-

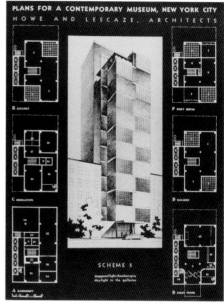

38. A. J. van der Steur, Boymans Museum, Rotterdam, 1935, interior view.

39. George Howe and William Lescaze, *Plans for a Contemporary Museum, New York*. From *Architectural Record* 79 (July 1936).

chines for the display of art." "In a word, the architecture of a museum is not to play the role of poor relation." Cret's own buildings, notably his Detroit Institute of Arts (1920–27), featured atmospheric interiors that struck a chord with advocates of period rooms and the decorative arts, such as Detroit's William Valentiner and Philadelphia's Fiske Kimball.[46] But, as we shall see in the next chapter, by the late 1930s period decor, and Cret's approach to museum architecture more generally, were out of fashion.

The congruence of curatorial demands for utility and the modernist aesthetics of the International Style did produce a new museum paradigm in the 1930s, exemplified in the cool modernism of Henry van de Velde's Kröller-Müller Museum in Otterlo (1937–38), A. J. van der Steur's Boymans Museum in Rotterdam (1935; fig. 38), the Avery Wing at Hartford's Wadsworth Atheneum (Morris & O'Connor, 1934), and of course the Museum of Modern Art in New York (Goodwin & Stone, 1939). The architects Howe and Lescaze accompanied a 1936 design for a museum of modern art (fig. 39) with a

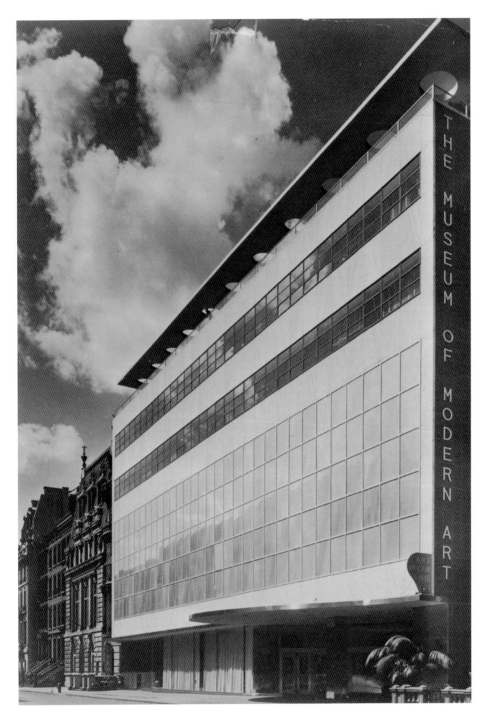

40. Philip Goodwin and Edward Stone, Museum of Modern Art, New York, 1939.
Photo: Digital Image © The Museum of Modern Art/Art Resource, New York.

statement that was music to a curator's ears: "Every architectural pretense should be avoided. A museum is best which is seen least, for it exists to display collections and it must not obtrude itself on them. It should focus attention on its contents by making itself least conspicuous."[47] Howe and Lescaze's design satisfied many of Bach and Youtz's desiderata. Easily mistaken for a domestic high-rise, their museum blended in with the street and was the antithesis of the stand-alone temple in the park. A modest awning replaced the monumental staircase and portico; inside, an elevator delivered visitors effortlessly to compact galleries on different floors. The interior and the exterior were compatible, overcoming the compromises involved in the Detroit Museum with its eclectic period decor, or the otherwise exemplary Fogg with its Georgian facade and Italianate courtyard. "Compromise leads to contradiction," Lescaze wrote, "and the result is a building true to neither its age, which no longer exists, nor to ours for which it has not been built."[48]

Despite their credentials, Howe and Lescaze failed to win the commission to design New York's Museum of Modern Art, which went to the firm of Goodwin & Stone (figs. 40–41). That Philip Goodwin was a trustee of the museum no doubt helped his cause, and although the final design lacked architectural distinction, its emphasis on internal efficiency and deference to contents made it the ideal museum for its time and place. The building aligned with Fifty-third Street, and the ground-level ("show") windows gave passersby full view of a lobby replete with public amenities. The unassuming exterior and modest entrance no longer functioned to induce reverence and wonder, as in the Beaux Arts temple; attention had shifted to the interior and the functions of the museum. With more curators than guards, much space was provided for offices, located on the upper floors. Ample space for storage was also included, and this too was kept

out of view. Beyond the lobby, the public encountered a courtyard sculpture garden and three floors of galleries, the most influential feature of the museum because the most "neutral" and least expressive in character. The galleries on the second and third floors had movable walls and track lighting, affording curatorial control and an open, casual spatial flow in stark contrast to a regimented Beaux Arts plan. The interior was well suited to the display of modern art but

41. Installation view of *Art in Our Time: Tenth Anniversary Exhibition*, Museum of Modern Art, New York, 1939. Photo: Digital Image © The Museum of Modern Art/Art Resource, New York.

also to the wide range of temporary exhibitions organized by Alfred Barr during the museum's formative years. As John Coolidge wrote: "The gallery floors of the Museum of Modern Art were the first in any major museum to be conceived like those of a warehouse, completely adjustable."[49] The simplified interiors were of a piece with the exterior but over time, as Coolidge remarks, came to be seen as a "benevolently neutral background" for the collection and thus as providing "architecturally the ideal museum."[50] While the external design of art museums has changed dramatically in intervening decades, the "white cube" aesthetic instituted at MoMA has remained remarkably constant. Indeed, so influential was MoMA's interior that early installation photographs look as if they could have been taken yesterday.

Comparisons between the modernist museum aesthetic and domestic architecture are very much to the point. Though open to the general public, MoMA had the feel of a private residence or club. The members' room on the top floor, outfitted with the latest in European design, like a contemporary period room, was among the first of its kind. The urban apartment rather than the ceremonial galleries of the Beaux Arts temple was the model for MoMA and the ideal setting for the intense viewing of modern art encouraged by Barr and later art critics. In the era of high modernism, the enjoyment of art was less a communal activity than an act of private communion. Significantly, the chapter in Russell Lynes's history of MoMA devoted to the building of the museum is entitled "Home Is Where You Hang Your Collection."

Wright's Guggenheim and the Return to Monumentality

Given the decisive turn toward clean, subdued, curator-friendly museum spaces in the 1930s, Frank Lloyd Wright's bold design for the Guggenheim Museum in New York (1942–59; figs. 16, 42) seems doubly subversive in retrospect. Encouraged by Solomon Guggenheim and his adviser, Hilla Rebay, to achieve a new monumentality in keeping with the progressive art and utopian mission of the museum, Wright created an enthralling building, at once utterly modern and indebted to the tradition of inspirational museum architecture.[51] Modifying the iconography of dome and circle, Wright conceived the Guggenheim as an inverted Tower of Babel that, instead of generating miscommunication and disharmony, fosters a sense of community through shared experience of space and art. In terms of the museum tradition, Wright's rotunda is a conceptual hybrid, combining Schinkel's initial space of delight and Durand's terminal *salle de réunion:* the visitor enters off Fifth Avenue through a dark, recessed door to experience the thrill of the towering space above and then returns to this point of origin at visit's end, having taken the elevator to the top of the ramp and spiraled down past the collection. One never loses sight of the majestic central court, or of other visitors.

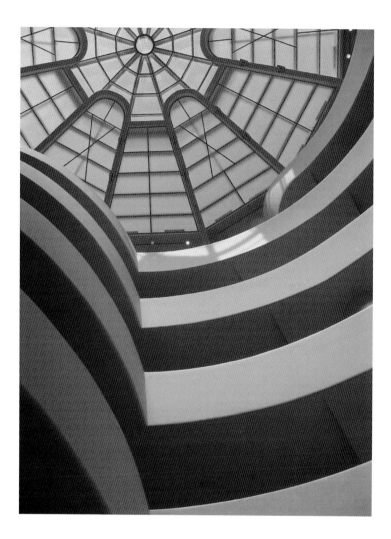

42. Frank Lloyd Wright, Guggenheim Museum, New York, 1959, interior view.

In terms that recall early responses to the Louvre's Grand Gallery, Peter Blake described the rotunda shortly after it opened: "It is a space of such grandeur that all the many justifiable criticisms of the building *as a museum* seem to become insignificant by comparison. It is impossible to describe the impact of this space; it must be experienced to be understood."[52] The striking novelty of design blinds us to other ways in which the Guggenheim connects to museums of the past. Like a Beaux Arts temple and in contrast to MoMA, the Guggenheim is set slightly back from the street and stands apart from the surrounding buildings. Wright described his museum as a "temple in a park," a deliberate throwback reference to the City Beautiful movement and the Metropolitan Museum across the street.[53] From the outside, the effect of the spiral rising above the broad horizontal band even recalls in an essential way the base-dome relationship in

Beaux Arts design. Inside, "flexibility" is greatly diminished: visitors follow a prescribed route rather than float freely through space; the walls and lighting are fixed. In ways both direct and subtle, Wright resurrected the museum's symbolic potential and returned a sense of occasion to the museum visit.

For many in the art world, then and now, Wright's privileging of the building over art was a sacrilege. To be sure, Wright addressed many practical concerns—elevators and the downward force of gravity answer the problem of visitor fatigue; a basement and separate wing house an auditorium, offices, and a trustees' room; and the original design called for the ramp to be divided into discrete viewing compartments—but there can be no denying the overwhelming drama of the architecture. Wright insisted he had achieved a "new unity between the beholder, painting and architecture, . . . a reposeful place in which paintings could be seen to better advantage than they have ever been seen," but even his greatest admirers have had difficulty agreeing with him here. The art critic John Canaday spoke for many when he countered: "If [Wright] had deliberately designed an interior to annihilate painting as an expressive art, and to reduce it to an architectural accessory, he could not have done much better."[54] (Is it a coincidence that forty years later Jed Perl used the same verb, *annihilate,* to describe the effect on art of Gehry's Guggenheim in Bilbao?) A young Hilton Kramer described the museum as a "cultural horror, a new disaster inflicted upon art."[55] The Guggenheim's first director, James Johnson Sweeney, moved uptown from MoMA to assume the position and did what he could to put the spiral back in a white cube, whitewashing the walls, installing artificial light, and suspending the paintings on rods away from the curved walls in an effort to give them greater autonomy.

Conceding the museum's shortcomings, we should remember that Wright was commissioned to do more than fashion another white cube for an elite of critics and collectors. The Guggenheim program called for a utopian building that would build community, and this Wright's design does to a remarkable degree. The open rotunda and prescribed circulation route force visitors to share the space with others in a way qualitatively different from other museums; visitors see the same people over again, on the ramp and across the rotunda, and overhear conversations rather than the muted drone of audio guides. Where MoMA pursued an ideal of individual self-actualization in the presence of isolated masterpieces, the Guggenheim aspired to unite people through the universal language of art. In Wright's own words, his museum would define "a new, more liberal idea of the nature of a public museum."[56] The first director had little sympathy for such social goals; from his perch above Fifth Avenue Sweeney was among the first to resent and resist the coming of the mass museum public in the 1960s. Embodying different brands of modernist form, MoMA and the Guggenheim also promoted different ways of thinking about the relationship between art and its consumers.

To blame the Guggenheim for the recent trend toward expressive, monumental museum architecture is to overlook the extent to which Wright was looking back to earlier museums and exploring the connection between the built form of a museum and its socioeducational role in an urban context. Boullée, Schinkel, and Cret had fully grasped the psychological allure and symbolic charge of a museum's architecture, and so had Wright. In the wake of New York's hugely successful 1939 World's Fair, the architectural critic and historian Henry-Russell Hitchcock remarked that museum designers stood to learn from its most popular attraction, the General Motors Pavilion by Norman Bel Geddes (fig. 43). If people cannot be made to attend museums and yet benefit from them when they do, wrote Hitchcock, then they will have to be enticed; like the General Motors exhibit, museums must learn to be entertaining as well as instructive: "[A museum's] purposes are best served, indeed can only be truly served, if it is . . . entertaining and appealing. . . . The museum . . . belongs in the field of democratic adult education. Its public ought to be a voluntary one. Therefore, it must practice a judicious showmanship and not be ashamed to entertain in order to teach."[57] The Bel Geddes pavilion, with its futuristic architecture, its curving ramps and walkways, proved irresistible to the masses and thereby gave its contents broad exposure. Wright believed his museum to be above the commercial interests and superficial entertainment of a world's fair, but he surely took its lessons to heart when designing the Guggenheim.

Tensions between the needs of art and the civic profile of a public museum may also be seen in the museum designs of Mies van der Rohe, which chronologically frame Wright's Guggenheim. Given that Mies was the chief exponent of a functional and flexible international modernism, we might expect a Mies museum to be the embodiment of curatorial ideals. Alfred Barr had wanted Mies to design the Museum of Modern Art, and he might well have done so but for trustee interference.[58] In 1943 Mies published his Museum for a Small City project, a domestically scaled, open-plan structure that would allow "every flexibility in use." Echoing mainstream curatorial priorities, Mies declared that the worth of his small museum depended "on the quality of its works of art and the manner in which they are exhibited."[59] Small paintings would hang on freestanding walls, but larger works would be suspended from the ceiling to enjoy a free-floating autonomy; sculptures

43. Norman Bel Geddes, General Motors Pavilion, New York World's Fair, 1939, design model. Photo courtesy of the Museum of the City of New York.

44. Mies van der Rohe, National Gallery, Berlin. View of the inaugural
Mondrian exhibition, 1968. Photo courtesy of Rheinhold Friedrich, Berlin.

on low plinths would similarly mingle with visitors and realize their three-dimensional
potential. Though the building was problematic as a public museum from the perspective
of conservation and security, the critic Peter Blake described it as "the realization of every
museum director's dream": "It is a large, open space, practically without columns, and . . .
utterly anonymous in character. The paintings and sculpture were King. Nothing in the
architecture was permitted to impinge upon the experiencing of the works of art dis-
played. Moreover, since no one could possibly predict what sort of art might, some day,
be displayed in the museum, the installation was made infinitely flexible."[60] The
difficulties of realizing such ideals were made abundantly clear, however, in the two
museum structures Mies completed in the 1960s and 1970s, the New National Gallery
in Berlin (1963–68) and the Brown Pavilion of the Museum of Fine Arts, Houston
(1973). In both cases Mies was asked to build an urban museum rather than a subur-
ban villa, and in both cases translations of scale and setting doomed the buildings as
a space for art. In Berlin the large hall on the ground floor was designed for temporary
exhibitions whose changing contents dictated an open plan and maximum flexibility,

45. Philip Johnson, Neuberger Museum of Art, New York, 1974, Stairway
Gallery. Photo courtesy of Neuberger Museum of Art, Purchase College,
State University of New York. Photographer: Jim Frank.

but in practice the space dwarfed most paintings and the light proved difficult to manage. William Rubin, Barr's successor at MoMA, recalled that the Mondrians displayed on hanging panels at the inaugural exhibition in 1968 (fig. 44) looked like "linoleum samples at a trade fair."[61] But Mies brushed aside complaints: "It is such a huge hall that of course it means great difficulties for the exhibiting of art. I am fully aware of that. But it had such potential that I simply cannot take those difficulties into account."[62] Similarly, the Brown Pavilion at the MFA Houston, though a grand public space, overwhelms all but the boldest of modern paintings. "Apart from the Houston Astrodome, one could barely imagine a less sympathetic space for showing art," quipped art critic Robert Hughes.[63]

Owing to their monumental character and deficiencies as exhibition spaces, the museums of Wright and Mies further enhanced MoMA's standing among critics and curators and fueled a backlash that took the form of undistinguished boxes aspiring to neutrality in the face of art, such as Philip Johnson's Neuberger Museum in New York (1974; fig. 45). A particularly hysterical example of backlash was the Newport Harbor

Museum in California, planned in the 1970s by a committee whose spokesman was the art historian Albert Elsen. Elsen envisaged an influential museum in the making when he wrote: "It will be an antidote to all of the showpiece museums. The building will be a series of boxes, and that will be all—no architect . . . I believe architects have been the assassins of museums."[64] Unfortunately (at least from a historical point of view) this attempt at "nonarchitecture" was not pursued—perhaps because no architect was at hand to supervise the project and because no one, in the end, could care about building, working in or visiting a characterless box.

The Pompidou Era

A year after the completion of Gordon Bunshaft's Guggenheim-inspired Hirshhorn Museum in Washington, D.C., in 1974, the critic Paul Goldberger sensed that the surge in "architectural hubris" in museum design initiated by Wright had run its course. "The great era of museum building is over," he declared, and "now that fashion is turning from the monumental to the modest. . . . [A]rt is likely to benefit."[65] In hindsight, of course, he greatly underestimated the extent of the museum boom and its architectural trajectory. Just three years later the Pompidou Center opened in Paris, setting off another, still more exuberant wave in monumental museum building that continues to the present.

Nothing could be further from the architecture-free space fantasized by Elsen than the futuristic, self-consciously monumental marvel designed by Renzo Piano and Richard Rogers (1977; fig. 46). Embracing high and popular culture, modern painting and sculpture as well as a multimedia library, a performing arts space, a cinema, cafés, shops, and great city views, the Pompidou was a new type of institution packaged in a radically new architectural envelope. On its western side, the architects added a public piazza that shows off the building and contributes to a festive, communal mood. With its open concourses inside and out, viewing platforms, bright colors, and permeable, transparent structure, the Pompidou invites participation and is palpably civic in orientation. Through daring form and an intentional blurring of boundaries between entertainment and education, it made a bold, utopian attempt to forge a new common space beyond the social and cultural hierarchies of old. Declared upon completion "the most stunning new 'go-to' to be seen in any city,"[66] it remains the most visited site in all of Paris, popular with tourists and residents alike.

The building was understandably controversial at first, but controversy suited its sponsor, the French government, precisely because it generated attention and popular interest. Conceived in response to social unrest in Paris in 1968, the Pompidou affirmed the government's commitment to the people. "We want to use the experiences of the

46. Renzo Piano and Richard Rogers, Pompidou Center, Paris, 1977.

'60s—what one learned in those years," said it first director, Pontus Hulten.[67] "Being more open is the basic idea. Open at night, open in the sense that it's not forbidding in any kind of way. Something not class oriented." Of course, the French have long used cultural and museum patronage for political ends; what was needed after 1968 was a popular monument that made the government and French culture seem "relevant." The architects Renzo Piano and Richard Rogers were chosen through a massive, open public competition. Young and foreign, they owed no allegiance to the French establishment, and their winning design willfully turned its back on tradition as it vaulted euphorically into the future. The building, as a transparent symbol of a progressive, open society, was central to the Pompidou's program, and on an important level its success was measured in terms of how many people came. As Jean Baudrillard noted, it might just as well be empty, for its true contents "are the masses themselves" "flowing through the transparent space," celebrating their access to culture, entertainment, and the city of Paris itself.[68]

The connection between alluring architecture and high visitor numbers has influenced subsequent museum design wherever sponsors have felt obliged, for reasons political or economic, to measure success in term of attendance and revenue. Whereas Philip Youtz once denounced architecture as an obstacle to access, a significant post-Pompidou trend looks to new buildings to draw the crowds. What made the Pompidou experiment still more compelling for other governments and civic authorities was the galvanizing effect it had on its neighboring community. Its astonishing popularity fueled the rehabilitation of the run-down Marais district, providing a model for urban gentrification throughout the developed world. The power of cultural centers to revive neglected neighborhoods has since become a cliché of town planning. But for those who believe art and museums should be their own reward, socioeconomic justifications of the sort associated with Pompidou and Bilbao entirely miss the point.

The diverse contents, spectacular novelty, and patent success of the Pompidou overshadowed the building's problems as a space for art. Moving the building's infrastructure to the exterior left the interior completely open and adaptable—ideal for the diverse functions and contents of a rotating contemporary art space, or *Kunsthalle,* but ill suited for the display of conventional modern art, which the top-floor galleries were supposed to house. The Pompidou demonstrated once more that paintings and sculptures need well-tailored spaces to be seen to advantage; with too much space and flexibility, architecture works against the interests of art and its viewers. After the Pompidou opened, Gae Aulenti (better known for her conversion of the Musée d'Orsay; see below) was hired to rework the top floor, masking the high-tech architecture with conventional white cube galleries, but still no one would rate it a happy place to look at Braque and Picasso. Both artists seem more comfortable in the Musée Picasso (1985), a converted seventeenth-century *hôtel* just a few streets away in the Marais.

47. I. M. Pei, Louvre Pyramid, Paris, 1989.

Though Goldberger underestimated the building boom, he correctly identified its root causes as an abundance of money and the tendency of cities to look to museums to give them instant cultural credibility. Writing in the midst of an economic recession, he failed to predict that when the recession ended and the money returned there would be many other communities waiting to be energized by a sparkling new art museum. And when the money did return, the Pompidou demonstrated that a dynamic new museum could more than pay for itself in terms of publicity, attendance, revenue, urban renewal, and civic pride. Furthermore, it launched the careers of Richard Rogers and Renzo Piano and inaugurated the "starchitect" phenomenon that has since dominated the field of museum design. From the 1980s clients banking on the rich potential of a new museum have relied on a small (but expanding) circle of celebrated international architects, listed at the start of this chapter, to give them a photogenic and alluring monument of their own.

Following the lead of President Pompidou, François Mitterrand used his presidency to mark the Parisian landscape with a string of grand cultural landmarks on the axis from La Défense to the new opera house at Bastille. At midpoint is the Louvre, whose expansion in the 1980s centered on I. M. Pei's glass and steel Pyramid (fig. 47). Controversial at the start for its dynamic modernism, flagrant disregard for the classical build-

48. I. M. Pei, Museum of Fine Arts, Boston, West Wing, 1981, interior view.

ings that surround it, and accommodation of everything (shops, restaurants, theaters, and the rest) but art, it soon captured the public imagination and now vies with the *Mona Lisa* and the Venus de Milo as the Louvre's trademark. Reminiscent of a structure Boullée might have designed, the Pyramid is a building that "delights" as it channels the masses into the belly of the world's most famous museum. Pei also designed the splendid new painting galleries, where the depth of the Louvre's collections may be seen, but it is the Pyramid we remember most. In the early 1980s Pei established himself as a master of the museum addition. His new buildings at the Louvre, Washington's National Gallery (1978), and Boston's Museum of Fine Arts (1981) all brought new life and services to aging museums. New wings at Washington and Boston housed temporary exhibition galleries, shops, and restaurants, which significantly boosted attendance and

49. Gae Aulenti, Orsay Museum, Paris, 1987, interior view.

revenue. Since then new additions featuring the same amenities have become ubiqui-
tous and have given rise to the common comparison of museums to shopping malls.
Enter the West Wing of the Boston MFA (fig. 48) and the analogy seems justified. An
atrium café with potted plants under a barrel-vaulted gallery, a large shop selling a va-
riety of more or less tasteful products, escalators, a suspended walkway, and the con-
spicuous use of glass, steel, marble, and reflective panels all recall the familiar features
of an upscale mall. But just as earlier architects took care to hide offices and storage
from public view, so Pei and others have separated the spaces and functions of com-
merce from the permanent collection. One does not interfere with the other.

Back in Paris, across the river from the Louvre, Mitterrand also opened a new mu-
seum in an abandoned Beaux Arts train station. The Musée d'Orsay (1987; fig. 49) took
over from the Jeu de Paume as the museum of French impressionism and postim-
pressionism. Gae Aulenti's adaptation of the nineteenth-century station for the display
of art from the same era made sense contextually and art historically (the Orsay as one
big period room), but the building proved unwieldy. Though the main hall delivers a

thrilling initial *coup d'oeil,* the Orsay, judged by standard museological criteria, cannot be considered a success. Circulation and signage are poor, the upstairs galleries for the impressionists are adequate but bland (and always crowded), and the cramped bunkers on the ground floor, displaying mid-nineteenth-century art, including the masterpieces of Manet, only make old-timers nostalgic for the Jeu de Paume. Not surprisingly, however, the fame of the collection and the power of the building have made the Orsay a tourist magnet.

The formula "build a museum and they will come" has been proven to work virtually wherever it has been tried. The phenomenon, described by Goldberger, of creating new art museums in smaller cities continues to bring high culture to new places and revitalize neighborhoods gone to seed. Richard Meier's High Museum of 1983 gave Atlanta an instant cultural profile, and his gleaming Museum of Contemporary Art helped lift the gritty El Raval section of Barcelona (1995; fig. 50), even though neither museum had much art to speak of. Some have said the same of Meier's Getty Center in California (1997; fig. 51), but thanks to a majestic building complex, breathtaking views, Robert Irwin's fantasy garden, and a monorail ride up the hill from the parking lot, the collection's shortcomings seem less evident and visitor numbers have greatly exceeded expectations. With the richest endowment of any art museum in the world, the Getty's collection will improve and eventually live up to its palatial quarters.

At the start of the new millennium the list of new and recent construction projects has been staggering in its breadth and range. At one end there are renovations of smaller institutions that rate only passing mention in the mainstream press (Rick Mather's face-lift of London's Wallace Collection [2000], for example, or the quality work of Ann Beha at the Portland Art Museum [2005]), and at the other eye-popping, multimillion-dollar wings and new museums that challenge the conceptual limits of the build-

50. Richard Meier, Museum of Contemporary Art, Barcelona, 1995, view through old streets.

51. Richard Meier, J. Paul Getty Museum, 1997.

ing type. The work of Daniel Libeskind and Santiago Calatrava stands out among the latter. Libeskind's Jewish Museum in Berlin (1998; fig. 20) is so extraordinary as a building that it drew 350,000 visitors over its first two years even though it was empty. By means of awkward spaces, unexpected turns, and jagged edges inside and out, the Jewish Museum is meant to evoke in itself the experience and memory of the Holocaust. Notwithstanding the obvious challenges that Libeskind's buildings present for the conventional display of objects, the magnetism of his architecture has won him further museum commissions. Announcing the "signing" of Libeskind in 2000 to build a new addition to its art museum, the mayor of Denver announced: "When the expansion is complete, this museum complex will be able to attract not only the world's greatest art to Denver, but also many thousands of visitors who will put us on the map as a world-class destination city."[69] Precisely the same goals motivated the city of Milwaukee to hire Calatrava to add an extraordinary new extension (2001; fig. 52) to its tired Saarinen museum dating from the 1950s. "We wanted a building that would scream art museum," said the museum's director of the $100 million addition with its kinetic *brise-soleil* and

52. Santiago Calatrava, Quadracci Pavilion, Milwaukee Art Museum,
2001. © 2006 ARS, New York/VEGAP, Madrid.

space-age interior.[70] Milwaukee got its wish: the Quadracci Pavilion won *Time* maga-
zine's Best Design Award for 2001 and has had art lovers visiting in droves.

As civic officials and museum directors fully understand, new buildings energize lo-
cal donors and citizens. They are relatively easy to raise money for, and (in theory at
least) once built they pay for themselves through higher attendance. New buildings also
inspire gifts of art. In a massively inflated art market where the cost of a single paint-
ing may exhaust annual acquisition funds, museums depend on wealthy collectors for
new acquisitions, and collectors are naturally motivated to give to institutions that have
enthusiastic visitors and a bright future. Build and they will come, but also build and
they will give. At the same time, new state-of-the-art facilities with environmental and
security controls, to go along with a stimulated visitor base, increase the likelihood of
loans and traveling shows, which in turn boost attendance, revenues, and the museum's
profile. It is hard to imagine, for example, that exhibitions like Leonardo da Vinci and
the Splendor of Poland (2002) or the popular Quilts of Gee's Bend (2003) would have
stopped in Milwaukee before the completion of Calatrava's new wing.

Backlash: The Return to "Traditional" Values

Despite, or because of, its remarkable success, not everyone in the art community has been sanguine about the "Bilbao effect." Some warn that new buildings give only short-term benefits, that without a strong collection the crowds will visit the museum once and not return. In the event of declining revenue streams and increasing operating costs, museums will be forced to invest still further in more buildings, special exhibitions, and commerce. More widespread are complaints that the new architecture diminishes art and cheapens the museum experience. The new Calatrava wing in Milwaukee has drawn criticism on both counts. Notwithstanding design awards and its power to draw crowds, cost overruns on the project left the museum in debt, and the complex building will no doubt prove expensive to maintain. Though wondrous in itself, the new wing feels disconnected from the original museum and the strong permanent collection it houses. There is something disconcerting about the public announcements that summon visitors to watch the opening of the winglike *brise-soleil* but fail to mention the twentieth-century collection in the (virtually empty) Saarinen building that would be the envy of many other museums. In the words of Paul Goldberger, the Quadracci Pavilion is a "spectacular building that has nothing to do with the display of art and everything to do with getting crowds to come to the museum."[71]

Practical issues aside, complaints about the display of art return us to the firmly entrenched priorities and prejudices of curators, art critics, and the elite museum-going public. That the new buildings and their amenities tend to be very popular with the mass public only deepens suspicions among art world professionals. It is hardly surprising, therefore, that the strongest protests against architecture tend to come from either museum staff who can afford to ignore the general public (because of healthy endowments or protective university environments) or art critics whose standing as arbiters of taste is undermined by architecture's mesmerizing appeal.[72] If people attend new museums in spite of the art, or lack thereof, what use are critics? By training and inclination museum directors and curators will naturally privilege art over architecture and commerce, but many can no longer afford to do so or at least must settle for compromise. Like it or not, for better or worse, museums and their architecture are part of the new cultural economy, a complex mix of financial pressures and revenue streams, political and public expectations, and shifting recreation habits.

More than simply whine about the Bilbao effect, those who enjoy the luxury of complaint promote a handful of architects who resist the spectacular and instead pursue refined conditions for viewing and contemplation through delicate lighting, quality materials, and serene public spaces. In such circles Renzo Piano is at the top of the list. The conservative backlash against expressive museum buildings—what can be called the "anti-Bilbao effect"—has made an understated Piano addition no less an architec-

53. Renzo Piano, Menil Collection, Houston, 1987.

tural cliché than Gehry's titanium shells. In radical contrast to (and atoning for?) his early Pompidou Center, Piano's "overwhelmingly nonmonumental"[73] buildings for the Menil Collection in Houston (1987; figs. 53–54) and the Beyeler Foundation in Basel (1997), both characterized by restrained exteriors and calm internal spaces, embody curatorial "art first" ideals. At the Menil the low-lying building blends into its residential neighborhood, and architectural embellishment is limited to high-tech louvers that filter the harsh Texas sun. Lighting, artful presentation, and the suppression of text panels and customary amenities (shop, restaurant) intensify the experience of art and help to make the collection seem stronger than it is.

54. Renzo Piano, Menil Collection, Houston, 1987, display of Cycladic sculpture.

There can be no denying the understated beauty of the environments Piano creates, but the Menil and the Beyeler are both small, well-endowed, private institutions; neither has a mandate to cater to the masses, and both can do without shops and restaurants. They retain the feel of a private collection, which no doubt helps to explain their appeal to the art world elite. A similar serenity and otherworldly spirit prevail in Tadeo Ando's Museum of Contemporary Art in Naoshima (1992; fig. 55), remotely situated on an island in Japan's Inland Sea, and his Pulitzer Foundation of the Arts in St. Louis (2001). With their austere exteriors, narrow audiences, and eschewal of commerce, both museums represent the antithesis of Bilbao.[74] Yoshio Taniguchi's sophisticated brand of late modernism has also caught the eye of conservative but quality-conscious museum professionals. Favoring precise use of high-quality materials and the subtle handling of space and proportion over bold effects, his Gallery of Hôryûji Treasures in Tokyo (1999; fig. 56) is crafted like a fine jewel and envelops its venerable eighth-century artifacts in a templelike tranquillity. Understated tranquillity is what MoMA hoped Taniguchi would bring to its own transcendent masterpieces in his ambitious $850 million new building (2004; fig. 57). Telling the MoMA establishment exactly what it wanted to hear, Taniguchi said: "If you give me enough money, I'll design you a beautiful

55. Tadeo Ando, Museum of Contemporary Art, Naoshima, Japan, 1992, gallery view.

56. Yoshio Taniguchi, Gallery of Hôryûji Treasures, Tokyo, 1999.

57. Yoshio Taniguchi, Museum of Modern Art, 2006, gallery view.

building. If you give me more, I'll make it disappear."[75] And disappear it does, though surely not in the sense he intended. At MoMA architecture doesn't overwhelm the art, but the crowds do, and the architecture with it. The museum's noble goal of creating "a more intimate experience between art and viewer"[76] is undermined by the hordes of people around every corner. The qualities that make Ando's and Taniguchi's museums appealing in Japan are lost in translation when transferred to the scale and hyperpopularity of the new Museum of Modern Art.[77] Perhaps no one anticipated the crowds, or perhaps Taniguchi and the museum are guilty of designing a museum in which the quality of space and detail can be appreciated only if you are alone in the galleries, as only the architect and the curators can ever be. Meanwhile, the public spaces—the entrance and atrium—are underwhelming, as if neither party wanted to invest too much in symbolic space.

Another form of backlash against the Bilbao effect is the new "loft museum," notable examples of which are the Andy Warhol Museum in Pittsburgh (1994), the Massachusetts Museum of Contemporary Art (Mass MoCA, 1999), and Dia: Beacon, north of New York City (2003; fig. 58). In some respects these museums echo strategies we have already seen. Like the Orsay, they make adaptive reuse of abandoned structures suited to their contents, in their case postwar Western art. Like the Pompidou or Bilbao, they have helped revitalize depressed neighborhoods and economies. But unlike those re-

58. Installation of Donald Judd's plywood boxes (1976) at Dia: Beacon, New York, ca. 2005. Dia Art Foundation; gift of the Brown Foundation. Photo: Bill Jacobson. Art © Judd Foundation. Licensed by VAGA, New York. Photo courtesy of the Dia Art Foundation, New York.

markable buildings, the loft museums are "nonarchitectural." Built for efficiency by no-name architects, the erstwhile factories and warehouses they inhabit are simple, flexible, and egoless. Even better, by emulating the spaces in which their contents were made, the studio lofts of modern artists, the loft museums are like late-modernist period rooms that transcend the usual commercial, political, and aesthetic associations of the art museum to achieve a kind of original purity. Here, according to the rhetoric, the art is allowed to speak for itself. At Dia: Beacon, as at the Menil or the Pulitzer, wall labels are minimal and so are the crowds, and the light is stunning: engaging with the art is what counts, and the "neutral" architecture lets this happen. "Beacon is the anti-Bilbao," the *New York Times* declared when it opened: "shaped by artists, not an architect; a harbinger, perhaps, of a straitened new century," or at least the future as one segment of the art world hopes it will unfold.[78] The ethos of the converted industrial museum type in its purest form may be experienced at the Chinati Foundation in Marfa, Texas (1994), another Dia-funded initiative and one of the most remote art institutions in the world.

Displaying significant works by Donald Judd, Dan Flavin, and others, and installed by the artists themselves in a set of reconditioned army buildings in the middle of nowhere, it is far removed from the normal circuits of tourism and the art world. What the Dia projects share with the Menil and Pulitzer is a commitment to the ideal of personal communion with serious art; they are pilgrimage sites for those in the know. Privately funded and financially secure, they have no need, or desire, to lure crowds.

It goes without saying, of course, that no architecture can be "neutral." Taniguchi cannot make his building disappear, nor should we want him to. The loft museums, too, contribute their own presence to the experience of art. Walk into Dia: Beacon and you are struck by the luxurious quantity and quality of space and light—functions of the building, not the art on display. "Neutrality" is the watchword for those in the art world whose utopian fantasy is, literally, a museum without walls.

Synthesis

By and large, recent museum buildings have attempted to resolve the tensions between art and architecture, private contemplation and civic engagement, through a synthesis that amounts to a separate-but-equal treatment of inspirational public spaces and deferential galleries. In essence this was Schinkel's approach at the Altes Museum, and it was central to the program of the Beaux Arts palace. Wright attempted to integrate the two, as did Mies in a different way, but architects since have learned from their bold mistakes, and in many new museums one finds both dramatic facades and atriums and delicately crafted galleries that answer to curatorial demands. (Of course, in most public museums shops and restaurants must also be accommodated, along with offices, storage space, and bathrooms, but these, too, are kept apart from the spaces of art.) At Herzog & de Meuron's Tate Modern in London (2001), for example, visitors pass through the vast (sublime?) Turbine Hall on the way to austere galleries designed to accommodate a variety of art forms; en route interstitial rest stops afford views of the city and back into the hall, encouraging reflection on the museum's public character. One could argue that the hall is too gargantuan and the galleries are too antiseptic, but the architects were conscious of the distinct value that both spaces contribute to the museum experience. The same can be said of other recent museums—for example, Mario Botta's San Francisco Museum of Modern Art (1995), a building whose plan bears a striking resemblance to Schinkel's Altes Museum; Meier's Getty Center; Ando's Museum of Modern Art in Fort Worth (2003); Robert Venturi's Seattle Art Museum (1991); Stephan Braunfels's Pinakothek der Moderne in Munich (2003); and even Gehry's new Guggenheim, where the dramatic exterior and thrilling atrium give way to variants of conventional white cube galleries.

In well-established museums, new additions and wings have been strategically de-

ployed to enliven or tone down existing architecture. As we have seen, new buildings by Pei, Libeskind, Foster, Calatrava, and others have rejuvenated numerous museums. Less commonly but just as significantly, new construction may counteract an expressive building and direct attention back to the collection. In Atlanta, for example, Renzo Piano was brought in to design an extension to the High Museum (2005) that provided more curator-friendly space and declared a new seriousness of purpose as the museum entered a new phase in its history. If at the start Meier's 1983 building was the High Museum's chief attraction, twenty years later the collection had doubled in size and improved in quality, and the time had come to assert the place of art. The choice of Piano over Meier (who was not asked to design the new addition to his own building) sent the message that Atlanta wanted to be known as a place for serious art and serious art people. Explaining why Meier had not been approached, the director put it simply: "Meier has a tendency to make spectacular buildings. We already had a statement building."[79] Having served its purpose, namely, to cultivate a public and a collection where there had been none, as officials concede it did very well, the Meier building now coexists with an addition that the curators hope will give new emphasis to the art. Commenting on another Piano extension, to the Whitney Museum in New York, Marcel Breuer's brutalist masterpiece, the director said: "First and foremost is not the spectacle of the museum, but the spectacle of the art."[80]

We may argue about the success of individual spaces and the degree to which a successful balance of celebratory and curatorial functions has been achieved. But both are vital to the public art museum, and always have been.

■ ■ ■

Perhaps more than any other museums of the late twentieth century, the buildings of Louis Kahn have been praised for the equilibrium they achieve between environment and objects, tradition and modernity.[81] Monumental yet respectful of art, stately but serene, his Kimbell Art Museum in Fort Worth (1972; figs. 59–60) and Yale Center for British Art in New Haven (1977; fig. 61) are universally admired. Trained by Paul Cret, and working in Cret's office when the latter wrote his defense of museum architecture in the 1930s, Kahn inherited a Beaux Arts approach to plan and circulation along with a belief in the value of monumentality and symbolism in important public buildings. In New Haven, Kahn's British Art Center confidently occupies its site on Chapel Street, yet is respectful of its neighbors. With shops at ground level and reflective materials on the facade above, the building interacts with the street in different ways. In a manner that recalls Wright's Guggenheim, a dark recessed entrance ushers visitors into an uplifting courtyard full of natural light. This front courtyard is paired with another on the far side of the stairwell, and together they give symmetry, a sense of occasion, and a

59. Louis Kahn, Kimbell Art Museum, Fort Worth, Texas, 1972.

source of unifying light to the museum as a whole. Repeated attempts over the years to display art in the forecourt have been unsuccessful because the space was designed, not for that purpose, but rather to welcome and inspire. The galleries ringing the courtyards, on the other hand, domestically scaled, beautifully lit, and punctuated with occasional views of the street below, are close to perfect for the display and viewing of conventional easel pictures.

More famous still is Kahn's slightly earlier Kimbell Museum. Here Kahn uses the same combination of materials—poured concrete, brushed steel, white oak, and Belgian linen—to create an environment that is clean and modern but easy on the senses and ideal for art. In both museums Kahn uses a modular plan derived from Beaux Arts teaching, but at the Kimbell the units are top-lighted, barrel-vaulted galleries that look back to Boullée and Soane. On the outside, the undulating forms roll with the surrounding plains, fully anticipating the internal volumes without betraying the sense of surprise generated inside by the soothing light that enters from above. In the Kimbell works of art seem refreshed and alive, and so do the visitors. The Kimbell and Yale Center have their

60. Louis Kahn, Kimbell Art Museum, Fort Worth, Texas, 1972, interior view.

61. Louis Kahn, Yale Center for British Art, New Haven, Connecticut, 1977, interior view.

limits: neither can accommodate large-scale works of art, paintings work better than sculpture, and much contemporary art would look out of place. But in both museums Kahn was designing for specific collections of older art, and given his brief he achieved an extraordinary synthesis of effects.

Because Kahn's buildings are so highly revered, it is instructive to recall an essay he wrote in 1944 that endorsed those qualities of experimentation and monumentality that are so controversial in the field of museum design today. In the essay, Kahn challenged his generation to design "buildings of high purpose" using new materials and forms that nevertheless would remain true to the "monumental structures of the past."[82] While outright imitation was no longer viable, he said, "we dare not discard the lessons these buildings teach for they have the common characteristic of greatness upon which the buildings of our future . . . rely." He imagined domes, vaults, and arches molded into new "gigantic sculptural forms of the skeleton frame" using modern "technology and engineering skill." Like Schinkel before him, Kahn believed that important civic buildings must "delight and serve," and in our time this applies not least to public museums. Consistent with Kahn's vision, if not his vocabulary, the recent museums of Gehry, Meier,

Hadid, Calatrava, Foster, and others have indeed explored new technologies and forms as they carry the museum idea into the future.

What critics of expressive architecture overlook is that people go to museums to be entertained and inspired, to be taken out of themselves, and to submit to the thrall of culture and tradition, and that such effects are a function of architecture as well as art and have been so for as long as museums have existed. A strong collection *and* an impressive building are both necessary components of a great art museum. We forget that Schinkel's Altes Museum was a striking building in its time, with grand internal spaces and external vistas, and that the Louvre when it first opened was a dazzling tourist attraction no less popular with a broad public than Pei's Pyramid or the Pompidou is today. The new museums may house activities that seem (to some) inconsistent with the serious consumption of art, but great architecture, far from cheapening the museum experience, frees us momentarily from the flow of everyday life and allows us to contemplate the products of human creativity. Museums are, moreover, among the few beautiful and inspiring civic spaces available in modern society. According to museum director Charles Saumarez-Smith, "[M]useums have become one of the last remaining sites for openly accessible and democratic urban experience, where individuals may seek to understand their history, their environment, their cultural opportunities, and themselves."[83] For the critic Paul Goldberger, the new museums celebrate "the ennobling potential of public places."[84] Herbert Muschamp spoke of the "extravagant optimism" that Bilbao inspires in those who make the "pilgrimage," while Peter Plagens called Gehry's museum "among the grandest examples of the hope that art . . . can rejuvenate . . . the human spirit."[85] Such sentiments smack of bourgeois mystification to the postmodern ear, but there is perhaps no surer sign of the will to transcend the pessimistic implications of postmodernism than the recent boom in museum architecture. If some years ago postmodernism decreed the obsolescence of the museum, the museums of the new millennium declare the irrelevance of postmodernism by reaffirming the spirit of Boullée and the utopian ideals of the Enlightenment.

The one major museum architect of recent years missing from the preceding account is James Stirling. For a brief period in the 1980s, Stirling's museums—the Staatsgalerie in Stuttgart (1983; fig. 62), Sackler Museum at Harvard (1985), and Clore Gallery at Tate Britain (1987)—led the field of innovative museum design along with the buildings of Pei and Meier. The *New York Times* hailed the coming of Stirling's Sackler Museum at Harvard University as "the architectural event of the 1980s."[86] Today, however, his museums seem outmoded and a bit too precious. I would suggest that they were doomed to become marginal because of the fundamental incompatibility of postmodernism—as critical stance and architectural style—with the art museum as an institution. Postmodernist architecture, which reached its peak in the 1980s and claimed

62. James Stirling and Michael Wilford, Staatsgalerie, Stuttgart, 1983. Photo: Richard Bryant/arcaid.co.uk.

Stirling as a chief exponent, derived its energy from a creative but mocking critique of modernist vocabulary. It took its lead from postmodern theory, which included the "new museology," and shared its terminal prognosis for all things modern. Significantly, architecture and theory came together in Douglas Crimp's pioneering postmodern critique of museums, *On the Museum's Ruins* (1993), in which Crimp characterized Stirling's Stuttgart museum, with its mock ruins, broken contours, Day-Glo colors, and playful quotation of classical forms, as a literal response to his earlier essay prophesying the end of the museum.[87] Such a reading was possible because of the deliberate ambiguity at the heart of postmodern architecture, with its unsettling blend of "self-importance and self-mockery," "deflatable pomposity," and "non-monumental monumentality."[88] By design, visitors to Stirling's museums are confused—historically, philosophically, and sometimes literally. While his galleries are conventional and well crafted (lighting and materials are a forte), his facades and public spaces are challenging, disorienting, and even uncomfortable, throwing into question the relationship between visitor and contents. Is one there to celebrate or mock, to contemplate or mourn? Postmodern theory is unwelcome in the art museum because it challenges notions of historical continuity, institutional authority, and unabashed celebration on which the museum depends. As an architectural style for museums, postmodernism was destined to be short-lived because it contradicted a fundamental purpose of the building type, namely, to delight, inspire, and transcend.

An efficient educational museum may be described as a collection of instructive labels each illustrated by a well-selected specimen. **George Brown Goode (1888)**

In a museum of fine art, are the labels really more important than the exhibits; or are the exhibits more important than the labels? **Benjamin Ives Gilman (1915)**

3 COLLECTING, CLASSIFICATION, AND DISPLAY

During the 1990s the conceptual-installation artist Fred Wilson mounted a series of brilliant temporary exhibitions, including Mining the Museum and The Museum: Mixed Metaphors, that had as a major theme the way museums organize their collections and highlight or suppress objects within them. Deeply informed by a postmodern awareness that all systems of classification are constructed, not neutral or natural, and that collections ordered in space tell stories that carry significant ideological implications, Wilson's exhibitions unmasked museological conventions that normally go unseen by the public and are taken for granted by museum professionals. I call them exhibitions, but *interventions* would be a more appropriate term, for Wilson inserts his "work" into the flow of a standing collection, relying on unexpected juxtapositions to create sudden moments of revelation in the beholder. In Mining the Museum, staged at the Maryland Historical Society in 1992, Wilson mined the society's holdings in search of objects, some familiar to the public and some never before displayed, that could be combined in exhibition to create new ways of thinking about Maryland's history, the museum's role and responsibilities, and the public's own expectations as visitors.[1] On a primary level, startling contrasts, such as a set of slave shackles displayed alongside refined repoussé silver in a case labeled "Metalwork, 1723–1880" (fig. 63), a whipping post set among a selection of chairs in a display of "Cabinetmaking, 1820–1960," or a Ku Klux Klan hood nestled in a perambulator, raised questions about America's racist past and the relationship between the lifestyle of the Maryland elite and the slaves who made it possible. How are African Americans represented at the Maryland Historical Society, except as the absent presence strapped to a whipping post or seen through the eyes of a Klan hood? But on another level, Wilson's installation prompted viewers to think about

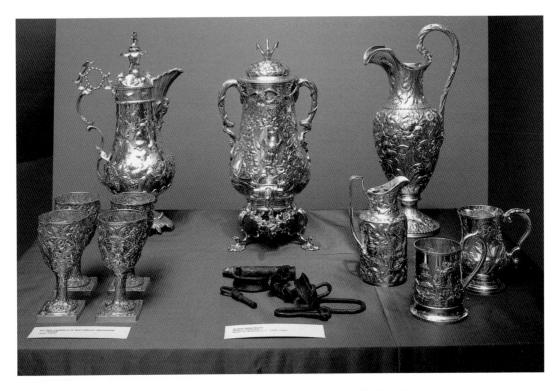

63. Fred Wilson, *Metalwork, 1793–1880.* Silver vessels in Baltimore repoussé style, 1830–80. Installation view from Mining the Museum: An Installation by Fred Wilson, 1992. Contemporary and Maryland Historical Society, Baltimore. Photograph: Jeff Goldman. © Fred Wilson. Photo courtesy of the Maryland Historical Society.

the choices institutions make—choices of objects and narratives—and the potential of possible *alternatives*. By clearly identifying himself as the author of the exhibition, Wilson left us to wonder: Who customarily chooses and arranges the objects we see in museums, and what story do they want to tell? What others stories might be told?

A year later in The Museum: Mixed Metaphors, at the Seattle Art Museum, Wilson intervened more directly in the life of a museum, once again using the device of juxtaposition to disrupt normal visitor expectations.[2] Prior to Wilson's intervention, the Seattle museum employed a typical division of its collections, with a chronological arrangement of European and American high art on the fourth floor and nonchronological, contextual displays of other cultures—Chinese, Japanese, Korean, African, and Northwest Coast Native American—on the floor below. But how is our understanding of what constitutes "American art" affected when tribal carvings from the Northwest Coast are

moved from their Native American home on the third floor to the nineteenth-century American galleries above and displayed next to contemporaneous works by Winslow Homer and William Merit Chase? What happens when the contextual trappings and interpretive materials normally reserved for non-European or American objects are exported to the galleries for modern Western painting? In the post-1945 gallery on the fourth floor, Wilson installed a "collector's living room" (fig. 64) in which Morris Louis's painting *Overhang* (1959–60) was framed by Barcelona chairs, an Oriental carpet, a coffee table, and two video monitors showing how modern art "functions" in two private collections in the Seattle area. To a display case of African robes, fabrics, and implements of power on the third floor, Wilson added a mannequin sporting a neat gray suit and reminded us in a wall label that notions of dress and power in Africa are not frozen in the "traditional" past usually favored by Western museums: "Certain elements of dress were used to designate one's rank in Africa's status-conscious capitals. A gray suit with conservatively patterned tie denotes a businessman or member of government. Costumes such as this are designed and tailored in Africa and worn throughout the continent."[3] Together with these and other reworked installations, Wilson selectively rewrote further wall texts and refocused spotlights on fire alarms and drinking fountains to create a

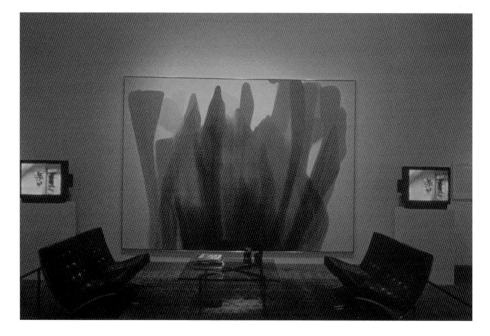

64. Fred Wilson, *Collector's Living Room*. Various media. Installation view from The Museum: Mixed Metaphors, Seattle Art Museum, Washington, 1993. © Fred Wilson. Photo courtesy of Pace/Wildenstein, New York.

charged environment in which a full panoply of curatorial strategies was itself on display and open to question. Familiar objects and ways of seeing were rendered temporarily strange.

In effect Fred Wilson's work puts into practice a form of Foucauldian analysis, or "archeology," of the museum, exploring and revealing the working parts and ideological foundations of the institution. For many artists, critics, and academics who came of age after the 1960s, Michel Foucault's penetrating critique of the contingency of the intellectual systems, hierarchies, and power relations naturalized in the institutions that structure our lives had the force of revelation—and nowhere more so than in our understanding that the categories, hierarchies, and canons museums use to order and explain their contents are culturally constructed. In the wonderful, oft-cited opening passage to his book *The Order of Things* (1966), Foucault undermined the epistemology of taxonomies we take for granted by encouraging us, momentarily, to think otherwise:

> This book first arose out of a passage in Borges, out of the laughter that shattered, as I read the passage, all the familiar landmarks of my thought—*our* thought, the thought that bears the stamp of our age and our geography—breaking up all the ordered surfaces and all the planes with which we are accustomed to tame the wild profusion of existing things, and continuing long afterwards to disturb and threaten with collapse our age-old distinction between the Same and the Other. This passage quotes a "certain Chinese encyclopedia" in which it is written that "animals are divided into: (a) belonging to the Emperor, (b) embalmed, (c) tame, (d) sucking pigs, (e) sirens, (f) fabulous, (g) stray dogs, (h) included in the present classification, (i) frenzied, (j) innumerable, (k) drawn with a very fine camelhair brush, (l) *et cetera,* (m) having just broken the water pitcher, (n) that from a long way off look like flies." In the wonderment of this taxonomy, the thing that we apprehend in one great leap, the thing that, by means of the fable, is demonstrated as the exotic charm of another system of thought, is the limitation of our own, the stark impossibility of thinking *that.*[4]

The effect of Foucault's analysis of epistemological systems (followed by equally incisive studies of prisons, mental asylums, and human sexuality) is that we are now able to view our own modes of thought as if from the outside—if not as "other," then at least as of our own making. The broad dissemination of his ideas has fueled within the museum a heightened self-consciousness of practice and recent, often controversial, experiments with internal organization (including the solicited interventions by Wilson), to which I will return. It also makes possible the writing of a history of collecting and display practices, which is the broad ambition of this chapter.

. . .

All museums rely on classification and display to give their contents coherence and meaning. Classification and arrangement are the lifeblood of any collection; collections differ from mere accumulations of objects by virtue of criteria of selection and a subsequent ordering of what is collected into meaningful categories and/or a sequence. Collecting is done with a purpose and usually entails a finite set or series of objects that one strives to complete (e.g., a complete set of Hummel figurines or prints by Hiroshige). Who collects what and following what criteria will vary according to personal interest, but at the same time it is important to recognize that such criteria are culturally determined (readers outside the United States may not know what Hummel figurines are; many within the United States will find the example appalling). On the one hand, psychology describes collecting as an extension of the self; we express ourselves through the things we own, and the more deliberate the process of acquisition and presentation, the more self-reflexive objects become.[5] What we gather around us and subject to rational order serves as a buffer to the "otherness" of the world. The fine line separating order from chaos, desire from obsession, is a recurrent trope in the literature on collecting, beginning with La Bruyère's profile of the collector (1688) driven to the edge of madness in pursuit of the only Jacques Callot print missing from his set, and continuing with Flaubert's tale of Bouvard and Pécuchet (1881), in which two men embark on the futile task of cataloging the junk of modern Paris.[6] On the other hand, we recognize that patterns of collecting and display vary from one culture and historical moment to another and within a given moment will be heavily conditioned by the matrix of factors—class, ethnicity, gender, and so on—that determine social status and identity. Who collects what and when, and how what is collected is organized and presented to the world, are thus matters of deep cultural and historic interest. In the words of Stephen Jay Gould, classification is "truly the mirror of our thoughts, its changes through time the best guide to the history of human perceptions."[7] What can be said for collecting on the individual level is equally true for societies at large: our public museums may be viewed as expressions of collective values and aspirations.

If the architecture of museums signals their civic and symbolic value in the world, what may be called the semiotics of the museum interior are no less important, for through the museum's internal codes and conventions, its modes of classification and display, hierarchies are affirmed and systems of thought and interpretation articulated. As James Clifford put it, the "taxonomic, aesthetic structure" of a collection constitutes the vital matrix within which individual objects are apprehended and given meaning.[8]

The value of order in museums is registered up front through the floor plan (fig. 65), available at the entrance to every museum. On a practical level the plan offers a means of orientation through space, but it also functions symbolically to signify a totality that is greater than the sum of its parts. By means of the plan one experiences the museum

Permanent Collections

13th- to 15th-Century Italian
Galleries 1–15

16th-Century Italian and Spanish
Galleries 16–28

17th-Century Italian, Spanish, and French and 18th-Century Italian
Galleries 29–34, 36–37

15th- to 16th-Century Netherlandish and German
Galleries 35–35A, 38–41A

17th-Century Dutch and Flemish
Galleries 42–51

18th- and 19th-Century Spanish
Gallery 52

18th- and Early 19th-Century French
Galleries 53–56

British
Galleries 57–59, 61, 63

American
Galleries 60–60B, 62, 64–71

19th-Century French
Galleries 80–93

Armand Hammer Galleries Prints and Drawings
G22–G22A

Prints and Drawings
Galleries G23–G29

Photography
Galleries G30–G34

Sculpture
Galleries G1–G21, G37–G40

Special Exhibitions
Galleries 72–79, G23–G34, G41–G43, East Building, Upper, Mezzanine, and Ground Levels

Modern and Contemporary
East Building, Tower, Upper, Ground, and Concourse Levels

Main Floor

65. Plan of the National Gallery of Art, West Building, 2006.
Photo: National Gallery of Art, Washington, D.C., Gallery Archives.

abstractly as a network of ordered spaces governed by categories of classification (American furniture, European paintings, etc.). The plan proposes a circuit through a rational and often symmetrical sequence of spaces that suggests a complete overview of the field in question, whether art, natural history, or Native American culture. Every object on display exists in its own rich particularity while also contributing to larger units that add up to a whole; a painting by Poussin, for example, represents the artist but also the seventeenth-century French school, one chapter in the narrative of European painting, which itself is a subsection of the history of art, whose parameters are signaled on the plan.

When a work of art is acquired for a museum, it must satisfy two criteria: first, it must be considered a good object of its kind ("good" entails judgments of quality, authentic-

ity, and condition made by curators and conservators); and, second, it should strengthen the museum by filling a gap in its collection (following a preconceived notion of what constitutes an ideal collection). In the case of Poussin, museums that already own a good example of his work might rather pursue a previously unrepresented artist. What is a good fit for one museum may be superfluous for another. Where a less than stellar or perhaps heavily restored Poussin might nevertheless enrich a small museum collection lacking in his work, it would hold little appeal to the curators of a collection already strong in his art, like the National Gallery in London or the Louvre. Those museums, great as they are, have gaps of their own to fill, though the gift of an important Poussin would probably not be rejected. Poussin would be altogether irrelevant to museums focusing on the decorative arts or Asian art, but those museums proceed in the same way toward their respective collecting ideals. The point is that no collection is ever complete. Museum directors and curators are always looking to improve their collections, and their fantasies revolve around how best that might be done. Witness a recent article in the *Wall Street Journal:* in the manner of an after-dinner game, six leading museum directors were asked to choose one work of art they coveted for their own collections. The choices—all paintings—reflected the directors' fields of interest and expertise, yet in each case quality, condition, and the needs of their museums were a top priority (authenticity was taken for granted, as was the primacy of painting). John Walsh, then director of the Getty Collection, a relatively new museum with plenty of gaps to fill, chose Robert Campin's *Merode Altarpiece* from the Metropolitan Museum, which he described as "perhaps the greatest early Netherlandish painting in America." The article continued, "While 'The Merode' is not for sale, Mr. Walsh says he'd love to have it. Experts say the Getty could use a blue-chip painting like this, to keep up with other museums its size."[9] In 2004 the Metropolitan filled a gap of its own through the purchase—for close to $50 million—of the last remaining painting by Duccio in private hands. The acquisition of the finely preserved *Madonna and Child* from circa 1300 filled "a gap in the [Met's] Renaissance holdings that the museum assumed it could not close," said Director Philippe de Montebello, and "will enable visitors to follow the entire trajectory of European painting from its beginnings to the present. . . . The first slide in an art history 101 course is a Duccio. He was one of the founders of Western art."[10] Many gaps can be filled with $50 million, but some gaps are more important than others. What Montebello tells us is that illustrating art history 101—in other words European art from the Renaissance—is the first goal of any major art museum.

To make these points more concrete, let us turn briefly to the National Gallery of Art in Washington and consider what visitors learn between the lines of their visit, so to speak. The building's title defines its contents as the nation's art, while the architecture, location, and tax-supported free admission underline the importance of its mission to

the American way of life. Orientation within its magnificent interior is provided by a floor plan, which directs the visitor upstairs to the suite of light-filled picture galleries. Like many traditional museums, the National Gallery locates the primary spectacle on the upper floor—the *piano nobile*, or "noble floor," recalling European aristocratic palaces and requiring that we ascend to encounter the highest of artistic achievements. Sculpture, the decorative arts, prints, and drawings, as lesser art forms, occupy the lower level. The principal galleries are numbered sequentially and trace a chronological path that begins with the Italian Renaissance (and another rare work by Duccio) and culminates at the dawn of modern art in the late nineteenth century. The narrative will be familiar to students of Art History 101. Western art began in Renaissance Italy, spreading north to Venice from Tuscany and Umbria; Italian art remained strong in the seventeenth and eighteenth centuries, influencing developments in Spain, before expiring with Tiepolo and Goya, respectively. The northern European schools of painting ran a parallel course, beginning with the Flemish and German masters (van der Weyden, Durer, etc.) and reaching maturity in seventeenth-century Belgium and Holland with Rubens and Van Dyck, Rembrandt and Vermeer. French and British art vied for attention in the eighteenth century before France prevailed in the nineteenth with Courbet, Manet, and the impressionists. The rise of America and modern art, charted at the end of the main building's circuit, culminates with post–World War II developments in I. M. Pei's East Wing of the gallery (1978).[11] Along the way, each school is represented by its great masters; luxurious wall treatments and the generous spacing of individual paintings suggest that everything on display is worthy of consideration. Truly outstanding works are singled out through isolated display and/or architectural framing (fig. 66). Labeling is discreet, and information is kept to a minimum; one is there to look, not read. Contemplation is the order of the day, and all activities incompatible with it, running, talking, eating, and so on, are forbidden. Though visitors may wander freely (and the freedom to go where we please and stay as long as we like is a main attraction of museums), the existence of a prescribed route and code of conduct lends the visit a ritual quality, as Carol Duncan and Alan Wallach have argued.[12]

The air of permanence and universality that hovers over the National Gallery and like museums disguises the degree to which what one encounters in the way of art and installation is the product of human judgment and susceptible to revision. A post-Foucauldian consciousness leads us to ask questions scarcely thinkable a generation ago: Why is the definition of art limited to a selective European heritage? Within that tradition, why do we find, say, no Belgian art of the eighteenth century or Spanish impressionism? Are we to suppose that Flemish painters after Rubens or Spanish artists after Goya were so intimidated by their predecessors' achievements that they abandoned painting for other careers? Why no Native American or folk art in the American gal-

66. Leonardo da Vinci's *Ginevra de' Benci* at the National Gallery of Art, Washington, D.C.

leries? Who decides that Leonardo's *Ginevra de' Benci* deserves to be displayed by itself on a velvet-covered wall in the middle of the room? The collection, in both its strengths and its weaknesses, reflects the governing tastes of the cultural elite who founded the gallery before and after World War II, men and (a few) women—Samuel Kress, Chester Dale, Joseph Widener, Paul and Ailsa Mellon, among others—whose names are sprinkled liberally across walls and labels. Only in the last twenty or thirty years have revisionist art history and multiculturalism drawn attention to the absence from the nation's pantheon of minority and women artists and traditions beyond Europe and the United States (eighteenth-century Belgian art still awaits its champion). Though the National Gallery limits itself to a narrow segment of Euro-American painting and sculpture and

has changed little since its inception in 1941, Washington's Mall has been greatly diversified in recent years to include new museums of Asian, African, Native American, and African American art and culture (a museum of Latin American art will surely soon follow).

Early Modern Paradigms

Washington's National Gallery may be taken as the epitome of modern museology with respect to the classification and display of canonical European and North American art. Viewed historically, however, the modern philosophy of display was not generated ex nihilo but evolved over time from earlier modes of presentation that today seem as alien as Foucault's Chinese encyclopedia. To a modern eye, accustomed to modern methods of organization and sparse museum displays, the *Kunst und Wunderkammer* (literally "art and wonder room") of early modern Europe seems little more than a disorganized heap of objects, an "aimless collection of curiosities and bric-a-brac, brought together without method or system," as one museum man put it in 1930.[13] Knowledge of these "curiosity cabinets," none of which survive intact, comes primarily through printed catalogs and their engraved frontispieces (fig. 67). Though recent research has shown that they functioned as sites of learning and possessed an underlying order, the dizzying spectacle of crowded walls and ceilings gives an initial impression of playful disorder at odds with serious study.[14] At the same time, a consistent emphasis on decorative, symmetrical presentation suggests that a desire to impress visiting gentlemen rivaled scholarly endeavor as a motivating principle. Collections were useful, but they also had to be pleasing to the eye.

It is also clear that despite standard references to the *Wunderkammer* as a microcosm of the world, early modern collections in fact "excluded 99.9 percent of the known universe" and concentrated instead on that which was most rare and wondrous.[15] The inscription above the door to Pierre Borel's seventeenth-century cabinet qualified universality precisely this way: "a microcosm or compendium of all rare strange things."[16] Though curiosity could lead to knowledge, a surfeit of wonder, according to Descartes, "can never be otherwise than bad [because it] prevents our perceiving more of the object than the first face which is presented, or consequently of acquiring a more particular knowledge of it."[17] Early curiosity cabinets appear guilty of profuse wonder, and travel journals indeed reveal that such collections quickly became destinations for the superficial wonder-seekers Descartes dismissed. Furthermore, as the rise of modern science stripped previously prized curiosities (bezoar stones, unicorn horns, two-headed calves, and so on) of their scientific value, the *Wunderkammer* survived mainly as a source of public entertainment.

67. The *Wunderkammer* of Ferdinando Cospi. Etching from Lorenzo Legati, *Museo Cospiano* (Bologna, 1677). By permission of the Houghton Library, Harvard University.

The collection of Marchese Cospi in Bologna is a good example of these tensions and trends. Formed by an aristocrat "as a noble pastime," the Cospi collection was nevertheless cataloged by a learned doctor, Lorenzo Legati, and eventually bequeathed to the city of Bologna in 1657 to join the famous natural history collection of Ulisse Aldrovandi at the Palazzo Publico. But a closer look at the collection and catalog has led modern scholars to conclude that "the fundamental aim of Cospi's museum was to provoke astonishment and wonder rather than analytically reconstruct the whole natural world."[18] Of Legati's catalog, Paula Findlen has observed that it "demonstrated over and over again [that] the objects worthy of possession served to delight an audience that perceived curiosity as an end in itself."[19] Though scholarly in format, the catalog made much of Cospi's courtly connections and upbringing, emblematized in the frontispiece bearing his coat of arms complete with Medici crest. Privileging curiosity and status above science, Cospi employed a dwarf—a curiosity in his own right, of course—to show the collection and sent complimentary copies of the catalog to "many Princes of Italy, Cardinals, and Knights of Merit."[20]

By the beginning of the eighteenth century, aristocrats like Marchese Cospi had largely turned their collecting energies and bid for social distinction toward art. Discredited by modern science, curiosity went underground, surviving in the "low" cultural orbit of freak shows and circuses until a recent revival of interest channeled through the high art of Diane Arbus, Damien Hirst, and others returned it to avant-garde respectability.[21]

Perhaps not surprisingly, in early art collections paintings were displayed much as natural curiosities had been, that is to say in densely packed, symmetrical arrangements that privileged decorative effect over taxonomic order or comfortable viewing. Once again, we know of these early art collections mainly through printed catalogs and accompanying engravings. A splendid volume of etchings by Frans van Stampart and Anton Joseph von Prenner records the sumptuous installation of the imperial collection in Vienna, completed in 1728 (fig. 68).[22] An elaborate scheme of gilt frames and rococo plaster-work locks the paintings in place like pieces of an elegant jigsaw puzzle. Some attempt has been made to pair subjects (portraits, genre pictures) across a central vertical axis, but order as we know it today was absent, and scrutinizing individual pictures would have been difficult. Furthermore, the tight symmetry we see required that some paintings be cut down or enlarged to fit into their appointed position on the wall.

In some cases, however, early modern arrangements were less arbitrary than they seem, or at least they could be made to serve a purposeful mode of viewing endorsed by art critics and theorists. Seemingly random or eclectic arrangements encouraged a kind of comparative viewing that revealed the distinctive qualities of the great masters.[23] According to early modern art theory, painting was divided into constituent parts—drawing, color, composition, and expression—and through the ages artists and schools tended to excel in one branch or another; the Venetians were held to be excellent colorists but deficient in drawing, for example, while the Florentines were the reverse. An arrangement that juxtaposed, say, Titian and Michelangelo would give connoisseurs and students a good understanding of their respective strengths and weaknesses (color vs. drawing). Texts by early art theorists, notably Roger de Piles and André Félibien, modeled comparative criticism though fictional dialogue among art lovers. In his famous *Entretiens (Conversations),* first published in 1666, Félibien took his readers on a tour of the French royal collection, then displayed in the Tuilleries Palace, through the eyes of an experienced art lover and his disciple. "Enter the gallery," said the expert, "and you will see excellent works by the great masters. It is there that each of them displays his strengths, and taken together their works form a marvelous concert. Their different beauties manifest the grandeur of painting. That which is peculiar to one, and which is not to be found in others, testifies to the vast extent of this art, which no one man can master in all its parts."[24] Surviving descriptions of the first public art gallery in France, opened in Paris at the Luxembourg Palace in 1750 with one hundred paintings from the royal

68. Installation view of the Imperial Gallery, Vienna. Etching from Frans van Stampart
and Anton Joseph von Prenner, *Prodomus Theatrum artis pictoriae* (Vienna, ca. 1735).

collection, show the comparative method in action. In one account, taking the form of a letter from a gentleman in Paris to a marquise in the provinces, the author entered the first room and relayed his delight in finding "thirteen paintings . . . whose variety offers the curious a sampling of the five different schools. The ingenious and agreeable contrasts!" Moving on to next gallery, he remarked, "The variety in this room was no less striking. . . . [T]he different schools demonstrate their respective strengths," and so forth.[25] The ultimate goal of a comparative hang was a better understanding of painting as an art form; early modern art lovers enjoyed the challenge of identifying and articulating what we would now call the stylistic traits of different artists.

Modern Methods

When the Louvre opened in 1793 the paintings were arranged much as they had been at the Luxembourg, but by this time a comparative arrangement had come to seem old-fashioned, out of step with developments in the art world. That the eclectic system had been favored by aristocratic art lovers did not help. Within months the initial comparative hang at the Louvre was replaced by a new system of national school and chronology, a system that privileged knowledge of art history over art and judgments of authenticity and attribution (i.e., connoisseurship) over style. Those values had long been important desiderata for critics and collectors. In the 1620s a treatise by Giulio Mancini defined connoisseurship as the ability to recognize a painting's medium, age, authorship, originality, and excellence.[26] A century later a general survey of European collecting by the German Caspar Neickel offered would-be art collectors the following guidelines: (1) collect only original works, no copies; and (2) give preference to "costly paintings by the best masters, such as Michelangelo, Raphael, Titian, Rubens, Durer, etc."[27] Beyond the market forces that drove up interest in the Old Masters and questions of attribution and authenticity, a new approach to the display of art received further impetus from Enlightenment historicism and emerging modes of classification in the parallel realm of natural history. New taxonomies pioneered by Buffon and Linnaeus ordered plants and animals into genus and species, a system that corresponded closely enough to the art world designations of school and artist. Historicism then arranged artists within each school in chronological order. By the mid–eighteenth century the early modern *Wunderkammer* had given way to collections of natural history governed by "a methodical order that distributed its objects by class, genus, and species," according to one of Buffon's disciples.[28] Art collections followed suit. In the 1790s the dealer, connoisseur, and art historian Jean-Baptiste-Pierre Lebrun declared that a picture collection not arranged by school and artist was "as ridiculous as a natural history cabinet arranged without regard to genus, class, or family."[29]

69. The Rubens Room, Electoral Gallery, Düsseldorf. Engraving from
Nicolas de Pigage, *Galerie Electorale de Dusseldorff* (Basel, ca. 1778).

An arrangement by artist and chronology first appeared in late-sixteenth-century
collections of prints and drawings bound together in book form so as to be "read" as an
unfolding linear narrative within each school.[30] Relatively inexpensive, plentiful, and
small in scale, works on paper lent themselves to connoisseurial manipulation. It wasn't
until the mid–eighteenth century that a classification by school and history worked its
way into the three-dimensional domain of the princely art gallery. At the Electoral Gallery
in Düsseldorf the artist, dealer, and connoisseur Lambert Krahe (who owned a print col-
lection arranged along art historical lines) rearranged the collection in 1756 by school
and artist, recorded in a magnificent catalog complete with installation views published
some years later (fig. 69).[31] In the Flemish section, Krahe went one step further and

70. Plan of the Imperial Gallery, Vienna. Engraving from Chrétien de Mechel,
Galerie des tableaux de la Galerie Impériale et Royale de Vienne (Basel, ca. 1784).

created a gallery devoted to the work of a single artist—Rubens. Though the paintings
conform to a harmonious symmetrical arrangement befitting a princely gallery, they
are now comfortably spaced and easily legible to afford the beholder an overview of the
great master's career and achievement. Similar efforts were under way at Dresden and
at the Uffizi in Florence at much the same time, but the most thorough and remark-
able reorganization took place at Vienna, where in the 1770s the sumptuous Baroque
display at Vienna's Imperial Gallery, discussed above (fig. 68), was dismantled and the
collection rehoused in a new modern-looking museum in the Belvedere Palace (fig. 70;
note the similarity in plan to Washington's National Gallery). Under the supervision of
the art expert and engraver Christian Mechel, paintings were returned to their original
shapes and given simple neoclassical frames; they were reorganized in schools and dis-
played chronologically with works by the same artist grouped together. Mechel explained
the dramatic overhaul of the imperial collection in the introduction to his catalog: "The
purpose of all our endeavors was to use the numerous separate spaces of this beautiful
building so that the whole arrangement as well as the individual pieces would be . . . a
visible history of art."[32]

71. Maria Cosway, View of Raphael's *Transfiguration* at the Louvre Museum, ca. 1803. Etching from Julius Griffiths, *Galerie du Louvre* (Paris, 1806). Photo: American Philosophical Society.

Though not the first to employ the new taxonomy of school and history, the Louvre of the revolutionary and Napoleonic era (1793–1815) became the most famous and influential example because of its size, quality, and fame. As definitively organized, the Louvre divided its paintings into the three main schools, the Italian, Northern, and French, and ordered each chronologically (the Italian and Northern schools were further subdivided into Florentine, Venetian, and Bolognese, and Dutch, Flemish, and German, respectively). The need to maintain decorative symmetry forced compromises in the arrangement, but to a remarkable and unprecedented degree the Louvre achieved its stated goal of displaying a "continuous and uninterrupted sequence revealing the progress of the arts and the degrees of perfection attained by various nations that have cultivated them."[33] A particularly celebrated section of the Grand Gallery dedicated to Raphael exemplified Enlightenment ideals of taxonomy and arrangement (fig. 71). The set of eight paintings at once conformed to expectations of symmetry and visual order (down to the

complementary compositions and matching canvas shapes on either side of a central axis) and illustrated a crucial chapter in the history of art using masterpieces of the highest rank. Following Vasari, Raphael's final great work *The Transfiguration* was surrounded by exemplary paintings by Raphael's teacher, Perugino (top register, left and right), and formative works from his own career, amounting to a condensed visual explication of his stylistic development from apprenticeship (middle register, left) through the influence of Leonardo (portrait of Castiglione and *La Belle Jardinière*, bottom and middle right) to final independence and genius represented in the central piece.

While the subtleties of this arrangement may have been lost on the masses, its lessons were fully absorbed by important museum men of the nineteenth century who visited the Louvre at its height. Georg von Dillis, future director of the Alte Pinakothek in Munich, spoke for many when he wrote from Paris: "One must admire everything here: the order, the systematic disposition of each branch of art, the free access. . . . It should become the model for all institutions."[34] Memory of the Louvre was still fresh in the mind of Gustav Waagen when he joined with Karl Friedrich Schinkel, Carl-Friedrich von Rumohr, and Wilhelm von Humboldt to plan the Altes Museum in Berlin in the 1820s. There the implicit tension between quality and history, neatly resolved in the *Transfiguration* bay at the Louvre thanks to a wealth of looted art, came to the surface when the four men argued with, and eventually prevailed over, the art historian Alois Hirt, who had earlier proposed a comprehensive scholarly program for the Berlin museum. Privileging the perceived needs of the general public over the narrower interests of artists and connoisseurs, Waagen and his colleagues left aside paintings valued primarily for their historical interest and focused instead on a smaller number of high-quality paintings laid out simply by school and chronology. On the ground floor below the paintings galleries, the collection of ancient sculpture was arranged thematically, with the most highly prized marbles housed under Schinkel's magnificent rotunda. The central display of timeless works in "a beautiful and sublime space," wrote Schinkel, "makes [the visitor] receptive and creates a mood of enjoyment and understanding for what the building contains."[35] "First delight, then instruct" was the guiding principle at the Altes Museum in the face of an expanding bourgeois public more interested in masterpieces and inspiration than in lessons in the history of art.[36] Balancing the needs of well-informed visitors against those of the lay public remains a significant challenge for the modern art museum.

Masterpieces

When Gustav Waagen traveled from Berlin to London to advise the British on their new National Gallery in 1853, he duly recommended highlighting the collection's better works

by displaying them with room to breathe: "Each painting becomes in this manner iso-
lated and its effect heightened."[37] Though Waagen's views on display were widely shared,
the growth of museum collections during the latter half of the nineteenth century left
most galleries looking as cluttered as curiosity cabinets of the ancien régime. An over-
abundance of objects obscured the virtues of classification and pleasures of easy view-
ing. The ill effects of overcrowding were noted on both sides of the Atlantic. A 1913 sur-
vey of German museums noted: "Restlessly [the visitor's] eye races from one object to
another in the crowded spaces, often captured by superficial things and overlooking what
is significant, until he is finally totally exhausted."[38] "The larger museums and exhibi-
tions became," wrote Friedrich Naumann, "the more oppressive was the burden of art
history for the individual visitor."[39] An anonymous letter to the *Atlantic Monthly* in 1929
complained about the "horrors of museum trotting" at the Metropolitan Museum with
too much to take in and precious little guidance; the letter concluded that the only so-
lution was to create smaller museums with less to look at.[40]

The inevitability of growth led early-twentieth-century architects to plan new muse-
ums (e.g., in the United States, in Brooklyn, Minneapolis, and Toledo) with room for
future expansion. The solution for existing public art museums was better collection
management, meaning the gradual thinning of displays and the creation of study rooms
and reserve collections for scholars. Rethinking standing collections also led to the de-
velopment of new techniques to highlight selected works.

Collectors and early museums had always found ways of promoting their masterpieces
(at the Uffizi as early as the sixteenth century the best of the Medici collection was gath-
ered in the Tribuna, for example), but with the spread of museums and the rise of mod-
ern museology in the late nineteenth century, efforts to refine display conditions and
concentrate the beholder's attention became a matter of systematic study.[41] The prob-
lem of clutter had become a widespread concern toward the end of the nineteenth cen-
tury. In London the Natural History Museum set an important precedent when in the
early 1880s it reorganized its massive collection into galleries of primary objects for the
general public and secondary, or reserve, collections for scholars.[42] In that decade Ger-
man directors and curators endorsed the same principle in the course of a comprehensive
review of the museum system initiated by Kaiser Friedrich III.[43] Led by Wilhelm von
Bode and Hugo von Tschudi in Berlin, German museums implemented various reforms
around 1900, including the simplification of museum design and collection installa-
tion. Apparently influenced by innovations in commercial galleries and exhibitions of
modern art, art museums throughout Germany removed damask wall coverings and
unnecessary furniture and reduced the number of paintings on display. New attitudes
toward display filtered across the Atlantic in time to influence the formation of Boston's
new Museum of Fine Arts, which was rebuilt in the first decade of the twentieth century

(figs. 33–34). Representatives from Boston visited over a hundred European museums, interviewed leading art historians and curators, and thoroughly reviewed the literature, preparing the way for what the critic Frank Jewett Mather, writing in the *Nation,* called a "new and revolutionary program." [44] The program was in fact much indebted to German museology, but the opportunity to realize the latest thinking with respect to contents, organization, and public relations in a new, purpose-built institution was new and worthy of note. Instead of a large, unified collection, which, according to Mather, "baffled" and "oppressed" the general public and satisfied only the "occasional savant or the loafer escaping the rigors of winter," the new MFA would be divided into the principal display galleries on the main (upper) floor, where, for the benefit of the general public, only the best original works of art were exhibited under optimal conditions of light and space, and the reserve collection on the ground floor, where objects of lesser aesthetic worth but historical value were housed in strict order for scholars and connoisseurs. Furthermore, as mentioned in chapter 2, the internal architecture was geared to public appreciation. The main galleries were "absolutely without architectural adornment" so that "nothing may attract the eye of the visitor from the objects therein displayed. . . . In a word, installation has been carefully studied to help the visitor to see and enjoy each object for its own full value." [45] (The exception was the contextual display of the Japanese collection, to which I will return.) The MFA's spokesman and theorist Benjamin Gilman was among the first to document the "museum fatigue" induced by old-fashioned display techniques and recommended various practical remedies, including, in addition to streamlined exhibitions, new display cases and gallery seating. He even designed a portable "skiascope" (fig. 36) to enhance visibility of "skied" pictures hung high on walls in galleries that still clung to old-fashioned display principles.

More than once in the first years of the twentieth century, Europe's leading art journal, the *Burlington Magazine,* applauded Boston's "aesthetic" approach and emphasis on "the power of full abstraction from surroundings and concentration upon one object at a time." [46] Reports issuing from international meetings and installation photographs in museum publications revealed the rise of a new orthodoxy. Before-and-after shots of a gallery at the Louvre (fig. 72) show a subtle but significant turn to lighter walls, a reduction in the number of pictures, and more intimate viewing with the removal of guard rails. Fewer objects more widely spaced relieved the monotony of paintings joined as one across the length of the gallery. Charles Loring summarized recent developments in 1927: "The trend is to concentrate on a few superior objects . . . [and] a greater use of small rooms where attention may be focused on two or three masterpieces, well lighted and set at the level of the eye against subdued backgrounds, rather than of long, wide galleries with skylights where the walls are crowded with a bewildering display." [47] At the Madrid museum conference sponsored by the League of Nations in 1934, Eric Macla-

gen from London's Victoria and Albert Museum specifically commended the so-called Boston system as the model to be followed, but by that date museums everywhere were already following it. Reporting from their respective institutions at the same conference, the directors of the Louvre, the Prado, the Rijksmuseum, London's National Gallery, Vienna's Kunsthistoriches Museum, and Budapest's Museum of Fine Arts described recent rearrangements of their collections undertaken to accentuate their "aesthetic value."[48] At each of those museums, the art was still displayed chronologically and by school, but the emphasis had turned decisively to the visual apprehension and appreciation of masterpieces. The director of the Budapest museum went so far to say that it would be a sacrilege to diminish the "artistic effect" of a work of art for the sake of historical explication. Maclagen and Alfred Stix from Vienna both warned against an overly art historical arrangement, which might please fellow curators but would mean nothing to the public, who, after all, "did not ask for systematic organization or the dis-

play of complete series" but came instead for "inspiration and pleasure."

The new approach to display found its way to the Toledo Museum deep in the North American heartland, where in the 1930s a remodeled interior housed selected works hung widely spaced in a single row at eye level (fig. 73). According to the director, the space around a work of art enhanced viewer appreciation, like "the silence that follows the execution of a piece of music."[49] School and chronology had been followed but not scrupulously, for, he maintained, visitors seek "the pleasures of contemplation more than those of a lecture."

In keeping with the drift toward quality over quantity, museums made a further effort to emphasize recognized masterpieces. At the Rijksmuseum, for example, within the chronological sequence of rooms, each wall "made evident some principal work" through its arrangement, and Rembrandt's *Night-*

72. Before and after reorganization of the Louvre in the early 1930s. From Office International des Musées, *Muséographie: Architecture et aménagement des musées d'art* (Paris: Société des Nations, 1935).

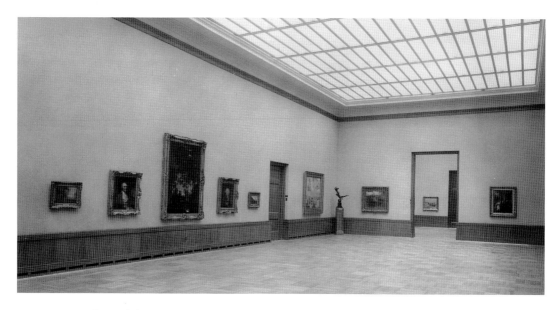

73. American Gallery, Toledo Museum of Art, 1930s. Photo courtesy of Toledo Museum of Art Archives.

watch got a room of its own. Similar arrangements were made at the Prado for Velázquez's *Las Meninas,* in Parma for Correggio's *St. Jerome,* at the Brera in Milan for Raphael's *Spozalizio,* and at the Louvre for the *Mona Lisa.* Today, as every visitor to Paris knows, the latter commands a generous wall in the center of a room to accommodate the crowds who come daily to pay homage.

These new trends in museum display received empirical backing from a study published in 1935 by Yale psychologist Arthur Melton. Experimenting with installations of varying density at the Philadelphia Museum of Art (fig. 74), Melton confirmed what many already knew, that the average visitor unschooled in art history had a limited attention span, suffered easily from museum fatigue, paid little attention to underlying systems of classification, and responded better to a limited offering of art that really mattered. Selectivity and presentation were of the greatest importance, Melton found, because most visitors were easily seduced by display conventions and would ignore a masterpiece poorly hung in favor of a poor painting prominently displayed.[50]

An exhibition at the 1937 Exposition Internationale in Paris assembled by a star-studded cast of French intellectuals and museum men identified the privileging of masterpieces in plain rooms as the key element of modernist museum aesthetics. The text accompanying the show described the tendency toward viewing art in autonomous and purely formal terms: "The modern sensibility, no longer seeking in a work of art an historical witness but an individual aesthetic phenomenon, has led museums to efface them-

selves behind the masterpieces they display. Walls stripped of decor are nothing more than an abstract background against which objects may be seen; those objects are well spaced so that the visitor may examine each one without distraction, all in keeping with the demands of the modern aesthetic."[51]

What this text alludes to, in effect, is the emergence of the "white cube," the essential building block of the modern museum. Itself an expression of the modern aesthetic, the white cube—characterized by unadorned and windowless white walls, polished wooden floors, and artificial ceiling light—may be viewed historically as crucial to the genesis of twentieth-century art (fig. 75). Designed to block out the external world and concentrate the beholder's gaze, the white cube encouraged the drive toward self-sufficiency, flatness, and purity that we now associate with high modernist painting (abstract expressionism, color field, etc.). So vital is the environment to the art, according to Brian O'Doherty, that we can't think of one apart from the other: "The history of modernism is intimately framed by that space; or rather the history of modern art can be correlated with changes in that space and in the way we see it. . . . An image comes to mind of a white, ideal space that, more than any single picture, may be the archetypal image of twentieth-century art."[52] And so vital was the white cube to modernism that postmodern art from the 1960s took on as one of its defining features a principled rejection of that space in the form of site-specific work, "happenings," and conceptual and performance art, which was either located far from the customary circuits of the art world or not easily bought and sold and hung on gallery walls.

In the 1920s and 1930s progressive architects turned their attention to the challenges of refined display, visitor fatigue, and public access. Conceptual designs by Clarence Stein and Lee Simonson imagined skyscraper museums in which elevators whisked visitors to compact exhibitions on different floors.[53] Luc Benoist and Charles Friésé went one step further in their fanciful design for an "automatic mu-

74. Experimental installations. From Arthur Melton, *Problems of Installation in Museums of Art* (Washington, DC: American Association of Museums, 1935).

75. "The White Cube" (Ellsworth Kelly at the Museum of Modern Art, 1990s).

seum," consisting of a Ferris wheel–like mechanism that revolved seated visitors past small displays of objects on different levels. At each stop the cabin doors opened onto small rooms of paintings or art objects that in turn rotated every thirty seconds to reveal new things. "In this way, in an hour and a half, a thousand visitors could view a thousand paintings without ever leaving their seats."[54] Numerous actual museums built between the wars give the impression of being planned from the inside out around a core of immaculately crafted display spaces. At the Boymans Museum in Rotterdam (fig. 38) or the Kroller-Muller Museum in Otterlo, for example, the quality of interior light and space and concern for internal circulation create a serene atmosphere for aesthetic contemplation. The same can be said for Goodwin & Stone's Museum of Modern Art in New York, which opened in 1939. The MoMA that Alfred Barr built struck a balance between history and quality by illustrating the development of modern art through masterpieces comfortably exhibited in a sequence of discrete rooms with low ceilings, controlled lighting, and neutral walls (fig. 41). Barr relied on a clean, standardized mode of display to persuade a skeptical American public that the works of Picasso and the European avant-garde were masterpieces worthy of comparison to Rembrandt and Leonardo. Though in obvious respects the antithesis of MoMA, the National Gallery in Washington dates from the same period and is equally characterized by a highly selective collection that promotes individual works within a chronological framework. Be-

76. Installation view of the Degenerate Art exhibition, Munich, 1937.
Photo: Bildarchiv Preussischer Kulturbesitz/Art Resource, New York.

hind the conservative facade and imposing communal spaces lie dignified, well-lit picture galleries that afford their contents room to breathe (fig. 66). Over thirty years after its completion, it was still considered a building that could "confirm as a masterpiece anything shown in its elegant spaces," in the words of the art historian Joshua Taylor.[55]

As a counterpoint to mainstream museums on either side of the Atlantic, the notorious Degenerate Art (Entartete Kunst) exhibition staged by the Nazis in Munich in 1937 (fig. 76) inverted the established conventions of display precisely to undermine the credibility of modern art. By means of a crowded, asymmetrical, out-of-kilter arrangement, disparaging wall graffiti ("Madness becomes method," "Crazy at any price," "Nature as seen by sick minds," etc.), and poor light, the organizers aimed to create an off-putting environment in which the artworks shown seemed anything but masterpieces. A contemporary witness later recalled: "All the pictures selected . . . were huddled together in these long, narrow galleries with the worst possible lighting. . . . The pictures were hung as though by idiots or children just as they came, as close together as possible, obstructed by pieces of sculpture on stands or on the ground, and provided with provocative descriptions and obscene gibes."[56]

Communist museology provided another important counterexample for museums in Europe and the United States in the 1930s. At the Hermitage Museum in Leningrad, for example, instead of stressing art's autonomy, the installation placed works of art in

the larger movement of history and class struggle with the aid of maps, charts, statistics, excerpts from literature, and didactic wall labels. In an article describing the Soviet museum system to the rest of the world, Theodore Schmit, professor at Leningrad, issued a well-informed rebuttal of Western priorities when he wrote: "The concept of art for art's sake, of art created by the isolated genius, of art possessing its own absolute value—this concept is incompatible with Marxist doctrine. . . . Art is but a manifestation of society, art is always propaganda for an entire ensemble of ideas and sentiments, for a manner of seeing and conceiving the world."[57]

By the 1930s museums had largely settled earlier problems of overcrowding through a more single-minded pursuit of quality. Increased focus on modes of display entailed higher standards in the permanent collection. Everything acquired had to be a masterpiece whose inclusion in the galleries could be justified primarily on grounds of quality. "Quality" and "rarity" were the chief criteria in acquiring new works, wrote the director of the Boston MFA in 1946, and surely no director or curator since would beg to differ.[58] As collections have grown, so has the pressure to add—and subtract—selectively following those criteria and the canon that governs the field in question. Defending a recent decision to sell (deaccession) an impressive landscape by Henri-Edmond Cross, a second-tier postimpressionist colleague of Seurat and Signac, MoMA's director remarked: "Cross just is not an artist the museum will collect in any kind of systematic way. We'd never show this picture."[59] Though the painting was perhaps Cross's finest work, Cross was no Seurat; he does not merit a place in art history 101. MoMA is gambling that what is considered the "best" of late-nineteenth-century French art won't one day shift to include Cross; in the meantime the proceeds from the sale of the Cross presumably went to buy a work judged worthy of the museum's exalted collection.

Lighting

The neutral walls and generous spacing of works of art have remained standard features of the modern museum. Owing to advances in technology and evolving standards of conservation, the most challenging and variable aspect of gallery design from the early twentieth century has been lighting. Perhaps because means and methods of lighting vary and evolve, it is a constant source of interest to directors and curators. Since its adoption at the Louvre in the late eighteenth century, top lighting has remained the system of choice in public art museums. Side lighting through conventional windows was used in the nineteenth century (for example, at the Rijksmuseum), and it was often recommended for the display of sculpture, but its obvious disadvantages in picture galleries (reduced wall space, shifting pockets of light and shadow) discouraged its broad adoption. The Kaiser-Friedrich Museum in Berlin (1904) featured both, with side light-

ing in use for three-dimensional objects in the perimeter rooms and top lighting in the central picture galleries. Controlling top light to temper glare and the damaging effect of direct sunlight has proved a constant challenge, however. Skylights, lanterns, and clerestory windows were all used at different times with varying degrees of success, and no one system became dominant. In the first half of the twentieth century, the Seager system, which deflected natural light from above onto sidewalls and left the viewer's space below in even shadow, enjoyed a limited vogue, though not everyone liked it.[60] Since then various related systems of filters, baffles, and louvers have been used to achieve a similar result.

The difficulty of controlling natural light, which of course fluctuates according to the season, time of day, and weather, together with the desire to make museums more accessible, made artificial light appealing, especially in northern climates, as it became safer and cheaper in the early 1900s. Before electricity became widely available, some museums, beginning with South Kensington in 1857, experimented with gas lighting. Despite the advantages it afforded with respect to access (evening hours helped give South Kensington higher attendance figures than the British Museum and National Gallery combined), the cost and corrosive side effects, not to mention the risk of fire, checked its spread.[61] In 1880 electricity replaced gas at South Kensington and was soon used at other museums, though again the cost and fear of fire (fires in Paris and Vienna were blamed on faulty electrical systems) limited its implementation until the 1920s and 1930s. Although many directors continued to insist that natural light was better for viewing art, the convenience and democratic advantages of electricity could not be denied, and most museums opted for a combination of the two. Frequently, electric lighting was installed above laylights, allowing the two light sources to be adjusted, mixed, and diffused according to need out of sight of the visiting public.[62] Electric light has held its own, of course, becoming a staple ingredient of white-cube galleries and museums like MoMA; technological innovations have created a spectrum of possibilities (fluorescent, incandescent, tungsten), each with its own strengths and weaknesses in terms of relative warmth and color of light, cost, and potential hazards to art.[63] Spot, or "boutique" lighting, pioneered in commercial environments and recommended for museum use by Lee Simonson in the early 1930s, has become a staple of museum display, serving effectively to concentrate the viewer's attention and create an aura around chosen objects. Many curators would still agree with Simonson's remark: "Much of the dealer's hocus-pocus of velvet hangings and dim, religious lighting is ludicrous. But the principle underlying his method is psychologically sound"—and therefore useful in museums.[64]

In the past thirty years or so, natural light has surged back into favor, becoming a virtual fetish of museum architects and directors. Though new museums make heavy use of electric light in the evenings and on overcast days (an exception being Dia: Beacon

[fig. 58], which relies solely on daylight and closes early in winter), the successful handling of space and natural light is a defining feature of contemporary museum design. It is certainly what accounts for the cult status of Louis Kahn and Renzo Piano (see chapter 2). In the buildings of Kahn and Piano, but also those of Richard Meier, Tadeo Ando, Rafael Moneo, and others, the treatment of light, subtly different in the hands of each architect, goes beyond illumination to take on a symbolic function, as Meier reveals in his commentary on the High Museum in Atlanta: "Apart from its purely functional role, light in this building is a constant preoccupation, a symbol of the museum's purpose. Light is basic to the architectural conception: the museum is meant to be both physically and metaphysically radiant. The building is intended both to contain and reflect light, and in this way to express the museum's purpose as a place of enlightenment and center of the city's cultural life."[65]

History versus Masterpieces

The eighteenth-century imperative to order art by school and chronology produced a second museum type that favored history over aesthetics and masterpieces. While the Napoleonic Louvre was setting standards for the public art museum, a second museum in Paris, the Museum of French Monuments (1795–1816; fig. 77), founded by Alexandre Lenoir, pioneered a strict historical classification that proved equally influential in its own way.[66] The Museum of French Monuments contained sculpture and stained glass from the medieval period to the eighteenth century, most of it salvaged from churches vandalized during the Revolution. Central to the ritual life and fabric of the church over the centuries but of little interest to serious art collectors, monumental tomb sculpture and stained glass, once liberated by the Revolution from their traditional place and function, were valued primarily for their ability to illustrate the development of French history through both the style of the objects and the famous personages they represented. Consequently, the museum's collection was arranged chronologically with rooms devoted to separate centuries, starting from the thirteenth and arranged in sequence around the cloister of an abandoned convent. To further demonstrate historical change, simulated architectural contexts suggestive of the respective centuries accompanied the chosen pieces of sculpture and glass. A tour of the museum offered a walk through history and testified to the evolution of French design, customs, and costume from the Middle Ages through the Renaissance to the present. The atmospheric effect of these early period rooms, combined with the parade of famous men and women in effigy, proved remarkably popular with the public (though some, especially foreigners, objected to the secularization of sacred objects).

Lenoir's museum helped spark a new appreciation for medieval art and a heightened

77. Thirteenth-Century Room, Museum of French Monuments, ca. 1815.
Engraving from Jean-Baptiste Réville and Lavallée, *Vues pittoresques et perspectives
des salles du Musée des monuments français* (Paris, 1816).

awareness of national heritage in the form of historical sites and monuments in the
first decades of the nineteenth century.[67] Though his museum was faulted for numerous
historical inaccuracies, Lenoir is remembered today for the impetus he gave to the study
of French history and the development of history museums combining original objects
and period decor. Advances in historical knowledge led to more authentic period dis-
plays, beginning with the Musée de Cluny, which opened in Paris in 1844 (fig. 78). In
place of simulated interiors stocked with displaced monuments and fragments, Cluny
strove for a new level of persuasiveness through a seemingly natural arrangement of
genuine artifacts in a real period interior. One visitor described the rooms in the fol-
lowing terms: "Furnishings, hangings, stained glass, armor, utensils and jewelry—all
has been miraculously recovered and preserved; you walk in the midst of a vanished

78. Francis I Room, Musée de Cluny, ca. 1845. Engraving from Alexandre du Sommerard, *Les arts au moyen âge* (Paris, 1838–46).

civilisation; you are enveloped by the good old chivalric times."[68] Whereas Lenoir's museum did nothing to disguise the assembled nature of the collection and the artificiality of the setting, the Musée de Cluny, as Stephen Bann has argued, effaced signs of curatorial intervention and created instead the illusion of a historical moment frozen in time. The "period room" as we know it begins here in the quest for transparency, for full immersion in the past.

In the second half of the nineteenth century, in step with the rise of nationalism and the success of ethnic pavilions at world's fairs, permanent history museums featuring authentic period rooms and settings grew in popularity, especially in northern Europe. New museums opened in Hamburg, Munich (Bavarian Museum), Nuremburg (Germanic Museum), Paris (Carnavalet), Arles (Arlaten), Stockholm (Skansen), and Zurich (Swiss National Museum), to name only the most prominent, to promote national and regional identity and preserve indigenous cultures against the homogenizing forces of modernity. Preservation movements turned historical sites into museums, in some cases with living guides simulating contemporary customs, dress, and speech (in the United States, Colonial Williamsburg is the best-known example).

79. Installation view of the Fifteenth-Century Tuscan Sculpture exhibition at the Kaiser-Friedrich Museum, Berlin, after 1904. Photo: Bildarchiv Preussischer Kulturbesitz/Art Resource, New York.

The relative merits and demerits of period settings were much discussed in Germany in the late nineteenth century. The influential director Wilhelm von Bode went back and forth on the idea, recognizing on one hand the educational benefits of combining the art forms of a period in the same room, yet regretting on the other the inevitably simulated quality of the ensemble.[69] In the end at the Kaiser-Friedrich Museum he settled for a compromise. While the central picture galleries concentrated exclusively on major paintings, the side galleries (fig. 79) offered a mixture of paintings, sculpture, and the decorative arts—displayed not as they might be in a private home but following public museum standards (note the *cassone* positioned on a low-lying pedestal rather than on the floor). In such rooms diverse art forms created a cumulative image of artistic production during a given period without sacrificing the legibility of individual objects.

Bode's disciple William Valentiner took the idea of integrated period displays to the United States and implemented it first in the European Decorative Arts section of the Metropolitan Museum, after 1906, and later in a more systematic fashion at the Detroit

Institute of Arts, where he took over as director in 1924.[70] Working in Detroit with the architect Paul Cret, Valentiner designed a sequence of simulated period environments for European art around a courtyard and filled them with authentic objects. The Dutch room was covered with red Spanish leather, the Italian room with red velvet, and the French, Flemish, and English rooms with original wood paneling, while the architecture and fenestration varied accordingly. The distance from Europe justified the importation and re-creation of entire "period rooms" with architectural ornament and matching furniture, as Fiske Kimball, pioneering director of the Philadelphia Museum, explained in the 1920s:

> We have conceived the interior of the Museum, in its principal area, as unrolling in historical order the pageant of the evolution of art, with paintings, sculpture and crafts of each period in association. We, in America, without the surrounding monuments of earlier ages everywhere found in Europe and Asia, have thought it suitable to include also works of architecture in the association. Thus while the majority of movable works are shown in galleries of simple wall surface, there are also many rooms which, beside offering a congenial atmosphere for their contents, are in themselves works of art.[71]

During the same period on either side of the Atlantic, so-called personal collection museums, consisting of highly decorated personal spaces and period settings, entered the museum movement. In Detroit, Valentiner hoped to make "[t]he whole museum . . . more like a private collection in a large private house,"[72] which, of course, precisely describes the Isabella Stewart Gardner Museum in Boston, the Wallace Collection in London, the Museo Poldi Pezzoli in Milan, and many others that opened to the public in the late nineteenth and early twentieth centuries. Those personal museums accentuated their difference from public museums in large part through the conspicuous pursuit of idiosyncratic modes of display, including seemingly random juxtapositions, sumptuous interiors, and frequent reminders of the collector's individual taste and will.

Despite, or because of, their popularity with a broad public (a survey conducted by Kimball at Philadelphia in 1929 had demonstrated their popular appeal), period environments fell into curatorial disfavor not long after their introduction.[73] With more than a touch of condescension, Europeans felt that period rooms might be appropriate in the United States, a nation of immigrants who "crave reminders of their transatlantic homes,"[74] but unnecessary in Europe itself. Eventually the artificiality of period ensembles, too often relying on objects cobbled together from different sources, conflicted with standards of authenticity upon which a curator's integrity depended. "There is nothing more damaging to [a curator's] prestige than buying a fake," wrote Thomas Munro, director of the Cleveland Museum in the 1940s, and almost all period ensembles were palpably fake.[75] Finally, the busyness of period rooms, with their wall and window treat-

ments, furniture, and decorative arts, stood in the way of direct appreciation of original works of art. The 1935 survey by Arthur Melton, cited above, determined that period settings reduced the visitor's ability to concentrate on individual objects. Melton's experiments with controlled installations led him to conclude: "One cannot mix the fine and decorative arts without sacrificing some of the interest which would be aroused by each class if exhibited in isolation. This may mean that the period room or the compositely installed gallery is no place to exhibit those pieces which the curator wishes to bring to the attention of the greatest number of people."[76] From the Victoria and Albert Museum, Eric Maclagen carried out an informal survey of his own and found that, public opinion notwithstanding, European museum professionals disliked period rooms for precisely that reason. Siding with Bode's compromise position, Maclagen believed that the decorative arts benefited from juxtaposition in a period setting but that "it is very seldom that furniture or pictures of first-rate quality are shown to the best advantage in a . . . paneled room," and in general period rooms "should not be regarded as an ideal setting for masterpieces."[77] Henri Verne, director of French national museums, thought period settings confounded "the natural hierarchy of the arts."[78] Kenneth Clark, at London's National Gallery, agreed: "If you put a work of art in a very decorative room and you hang it with objects of decoration, you reduce it to their level. The pictures of the Italian Renaissance, which used to be treated in this way, always gave me the impression that they were not the originals but clever reproductions such as one might find in an upholsterer's shop."[79] By the late 1930s the "architectural interior" had become "a thing of the past," according to Lawrence Coleman, president of the American

Association of Museums.[80] Though many period settings survived, others were dismantled in the middle decades of the century in a drive to rid museums of expressive architecture. An extreme negation of period interiors was achieved in the 1950s in the work of Carlo Scarpa and Franco Albini, whose modernization of the Museo Correr in Venice (1953–61; fig. 80) and the Palazzo Bianco in Genoa (1950–51), respectively, all but erased signs of the original architecture and left art

80. Carlo Scarpa, Museo Correr, Venice, late 1950s, gallery interior.

isolated, even frameless, in a setting that untouched would have been more or less historically compatible with it. Of the Palazzo Bianco, it was said: "In the interests of education, the palace concept was abandoned . . . [together with] all embellishments either in material, form or color—the intention being to provide a tranquil visual background . . . for the contemplation of a work of representational art."[81]

The Art of the Other

At the same time that art museums were debating the merits of contextual display for Western art they were also considering whether and how to assimilate the visual culture of other world traditions. The advent of world's fairs after 1851 and the spread of colonialism gradually widened the Western conception of art to include the applied or industrial arts and the visual traditions of non-European civilizations. Following European territorial ambitions eastward through the Mediterranean, the products of Egypt and Mesopotamia, then India, Japan, and China, were gradually added to the canon. But how to display these newly recognized "arts"? Like medieval objects in the early nineteenth century, non-European objects needed mediation on account of their exoticism and aesthetic variance from the Greco-Roman ideal. Following the lead of Cluny and other regional museums, one obvious form of mediation was an "explanatory" architectural environment. As contextual settings faded out for the display of Western art, they reappeared to aid in the interpretation of non-European cultures. Significantly, at the new Boston MFA after 1909, even as European paintings were reinstalled as masterpieces in clean, modern galleries, highly important objects from Japan went on display in heavily accented rooms around a Japanese garden and pool complete with goldfish, raked sand, and stone lanterns. Rice paper window screens, dim lighting, and replicas of Nara period columns and brackets provided "an appropriate and natural setting" for an exceptional collection of Buddhist sculptures (fig. 81).[82] The allusion to an original context was in keeping with the pedagogic philosophy of early curators of the Asian collections, Ernest Fenollosa and Ananda Coomaraswamy, who, though fully alive to the aesthetic value of their treasures, felt the need to encourage cultural understanding as well as aesthetic appreciation (the MFA's Japanese collection originally comprised a mass of ethnographic material). In the 1930s, Coomaraswamy swam against the tide of formalist autonomy by advocating an "anthropological approach" to art, hoping through education to help museum-goers see other cultures through something akin to native eyes.[83]

A remarkable exhibition of Native American art that traveled from San Francisco to MoMA in 1941 gave viewers the best of both worlds through a wide variety of installation strategies, from a white-cube display of Mimbres pottery and a spotlighted gallery

81. Japanese Temple Room, Museum of Fine Arts, Boston, 1910.
Photograph © 2006 Museum of Fine Arts, Boston.

for Nahavo textiles to simulated Pueblo dwellings, re-creations of wall pictographs from Utah, and performances of tribal rituals (sand painting and dance). The curators, Frederic Douglas and René d'Harnoncourt, explained: "In theory, it should be possible to arrive at a satisfactory aesthetic evaluation of the art of any group without being much concerned with its cultural background. . . . Yet we know that increased familiarity with the background of the object not only satisfies intellectual curiosity but actually heightens the appreciation of aesthetic values."[84] Alfred Barr later praised the exhibition for avoiding "both the purely aesthetic isolation and the waxworks of the habitat group" and for including the Navaho sand painters "in a Museum gallery but without scenery."[85]

Striking a balance between the aesthetic expectations of Western viewers and the values of other cultures remains a live issue for art museums. In recent decades debate has focused most heavily on the collecting, display, and interpretation of African and indigenous arts of North America and Oceania. While objects from the ancient and "evolved" civilizations of Asia and the eastern Mediterranean were considered "art" and avidly pursued by collectors and art museums from the late nineteenth century, objects from the new and "primitive" worlds of Africa, the Americas, and Oceania were at the same time valued primarily as anthropological documents and destined for natural history or ethnography museums, where they were sorted by tribe and often displayed in dioramas. Though admired by a few avant-garde artists and maverick collectors (e.g., Picasso, Alfred Stieglitz, Roger Fry, and Alfred Barnes), African sculpture migrated to art museums from its customary home in ethnography museums only fitfully through temporary exhibitions (notably MoMA's African Negro Art exhibition in 1935) until the 1960s. The opening of the Museum of Primitive Art in New York in 1957 in tandem with the civil rights movement generated the first curatorial positions in African art (often lumped together with Oceanic and Native American). A great many encyclopedic museums and national museum networks have since built permanent collections and new buildings dedicated to those fields (e.g., the Musée du Quai Branly in Paris, 2006). The principle of universality to which they adhere has made it straightforward conceptually to add new art forms to the fold, as if they had always been there, but the question of *how* to represent those visual traditions within the space of the museum has been more problematic.

After decades of exclusion from the privileged circle of art-producing cultures, the first impulse was to highlight the previously overlooked aesthetic power of traditional African objects. If in ethnography museums African artifacts had been valued primarily as specimens of Fang or Yoruba culture and only secondarily (at best) as objects of aesthetic interest, the goal of art museum displays was to reverse those priorities. African "art" should be treated just like Western art. When Susan Vogel installed the Met's first exhibition of African art in 1982 (fig. 82), conformity with the museum's "house style"

was a given: "In the context of the Metropolitan, at least at the beginning, it had to be presented as art—pure art, high art, the equal of any in the building. This meant installation techniques used in natural history museums were out. No mannequins, no photomurals, no music."[86] Instead of mannequins and music, boutique lighting and a nonhierarchical organization of various types of objects encouraged aesthetic appreciation of each without regard to social function or ethnographic significance. And when Vogel organized the inaugural exhibition of the Center for African Art in New York in 1985, entitled African Masterpieces from the Musée de l'Homme (in Paris), a similar aestheticizing ambition was in evidence. The goal of the exhibition in this new art space was, as the title suggests, to reveal the artistry of objects originally consigned to a museum of ethnography. Things that had been collected and displayed for their anthropological value were now brought to New York and reidentified as masterpieces of African art. In Vogel's words, the exhibition declared: "[T]he sculpture of Africa is real art, as

82. Michael C. Rockefeller Memorial Wing, Gallery of African Art, Metropolitan Museum of Art, New York, 1982. Image © The Metropolitan Museum of Art.

potent and as worthy of respect as the art of any other time or place in history."[87] The same motive guided the massive exhibition Africa: The Art of a Continent, which opened at London's Royal Academy in 1995 and later traveled to Germany and New York. Spanning sub-Saharan and Islamic North Africa (including Egypt) from prehistoric times to the twentieth century, and employing standard art museum tactics—spotlighted displays in dim rooms, minimal labeling—the exhibition boldly assimilated the African continent, in all its visual and cultural diversity, into the realm of Art. According to the catalog: "The time is at last ripe perhaps for an assertion of Africa's artistic wealth to need no alibi, either political or ethnographic."[88]

These exhibitions were provocative, however, in the sense that the terms *masterpiece, sculpture,* and even *art* used to frame their contents in the familiar Occidental discourse of art do not correspond to the objects' original purpose or their makers' intentions. "Art," as we understand it in the West, has no exact corollary in traditional African thought or language. The imposition of Western aesthetic conventions on African objects therefore distorts our understanding of those objects and the culturally varied, geographically dispersed societies that produced them. How and why were those objects created and used? Can we properly "respect" another culture without understanding it? Displayed aesthetically, objects "speak to us *across* time and culture" as "[high] points of human achievement," as a label in the Vogel's Masterpieces show stated, but they cannot tell us *about* the time and cultures in which they were made.[89]

The suppression of contextual material in many museum displays prompted the ethnographer James Clifford to remark: "[A]n ignorance of cultural context seems almost a precondition for artistic appreciation."[90] Precisely such criticism has prompted a reevaluation of installation techniques in many art museum collections of African and indigenous material. After consciously eschewing the methods of the natural history museum, a modified contextual approach has swept into many African collections (fig. 83) in the form of extensive wall labels and photographs or films documenting the use of like objects in performances and ritual activity. A wall label accompanying a display of African masks at the Brooklyn Museum offers a good example of the dual aesthetic/anthropological focus that is now commonplace: "While we may appreciate masks as aesthetic objects, when used with music and dance they have the capacity to animate, energize, and enhance funerals, initiation ceremonies, and other special events."

Further refining the new contextualism, Susan Vogel has argued that there are limits to how far museums can go in explaining the original contexts and belief systems of alien cultures, and that since it is our habit in the West to attribute "to the art and artifacts of all times the qualities of our own: that its purpose is to be contemplated, and that its main qualities can be apprehended visually" it would be dishonest and condescending not to treat objects from other cultures in the same way. After all, she notes:

83. Installation view of the African Gallery, Brooklyn Museum of Art, New York, 2004.

"We can be insiders only in our own culture and our own time."[91] In her landmark 1997 exhibition Baule: African Art/Western Eyes, Vogel attempted to combine approaches by alternating aesthetic and ethnographic modes of display, using spotlighted high-art vitrines in one gallery and dioramas of Baule houses and shrines in another. She summarized her purpose in the accompanying catalog: "This book is inspired by my enjoyment of certain objects of Baule material culture as works of art in a Western sense, but it seeks to explore what 'artworks' mean in Baule thinking and in individual Baule lives."[92]

It remains to be asked why an integrated, or balanced, approach to installation, now widespread in installations of African, Asian, and Native American material, is so rarely used for Western art. Why not treat European art as Vogel did Baule culture? The obvious answers—first, Western viewers are unfamiliar with other cultures and, second, the artifacts of those cultures had ritual functions and were not intended for visual scrutiny in a museum—could be said to apply equally to a great many Western objects on view in our art museums. We assume that Western art and its ritual associations are familiar and need no explanation (contextual or textual), but to what extent is the purpose of a Roman sarcophagus or a medieval reliquary understood by museum-goers (anywhere)

84. Installation view of The Birth of Impressionism: From Constable to Monet, Glasgow Museums, 1997. Photo: Glasgow City Council (Museums).

in the twenty-first-century? Even the cultural context of impressionist painting is but dimly grasped by the legions of its admirers. Why is it that the Boston MFA continues to display its celebrated Japanese Buddhas in a dimly lit templelike setting but would never dream of exhibiting, say, an Italian altarpiece in a mock chapel setting with altar, candles, incense, and music? While such a setting would be considered demeaning to the painting and the religion it represents, the same is not said about the Buddhist sculptures. Not infrequently museums in the United States provide ambient settings for Buddhist objects and "instruction" in profound Buddhist practices, but only a Fred Wilson would dare attempt a parallel approach in the European or North American collections.

Reflecting on her early days at the Met, Susan Vogel said that she had considered using photomurals and music but changed her mind "because I felt that in the context of the other installations in the building, they would have conditioned perception of the African galleries as an anthropological exhibit. On the other hand, I would have welcomed the addition of music and contextual devices to the galleries of Dutch painting, say, or of arms and armor. I would then have been happy to see the same in the African galleries."[93] Where bold attempts at contextualization have occurred in Western muse-

ums they have been met with scorn. As early as 1930 in a scathing attack on period interiors, Frank Jewett Mather asked, Why stop with a few architectural details? "Why not introduce a priest, waxen or in the flesh? Why not hold a mass, oral or phonographic?"[94] An impressionist exhibition at the Glasgow Museum in 1997 (fig. 84), with Salon-style hanging, costumed mannequins, and a reconstruction of Monet's studio boat, was widely derided in the press.[95] In France in the early 1980s, following the election of a Socialist government, leftist factions within the political and academic establishments had visions of making the new Musée d'Orsay a dynamic history museum through the addition of audiovisual aids, a nineteenth-century train, and workers' tools and clogs displayed alongside paintings by Millet and van Gogh. The curatorial staff rebelled. "We refused to view the museum as an illustrated history book," said then chief curator Françoise Cachin.[96] In the end the two sides settled for a watered-down commitment to including once-popular but now-forgotten "academic" painters together with the once-maligned, now-adulated impressionists. Even then critics felt the interests of "context" had been taken too far. Stephen Greenblatt, for one, argued (seemingly at odds with his own practice of contextual literary analysis) that outstanding works of the French avant-garde had been degraded through what he viewed as a heavy-handed attempt to place them in the cultural milieu of the day. "What has been sacrificed on the altar of cultural resonance," lamented Greenblatt, "is visual wonder centered on the aesthetic masterpiece."[97]

Postmodern Conundrums

What bothered Clifford and others about early installations of African and indigenous art was the lack of reflexivity or transparency in the way in which collections were presented. There was no awareness or acknowledgment of the ways in which a museum display intervenes between object and viewer and conditions the viewer's response. In Clifford's field of interest, there was no acknowledgment that Western museum displays represented in effect a continuation and validation of colonial power relations through their imposition of Western norms and disregard for local beliefs and perspectives. He pointed to one especially egregious example, the exhibition "Primitivism" in 20th Century Art: Affinity of the Tribal and Modern, held at MoMA in 1984–85. In keeping with MoMA's traditional emphasis on the aesthetic dimension of high art, the exhibition examined the influence of certain "primitive" traditions on European modernism beginning with Picasso. "Beneath this generous umbrella," wrote Clifford, "the tribal" seemed "modern and the modern more richly, more diversely human," but in the end "the affinities shown at MoMA are all on modernist terms"; genius and innovation were shown to lie with the Western artists who found inspiration in the mute tribal specimens brought

to Europe as ethnographic trophies.[98] Nothing was said about the masks themselves, why they were made, how they arrived in the West, or how contact with the West inspired their makers.[99] Nor did the exhibition venture into the broader context of Western appreciation of "Negro" culture at the time, with its disturbing currents of racism and sexual exploitation. Following the exhibition, the masks and other objects imported to celebrate a Western achievement returned whence they came. The "Primitivism" show could not have been more poorly timed, as it managed all at once to highlight disparities in the Western museum's representation of the "other," to suppress larger questions of history and context, and to evade debates about the trajectory of modernism, all of which were being subjected to the critical scrutiny of postmodern theory and revisionist art history.

Yet, as Clifford says, "One of the virtues of an exhibition that blatantly makes a case or tells a story is that it encourages debate and makes possible the suggestion of other stories."[100] Criticism, in other words, opens the door for change, and change has been manifested in a greater reflexivity and multivalent perspectives found in many exhibitions and museum installations from the late 1980s, including those just listed above. Curators are more conscious of their role in mediating the visitor's experience through the choice, arrangement, and interpretation of exhibits. Some curators now reveal their hand by signing their wall labels; some museums solicit visitors' opinions (and even invite them to write labels),[101] and others have broadened the outlook and backgrounds of those they hire as docents. Experimentation is now commonplace in museum practice. Sounding more like a postmodern critic than the director of the British (Ur-)Museum, Neil MacGregor recently stated: "The museum is not a temple of eternal verity; it is at best a workshop for conflicting interpretations, a house of provisional truths."[102]

Because of proximity to the theorized world of academe and government pressures to increase public access to high culture, art museums in Britain have lately become notable sites of museological innovation. One need look no further than the major "nationals" in London (though regional museums and art centers—in Newcastle, Liverpool, Walsall, and Glasgow, for example—have equally come to life in recent years). The Victoria and Albert Museum has undertaken a bold overhaul of its British, medieval, and Renaissance collections. Taking advantage of deep and eclectic holdings, it has replaced a traditional material-type (painting/sculpture/furniture . . .) division of its holdings with a sequence of thematic installations that use a remarkable juxtaposition of paintings and photographs, books and miniatures, textiles and prints to offer focused insights into historical phenomena and moments. Traditionalists complain that important works of art have been reduced to material culture and that theme-oriented displays will soon grow tired and need revision, but the changes have energized the museum and proven popular with the general public, school groups, and hard-to-please academics.

The cultural range of its collections, meanwhile, has allowed the museum to examine issues of colonialism and cultural hybridity in an unusually candid way. A similar openness to contemporary concerns has led the National Portrait Gallery to go beyond patriotic hagiography and mount engaging thematic exhibitions, such as David Livingstone and the Victorian Encounter with Africa, "Conquering England": Ireland in Victorian London, and Between Worlds: Voyagers to Britain 1700–1850. The National Gallery remains deeply traditional in its installation and contents, but the public interpretation of the collection and occasional programming has been remarkably adventurous at times. For example, in 2004 the gallery acquired Raphael's *Madonna of the Pinks* with substantial help from public funds. To justify spending twenty million pounds on a single canonical painting, the gallery's education department sought to connect the Raphael and its age-old mother-and-child theme to an unusual constituency—underprivileged teenage mothers. Convening a group workshop around the Raphael, the young women began to "talk about their own situation, and come to terms with what they are doing with their lives."[103] In 2006 a gallery was set aside for children's artistic responses to a rather obscure and old-fashioned picture—Mignard's *Marquise de Seignelay and Two of Her Sons* (1691).

Perhaps the most daring and controversial initiative was the installation of London's two new Tates: Tate Modern and Tate Britain. When the two galleries opened in 2000, both had rejected the standard organization of their collections by schools and chronology—what director Nicholas Serota described as "the conveyor belt of history"— and instead gone with an alternative hang that juxtaposed artists of different periods and (at Tate Modern) nationalities under a set of master themes. At Tate Britain the shake-up produced new rooms entitled "Art and Victorian Society," "The Cult of Youth," and "Ways of Seeing Revisited." At Tate Modern, the section "Landscape/Matter/Environment" paired Claude Monet's painted *Water Lilies* (after 1916) with Richard Long's earthwork *Red Slate Circle* (1988). In "Nude/Action/Body," Matisse, Bacon, and Giacometti went head to head with Bruce Naumann, Tracey Emin, and Gillian Wearing. The idea was to challenge the unquestioned authority of the constructs "history" and "school" and to allow "each of us, curators and visitors alike," in Serota's words, "to chart our own new path, redrawing the map of modern art, rather than following a simple path laid down by a curator."[104] The present was put in direct dialogue with the past, artists from one nation with those from another, reflecting the new open-ended worldliness of the contemporary art world. What Serota and his team intended as an antihierarchical, postmodern salvo was attacked by numerous critics as the height of curatorial presumption, however. The *Burlington Magazine* labeled Tate Modern a "curatorial playground" and mocked the "clever subversions and pick-and-mix variety."[105] The Monet/Long comparison struck one critic as overly "scripted,"[106] and even the late Kirk Varnedoe,

MoMA's chief curator, joined the negative chorus. "When you put a Richard Long next to Monet," he wrote, "you are forcing viewers to be bound by the curator's vision. I would prefer to have curators try to correspond to some external sense of reality."[107] By "external sense of reality" Varnedoe meant history and the canon, the constructedness of which the Tate curators hoped to avoid. The influential flowchart of modern art devised by Alfred Barr in the mid-1930s, according to which postimpressionism begets cubism and fauvism, et cetera, on the road to pure abstraction, was precisely the authoritative script the Tate tried to revise in the interests of encouraging new ways of seeing. But for unregenerated modernists chronology could not so easily be dethroned. Siding with Varnedoe, David Sylvester wrote: "It is all very well for curators to want to ignore chronology. But chronology is not a tool of art-historical interpretation which can be used at one moment, discarded at another. It's an objective reality, built into the fabric of the work. And into the artist's awareness."[108]

Critical reaction intensified when what the *Burlington* called the "epidemic of millennial fever" crossed the Atlantic to New York. The Tate's new hang could be dismissed—and was—as an attempt to disguise gaps in a mediocre collection, but the same could not be said about MoMA. In a review of the multimedia, nonchronological Modern*Starts* installation in 2000, designed to "provoke new responses and new ideas about modern art,"[109] *New Yorker* critic Peter Schjeldahl exclaimed: "Forget chronology. Goodbye to MoMA's old, rigid catechism of modern styles. Hello, postmodernistic mix-and-match. . . . I've never seen anything so overwrought." At the root of the problem, he explained, was a loss of faith in the verities that had long sustained our cultural institutions: "MoMA faces a historic crisis. It is a victim of its own success as the world's most authoritative institution of twentieth-century visual culture, at a time when that culture is entering a blind spot of a future-preoccupied present. MoMA was founded to advance ideas of progress that are now dead. . . . Trendy museology stands in for fading intellectual pertinence."[110] Jed Perl, writing in the *New Republic,* came to the same conclusion: the "splice and dice . . . anti-chronological installations . . . at MoMA and Tate Modern suggest exactly how badly the foundations of these museums have been shaken."[111]

Perl needn't have worried so much, however—or perhaps his critique brought the museums to their senses. Within a few years a conventional order was restored to both MoMA and Tate Modern. When MoMA reopened its new midtown complex in 2004 almost nothing of the Modern*Starts* radicalism remained. Yoshio Taniguchi's simple exterior and white cube interiors connect with the museum's past, and MoMA's parade of masterpieces can again be seen (but for the crowds) in all their glory. Chronology has returned and the decorative arts have been put back in their place. Taniguchi's sensitivity to MoMA's "unique history and context"[112] and reaffirmation of tradition, with

only a nod to postmodern alternatives, no doubt endeared him to the board. "Visitors may view the collection galleries in chronological sequence by the normal route or may create their own paths," wrote the architect. "Various opportunities for jumping forward or backward in the chronology through interstitial spaces, variable galleries, and interconnecting stairways are provided."[113] In other words, it's business as usual, unless you happen to lose your way. To be sure, a few new artists were added to the mix (Frida Kahlo, Rufino Tamayo, Antonio Tàpies, Howard Hodgkin), and the central atrium has become a place for unexpected juxtapositions, yet the ghosts of MoMA's past, from Alfred Barr to Kirk Varnedoe, would have little reason to complain. The looming crisis of how MoMA would absorb the lessons of postmodernism—including postmodern art, so much of it inimical to a museum environment—has been largely avoided. While insisting that MoMA is not a "museum of modernism in a closed sense," Kirk Varnedoe's mainstream vision of modern and contemporary art loyal to its roots "primarily in a Western European background" has been realized.[114] "We don't collect everything that's made in contemporary art," he noted. "We collect that part of contemporary art which we think honors the ideals or the ambitions and achievements of the founders of modern art."[115] In 2006 Tate Modern quietly retired its inaugural "mix-and-match" installation in favor of a return to a progression of the familiar "isms" (cubism, surrealism . . .) of the twentieth century. A large mural adaptation of Barr's famous flowchart of modernism adorns the wall leading to the permanent collection.

If in the end major institutions with canonical collections prove reluctant to change, we are more likely to encounter experiment and change in temporary installations and exhibitions and second-tier museums. Removed from the critical spotlight, many smaller museums have become more adventurous in what they do. If MoMA is bound to a conservative vision of modern art, new spaces like MoMA's branch museum, P.S. 1, the "Temporary Contemporary" in Los Angeles, and the Massachusetts Museum of Contemporary Art in western Massachusetts (fig. 85) have arisen to accommodate virtually anything calling itself art. New museums of contemporary art are comfortable exhibiting contemporary art from beyond the Euro-American orbit in ways mainstream museums are not. Venerable museums in Brooklyn, Newark, and Cincinnati have all lately experimented with thematic and mixed-media installations. In Belgium, the new Memling Museum in Bruges (fig. 86), housed in what was originally a medieval hospital, has (re)installed its masterpiece by Hans Memling in the chapel setting for which it was made, where it begs comparison with Michelangelo's *Virgin and Child* (fig. 87) *in situ* across the street in the church of Notre-Dame. In one direction, the new museum-chapel has restored some of the Memling's spiritual effect; in another, the visual parallels between the two buildings remind us that the tourist-driven global economy has made museums of many of the world's sacred sites. Where the British Museum feels

85. Installation view of Tim Hawkinson's *Überorgan* (collection of Andrea Nasher) at Massachusetts Museum of Contemporary Art, 2000.

compelled to display its collection of Benin bronzes as art (see chapter 6) with no mention of their provenance or of Nigerian demands for their repatriation, the Horniman Museum, located in an ethnically diverse area on the other side of London, offers its own Benin plaques as the focal point of a conversation involving different voices, including the views of Africans living in the United Kingdom.[116]

Numerous mainstream museums have experimented with change through the short-lived and controlled medium of temporary exhibitions. For example, a broad cross section of institutions has welcomed Fred Wilson's typically irreverent interventions, knowing they will soon disappear. Precisely the same curatorial strategies that provoked such ire in the collections of MoMA and the Tate may be greeted as a welcome breath of fresh air when confined to a brief installation. Witness Holland Cotter's response to an eclectic retrospective of the Whitney Museum's collection in 2006: "The work is mostly arranged by loose theme rather than date, an approach I like. It enlivens objects by setting them in unexpected, often energizing company. And it points up the basic arbi-

86. Memling's *Altarpiece of St. John the Baptist and St. John the Evangelist,*
1474–79, on display at the Memling Museum, Bruges, 2003. Oil on panel,
173.6 × 173.7 cm (central), 176 × 78.9 cm (each wing).

87. Michelangelo's *Virgin and Child,* 1501–5, at the Church of Notre-Dame,
Bruges, 2003. Marble, h. 128 cm.

trariness of orthodox art history and critical opinion. An unfamiliar little piece off to
the side is revealed to be every bit as interesting as a celebrated big piece in the center
of the room."[117]

Among the most remarkable developments of recent years has been the emergence
of indigenous museums embracing an alternative point of view. In Australia, as Tony
Bennett relates, "a handful of Australian museums . . . have ceded to Aboriginal peoples
the right to refashion the display of Aboriginal materials in order to make their own
statements on their own terms."[118] In the Pacific Northwest, James Clifford discovered
an oppositional museum practice in four tribal museums that registered "the irruption
of history and politics in aesthetic and ethnographic contexts, thus challenging the art-
culture system still dominant in most major exhibitions of tribal or non-Western work."[119]

Each museum offers indigenous perspectives with respect to cultural usage of the work displayed. Equally important, and in contrast to the reluctance of mainstream museums to reflect on the formation of their collections, they record a local view of history that includes the catastrophic intervention of white settlers and subsequent struggles to retain tribal traditions and memory. Similar strategies and a similar purpose inform the new National Museum of the American Indian (NMAI) on Washington's Mall. Opened in 2004 and dedicated to "reaffirming traditions and beliefs, encouraging contemporary artistic expression, and empowering the Indian voice," the NMAI incorporates "Native methodologies for the handling, documentation, care, and presentation of collections" and "actively strives to find new approaches to the study and representation of the history, materials, and cultures of Native peoples."[120] At NMAI tribes are responsible for telling their own stories, and the results are unconventional by normative Western standards.[121]

The problem with alternative spaces and visions, of course, is that they are no less vulnerable to ideological distortion in their own way. The NMAI, for example, has been criticized for essentializing Indian culture and idealizing history, suppressing unflattering aspects of the Native American record (e.g., intertribal war practices no less brutal than those perpetrated by whites) in pursuit of a celebratory, mythic Indian past. "The result," said Edward Rothstein in the *New York Times,* "is homogenized pap in which the collection is used not to reveal the past's complexities, but to serve the present's simplicities."[122] That exactly the same criticism was leveled against the National Gallery's Circa 1492 exhibition a decade earlier (see chapter 1)—criticism that helped create the NMAI—reminds us that all museums have a point of view and construct certain narratives at the expense of others. As fields of cultural and historical representation operating in the public sphere, museums will always be contested spaces. The lesson of postmodernism is that there are many stories to tell, many publics to serve, and that only a multiplicity of museums, embracing different voices and aspirations and each evolving over time, can hope to please at least some of the people much of the time.

The problem of the present is the democratization of museums: how they may help to give all men a share in the life of the imagination. **Benjamin Ives Gilman (1909)**

The highest experiences of art are only for the elite who "have earned in order to possess." **James Johnson Sweeney, director of the Guggenheim Museum (1961)**

4 THE PUBLIC

The transition from princely collection to public museum at the turn of the nineteenth century raised the question of who constituted the new museum public and how it should be served. The shift from private to public was gradual and uneven, occurring more rapidly and completely in some countries and at some institutions than at others, and nowhere did it occur without friction. Experts worried about the overexposure of delicate masterpieces to the gawking masses; bourgeois visitors complained about having to share a once-privileged space with their social inferiors and bemoaned new arrangements and precautionary measures aimed at the general public; guards monitored visitor behavior and attire, but little was done to instruct the novice. Throughout the nineteenth century, cartoonists made fun of the ignorant, reminding the uninitiated that they didn't quite belong.

The history of the art museum can be written as a history of efforts to reconcile the different needs and expectations of the museum-going public. The relationship between the museum and its publics has always been a live issue, but in recent decades it has become arguably *the* issue as external pressures have compelled museums to make public access and outreach an equal (and in some cases a greater) priority than the collecting and preservation of objects. The forces behind the transformation "from being *about* something to being *for* somebody," as Stephen Weil put it, are ideological and financial.[1]

The "democratization of museums" has long been an ideal, but it has not always been a common cause among museum men, as the two epigraphs make clear. Tensions between the museum's goals to collect and preserve and to educate are built into the structure and staffing of museums. Some objects are deemed too delicate to be lent to exhibitions or displayed at all, limiting public access. Etymologically, the word *curator* comes

from the Latin *curare,* to care, and to the extent that curators are trained and hired to care for their collections, they are drawn away from the visiting public. Care for the public is left largely to educators and volunteers, who, since their first appearance a century ago, have occupied a lower rung in the museum hierarchy. The exceptional rarity and value of art objects tend to make tensions between curators and educators especially prevalent in art museums. That the hierarchy is still alive and well is revealed by Philippe de Montebello's blunt admission: "To me, audiences are second. . . . Our primary responsibility is to works of art."[2] A further obstacle to democratization stems from the origins of our public museums in private collections. Alongside declarations of public service, art museums honor an aristocratic pedigree by occupying princely palaces (or purpose-built imitations of them) and cultivating ties to wealthy donors. While they invite the public to partake of their treasures, they also court collectors and patrons with a deference fit for a Renaissance prince. For some, the lingering aura of privilege is intimidating, but for just as many it is part of the allure. Like it or not, there would be no public art museums without the support of private benefactors.

What has tipped the balance toward audiences in recent decades has been the rise of social activism—political demands for museums to be more inclusive—and the need to meet escalating operating costs through higher attendance. Economic survival and the fear of being labeled elitist have combined to cast a negative light on Montebello's stated priorities. Curatorial attitudes notwithstanding, most museums can no longer afford to blithely concentrate on their collections at the expense of their visitors. At many museums, a shifting emphasis is reflected in diverse education and outreach initiatives, blockbuster exhibitions, and expanded recreational opportunities. A newspaper ad campaign for the Boston MFA from 1993 is representative of broader efforts at art museums to become all things to all people. Even the "top-ten" format of the ad borrows from a signature feature of a popular late-night television program (David Letterman):

> *Top 10 Reasons to Visit the MFA This Fall*
> 10. Elvis was spotted wearing a security guard's uniform.
> 9. Chocolate Mousse Cake in Galleria Café.
> 8. The Museum Shop won *Boston Magazine*'s "Best Shopping" Award.
> 7. "Robert Cumming: Cone of Vision"—his work can change the way you view the world.
> 6. It's changed a lot since you were in sixth grade.
> 5. Peter Tosh's "Red X" tapes on film through September 19.
> 4. Best people-watching off Newbury Street.
> 3. African sculpture—explore its secrets with a Nigerian art historian—September 29.
> 2. Nancy Armstrong and Robert Honeysucker sing Gershwin songs on September 26.
> 1. Escape to *The Garden of Love* in "The Age of Rubens," beginning September 22.

Art museum audiences have certainly grown since 1993, but it is less clear that higher numbers mean broader demographic diversity. At the same time, the turn to populism has frustrated seasoned art lovers who fear the loss of the museum they once knew. Recent programming trends have put pressure on traditional museological functions—scholarship, collecting, and conservation—not to mention works of art themselves, the most celebrated of which are frequently on loan to traveling exhibitions. Curators are now expected to be showmen as much as scholars and have drifted apart from their colleagues in academe, whose specialized knowledge is in turn increasingly marginal to the number-driven metrics of the successful museum. Shifting priorities are also changing the profile of museum directors and the composition of museum boards. In this time of contested ideals, growing popularity, and financial uncertainty, satisfying the museum's multiple constituencies constitutes one of the museum's greatest ongoing challenges.

The Age of Enlightenment

Collecting and enjoying art has long been an elite pastime. The emergence of art as an elite commodity coincided with the great age of Renaissance patronage and the creation of an aesthetic discourse that distanced art from social utility and privileged considerations of form, pictorial conceit, and authorship over function.[3] As princes and kings turned to collecting art to affirm wealth and power, artists saw their own status rise and moved to define their craft as a liberal art worthy of comparison to poetry and philosophy. From newly created art academies a theory and history of art developed that articulated criteria for the proper evaluation of painting and sculpture. Emulation of princely example caused art collecting and appreciation to spread into polite society and become the mark of the gentleman. While not all aristocrats and wealthy bourgeois actively collected art, familiarity with classical antiquity and the fine arts conferred social distinction and indicated fitness to rule.[4] By the eighteenth century an international network of critics and dealers, artists and collectors formed the infrastructure of an elite art world bound together by social contacts and shared discourse. Admission to the art world required appropriate social standing but also a mastery of critical terms and history. As mentioned in chapter 3, popular theorists such as André Félibien and Roger de Piles wrote books modeling connoisseurial dialogue for would-be art lovers, who in turn brought those texts to life in private collections across Europe. Though access to those collections was limited to recognized amateurs, much art could still be seen in churches and public spaces, but no matter where the art was displayed, the "public for art" effectively included only those who were capable of critically informed, aesthetically disin-

terested judgment. Conversely, those who responded to works of art with inappropriate emotion, or who attended to the content of a painting more than the way it was painted (the signified more than the signifier), revealed themselves as ignorant. These tendencies were eventually codified in the Enlightenment aesthetics of Kant and others, who defined legitimate aesthetic response as the prerogative of elevated beholders who were "freed from subjectivity and its impure desires."[5]

Increases in wealth and education in the eighteenth century produced a concomitant expansion of the public for art, as reflected in the growth of the art market and the advent of public exhibitions and museums. Public sales and auctions became an early venue for an art-hungry public, and dealers used new marketing strategies—shop windows, newspaper ads, sales catalogs—to seduce the moneyed classes into the pleasures and social advantages of collecting.[6] Engraving greatly extended the reach of high art, and the collecting of drawings became fashionable, but ownership of painting and sculpture required deep pockets. Critics demanded greater access to art on behalf of an expanding bourgeoisie without collections of their own, and from midcentury their calls were answered. Academies began to sponsor exhibitions of their members' work, the best known being the so-called Salon in Paris (from 1737) and the Royal Academy exhibitions in London (1768). Temporary exhibitions promoted artists' careers by introducing their work to potential patrons, but they also proved enormously popular with the public at large, consistently attracting large and diverse crowds. Overnight the public for art expanded beyond established amateurs and the cozy confines of collector's cabinets, and in the process became fragmented and difficult to define. As early as 1750 the painter Charles-Antoine Coypel remarked that the Salon attracted "twenty publics of different tone and character in the course of single day: a simple public at certain times, a prejudiced public, a flighty public, an envious public, a public slavish to fashion. . . . A final accounting of these publics would lead to infinity."[7] Self-styled critics stepped forward to guide this new and amorphous public. Private entrepreneurs seized on the public's enthusiasm and created commercial venues, such as Sir Ashton Lever's Museum in London (1773) and the Colisée in Paris (1776), offering potent mixtures of art, curiosities, and popular entertainment.[8] The blurring of boundaries between high and low culture jeopardized the integrity of the fine arts and provoked disdain from the establishment, though the general public evidently paid little attention to such distinctions.

For our purposes the most significant innovation in eighteenth-century Europe was the gradual opening of royal and princely galleries to an increasingly broad cross section of the public. In the middle decades of the century, private and princely collections in Paris, Rome, Berlin, London, St. Petersburg, Florence, Stockholm, Vienna, Dresden, Düsseldorf, Kassel, and elsewhere opened to the public with varying degrees of liber-

ality.[9] In Paris and Kassel, museums were open to all (though it is not clear who actually came), while in Berlin and London visitors needed to apply in advance, and in Vienna entry was barred to those without clean shoes. International travelers on the Grand Tour tended to be welcome everywhere. As the Age of Absolutism gave way to the Age of Enlightenment, patronage of museums and related institutions became the mark of enlightened rule and superseded ceremonial pomp and grandiose monuments as a form of princely patronage. In Paris Louis XVI (1754–93) chose not to erect a public statue of himself in emulation of his Bourbon ancestors and instead invested in the Louvre museum as his monument to posterity. Many collections were relocated or reinstalled according to scholarly standards by newly hired curators. Those curators published catalogs (e.g., figs. 67–70) making the collection accessible to educated readers. Once opened to the public, princely collections came to be seen as the national patrimony, stewardship of which became a measure of good government. These fundamental transitions, part and parcel of the transition toward modern nationalism, occurred at different rates in different countries, but the signal moment in the evolution of the public art museum was undoubtedly the creation of the Louvre during the French Revolution.

As we have seen in chapter 1, the Louvre, founded in 1793 at the height of the Revolution, was "public" and "national" like no museum before it. Full of the confiscated and nationalized property of church and crown and housed in a royal palace turned palace of the people, the Louvre museum embodied and made tangible the principles of liberty, equality, and fraternity for which the Revolution stood. Admission was free to all, and shared enjoyment of the republic's patrimony aimed to cement the bonds of citizenship and foster devotion to the nation. Foreigners were surprised to be admitted without an introduction or a fee, and once inside they were equally surprised to find themselves rubbing shoulders with "the lowest classes of the community."[10] That the latter stood out so conspicuously revealed, however, that the stratified publics of the ancien régime could not so easily be made one. Even republican journals satirized the uninitiated, revealing the bourgeois underpinnings of the museum (and the Revolution itself).[11] The mingling of classes and social types at the museum (and adjoining Salon) made the Louvre a microcosm of the modern social order and the setting for some of Honoré Daumier's most enduring caricatures. In one, *"The Egyptians weren't good-looking!"* (fig. 88), a humble family commits a faux pas no bourgeois would want to make in misconstruing the hieroglyphic conventions of the ancient Egyptians. Nothing was done to help the uneducated understand what they saw. There were no education programs or text panels in the gallery, and the printed catalogs sold at the door were beyond the means of the poor, assuming they could read. Absent prior knowledge or active gallery instruction, the methodical arrangement of the paintings, so instructive to the amateur, meant little to the man in the street.[12]

88. Honoré Daumier, "The Egyptians weren't good-looking!" 1867. Wood engraving.

At odds with the symbolic role of the Louvre as embodiment of a regenerated, egalitarian society was its propaganda value as a showcase of republican culture. To counter the impression of an anarchic society governed by mob rule, summary justice, and contempt for tradition, the Louvre offered itself as the supreme manifestation of aesthetic ideals shared by all civilized Europeans. At least as important as the local public, therefore, were international travelers who would take home with them a lasting image of canonical masterpieces preserved and displayed according the highest standards. To en-

sure that they did, a number of days each week were set aside for their exclusive enjoyment. Some foreign visitors were also interested in the spectacle of the mass public and came back during general open hours. Though the public days "were not suited to study or careful examination and reflection," noted Carl Christian Berkheim from Germany, "on the other hand, it is interesting to hear the often bizarre observations that are made and to observe the hordes of people drawn from all classes and walks of life as they traverse the gallery."[13]

Tourists flocked to the Louvre, as they have done ever since (today more than half of the Louvre's six million visitors are foreigners). At the height of his power, Napoleon remarked, "[I]t would please me to see Paris become the rendezvous of all Europe," and thanks to the Louvre it largely did.[14] As the city's chief cultural attraction, the museum figured prominently in every guidebook and itinerary. For many it was the first port of call, and repeat visits were customary. The fall of Napoleon and the prospect of the Louvre's dispersal prompted one Henry Milton to confess, as he crossed the English Channel for the first time: "I much doubt whether I should have taken the trouble to visit France had it not been for this collection."[15] John Scott, in his *Visit to Paris in 1814*, tells of a shopkeeper who made the journey with him with the express purpose of seeing "for himself what was fine in the Louvre."[16] In the stories of these early visitors to the Louvre we see the fault lines that divided, and still divide, the art museum public. Experienced travelers like John Scott recognized with regret that the Louvre would fundamentally change the way people engaged with works of art: the days of the Grand Tour and pleasures of private viewing were coming to a close, replaced by something new and *public*. Scott remarked that the combined glories of the new museum shone "with a lustre that obscures every thing but itself. In it are amassed the choicest treasures of art, that have been taken from their native and natural seats, to excite the wonder of the crowds instead of the sensibility of the few."[17] Alongside Scott there were fellow aristocrats, like the party of Sir John Dean Paul, banker, baronet, and author of *The ABC of Fox Hunting*, who evidently cared little for art but were drawn to the Louvre as a novel spectacle and rendezvous for the exchange of society gossip.[18] There were also earnest bourgeois, like Scott's shopkeeper, or Henry Milton, who valued the convenience of a centralized museum and viewed those who failed to appreciate its wonders with contempt. "It is laughable," Milton remarked, "to observe how very few are really attentive to the treasures which surround them."[19] Milton perhaps had more sympathy for the illiterate Parisian than he did for the likes of John Dean Paul. In any event, early testimonials suggest that public museums have always been a space of social encounter in which the needs of the uneducated and the elite, the art lover and the shallow tourist, democracy and diplomacy, are in play and potential conflict.

One further constituency served by the revolutionary Louvre was practicing artists,

who, together with tourists, were given privileged access to the museum for the purpose of copying the Old Masters. The study and selective imitation of past art had been a cornerstone of artistic theory and training for two hundred years, and this practice was institutionalized at the Louvre and other museums. Art schools were often associated with and built near art museums well into the twentieth century. But over the past century the decline of copying, the accelerated pace of avant-garde movements, and the ambivalent place of contemporary art in many mainstream museums have together reduced the standing of living artists among the museum's publics.[20]

Victorian Ideals

With the spread of museums and their integration into the cultural apparatus of the modern state after 1815, the question of the public became not so much who was granted admission, for in time virtually all were welcome, but how museums could be called upon to shape the public in keeping with perceived political and social needs. In what ways could museum-going benefit the public, and thus the nation as a whole? During the Victorian era and beyond, the museum public was commonly represented as an idealized projection of what patrician politicians and social critics hoped it would become (fig. 89). The rhetoric of aspiration informed official discourse and mission statements and tells us more about what a museum aimed to do for its visitors than what it actually did. Throughout the nineteenth century, utility and progress, instruction and innocent recreation, were the watchwords for all public institutions, including art museums. A "gallery . . . erected at the Nation's expense . . . must of course be rendered as generally useful as possible, every one being admitted capable of deriving from it enjoyment or instruction," according to Gustav Waagen, director of the Berlin Museum.[21]

During the Victorian era, in the context of unprecedented challenges arising from the Industrial Revolution, utility was measured primarily in socioeconomic terms. In Britain especially, owing to its vanguard position in the industrial movement, an explosion of urban populations teetering on the edge of poverty, immorality, and anarchy prompted the need for new social controls, systematic education, and healthy recreation. The desire to control and civilize the masses was all the more pressing as successive political reforms gave voting rights to larger segments of society. Politicians supported the diffusion of museums in the belief that they would contribute to the moral and intellectual refinement of "all classes of the community" and the formation of "common principles of taste," to quote from a parliamentary report of 1853.[22] For Matthew Arnold, writing in 1869, a common culture disseminated through educational institutions should take the place of organized religion as the necessary adhesive for the new society in the making.[23] Arnold believed in the top-down imposition of what we would today call canon-

89. "A Party of Working Men at the National Gallery," *The Graphic*, August 6, 1870.

ical values as the means of elevating the populace to a more enlightened level of exis-
tence. The hero of Walter Besant's novel *All Sorts and Conditions of Men* (1883) took the
belief in the softening effect of culture to the point of caricature when he insisted that
the arts could tame "the reddest of red hot heads": "He shall learn to waltz. . . . This will
convert him from a fierce Republican to a merely enthusiastic Radical. Then he shall
learn to sing in part: this will drop him down into advanced liberalism. And if you can

persuade him to . . . engage in some Art, say painting, he will become, quite naturally, a mere conservative."[24]

London's National Gallery went beyond the museums of Paris and Berlin by actively encouraging visits by the laboring classes. Despite concerns that the smoky chimneys and noxious breath of the poor threatened the nation's pictures, the gallery remained in Trafalgar Square within reach of the "grim city-world of stone and iron, smoky chimneys, and roaring wheels."[25] A survey of area businesses in 1857 revealed that the gallery was indeed popular with local tradesmen and workers. During the previous year, among various firms surveyed, 338 men from Jackson the Builders went to see the pictures 583 times; 46 employees of Hooper the Coach Makers made 66 visits; and Cloughs the Printers reported 117 workers visiting the gallery 220 times.[26] The Working Men's Club and Institute organized tours, and the *Pall Mall Gazette* published a guide aimed at laborers that went through many editions from the 1880s.[27]

For those with firsthand experience of conditions in London's East End, however, Trafalgar Square was too remote to make a difference, and rather than oblige workers to travel to the West End, the founders of the Whitechapel Gallery, the Reverend Samuel Barnett and his wife, Henrietta, brought high art to the poor. Starting in the early 1880s, the Barnetts organized an annual exhibition of paintings, borrowed from artists and collectors, intended to stimulate moral sentiments, patriotism, and a feeling for beauty among the residents of the East End slums and settlement houses. As the vicar of St. Jude's, Whitechapel, Barnett spoke with authority when he said: "[P]ictures in the present day take the place of [biblical] parables."[28] By his reckoning 95 percent of the local population did not attend church; organized religion had lost its moral force where it was most needed.[29] Open every day, including Sundays, for two to three weeks around Easter, the exhibitions proved enormously successful. The first year's exhibition, in 1881, drew ten thousand visitors; a decade later attendance had risen to seventy-three thousand. In 1898, the temporary exhibitions became the basis of a permanent gallery (the present Whitechapel Gallery) erected alongside the public library. For her part, Henrietta Barnett was an important advocate of philanthropy and among the first to suggest that women had a special role to play in outreach efforts in museums and galleries. "Why should the poor spend their hardly earned pence in taking the journey to see treasures the beauty of which they do not half understand, having never been educated to see and appreciate them?" she asked. If women devoted themselves to bringing "beauty home to the lives of the poor," through the loan of pictures or by taking "groups of her poor friends to see galleries or exhibitions," "they would find a field of work but yet little trodden, a wealth of flower-rewards only waiting to be plucked."[30] Well-educated women would soon become the mainstay of education departments and volunteer programs in twentieth-century museums (fig. 90).

90. Apprentice Docents, Newark Museum, 1929–30 (from left to right: Freda House, University of Chicago; Lois Cole, Wheaton College; Helen Jenkins, Mount Holyoke College; Grace Jones, Wheaton; Rosaline Forman, Mount Holyoke; Harriet Seelye, Smith College; Emily Cooley, Wilson College; Caroline Green, Wheaton). Photo courtesy of the Newark Museum.

The South Kensington Museum also had populist goals, as discussed in chapter 1. Its founder, Henry Cole, hoped the museum would stimulate native design and industry while improving the taste of ordinary Britons and providing amusing diversion during hours of leisure. Given the enormous popular success of the Great Exhibition, staged nearby in Hyde Park, a permanent museum displaying household objects and decorative arts had a good chance of being "useful" on numerous levels. Promotion of everyday aesthetics and the conscious rejection of the art connoisseur's priorities contributed to making the South Kensington Museum the most popular museum in Britain. Annual attendance rose from 456,000 in 1857 to over a million in 1870. The combination of free admission, evening hours, and a popular holiday could boost single-day at-

tendance above twenty thousand. Cole envisaged similar museums achieving like success across the land, bringing about a revolution of popular taste among "all classes of people."[31] Just as medieval England once "had its churches far and wide," so modern Britain would have its engines of social reform in the form of museums.[32]

As we might expect, given the capitalist underpinnings and trickle-down aesthetics of the Victorian museum, the ideal public consisted of those most eager to help themselves. Virtually everyone who spoke on the subject agreed with Ruskin when he said that museums, while instructive for the multitude, must not be "encumbered by the idle, or disgraced by the disreputable." He wrote to a correspondent in Leicester: "You must not make your Museum a refuge against the rain or ennui, nor let into perfectly well-furnished, and . . . palatial rooms, the utterly squalid and ill-bred portion of the people. There should indeed be refuges for the poor from rain and cold, and decent rooms accessible to indecent persons . . . but neither of these charities should be part of the function of a Civic Museum."[33] Similarly, Gustav Waagen was in favor of discouraging visits from those "whose dress is so dirty as to create a smell obnoxious to the other visitors" or babes in arms escorted by their wet nurses. In his opinion, both groups were too plentiful at London's National Gallery, obliging him "more than once . . . to leave the building."[34]

Excluding the squalid and ill-bred suited the middle classes, but it also benefited the aspiring laborer, for, as Tony Bennett has argued, the Victorian museum was a "space of emulation" where watching others and being seen was as important as scrutinizing the art. To the extent that museums functioned as arenas "for the self-display of bourgeois-democratic" values, they had to offer an environment in which appropriate civil behavior was encouraged and its opposite forbidden.[35] For Arnold, the purpose of culture was ultimately "to do away with classes; to make all live in an atmosphere of sweetness and light," which in effect entailed the eventual "embourgeoisiement" of society.[36] To achieve societal progress, "all our fellow-men, in the East End of London and elsewhere, we must take along with us in the progress towards perfection,"[37] and this could best be achieved by helping those who most wanted to help themselves. "The best man is he who most tries to perfect himself, and the happiest man is he who most feels that he *is* perfecting himself," said Arnold.[38] As we have seen, for Arnold, the spread of culture would address not only the brute ignorance of working men and women but also the shallow materialism of the expanding middle classes. Material wealth was not an end in itself to be pursued for individual satisfaction but the means to lift all toward an "ideal of human perfection and happiness."[39] The beauty of philanthropy was, and remains, that it allowed those who supported museums to prove their own sophistication while discharging a civic duty by lifting the less fortunate around them upward toward the light.

The goal of museum advocates was to transform art from, as Arnold put it, "an engine of social and class distinction, separating its holder, like a badge or title, from other people who have not got it,"[40] into a source of common inspiration, and to make museum visits a form of recreation for all classes. Henry Cole envisaged evening hours at South Kensington as a great boon to working-class families: "The working man comes to this Museum from his one or two dimly lighted cheerless rooms, in his fustian jacket, with his shirt collars a little trimmed up, accompanied by his threes, and fours, and fives of little fustian jackets, a wife, in her best bonnet, and a baby, of course, under her shawl. The looks of surprise and pleasure of the whole party when they first observe the brilliant lighting inside the Museum show what a new, acceptable, and wholesome excitement this evening entertainment affords to all of them."[41]

Evidence and common sense suggest, however, that the barriers of class were not so easily overcome, that the hard-won politesse of the bourgeoisie was not graciously forsaken in the interests of class harmony. The space of emulation could also be a space of contempt, condescension, and disappointment. Henrietta Barnett, eavesdropping at the Whitechapel in the hope of gleaning evidence of some good rubbing off on her East End flock, tired of people wondering how much the pictures were worth and at times overheard the voice of daily struggle: "*Lesbia,* by Mr. J. Bertrand, explained as 'A Roman Girl musing over the loss of her pet bird,' was commented on by, 'Sorrow for her bird, is it? I was thinking it was drink that was in her'—a grim indication of the opinion of the working classes of their 'betters'; though another remark on the same picture, 'Well, I hope she will never have a worse trouble,' showed a kindlier spirit and perhaps a sadder experience."[42] Following a visit to the same gallery in 1903, Jack London concluded that the poor "will have so much more to forget than if they had never known or yearned."[43] One thinks of Henry Cole's family returning to their "dimly lighted cheerless rooms" after seeing the beautiful things at South Kensington.

In a society dominated by class, in which art and cultural knowledge continued to circulate as elite commodities and museums depended on the rich for support, it was at best highly idealistic to expect art to cease to function as a badge of privilege. Moreover, the bourgeois ideal of elevated aesthetic contemplation, manifested in Hazlitt's account of the Angerstein collection from chapter 1 ("We are transported to another sphere . . . we breathe the empyrean air"), became difficult to achieve when the Angerstein pictures went to Trafalgar Square and the presence of laborers and wet nurses polluted the air with noxious fumes. On those days popular with the broad public, the likes of Hazlitt and Gustav Waagen were inclined to stay at home. For utilitarian reformers like Greenwood, "art should not be approached as something unusual . . . for the aristocratic few, and not for the many,"[44] but for the amateur it was precisely what made art unusual, rarefied, and difficult to grasp that mattered.

The Progressive Era: Museums for a New Century

What could public museums do to demystify art and bridge the gap between the in-formed and the ignorant? The need to overcome barriers to broad participation in museum culture led to two major innovations: first, the systematic rearrangement of collections in the interest of visitor comfort and comprehension, discussed in chapter 3; and, second, the development of museum-based education programs. By the late nineteenth century, the growing clutter of the Victorian museum had come to be seen as an impediment to popular instruction. Swelling collections and increased attendance raised visitor fatigue and diminished the visibility of the most important objects on display. William Stanley Jevons, a staunch supporter of public libraries, had his doubts about the utility of museums because of the failure to make them comprehensible and appealing to the broad public. In particular he lamented the lack of attention paid to presentation and the visitor's physical comfort. At South Kensington, for example, "The general mental state produced by such vast displays is one of perplexity and vagueness, together with some impression of sore feet and aching heads."[45] Jevons led a growing chorus of voices recommending simpler displays, clearer organization, and public education. Recognizing different publics with different needs, Jevons and others called for a distinction to be made between public galleries featuring highlights for general consumption and research collections containing everything else for the use of students and scholars. A Professor Herdman of Liverpool went so far to say: "It should always be remembered that public museums are intended for the use and instruction of the general public . . . and not the scientific man or the student."[46] Not only should the public's attention be focused on masterpieces, but the underlying system of classification should also be made visible. For Greenwood, "[T]he usefulness of a museum does not depend entirely so much on the number or intrinsic value of its treasures as upon proper arrangement, classification, and naming of the various specimens in so clear a way that the uninitiated may grasp quickly the purpose and meaning of each particular specimen."[47]

German museum men reached the same conclusions during the reform movement of the 1880s and 1890s sponsored by Kaiser Friedrich III.[48] Wilhelm von Bode, Alfred Lichtwark, Karl Osthaus, and others helped to redefine the modern museum around notions of simplified displays and public pedagogy. Lichtwark, director of the Hamburg Kunsthalle, was especially active on the latter front, advancing his museum's role as an "institution . . . actively engaged in the artistic education of our community" through programs for children and adults alike.[49] New German thinking about education and museum management and design formed an important resource for museum pioneers in the United States in the decades on either side of 1900, and nowhere more so than in the planning of Boston's new Museum of Fine Arts, opened in 1909.

As we have seen, the shift from the old to the new museum entailed abandoning a utilitarian purpose and collection in favor of high art and aesthetics. It also ushered in a new commitment to public education. "The problem of the present," wrote Benjamin Gilman, the museum's longtime secretary, "is the democratization of museums: how they may help to give all men a share in the life of the imagination."[50] Gilman and his colleagues at the MFA undertook a number of influential initiatives intended to make the museum more effective as a tool of public education. As discussed in chapter 3, secondary objects were relegated to the study collection on the lower floor while the best art was presented to the general public on the main floor in simple, spacious, well-lit galleries, "to help the visitor to see and enjoy each object for its own full value."[51] Gilman's training in the nascent discipline of psychology made visitor response a priority and led to improvements in lighting and hanging, seating and signage, all aimed at reducing what he termed "museum fatigue." Under Gilman's leadership a broad array of education programs came into being. Acknowledging that the ability to appreciate and understand art was "left aside in our educational system," Gilman invented the idea of gallery "docents," whose purpose was to provide "companionship in beholding," or what today we would call art appreciation. The purpose was not to offer a watered-down art history but to call attention to the "vital elements in a work of art, . . . insuring that it is really perceived in detail, and taken in its entirety."[52] The docent program was a great success. In 1916, for example, some thirty trained docents served 4,300 visitors "of both sexes and all classes" without charge. In that same year the museum also welcomed 5,600 schoolchildren and their teachers, as well as a further 2,380 students who came on their own. Teacher training was offered, also free of charge, and museum staff visited every school in Boston and distributed some twenty-five thousand reproductions for classroom use. During the summer 6,800 underprivileged children were bused to the museum from settlement houses, and a further 850 children attended story hour on Saturday afternoons (repeated on Sundays for Jewish children).[53] The effort to cultivate interest among the young was particularly forward looking and influential. "If the children of Boston can learn to enjoy works of art as children," wrote the director, Arthur Fairbanks, "a more wide and real and intelligent enjoyment of art may be expected in another generation than exists today."[54] Sunday opening hours at Boston and other museums, though controversial at first for religious reasons, greatly expanded the public. "The Sunday visitors especially represent the American public at its best," wrote Gilman. "All sorts and conditions of men contribute their quota to the well-behaved, interested, almost reverent throng."[55] In 1918 the MFA abolished admission fees (it had been free hitherto only on certain days) to encourage adult visitors, and attendance soon doubled. In 1924, Gilman's last year at the museum, attendance rose above four hundred thousand, and more than nine thousand people signed up for docent tours. To sup-

91. Instructor Ruth Krupp leading a class at the Toledo Museum of Art, 1936.
Photo courtesy of the Toledo Museum of Art Archives.

plement guided tours, Gilman wrote a jargon-free handbook of the collection, copies of which were available for consultation in the galleries and for purchase at the front door. During the same years, a similarly impressive record of educational programming and docentry was achieved at the Metropolitan Museum in New York under Henry Watson Kent and at Newark under Dana.[56]

Gilman and Kent's reforms in education and classification provided a blueprint for art museums from the 1920s; by the Second World War scarcely a museum could be found that had not culled its collections, adopted simplified display techniques, and embraced public participation as an ideal. In the United States, especially, education programs of the sort pioneered in Boston and New York became commonplace. In 1936, for example, the Toledo Art Museum in Ohio published a report that represents a high-water mark for prewar efforts to make a local art museum central to an urban community (fig. 91). The report opened with a straightforward statement of mission: "The Toledo Museum purpose is to lead people to like art, to apply its principles to their daily living,

and to discriminate between good and bad pictures, sculpture and music. It aims primarily to help them to enjoy looking at art and listening to music, and teaches them how to go about it to receive their fullest reward."[57] Backing the rhetoric was an astonishing range of educational activities that reached all ages and walks of life. Beyond the usual "talks, tours, illustrated lectures, forums on current exhibitions and talks which relate art to the subject matter of the elementary and secondary schools," the museum offered practical instruction in music and art for children and teens from the age of five (in art alone "students fill twenty-one classes of the Museum school each Saturday and delight in their thirty-eight weeks course in color, design, water color, drawing and modeling"); classes for women in clothing and home furnishing; classes for department store buyers, managers, and salespeople; classes for designers from local industries; general classes in color and design for dressmakers, florists, contractors, architects, and furniture dealers; evening music classes for adults; and frequently scheduled concerts and "educational movies."

At the same time, however, the interwar years witnessed a sharp increase in the professionalization of museum staff, which had the effect of separating curatorial responsibilities for acquiring and arranging works of art from the work of public interpretation. While educators and docents worked with an expanding range of visitors, newly minted curators, trained at universities as art historians, turned inward on their collections. Though committed to a broadly democratic mission, museums in the United States were equally determined to catch up to their European counterparts in terms of their holdings, making it imperative that "the curatorial staffs . . . be recruited with . . . reference to scholarly competence and training," in the words of Charles Rufus Morey, chairman of Princeton's art history department.[58] Paul Sachs, whose Museum Course at Harvard trained many prominent curators and directors between the wars, argued vigorously that a museum's integrity depended on maintaining the highest scholarly standards. Taking a swipe at populist programming, he told the dignitaries assembled for the opening of MoMA in 1939:

> Let us be ever watchful to resist pressure to vulgarize and cheapen our work through the mistaken idea that in such fashion a broad public may be reached effectively. In the end a lowering of standards must lead to mediocrity and indeed to the disintegration of the splendid ideals that have inspired you and the founders. . . . The Museum of Modern Art has a duty to the great public. But in serving an elite it will reach . . . the great general public by means of work done to meet the most exacting standards of an elite.[59]

Needless to say, meeting the "most exacting standards of the elite" inevitably meant that the narrow cut of collectors, scholars, critics, and fellow museum professionals, not the general public, constituted the curator's primary audience. "The museum of the future,"

concluded Sachs, "should be a comprehensive and enduring community of scholars" pursuing the functions of "study, teaching and research."[60] Instead of museums reaching down to an uninformed public, Sachs implied that the public should rise up to the standards of those in the know. Dana, for one, had warned that curators, "once enamored of rarity," were at apt to "become lost in their specialties and forget their museum . . . its purpose . . . [and] their public."[61] And according to Theodore Low, a pupil of Sachs who took an unusual turn (for a man) into museum education, that is precisely what happened. Writing in 1942, Low lamented the failure of American art museums to live up to the democratic promise of their founding charters and laid much of the blame on the seductive "charms of collecting and scholarship."[62] The mutual interest of benefactors and directors (drawn from the ranks of curators) in collection building on the European model had reduced education to a "moral quarantine" within the museum, "a necessary but isolated evil."[63] "As a result museum men have drifted further and further away from the public."[64] Twenty years later the situation had not changed, according to the director of Washington's Smithsonian, who noted that curators regarded "teaching and explanation" as a "descent from the sacred to the profane."[65]

At the root of the problem, Low felt, was the narrow focus on connoisseurship in graduate art history programs, including Sachs's Museum Course, in which "the approach to the public" had been ignored in favor of "the training of connoisseurs for curatorial work."[66] No doubt because conventional doctoral programs, like Princeton's, viewed (and still view) vocational training with contempt, Sachs was careful to emphasize his unequivocal commitment to museum scholarship.[67] It is telling that neither Gilman nor Dana figured prominently in the Museum Course bibliography despite their standing in the field. In 1945, Francis Henry Taylor, then director of the Met, echoed Low by arguing that Americans, "of all the peoples of history, have had a better, more natural, and less prejudiced opportunity to make the museum mean something to the general public," yet had failed.

> We have placed art . . . both literally and figuratively, on pedestals beyond the reach of the man in the street. . . . He may . . . visit the museum on occasion, but he certainly takes from it little or nothing of what it might potentially offer him. This is nobody's fault but our own. Instead of trying to interpret our collections, we have deliberately highhatted him and called it scholarship. . . . There must be less emphasis upon attribution to a given hand and greater emphasis upon what an individual work of art can mean in relation to the time and place of its creation. . . . There must also be a more generous attitude on the part of the scholar toward the public.[68]

What Taylor and Low were speaking to was the proper balance between the goals of collecting and interpretation, an equilibrium difficult to achieve owing to the imbalanced power structure within the museum: on one side curators and directors emulating a

92. Sixty-ninth Street Branch Museum, Philadelphia, 1931.

European model and academic standards, and on the other educators mindful of a broad public hungry for knowledge. Low meant it as a compliment when he said of Dana: "He was an American rather than a pseudo-European . . . and thought in broad terms of the American social scene."[69]

To be sure, the 1930s witnessed an extraordinary expansion of educational activity and outreach in U.S. museums, motivated in good part by social pressures arising from the Great Depression. Writing in 1932, Paul Rea, author of *The Museum and the Community,* an influential study sponsored by the Carnegie Corporation, argued that museums should offer more in the way of public service in exchange for the tax support they received. One man who took Rea's study to heart was Philip Youtz, who directed the short-lived, Carnegie-funded Sixty-ninth Street Branch of the Philadelphia Museum of Art (fig. 92), one of a number of branch museums created in the 1920s and 1930s in imitation of branch libraries (pioneered by Dana in his first career as a librarian) to spread art to the masses. Like Dana, Youtz believed that museums had much to learn from department stores and commercial venues in their effort to reach the community, and he located his branch museum in a storefront across the street from a supermar-

ket and a five-and-dime. Objects displayed attractively in street-level windows lured passersby, and the museum remained open daily until 10:00 P.M. Whereas most museums arranged their collections "according to the tastes and interests of the staff and trustees" and the public encountered only the guards, at the Sixty-ninth Street museum the interests of "the public at large" were borne in mind and the staff "maintained intimate contact with the public it serves." "It is high time that museums of all kinds became more definitely oriented toward the public," Youtz declared. "The aloof policy inherited from old private collections must be abandoned and museums must accept the leadership in public education."[70] When he took over at the Brooklyn Museum in 1934, Youtz sought to infuse the stately Beaux Arts temple with the populism of a branch museum, stating at the outset, "[T]he public is the starting point, not the collections."[71] Following Rea, Youtz believed museums had an obligation to serve the public, especially in difficult times like the Depression. "The detachment and calm which is experienced by a visitor to a museum helps to maintain public morale in the face of severe social tension," he wrote. "Museums offer a necessary and essential form of recreation to an over-burdened and distraught citizenry."[72]

While branch museums were short-lived owing to a lack of consistent funding, mainstream art museums on both sides of the Atlantic explored ways of making their collections seem more relevant to their audiences. For a brief moment before the war, numerous Western museums experimented with programs that promoted cultural history in ways that seem surprising today. In his survey of educational trends, Theodore Low quoted prominent museum men such as Victor d'Amico, head of education at MoMA, who held that "art is an expression of a culture and society" and that "to isolate a work of art from its background and set it up alone in a glass case is to deprive it of the fullness which gives the work significance and beauty."[73] As early as 1930, Philip Youtz stated: "Art is meaningless without its social setting. . . . To try to study art apart from sociology, economics, social history, and anthropology, is as ridiculous as it would be to investigate coral without considering the life cycle of the zoophytes which produce it."[74] A few years later he described the tendency to segregate art from life as the gravest symptom of "museumitis," a disease that could be cured only by "a new kind of art education that shall stress the vital social connection of art." "Appreciation courses have failed," he said, because they neglected "the rich fabric" of a culture and made an "idol" of art.[75]

Yet Youtz and Low, Taylor and d'Amico understood that their efforts to promote social art history ran counter to the rising tide of "aesthetic idolatry." Everywhere one turned, Newark and Brooklyn aside, one found Gilman's "appreciative acquaintance" alive and well. Even museums commended by Low for their educational initiatives, such as the Toledo Museum, happily admitted that "their primary interest is in the development of

public appreciation of art."[76] Under the leadership of Sachs's disciple Alfred Barr, MoMA established new curatorial standards with respect to the quality of acquisitions and shows, installations, and scholarship. Consistent with the clean, new, autonomous interiors of the museum, yet evidently at odds with the philosophy of his education staff, the exhibitions organized by Barr in the 1930s and the exemplary catalogs he wrote to accompany them were emphatically visual in nature; installation and text combined to encourage familiarity with the "formal" properties of modern art and the stylistic influences linking one artist and school to another. Barr tended to neglect the social import of avant-garde movements like the Bauhaus, Dada, and De Stijl. In the mid-1930s Meyer Schapiro criticized Barr for his neglect of the social and political contexts for modern art, but Barr was indifferent to such concerns, and his example proved enormously influential for later museums.[77]

On one important subject—the display of art—curators and educators could agree. The introduction of single-row hangs, controlled electric lighting, and the elimination of architectural distraction all favored the easy visual consumption of select masterpieces. Pioneering studies of visitor behavior conducted in the late 1920s and 1930s by the Yale psychologists Edward Robinson and Arthur Melton had demonstrated empirically that the dense arrangements prevalent in older museums increased fatigue and loss of attention (fig. 74). But in the process of streamlining gallery installations, interpretation in the form of gallery texts and docent tours came under review as a potential distraction in itself. As we have seen, the ethos of the modernist museum dictated that masterpieces speak for themselves, rendering suspect efforts to speak on their behalf. Even Benjamin Gilman was ambivalent about wall labels and guided tours. Gilman created his docent program because he understood that many people needed instruction to help them appreciate what they saw, yet he also worried that the "the use of galleries for *vive voce* instruction may become a disturbance of the public peace for him who would give ear to the silent voices therein."[78] Similarly, though he made heavy use of written gallery aids he looked forward to the day when they would no longer be necessary. Indeed, when the new Boston museum was under construction Gilman experimented with a mock-up gallery without labels: "The impression was that of ideal conditions, surely to be realized in the museum of the future." Without labels the works of art "were able to create about themselves a little world of their own, most conducive to their understanding."[79] Gilman's successors shared his misgivings, much to the frustration of populist critics. In his 1935 study, Arthur Melton criticized the minimalist labeling practices of art museums for conflating "the typical visitor" with "those individuals who manage museums" and omitting "essential information which is assumed to be the knowledge of everyone."[80] The left-leaning museum critic T. R. Adam bemoaned the "mystification in this

belief in the power of great paintings to communicate abstract ideas of beauty to the uninformed spectator."[81] After the war an official report on participation in the arts in Britain urged art museums to better serve their visitors. "The majority of their visitors do not know how to look at works of art and all too many walk around an exhibition and out again without having stopped to consider any one of the individual works. . . . Well-printed labels and catalogues giving adequate information will help to arrest their attention."[82]

But museum professionals held their ground. In 1945, Kenneth Clark, director of London's National Gallery, insisted that with works of art "the important thing is our direct response to them. We do not value pictures as documents. We do not want to know *about* them; we want to know *them,* and explanations may too often interfere with our direct responses."[83] A few years later, the Fogg Museum's director, John Coolidge, insisted: "The primary way to explain a work of art is to exhibit it." "Let us isolate the object," he urged, "let us be sure that it is at all times lit to the greatest advantage, and let us so arrange the gallery that the visitor can sit comfortably in front of it and lose himself in communion with the work of art."[84] Despite recent efforts to make museums more user-friendly and the introduction of audio guides and multimedia support in a select few galleries (notably African), attitudes to interpretation remain generally conservative. Note, for example, how relevant the following statement issued by the Cleveland Museum of Art in 1971 still is today: "The Museum's permanent galleries . . . are designed as quiet areas where the individual visitor can see and respond to the individual work of art. This personal encounter between the viewer and the object is the deep and particular satisfaction a museum offers. Explanatory gallery labels usually keep their text to a minimum to avoid intruding between the visitor and the work of art."[85]

Education programs took root in art museums everywhere in the middle decades of the century, yet residual attitudes among directors and curators suggest that Low's description of their "moral quarantine" was scarcely an exaggeration. In the eyes of some, the public itself became a nuisance to be tolerated but not indulged. Take the case of Eric Maclagen, director of the Victoria and Albert Museum in the 1930s. When asked if his museum had become "a mere museum for connoisseurs and collectors," he agreed it was a fair description "but for the insertion of the word 'mere.'"[86] A few years later he had this to say to a gathering of fellow museum professionals: "If we were to be entirely candid as to the view taken by museum officials with regard to the public I fear we should be bound to admit that there are occasions when we have felt that what is wanted might be described in the language of the cross-word puzzle, as a noun of three letters beginning with A and ending with S. We humour them when they suggest absurd reforms, we placate them with small material comforts, but we heave sighs of relief when they go away and leave us to our jobs."[87] And lest we dismiss such talk as after-

dinner humor from an aloof British aristocrat, we find much the same relief expressed by John Walker, director of Washington's publicly funded National Gallery, as he anticipated the departure of the day's last visitors:

> When the doors are closed a metamorphosis occurs, and the director or curator is transformed into a prince strolling alone through his own palace with an occasional bowing watchman accompanied by his dog the only obsequious courtier. The high vaulted ceilings, shadowy corridors, soaring columns, seemed to have been designed solely for his pleasure, and all the paintings and sculpture, those great achievements of human genius, to exist for no one else. Then, undisturbed by visitors, he experiences from time to time marvelous instants of rapt contemplation when spectator and work of art are in absolute communion. Can life offer any greater pleasure than these moments of complete absorption in beauty?[88]

If characteristic images of the Victorian museum show healthy crowds (fig. 11) seeking wholesome recreation, the twentieth-century curatorial ideal in the form of the "installation shot" (fig. 41) rids the gallery of visitors altogether, leaving the disembodied eye to roam freely without distraction.[89] Curators and art critics customarily enjoy the privilege of seeing and reviewing new exhibitions and installations without the throngs who make those events so challenging for the average museum-goer.

Given that social history had found a natural home in the art museums of the Soviet Union and was preferred in the West by labor unions and leftist educators, is it any wonder that it had so little purchase with mainstream museum donors, trustees, and curators?[90] And what support it had was washed away in the wake of World War II and the rise of the cold war, an era that sealed the ascendance of a universal conception of art in landmark exhibitions such as MoMA's Timeless Aspects of Modern Art (1948–49) and The Family of Man (1955). Where art had been reduced to propaganda under fascist and communist regimes, in the West it became the embodiment of individual freedom, and this freedom extended to the public to enjoy a museum's contents without interpretation, at least of a social nature. In art history graduate programs social art history experienced the same eclipse. At Harvard Paul Sachs's famed Museum Course was taken over by Jakob Rosenberg, who steered the program, and future curators, still further toward connoisseurship.

Though perhaps not intended, the triumph of silent contemplation in the art museum reversed the social activism of the 1920s and 1930s and lessened the appeal of museums for the uninitiated. In Britain, the 1946 report cited above found that museum attendance had dropped 25 percent in the previous twenty years and concluded: "[T]he numbers might be very much greater if the directors and their staffs were as interested in attracting and educating the public at large as they are in the specialist needs

of students and connoisseurs."[91] One wonders if the same causes were behind a similar decline registered at the Metropolitan Museum over the same period, notwithstanding extensive educational programming. Theodore Low's 1948 report on the state of the field noted that the Met's visitors came disproportionately from the "upper circles" and that educational services at all art museums tended to be monopolized by the "upper layer of cultured residents," hampering the efforts of educators to expand the public.[92]

Postmodernism: The End of Innocence?

It is a mark of how completely social activism had disappeared from museum discourse that its return in the 1960s in the context of broad social upheaval and looming financial crisis seemed radical and without precedent. Or perhaps it would be more accurate to say that while many education programs carried on as they had for decades and directors and trustees continued to believe they were serving their institutions and communities, the world beyond the museum had changed dramatically and many museums, especially those in urban settings, awoke to find themselves out of touch with social developments.

Social activism and protest directed at art museums on both sides of the Atlantic concerned public access, who went to museums and who did not, and why. In what ways could museums become more socially inclusive and responsive to the needs of the public? In 1966 the French sociologist Pierre Bourdieu teamed with statistician Alain Darbel to write *The Love of Art,* a comprehensive analysis of participation in museum culture in France. Armed with carefully compiled empirical data, Bourdieu and Darbel argued (as others had done before) that the art museum public consisted overwhelmingly of the "cultivated classes." In their broad demographic survey, 75 percent of visitors could be identified as belonging to the upper classes, against just 4 percent from the working classes. Bourdieu explained this social imbalance in terms of "habitus"—superior access to the codes of art appreciation and rituals of museum-going available to the upper classes through education and upbringing. Schooling had the potential to level the field—indeed, Bourdieu argued, it is the "specific function of the school . . . to develop or create the dispositions which make for the cultivated individual"—but if and when schools fell short, that left "cultural transmission to the family," perpetuating "existing inequalities."[93] "There is nothing better placed to give the feeling of familiarity with works of art than early museum visits undertaken as an integral part of the familiar rhythms of family life," he wrote.[94] According to Bourdieu, museums helped maintain the status quo by assuming knowledge in visitors and failing to help the uninitiated make proper sense of what they saw; in so doing, they betrayed "their true function, which is to reinforce for some the feeling of belonging and for others the feeling of exclusion."[95]

Bourdieu's critique inspired protests against museums during and after the Paris up-risings of 1968 and laid the ground for the opening of the populist Pompidou Center in 1977 (fig. 46).[96] Across the Atlantic social ferment fueled similar protests at the major New York museums. As mentioned in chapter 1, various groups—including the Art Workers' Coalition, Women Artists in Revolution, the Black Emergency Cultural Coalition, and the Guerrilla Girls—called for greater representation of women and African Americans at all levels of museum life. In 1970 protesters crashed the annual meeting of the American Association of Museums to demand greater "democratization" of museums as well as an end to the Vietnam War and persecution of the militant Black Panthers. After heated debate, the conference concluded that museums, as collections of objects, "are not those organizations best suited to cope with the social and political concerns of the moment" but that at the same time "neither are [they], surely, doing everything they might to bring to bear their own special resources on what now shakes the peace of mind of their visitors."[97] To which Nancy Hanks, chair of the National Endowment for the Arts, responded: "I do not think we can any longer spend time discussing the role of the museum as a repository of treasures versus its public role. It simply has to be both."[98]

Bourdieu's critique of museums focused on making the high art of mainstream museums more accessible to a broader audience, but a second approach revived prewar ideas about validating popular culture and creating local museums responding to specific community needs. In France, "Ecomuseums" showcased regional popular culture across the country.[99] In the United States, the Anacostia Museum opened in 1967 in a depressed area of Washington, D.C., under the aegis of the Smithsonian Institution, reviving the prewar concept of the branch museum. Led by John Kinard, Anacostia was run by members of the local community and focused on "social issues affecting its constituents and neighbors"[100] but also on "Afro-American history and culture."[101] Kinard intended the museum to be a showcase for the "unique and creative . . . contributions of the black man to America."[102] The museum was conceived by the director of the Smithsonian Institution, S. Dillon Ripley, who wanted to extend the museum's benefits to "all our people, those . . . who most deserve to have the fun of seeing, of being in a museum," especially in light of the crisis that gripped many U.S. cities, including Washington.[103] Though Ripley was himself thoroughly at home in the corridors of high culture (he felt no "generation gap" separating him from the great masterpieces of the past, for example), he understood that mainstream art museums, because of their continued dependence on the "dominant forces in the community, the civic boosters and the wealthy," had neglected various constituencies, including artists and art historians, but above all "the poor people, products of a self-perpetuating disease found in our cities." He continued: "Such people were neither objects of pride to our civic boosters nor par-

preface
anatomy
of anger

John Kinard (center), director of
Anacostia Neighborhood Museum
in Washington, D. C., and seminar
panelist.

93. John Kinard at the Seminar on Neighborhood Museums, Brooklyn,
New York, 1969. From Emily Dennis Harvey and Bernard Friedberg,
A Museum for the People (New York: Arno Press, 1971).

ticular objects of concern to our aggressive middle class who had responded to the urge
to better themselves. If the art museum had become a symbol only to the community
leaders and those conditioned to the concept of getting ahead, who realized that art was
a subject of elitist veneration and that culture should be subscribed to and taken in doses
like vitamin pills, then of course it had failed."[104]

The success of Anacostia gave rise to a remarkable Seminar on Neighborhood Mu-
seums held in Brooklyn in 1969 (fig. 93) at which the frustrations of marginalized
urban minorities came to a head. A succession of speakers, including Kinard, denounced
the failure of mainstream museums to understand or grapple with the needs and in-
terests of local communities. Also present was Allon Schoener, director of the visual
arts program of the New York State Council on the Arts and organizer of the Met's Harlem
on My Mind exhibition. Challenging the social relevance of mainstream art museums,
Schoener used Cleveland, whose director, Sherman Lee, had been the most vocal critic
of the Harlem exhibition, as his example:

> I think there is another measure (other than fine collections) which has to be applied to institutions like the Cleveland Museum of Art—and that is, how does this museum relate to the community? The Cleveland Museum sits on an idyllic island with only one entrance. It's surrounded on three sides by one of the worst black areas in the United States. Within the last few years, the Cleveland Museum has obtained a bequest of $20 million, and the $20 million is going to be used to build a new building, buy more collections—and it isn't really doing anything in relationship to the community that is right at its doors. How can major cultural institutions in our society today be so oblivious?[105]

Representatives from major museums were largely absent from the event, and those who came offered little in the way of defense. Among the conclusions summarized by one of the organizers, Emily Dennis Harvey, were the need to reexamine "fundamental questions about art and culture, about their function in a community, what a museum is and what its function should be" and the "realization of the extreme difficulty of communication between members of the museum establishment and representatives of militant minority groups."[106] The museum establishment had little interest in changing the fundamental nature of the art museum, or in addressing the social issues that surrounded them. In response to Thomas Hoving and calls for social relevance, most mainstream directors reiterated a commitment to their collections and left it to the educators to cope with the growing audiences asking to be heard. As early as 1961, the Guggenheim's first director and former MoMA curator, James Johnson Sweeney, railed against the rise of education programs and hoped his colleagues had "the courage to face the fact that the highest experiences of art are only for the elite who have 'earned in order to possess.'"[107] Some years later in the wake of the Harlem brouhaha, John Walker, safely ensconced across the Potomac from Anacostia at the National Gallery, bemoaned the pursuit of "relevance" and hoped the future would return museums to "their original mission, which once was to assemble and exhibit masterpieces."[108] Though by hosting the *Mona Lisa* at the National Gallery in 1963 he was responsible for one of the most popular exhibitions of all time, Walker was baffled by the crowds and continued to believe his primary responsibility was to his collection and the small minority who really understood it: "I was, and still am, an elitist, knowing full well that this is now an unfashionable attitude. It was my hope that through education, which I greatly promoted when I became a museum director myself, I might increase the minority I served; but I constantly preached an understanding and a respect for quality in works of art. . . . The success or failure of a museum is not to be measured by attendance but by the beauty of its collections and the harmony of their display."[109] In response to the misguided populists, Sherman Lee in Cleveland also took issue with the idea of the museum as instrument of mass education or social action. "Merely by existing—preserving and exhibiting works of art," he wrote, "it is educational in the broadest and best sense,

though it never utters a sound or prints a word."[110] He supported education programs so long as they respected the silence and integrity of the visual experience of great art, and consequently he also rejected the hoopla of blockbuster exhibitions, fund-raising cocktail parties, and audio tours, suggesting that such activities, if necessary at all, should be held at a separate site, like a branch museum.[111]

The 1970s witnessed a deepening divide between director-curators and educators in art museums. A 1984 report *Museums for a New Century* noted that an unparalleled movement in the direction of "democratization," access, and involvement "in our nation's social and cultural life" over the previous fifteen years had done nothing to close the gap between education and curatorial departments or lessen the tendency to keep audiences in the dark about choices affecting exhibition programming and the collection.[112] However, external forces were already working to foster closer collaboration between the two and to raise the profile of "visitor services." Even as Allon Schoener bemoaned the lack of community involvement at mainstream art museums, he correctly predicted that change for the better would come from funding sources. "The problem museums are facing today, I think, is one of changing patronage," a shift from reliance on "a few billionaires" to businesses and government agencies that, as a condition of funding, would ask probing questions: "Who is being served by the money that is being spent? How many people are going to experience something as a result of this? Where is the money going to be used?"[113] Schoener recognized that museums were entering a new age of accountability, in which visitors would begin to matter as much as the permanent collection.

Pressure to know who visited art museums and who did not, and why, prompted a surge in audience research and evaluation that continues to this day. The museum literature is now rich in "easy-to-understand" guides to "designing and conducting your own visitor survey from start to finish"; helping "museum staff understand their clientele and their interactions with them"; "assessing the impact of exhibitions"; investigating "how people learn, their understandings, attitudes, and beliefs"; and so on.[114] Audience surveys have become a staple of all museums, but especially those dependent on visitor revenue or public or foundation grants that come with social desiderata. Perhaps the strongest—or at least most public—example of conditional funding comes from the United Kingdom, where under the Labour government of Tony Blair national museums were asked to undertake serious diversity reviews as a condition of continued state support. Major museums were even given minority visitation targets (British Museum, 11 percent of total admissions; Tate Gallery, 6 percent, etc.).[115] Though such targets are somewhat arbitrary and impractical (how are minorities to be counted?), the point behind them has been taken to heart by museums in Britain.[116] Similar expectations now accompany many grants-in-aid from private and public funding agencies elsewhere.

In addition to external pressure to monitor and diversify audiences, internal pressure to generate more revenue has equally motivated private museums to find out more about who goes to art museums and who does not. Surveys help to develop larger and more loyal audiences, which mean more income. Where revenue is the driving force behind visitor evaluation, the size of the audience matters more than its color or ethnic diversity. Knowing your audience means knowing what it likes and is willing to pay for in the way of programs and ancillary services. The line between visitor surveys and marketing blurs.

It was recognized long ago that temporary exhibitions were a most effective audience enhancement tool, but from the 1970s the blockbuster became a way of life at museums in search of more visitors and money.[117] The overlap of exhibition programming, audience enhancement, and revenue growth may be clearly seen at Boston's MFA in the late 1970s, when the need to impose admission charges (for the first time since Gilman's day) to offset mounting operating costs resulted in significant declines in attendance and prompted a sudden need to program special exhibitions the public was willing to pay for. Visitors responded in record numbers, and the MFA, like many other museums, has been dependent ever since on a steady diet of special shows to keep people coming. To house the exhibitions and ancillary services, museums embarked on extensive physical expansion. I. M. Pei's West Wing at Boston, opened in 1981 (fig. 48), houses functions—special exhibition spaces, multiple restaurants, a cloakroom, bathrooms, a bank machine, an ever-expanding shop, and an information desk—whose aim is to entice visitors and keep them entertained. Should we be surprised that the West Wing also houses the education department and school reception area? Where once architecture was criticized as a barrier to public use, new buildings have become crucial attractions in themselves. Pei's Boston wing was hailed as a "temple of cultural democracy" when it opened, and during the 1980s his high-profile additions to the National Gallery in Washington (East Wing) and the Louvre in Paris (fig. 47) helped to redefine the art museum as a multipurpose leisure destination and to greatly increase attendance.[118] More recently, Calatrava's Quadracci Pavilion (fig. 52) has similarly transformed Milwaukee's old art museum. The new wing does nothing to enhance the permanent collection, but it provides much-needed space for blockbusters, commerce, school and group visits, and so on, in addition to an exciting new destination for locals and tourists alike.

At the end of the 1960s, the anthropologist Margaret Mead recommended that museums invest in shops, restaurants, and other amenities in an effort to combat their "snobby" profile and "welcome those people unaccustomed to the way of seeing and being of museums."[119] The advent of new programs and amenities has certainly increased visitation numerically, but it is less clear that audiences have expanded in ways

Mead and others wished. As visitor numbers began to rise early in the 1960s, Rudolph Morris wondered whether larger attendance would also mean "a breakthrough to social classes formerly not affected by the existence of art museums." He predicted that further increases were likely to be among "individuals of higher socio-economic status and better educational background."[120] According to Alan Wallach, Morris was largely correct: recent gains in audience size at art museums are the product of a swelling population of the educated and affluent whose appetite for art has been whetted by expanding university curricula and television (Kenneth Clark, Sister Wendy, etc.).[121] In other words, as the educated population increases, so does the public for art museums; but museums still have difficulty reaching the underprivileged. The poor and marginalized people interviewed by Robert Coles many years ago who knew instinctively that art museums were "for other people, not for us" would have little reason to think differently today.[122]

It could be argued, furthermore, that the pursuit of revenue generated by entrance and exhibition fees directly conflicts with the goal of social inclusion. Rising ticket prices obviously limit attendance on strictly economic grounds. Museums counter that admission charges are a good value compared to other types of recreation—theater, rock concerts, sporting events, and so on—but there can be little doubt that higher gate fees hinder novice participation and reinforce elitist perceptions among the less well-to-do. Rising ticket prices make membership more attractive, guaranteeing predictable revenue streams and encouraging allegiance among those who join, but what is the demographic profile of typical art museum members? Private museums also point out that without public funding they have no choice but to charge for admission. And even some venerable state-funded museums, including those symbols of French egalitarianism, the Louvre and Pompidou, now charge for admission. It turns out, however, that museums earn only a fraction of their revenue from admissions—roughly 5 percent on average, according to the Association of Art Museum Directors (at the Met and MoMA, two of the most expensive museums in the world, the percentages are higher, 12 percent and 15 percent, respectively).[123] And while some institutions raise prices, others have made lowering, or eliminating, admission costs a priority and have sought funding for that purpose. The Cincinnati Art Museum went free in 2003 and reported a 25 percent increase in attendance in the first year.[124] With help from the city, the Baltimore Museum of Art eliminated charges in 2006, bolstered by evidence that nonwhite visitors nearly tripled during the museum's free hours.[125] How far would the $50 million it cost the Met to buy its new Duccio go toward making the museum free for all?

Increased reliance on exhibition revenue affects audience diversity in another way. To make money, museums and their corporate sponsors need exhibitions that will "sell,"

that appeal to broad tastes. Hence the steady diet of impressionism, mummies, and anything with "gold" in the title. Divergence from the tried and true has tended to be in the direction of crossover pop culture themes, such as "Star Wars," Ralph Lauren's vintage cars, or Armani fashion, that have built-in celebrity name recognition working in their favor.

The search for new audiences has led some museums not only to tackle novel exhibition subjects but to venture into terrain that until recently would have been thought deeply inhospitable to art. Arrangements between the Guggenheim (fig. 94) and Boston MFA and resort-casinos in Las Vegas stand out. For Krens the move was a natural extension of the entrepreneurial spirit that has guided his tenure at the Guggenheim (see chapter 5). Justifying his new Guggenheim in the land of casinos, he said, "[Y]ou go where the heathens are," and his partner in that enterprise from the Hermitage Museum in Russia added, "[W]e work for the masses, and art belongs to the masses."[126] Marxist rhetoric in the capital of decadent capitalism jars at first, but Las Vegas is one of the fastest-growing North American cities and a major international tourist destination; why shouldn't high art be part of its cultural landscape? Precisely, argued MFA director Malcolm Rogers as he entered into a lucrative partnership with the Bellagio resort. In defense of his much-criticized "loan" of impressionist paintings to Bellagio's Fine Arts Gallery, Rogers remarked: "Las Vegas is America's fastest growing city, and, on a recent visit there, I was delighted to hear that a TV weather-forecaster broke into his broadcast to ask 'Who are these art snobs who say we can't have Monet in our town?' Increased accessibility does not preclude excellence; rather it is fundamental that museums . . . present a vision of excellence to the broadest possible public."[127] Is this genuine populism in the tradition of Dana and Youtz or rhetoric masking an opportunistic pursuit of the dollar, or both? Boosters argue that populist themes and venues expand the public for art and encourage future visitation (an adult version of the school trip rationale: get them in once and maybe they'll come back), but do newcomers become museum regulars or venture from special exhibitions into the permanent collection? What do visitors to the Bellagio gallery or the Guggenheim/Hermitage Las Vegas make of the experience? Is it their first visit to a museum? If not, do they find anything odd about a display of high art in a casino? The same questions could be asked of people lured into museums to see exhibitions with clear multicultural content, such as *Black Male* at the Whitney (1995) or the series on slavery at the New York Historical Society (2005–7).

Whatever the motivation, the turn to populist or multicultural programming at selected institutions has fueled a predictable backlash from the art establishment. Responding to the threat of mass/marginal culture and commercialism to the very definition of the art museum, critics and museum professionals have re-endorsed the

94. Guggenheim/Hermitage Las Vegas, Venetian Casino and Resort, Las Vegas, 2005.

centrality of traditional values—aesthetic contemplation, object-based scholarship, and cultivation of the permanent collection. The centrist alliance has been led by Thomas Hoving's successor at the Met, Philippe de Montebello, and James Cuno, director of the Art Institute of Chicago. Through the din of cash registers, cafés, and blockbusters, they have called for a return to core ideals. "I know it sounds old-fashioned," Cuno wrote, "but I believe that an art museum's fundamental purpose is to collect, preserve, and exhibit works of art as a vital part of our nation's cultural patrimony."[128] In Britain an op-ed piece in the *Times* insisted that the purpose of museums today, "just as 250 years ago, [is] the preservation, collection, display and study of precious objects. If they also bolster their visitors' education, self-esteem, or sense of community, all to the good, but these are merely side-effects, not a museum's *raison d'être*."[129] All three would agree that a museum's work is by definition "elitist," though no more so than the pursuit of scholarship in a university or excellence in schools and anything else we judge in terms of quality. The crime is to pretend that quality doesn't matter and to act as if audience size counts for more than what people experience. The traditionalists' ideal, presumably, is to increase the number of people interested in and able to partake of the museum's traditional virtues.

The problem for traditionalists is twofold. First, the status quo in art museums has arguably shifted to the point that a majority of museum-goers today not only accept but expect amenities and special exhibitions and would not welcome their removal. Adam Gopnik and Jed Perl have lately lamented the demise of serious museum-goers for whom the permanent collection and a scholarly catalog are reason enough to visit; they still exist, of course (and I count myself among them), but not in sufficient numbers to keep many institutions afloat.[130] Visitor surveys are better at counting heads than at determining what visitors get from their visit, but it is clear that, for most, a museum visit involves more than looking at art. (At the same time, of course, people are not paying high admission fees just to have a cup of coffee.)

Second, if we grant that meaningful aesthetic engagement with art objects is the museum's chief raison d'être, how to enlarge the circle of those able to enjoy it? As Cuno put it in a published lecture not long ago: "How can we get our visitors to slow down and look closely at individual works of art; how can we direct their curiosity to the most subtle and profound aspects of works of art without 'explaining' those works of art, without reducing their ambiguities and complexities to sound-bite explanations?"[131] How, he might just as well have said, can museums help the general visitor see as the trained curator or art historian sees? When Cuno elsewhere in his talk gave examples of the kind of sustained engagement with art he wants everyone to have, he revealed the challenges museums face in trying to go beyond "sound-bite explanations" for the uninitiated. He

offered up for consideration a pair of delicate Bernini terra-cotta angels at Harvard's Fogg Museum that would leave most museum-goers cold without the aid of coaching from an enthusiastic cicerone. Cuno points to the effect of "wind rippling through their hair and drapery," encouraging us to see in them not earthbound clay figurines but "heavenly beings with wings [that] hover in the magical wind of Transubstantiation that emanates from the altar on which the Eucharistic elements of bread and wine are converted into the body and blood of Christ."[132] The artist's own miraculous powers of transubstantiation come into view when we are told these clay works are but preparatory models for much larger bronze figures, which are themselves part of a complex altar ensemble at St. Peter's in Rome. We are further told that museum-based study of these delicate objects delivers insights into the magic of artistic creativity condensed in the faint traces of tool marks, fingerprints, and additive modeling on the surface of the clay. In the museum itself, plexiglass cases limit our relationship with the sculptures, but Cuno shares important qualities that we could never apprehend on our own: "These are not heavy objects. They can be held easily in our hands. Their size, scale, immediacy of effect, and familiar material invite our touch." The same breezy assumption of curatorial privilege informs a follow-up description of some seemingly ordinary Etruscan pot shards: "The fact that these vase pieces are fragments, no larger than a coin or the lid of a small jar, means that we can easily hold them in our hand and feel the character of their surfaces, and then turn them over to compare the quality of the painted and unpainted surfaces, and marvel at the thinness of their walls."[133] It is safe to say that anyone fortunate enough to accompany Cuno on a tour of his collection, seeing as he sees, knowing what he knows, and holding things in their own hands, would become a museum lover for life.

Making art galleries spaces of active engagement and learning for a broad spectrum of people with different expectations and experience remains an enormous challenge. A half-century ago, John Coolidge of the Fogg Museum commented: "[T]he real criticism of the galleries of our museums . . . is their educational ineffectiveness. . . . The typical museum gallery is a passive space which contributes nothing to the understanding of the object," and in most museums little has changed.[134] Apart from the odd gallery talk (very rarely given by a curator or director), silent contemplation still reigns. New techniques for teachers and docents, notably VTS (Visual Thinking Strategies), designed to help inexperienced museum visitors gain confidence and ability to find meaning in art, have enjoyed some success.[135] However, the open-ended nature of the learning process in VTS has annoyed conventional educators and curators for whom not all responses to art are equal. Recent rehangs of certain permanent collections (see chapter 3) were intended to stimulate new ways of seeing, but they too have been largely scorned by the initiated. Audio guides and podcasts hold out the promise of customized information

delivery without the limitations of static computer terminals in an out-of-the-way "learning center." But surely the biggest obstacle to democratizing museums lies in the fact that looking at art, and the art of looking, are "left aside" in our educational system, as Gilman noted a century ago. The lack of broad support for the arts and art education in our schools puts unreasonable pressure on museums to make a difference. Too many people come to museums unprepared; or perhaps more to the point, too many people never come to museums in the first place because they feel unprepared. As Bryan Robertson observed decades ago: "[O]nly an exceedingly small proportion of those who enter a museum are even remotely prepared for what awaits them, and only a total revolution in our educational system could remedy this deficiency."[136]

Back in the 1920s a collaborative effort between the Art Institute of Chicago and the city's public schools gave R. L. Duffus great cause for hope:

> The result is, or will be, that a bowing acquaintance with the A-B-C of the arts will cease to be a mark of caste or class. Any child in Chicago who really wishes to do so may take in art along with his grammar, arithmetic and geometry. The fact that his father works in the stockyards or that he himself has been brought up in the streets and encouraged to take not more than one bath a week is no real obstacle. There is at least a potential democracy. . . . Twenty years from now, perhaps, we shall be able to measure the tangible results attained by what is being done at this moment among the public school children of Chicago under the patronage and encouragement of the Art Institute.[137]

Needless to say, this and countless other long forgotten initiatives evaporated (including the branch museums mentioned earlier), leaving critics to observe that museums cannot provide acculturation on their own.[138] Museum educators do their best, but it is remarkable how many creative outreach projects must rely on short-term financial support from private corporations.[139] We don't count on private philanthropy to run our public schools. It is a cliché that arts education is the "first thing to go" in cash-strapped school systems, and with each cut a generation of children loses incentive to discover what art museums may have to offer. Given the way we fund museums and arts education, it should come as no surprise that visitor studies continue to confirm that, despite decades of outreach, those who go to art museums are still the well educated who view the cost and experience as a worthwhile investment in a process of lifelong learning, for both themselves and their children.[140] Those same studies conclude that school involvement, such as it is, is much less effective for developing lasting interests than family encouragement. Annual visits to local art museums by elementary schools are routine in many U.S. cities, but a casual glance at the fee-paying public on any given day suggests that many of those children are not returning as adults. These findings support Bourdieu's thesis that early exposure in an integrated milieu of family and school-

ing largely determines adult attitudes to art and culture. But if upbringing is so important, how can museums ever compensate for it?

Another option is to follow Sweeney in denying that mainstream art museums can ever be for everyone. Despite his efforts to spread appreciation, Gilman wondered if it were possible "to make a museum of fine art in any vital sense a popular institution," and Cuno has echoed those doubts by suggesting that art museums are "of interest to only a relative few (perhaps 20 percent of our population)."[141] Such sentiments may be deemed politically incorrect these days, but are they wrong? Cuno's brave assessment begs the question of why we care if art museums serve everyone, especially when we don't care or monitor who attends sporting events or other cultural venues. One obvious answer is that we continue to harbor utopian expectations about the role of art and museums in society. Because they are educational and good for us, however defined, they should be made available to all. The report *Museums for a New Century* (1984) takes this position when it states that museums contribute to the "national crusade" of education, which is "a pillar of democracy" and key to "American optimism."[142] At the same time, however, because we don't support museums or compel people to attend them as we do schools, they are left to attract visitors as best they can, making them most accessible to those who are willing to pay the price of admission. This also raises another important question for museums, especially those facing challenging financial circumstances: Should they concentrate their resources on the public they already have and hold, or should they try to cultivate new audiences?

Proponents of greater access argue that knowledge of art is a form of cultural capital without which advancement in the world is barred. Vera Zolberg has said: "[A]nything short of complete democratization is the maintenance of hegemony."[143] But is it clear in our postmodern age that hegemony of high culture translates into other spheres? Put differently, is it the case that a lack of cultural knowledge, or more specifically knowledge of high art, stands in the way of social, political, or material success? That there is a clear correlation between higher education and a higher standard of living is not in doubt, but is knowledge of art a necessary part of that education? For many, knowledge of sports would be more useful around the water cooler than an understanding of Rembrandt. It may be that museum trustees are rich and powerful, but many rich and powerful people live happily ignorant of art. And for the poor and dispossessed there are surely more pressing concerns than access to canonical Western paintings.

If people can't be made to go to museums, they will go only out of (self-)interest. The visitor study cited above suggests that if museums want to attract currently underrepresented constituencies, they will have to be "thoughtfully wooed by special marketing promotions, and served by programs and exhibitions that cater to . . . specific cultural

and historical backgrounds and interests." Some museums have begun to do this through special exhibitions and programs, but unless deeper changes are made to the structure of the collections and staff it is surely naive to think such visitors will ever become loyal patrons. When you get past the temporary exhibitions and education programs, mainstream art museums appear to have changed very little in recent decades. Despite calls in the 1970s for museums to become more diverse, boards of trustees and the people they hire to run their institutions are still overwhelmingly white, well off, and well educated. Why should we expect the public to become more diverse when the museum itself does not? A report from a British National Museums Directors' Conference on Cultural Diversity in 2006 concluded that more diverse audiences would result from "high quality, consistent and properly resourced programmes," greater information and collection sharing between mainstream museums, and "smaller, specialist cultural and community organisations." It insisted, furthermore, that museums had a "duty to promote race equality, and must reflect—within their own staffing and trustees—the cultural and racial mix of those they aim to serve."[144] Most institutions (not just museums) would no doubt agree with these goals. But staffing changes require training and education beyond the museum's walls as well as a change of culture within them. Temporary exhibitions can be organized relatively quickly, but permanent collections evolve slowly subject to market forces and the whims of donors.

A positive development in recent years has been the emergence of new museums for different publics. If no one museum can cater to all people or everything we might want to call art, then more museums and different museums are the answer. A hundred years ago mainstream art museums stood alone at the center of a community defining art and reaching out to all citizens; now those same museums struggle to accommodate new art forms and different cultures and patently serve certain sectors of the public better than others. They are now joined by dozens of alternative museums and display spaces supporting a range of artistic production and targeting previously underserved interests and publics. Where the Metropolitan Museum fails to serve the ethnically diverse communities of New York, the Studio Museum of Harlem, the Museo del Barrio, the Jewish Museum, and the Asia and Japan Societies, among others, help to fill the gap.[145] If MoMA is wed to a conservative vision of modern art, the cutting edge of contemporary art may be sampled at P.S. 1 or the New Museum of Contemporary Art, as well as the commercial gallery scene. The British Museum may display its Benin bronzes as uncontested and decontextualized works of art, but the Horniman Museum in ethnically diverse south London uses its own Benin plaque as a focal point for alternative perspectives and community dialogue. This is not to say that the Met or any other museum should stop trying to expand its appeal but to suggest that institutional constraints within

a given museum may circumscribe the way it displays and interprets its collection and the publics it serves. At the same time, the Met is clearly serving its current visitors very well, as is the Fogg, whose primary public (students, professionals) is more specialized than the Met's. Those museums may be in a position to resist the changes taking place in art museums around them, and if they do, all the better for those who know how to enjoy them. But popular blockbusters serve a purpose as well, and in any case they are here to stay for the foreseeable future. Temporary exhibitions in the postmodern era have expanded the possibilities of what may be shown in an art museum and, at least to some extent, the publics who attend. Though such exhibitions, and the shops and visitors that come with them, may annoy traditional museum-goers, including art historians, the permanent collections of most museums remain blissfully insulated from the shifting trends of the postmodern world.

Increasingly different in themselves, museums serve different purposes for different people; and of course they also serve different purposes for the same people. It is the diversity and flexibility of art museums—their ability to give various publics a variety of experiences across a broad museological landscape—that will ensure their survival in the long run.

Money and fine art are like oil and water: differing and even mutually repelling in essence. **Benjamin Ives Gilman (1918)**

Museums are the only symbol our money culture has left. **Philip Johnson (1986)**

5 COMMERCIALISM

Perhaps no development in the art museum of the last half-century has been more dramatic or controversial than the increase in commercialism, by which I mean the expansion of museum shops, the rise of the blockbuster exhibition and corporate sponsorship, and the influx of marketing and fund-raising personnel. A time traveler from the 1950s would surely be astonished to discover that it is now possible in our museums to eat (and eat well), shop, see a film, hear a concert, mingle at "singles night," and attend a corporate function or wedding reception without seeing a single work of art, or to globe-trot from one museum to another and experience a seemingly unending round of blockbuster exhibitions, each accompanied by widespread advertising, a dizzying array of more or less art-related products for sale, and bundled package deals from airlines and hotels. Armed with sophisticated marketing and PR staff, museums have been working hard to shed their image as stuffy repositories. In London in the early 1990s Saatchi & Saatchi caught the public eye with an ad that described the Victoria and Albert Museum as "an ace caff with quite a nice museum attached." In 2000 the venerable Worcester Art Museum in Massachusetts launched a membership drive aimed at younger visitors called "Friends of Steve" that used an image of the museum's founder, Stephen Sainsbury III (1835–1905), dressed in sunglasses, goatee, and a backward-turned baseball cap (fig. 95). The brochure asked: "Would you like a place to *socialize* with your contemporaries? Do you enjoy *great parties* and making new friends? Are you in your twenties or thirties? *Worcester Art Museum's* newest membership category is for you!" In New York the Guggenheim's Thomas Krens ruffled conventional feathers by suggesting that the successful twenty-first-century museum should

95. "Friends of Steve" marketing flier, Worcester Art Museum, ca. 2000.

include—besides a strong collection of art—a great building, multiple special exhibitions, shops, and eating opportunities (see below).

Thanks to such initiatives art museums have never been more popular. Attendance is robust and special exhibitions are routinely congested, with some staying open overnight to accommodate the crowds. Once-sleepy shops stocked with postcards and scholarly catalogs have become attractive shopping destinations with satellite outlets and catalog-Internet operations. Many museum restaurants boast fine cuisine and merit culinary reviews. Despite the signs of success and visitor satisfaction, many in the art world have been disturbed by recent trends. Though on some level everyone in the art world benefits from the increased popularity of museums, a good number of academics, art critics, and museum professionals fear the erosion of the museum's integrity and scholarly profile through a "dumbing down" of standards in pursuit of larger audiences and enhanced revenue streams. Those critics liken the new museum to theme parks and shopping malls in which the viewing of art seems like an afterthought.

Press coverage of the art museum's metamorphosis has shifted over the years from wry observation to undisguised contempt. "Glory Days for the Art Museum," declared the *New York Times* back in 1997: "It's cheap. It's fast. It offers great shopping, tempting food and a place to hang out. And visitors can even enjoy the art."[1] Another *Times* article a few weeks later announced: "This Isn't Your Father's Art Museum: Brooklyn's Got Monet, but Also Karaoke, Poetry and Disco."[2] An airline magazine informed weary travelers: "No longer the nation's attic, museums are now the places in town where lots of things happen."[3] But within a few years frontline journalists covering the art world had grown tired of the distractions. "What do art museums want?" asked Roberta Smith in the *Times* in 2000, since "it increasingly seems that they want to be anything but art museums." "Don't Give Up on Art," she pleaded.[4] A year later Smith's colleague at the *Times,* Michael Kimmelman, chimed in that "museums are at a crossroads and need to decide which way they are going. They don't know whether they are more like universities or Disneyland, and lurch from one to the other."[5] Four years later Kimmelman was angry: "Museums are putting everything up for sale, from their artwork to their authority. And it's going cheap." "Money rules," he added, "and at cultural institutions today it seems increasingly to corrupt ethics and undermine bedrock goals like preserving the collection and upholding public interest."[6]

Alarmed by the drift away from traditional values within their own institutions, a group of leading museum directors in the United States came together early in the new millennium to insist on the need to demonstrate "clear and discernible" differences between art and entertainment and a sharper contrast between the museum's activities "and those of the commercial world."[7] In their opinion, nothing less than public trust in the insti-

tution was at stake. As Philippe de Montebello put it: "It is clearly by differentiating our-selves from all manner of entertainment that we maintain our integrity."[8]

Despite the dire warnings, the directors offered no easy solutions to the problem; nor did they acknowledge the extent of their own involvement in the situation they described. In an ideal world, most museum directors would do away with glitzy shops and block-busters, marketing personnel and corporate sponsors. But in the real world, only ex-tremely well-endowed museums (e.g., the Getty or Menil) can survive without them. Also missing from arguments against commerce and entertainment is concrete evidence of public disaffection. What evidence do museums have that public trust is weakened by blockbusters and corporate sponsorship? Is there reason to think the public would prefer museums without shops and restaurants, or to the contrary are they now both crucial ingredients of the museum experience? Are museums and commerce incom-patible? The purpose of this chapter will be to survey the art museum's complex his-torical relationship to commerce, industry, and money. Because no two institutions are the same and funding patterns differ from one country to the next, this account can do no more than outline general trends and pressing theoretical issues.

■ ■ ■

Art and commerce have long enjoyed an uneasy relationship. Artists have always worked for a living, but beginning with the creation of art academies during the Renaissance they have projected an image of indifference to material concerns. The purpose of early art academies was to elevate the fine arts of painting, sculpture, and architecture above manual labor and the base concerns of the marketplace. In concert with princely pa-trons who transformed material wealth into symbolic capital through artistic patron-age, artists of the early modern period distanced themselves from the artisanal crafts of the guilds by asserting the intellectual, nonmaterial value of their work. Academic art theory worked to ally the "high" arts with poetry, philosophy, and the pleasures of the imagination and to relegate the decorative arts to a lower plane of ornament, craft, and utility. Within the high arts, academies established a hierarchy of genres that deliber-ately inverted market forces by privileging "history painting" (the depiction of noble hu-man actions) above the more popular and lucrative categories of landscape, still life, and portraiture. From the seventeenth century, the Royal Academy in Paris prohibited its members from engaging in overt commercial activity (advertising, setting up shop, etc.); as recipients of royal patronage and pensions, tax exemptions, exclusive exhibi-tion rights, and royal accommodation, artists were liberated (in theory at least) from the normal circuits of economic exchange. Strictures and privileges may have been weaker in other countries, but in general membership in a fine arts academy implied genteel status and a corresponding distance from money. Sir Joshua Reynolds began his inau-

gural "Discourse" (1768) to the newly founded Royal Academy in London, for example, by insisting that its members ignore "mercantile" concerns and concentrate instead on the "Polite Arts."[9] What he termed the "inferior ends" of commercial design were consigned to separate organizations established alongside the fine arts academies—in London the Royal Society of the Arts (1753) and in Paris the École Royale Gratuite de Dessin (1767). According to nineteenth-century stereotypes, artists took to living in garrets and wore their lack of material success as a badge of honor.

At the same time, however, governments invested in the fine arts in good part for economic reasons. Producing superior artists glorified the nation, but it also produced objects that could be sold abroad; indeed, one measure of superior art was its standing among foreign patrons. Notwithstanding theoretical distinctions between "high" and "low" art, in France established academy artists produced tapestry and porcelain designs for the royal Gobelin and Sèvres factories, both of which were admired across Europe for the quality of their goods. "Art can be looked at from a commercial point of view," wrote C. L. von Hagedorn of the Dresden Academy in 1763; "while it redounds to the honour of a country to produce excellent artists, it is no less useful to raise the demand abroad for one's industrial products."[10] Hagedorn had in mind the growing international competition in china and textiles, and he understood that commercial success in the decorative arts depended on high standards of artistry, which it was the function of academies to provide. Moreover, economic necessity forced many artists, Reynolds included, to pursue the lower genres and contribute to the production of decorative arts and commercial engraving.

Given that the first museums were commonly associated with fine arts academies, it is hardly surprising that they were dedicated from the first to high art. Yet here, too, ambiguities may be found. Witness the early Louvre. Disregarding the art market, which prized portraits and small decorative pieces for the home above all, the Louvre aimed to promote serious history painting and sculpture and thereby demonstrate the superiority of the French school and its academic system. In the 1780s the state commissioned patriotic statues of French heroes and grand moralizing paintings from David (the *Oath of the Horatii* and *Brutus*) and his colleagues to line the walls of the museum. Yet each of those paintings and sculptures was also intended to serve as a model for commercially available reproductions in tapestry and (on a reduced scale) in porcelain. And at least one Sèvres piece—a magnificent "Grand Vase" designed by the sculptor Boizot—was created especially for display at the Louvre to advertise the combined strengths of French art and manufacture.

When the Louvre opened definitively in 1794 at the height of the French Revolution it featured only Old Master paintings and ancient sculptures; the decorative arts, as a luxury commodity and staple of aristocratic interiors, were banished. The example of

the Louvre did much to define the art museum as an exclusive space of authentic, high-art masterpieces. Separate museums were created in and around Paris for the applied arts and modern French painting and sculpture.[11] The Louvre hosted occasional exhibitions of new inventions and machines from the late 1790s, but they never compromised the museum's identity as a bastion of high art.[12] Though the Louvre was "pure" in its contents, the commercial advantages it brought to France were not ignored. For ideological and economic reasons, foreign visitors were always vital to the museum. The Louvre "must attract foreigners and fix their attention," in the words of the revolutionary minister who supervised its creation.[13] The many thousands of visitors who flocked to Paris during peaceful interludes to see the Louvre commented on the inflated prices of food, accommodation, and transportation in central Paris. A British banker who made the trip in 1802 noted: "[T]hese pictures and statues must prove a mine of wealth to Paris, as all the world will go to see them."[14] Visitors bought catalogs offered for sale at the door, and from 1797 on they could also buy engraved reproductions of key works produced at the Chalcographie Nationale.[15] In the second half of the nineteenth century, photographs and postcards replaced engravings, and competition among firms for the lucrative tourist market at the Louvre was intense.[16] (The Chalcographie survived, ironically, by continuing to provide more expensive and "artistic" interpretations of original works of art.) From an early date the Louvre and other museums that followed its lead participated in and profited from the commercial reproduction of their masterpieces.

Utilitarian Commerce

As art museums evolved from princely collections to state-run institutions with a public purpose, economic justifications soon followed. In addition to bolstering national or civic pride and educating young artists, museums contributed to the elevation of taste among the general public—a matter of direct economic consequence, since improved taste made for better producers and consumers of art and manufactured goods. In the first decades of the nineteenth century the connection between the public display of high art and improved standards of design surfaced frequently to support investment in museums in Paris, London, and Berlin.[17] In 1835 a Select Committee of the British Parliament, concerned that native industries suffered in the world marketplace because of inferior design, launched an inquiry "into the best means of extending a knowledge of the arts and of the principles of design among the People (especially the Manufacturing Population) of the Country." A year later it concluded:

> In many despotic countries far more development has been given to genius, and greater encouragement to industry, by a more liberal diffusion of the enlightening influence of

the Arts. Yet to us, a peculiarly manufacturing nation, the connextion between art and manufactures is most important; and for this economical reason (were there no higher motive), it equally imports us to encourage art in its loftier attributes; since it is admitted that the cultivation of the more exalted branches of design tends to advance the humblest pursuits of industry, while the connextion of art with manufacture has often developed the genius of the greatest masters of design.[18]

After 1837 schools of design opened in London and the provinces for the purpose of training artisans. At the same time it became clear that *consumers* also needed training, and the means to that end were public exhibitions. Temporary exhibitions of domestic wares in Paris and London in the 1840s prompted Sir Henry Cole to organize a comprehensive international exhibition of manufactured goods, which resulted in the Great Exhibition of 1851 in London. In terms of its scale and drawing power it had no precedent. Over a five-month period, some six million visitors paid to see a stupendous array of one hundred thousand objects from around the world. Sir Joseph Paxton's building of glass and iron, known as the Crystal Palace, was itself worth the price of admission. Recreation at once useful and entertaining afforded to so many ideally met the needs of an emerging industrialized society. The overlapping economic and social benefits were plain to see, according to one report: "Magnificent was the conception of this gathering together of the commercial travelers of the universal world, side by side with their employees and customers, and with a showroom for their goods that ought to be such as the world has never before beheld."[19] So successful was the Great Exhibition and so contagious was Cole's vision of improved technology and design leading to peace, progress, and class harmony that for the next century and more Western nations competed for the right to host similar fairs. Civilization and progress, as defined by the expositions, required the marriage of industry and art, the ability to both produce and appreciate, and therefore consume, good design.

The ability of international exhibitions to stimulate taste and competition was limited, however, by their short duration, irregular occurrence, and shifting location. What was needed, as Horace Greeley put it at the time of the New York World's Fair in 1853, was a *permanent* "art and industry show-house . . . a broad national and cosmopolitan platform whereon genius or ingenuity may at once place its productions and obtain the highest sanctions."[20] Fully in agreement, Henry Cole created the South Kensington Museum in 1857, the first museum dedicated to the applied and decorative arts. Consistent with the twofold purpose of the Great Exhibition, to instruct and entertain, Cole's museum classified its contents (some of which had come from the Crystal Palace) by material and process (metalwork, glass, textiles, etc.), the better to serve the artisan and designer, yet also catered to a broad public by displaying domestic, commercially available objects, adopting evening hours, and opening a restaurant.

Just as the Great Exhibition spawned dozens of world's fairs, so the South Kensington Museum was imitated throughout Europe and the United States in the 1860s and 1870s, for each metropolitan center needed its own permanent design resource.[21] Dedicated applied arts museums became especially popular in the industrialized countries of northern Europe, beginning with Germany, Austria, and France, while in the United States new museums sought to combine the virtues of the high-art museum and the *kunstgewerbe* type. The founding charter of New York's Metropolitan Museum, for example, spoke of "encouraging and developing the study of the fine arts [and] the application of arts to manufacture and practical life, . . . furnishing popular instruction and recreation."[22] The Met's first director, General Cesnola, argued that the "practical value of the American museum" entailed that it become "a resource whence artisanship and handicraft of all sorts may better and beautify our dwellings, our ornaments, our garments, our implements of daily life," while also providing entertainment to the "casual visitor."[23] In like spirit, the Boston Museum of Fine Arts adopted "Art, Education, Industry" as its motto.

Over time, however, as discussed in chapter 1, the South Kensington philosophy came under fire on both sides of the Atlantic for failing to produce any demonstrable improvement in design standards or public taste. Manufacturers did not send workers to study in the museum. William Morris, among others, doubted whether a collection of artifacts could inspire new art. On a deeper level, he and John Ruskin rejected the notion that industrial production could yield good art and design, for in their eyes machine manufacturing violated the dignity of human labor.[24] Instead of progress and higher living standards for all, industrial society had produced demeaning work routines, shoddy products, and urban slums. Meanwhile, the school of design affiliated with the museum had degenerated into a second-rate art school "for the delectation of shoals of female amateurs, and for the turning out of a cartload of mostly mediocre artists of both sexes."[25] What was worse, according to the painter Herkomer, it had led young artisans astray, filling their heads with high-art ambitions and diverting them from the "dignity of their craft."[26]

Art and Antimaterialism

In the wake of growing mechanization and what Ruskin termed the "fury of avaricious commerce," art museums became more a refuge from than a handmaiden to progress and modernity.[27] For the likes of Ruskin, Morris, and Matthew Arnold, art and culture were the source of morality, transcendent beauty, and humanity, and as such an antidote to the dehumanizing consequences of capitalism and industry. Ruskin's experimental utopia, the Guild of St. George, banned machinery and common currency; as

we have seen, his own museum near Sheffield (fig. 10) was devoted to the nonutilitarian education and delight of factory workers. The equally idealistic Arts and Crafts movement founded by Morris and his followers attempted to revive handicrafts and the premodern guild system. Arnold preached the widespread dissemination of "sweetness and light" as a remedy for poverty, ignorance, and soulless materialism. By century's end, the equation of material progress and civilization, and with it South Kensington's forced marriage of art and industry, had lost much of their credibility.

At international expositions the fine arts grew more autonomous. Following their happy union at the Philadelphia World's Fair of 1876, art and industry experienced a trial separation at the 1893 Columbia Exposition (see chapter 1), and then a complete divorce at Chicago's Century of Progress Fair in 1933, where the fine arts exhibition was held off-site at the Art Institute and, contrary to the fair's spirit, celebrated the past instead of the future.[28] Similarly the Masterpieces of Art exhibition at New York's 1939 World of Tomorrow fair was decidedly antimodern, and even anti-American, in its focus on the "great epochs in the art history of Europe, from the beginnings of easel painting, about 1300, until the time of the French Revolution which marked the beginning of modern painting."[29] In the decades following the landmark Columbian Exposition, antimodern temples of art arose in urban parks (often in cities that had just hosted world's fairs, such as Buffalo, St. Louis, and San Francisco) as respites from city life. The selfsame industrialists and merchants whose products filled the exhibition halls relied on the collecting of (preindustrial) art and the patronage of classical museums to disprove Arnold's assertion that the United States had no culture.

The strongest proponent of art's divorce from utility and commerce was Benjamin Ives Gilman in Boston. At the new Museum of Fine Arts, opened in 1909, the merger of art and industry that had characterized the first museum disappeared and, as we have seen, was replaced by a Grecian temple dedicated to aesthetic contemplation of fine art (figs. 33–34). When Gilman stated that art museums were not primarily educational in purpose, he meant that they were not utilitarian and had no business competing with colleges and schools in the training of craftsmen or scholars. Heavily indebted to Arnold and Ruskin, and hoping to rebut charges of American philistinism, Gilman argued that art was not a means to an end but an end in itself.[30] Because art's true utility resided in its transcendent aesthetic value—that is, its practical *uselessness*—Gilman insisted that art museums should reject associations with money and commerce, beginning at the front door with the abolition of admission fees: "For a museum of art to sell the right of admission conflicts with the essential nature of its contents."[31] Gilman continued: "Money and fine art are like oil and water: differing and even mutually repelling in essence. Art is necessarily joined with its ill-assorted companion in origin and generally in fate. Artists must make a living, and collectors inevitably compete for their achievements. A

work of art is rescued from this companionship with money when it reaches a museum. Yet the divorce is not complete while money is demanded as the price of its contemplation. The office of a museum is not ideally fulfilled until access to it is granted without pay."[32] He also deemed publicity inappropriate because it made a museum seem too much like a commercial enterprise, and because a museum's effectiveness should not be measured in terms of visitor numbers, an increase in which was publicity's chief goal. Museums would not be more "effective because they gather crowds," he insisted.[33] For Gilman, visitor numbers and revenue were irrelevant and even contrary to the aesthetic experience of the individual beholder.

To suggest that art museums completely washed their hands of industry and commerce in the early 1900s would be incorrect, however. Gilman's principled rejection of utility, money, and publicity and his insistence on the integrity of aesthetic experience would become commonplace in the second half of the century—indeed, his ideals retain their currency today—but at other prominent museums the situation was more complicated. Though under attack from the late nineteenth century on, the utilitarian museum philosophy did not so much disappear as change focus. At museums dedicated to the applied arts, attention shifted from training artisans to producing informed consumers in the belief that refined taste would heighten demand for better products and thereby force improved design standards through a market form of natural selection. Museums in Germany were among the first to replace an emphasis on materials and techniques with contextual installations and period rooms in order to "raise the general popular taste" by demonstrating "the living connection of things."[34] By the 1920s Charles Richards could assert unequivocally "that the first and highest purpose of industrial art collections is the education of public taste."[35]

In the United States, where commercial interests and their denial wrestled with each other in the hearts and minds of museum boosters, the first decades of the twentieth century witnessed tensions between a populist, consumer-oriented utilitarianism and Gilman's aesthetic philosophy. The pragmatic strain in North American museum thinking had deep roots. In a talk entitled "Museums of the Future," given in 1889, George Brown Goode of the Smithsonian declared: "The museum of the past must be set aside, reconstructed, transformed from a cemetery of bric-a-brac into a nursery of living thoughts. The museum of the future must stand side by side with the library and the laboratory . . . as one of the principal agencies for the enlightenment of the people . . . adapted to the needs of the mechanic, the factory operator, the day laborer, the salesman, and the clerk, as much as those of the professional man and the man of leisure."[36] Goode's utilitarian ideals were embraced by John Cotton Dana at the Newark Museum, opened in 1909 at the heart of an industrial, immigrant-rich city. Indebted to Goode, but also to Thorstein Veblen, who viewed collections of art less as an antidote to capi-

talist excess than as a fetishized product of it, Dana defined his own museum in marked contrast to everything Gilman's art museum stood for. Where the latter housed expensive and unique treasures imported from Europe, Dana's museum promoted the everyday, often mass-produced products of local industries. Realizing that the Arts and Crafts movement had done little more than create expensive commodities for the moneyed classes, he embraced "articles made by machinery for actual daily use by mere living people," not excluding shoes and shop signs, table knives and hatpins.[37] Given the expansion of industry and mechanization, the "useful" museum should embrace the machine age and enable the public to master its possibilities. Dana saw his museum as an active learning center located at the hub of a working community rather than a passive receptacle of artifacts isolated in a distant park. To better serve area businesses, workers, and consumers, he recommended museum advertising in all forms. And Dana was at his most provocative when he acknowledged the "frankly commercial" nature of his enterprise while mocking the bourgeois discretion of "gazing museums" full of costly treasures. "Commerce is not sinful," he wrote. "It exudes no virulent poison which is harmful to the elevated souls of art museum trustees, administrators and visitors."[38] If we were to judge the Newark Museum by its contents alone it would hardly merit discussion in a book on art museums, but it belongs here because art museums served as a point of departure and contrast for everything Dana did.

If Dana and Gilman represented opposite poles of museum theory and practice, a number of prominent art museums, including the Brooklyn Museum, the Met, and MoMA, searched for middle ground, promoting design and experimenting with strategies pioneered in the commercial sphere, notably in department stores, which for much of the twentieth century drew comparisons with museums as popular urban destinations.

Department Stores and Design

When it came to molding public taste with respect to domestic products, museums were soon surpassed by department stores, which by the 1920s had assumed a central place in the life and economy of North American and European cities. Like museums on the South Kensington model, department stores, often built of modern materials (steel, glass, terra-cotta) and organized by materials (glassware, linen, etc.), shared an origin in world's fairs. Though Henry Cole imagined that museums would make up for the impermanence of fairs, museums proved more interested in the past than the present, and the role of permanent bazaar was taken over by the store, which offered the public a constantly revolving spectacle of novel products and the appeal of instant consumer gratification. Motivated by profit, store managers exploited novel advertising and retail strategies, including seductive shop window displays, to seize the public's imagination

and rival the museum as a source of visual delight and instruction. Stores invested in aesthetics and consumer psychology because they helped to sell products, and museums came to realize they had something to learn from their commercial cousins.[39] Though museum men and store managers were quick to insist on the differences between their goals and functions, they nevertheless acknowledged common concerns. Jesse Strauss of Macy's, for example, stated categorically that "a successful store is not a museum" but then sounded like a curator in endorsing "clean-line modern architecture" and the avoidance of visual distractions in order to focus attention on products displayed.[40] With equal ambivalence, Carlos Cummings, director of the Buffalo Museum of Science, titled a comparative study of museums, fairs, and merchandisers *East Is East and West Is West* (1940), as if never the twain should meet, yet proceeded to liken museum displays to "modern high pressure advertising" used "to sell a customer an object of real service to him," and to urge his museum colleagues who were in search of new display strategies to examine "high-class shop windows in almost any big city."[41] What museums and stores had to "sell" might have been quite different, but the means of engaging their publics could be the same.

In the context of a rapidly expanding modern consumer society, a society hungry for material comforts as well as culture, museums and department stores enjoyed a degree of collaboration that today seems surprising. For an extended period in the 1910s, 1920s, and 1930s there was significant overlap between the spheres of retail and high culture. Store windows were likened to picture frames, and significant artists, architects, and designers—Archipenko, Georgia O'Keefe, Frederick Kiesler, Norman Bel Geddes, Raymond Loewy, Lescaze and Howe, and Mies van der Rohe—lent their talents to the enhancement of commercial spaces.[42] Department stores displayed and sold contemporary art, often of the highest quality, and many major patrons of North American museums—George Hearn, Benjamin Altman, Samuel Kress—were department store magnates. Classes and clubs for businessmen, store buyers, and salespeople became commonplace at museums on the East Coast and in the Midwest.[43] In the hope of attracting more visitors to his downtown branch museum in Philadelphia (fig. 92), Philip Youtz consulted with local merchants about marketing strategies and local shopping patterns. He learned that shopping picked up toward the weekend and that constant novelty was needed to keep customers coming back, which argued for closing museums early in the week and offering temporary exhibitions and programming.[44]

As we might expect, Dana was among the first to see the department store's potential and was typically polemical in his views: "A great city department store of the first class is perhaps more like a good museum of art than are any of the museums we have yet established," he wrote in 1917.[45] For Dana, "good art" was not limited to the contents of art museums but could be found "wherever the interested and intelligent open their

eyes and find color, form, line and light and shade." That included the shop windows of New York City, where millions of ordinary consumers unwittingly received daily lessons in art, design, and color harmony. "In fact, these millions of shoppers are building their own art content better than they know!"[46] If anything, the traditional art museum impeded such learning by insisting on its own hermetic values, and one of Dana's goals at Newark was to liberate ordinary people to see beauty in their everyday environment. Among his many remarkable display initiatives were cases that featured everyday products that could be had for fifty cents or less (fig. 13). In conjunction with department stores, the useful museum would help to prepare the populace for the brave new world of industry and commerce. Significantly, the new building for the Newark Museum (opened in 1926) was the gift of local department store owner Louis Bamberger, who supported the museum over many years.

Perhaps the most interesting, and in hindsight most surprising, example of collaboration involved the Metropolitan Museum in New York. From 1917 through the 1930s, the Met hosted annual exhibitions of contemporary craft and industrial design together with programs for people involved with commerce. Richard Bach was hired as an associate in industrial arts and put in charge of the exhibitions. He described himself "as a sort of liaison officer between the Museum and the world of art in trade," assisting "manufacturers and designers from the standpoint of their own requirements." Visiting shops and workrooms and staying abreast of market trends, he aimed "to visualize trade values in museum facilities and thus help manufacturers towards their own objectives."[47] Working between designers and manufacturers on the one hand and the consuming public on the other, the Met mimicked the department store in obvious respects. As Richard Bach wrote in the trade magazine of Chicago's Marshall Field's department store: "Manufacturers, merchants, and the Museum of Art together seem to form a new magic circle of industry, a continuous and certain means of bringing art into the furnishings and clothing and other homely factors of daily life."[48] The president of the Met, no less, sounded like a Dana disciple when he told a gathering of business executives: "[Y]ou can all be missionaries of beauty. Your influence is far greater than that of all museums. You are the most fruitful source of art in America."[49] Also in 1917 the Met hosted a session of the American Association of Museums conference devoted to "Methods of Display in Museums of Art," which included presentations by a representative from the Gorham Corporation and Frederick Hoffman, a well-known window dresser at Altman's.[50] Ten years later, in 1927–28, the Met joined forces with Macy's to organize the "Art-in-Trade" expositions featuring contemporary room settings installed and furnished by major designers. Similar in appearance and purpose, the exhibitions at both venues attracted crowds that reached modern blockbuster proportions: some 250,000 people saw the Macy's 1928 trade show, and 185,000 went to see the Met's exhibition a

96. John Wellborn Root, "Woman's Bedroom," from the exhibition The Architect and the Industrial Arts at the Metropolitan Museum of Art, New York, 1929. Image © Metropolitan Museum of Art, New York.

year later.[51] Collaboration gave the Met an opportunity to "compare the attractive force of a purely artistic demonstration against a background of business life with the results of similar displays in the atmosphere of the museum."[52] By all accounts the museum benefited more from the exchange, for, as Dana and others implied, there was nothing to compare with the visual allure of the modern shop window.

The 1927 Macy's exhibition was organized by the well-known theatrical set designer Lee Simonson. Simonson, a Harvard graduate equally at home on Fifth Avenue and among the artists and impresarios who pioneered the modern movement in the United States, also had strong opinions about museums. In his view, what theaters and department stores had in common and museums sorely needed was "showmanship." As early as 1914 he had complained that museums were "dreary asylums" owing to overcrowded and unimaginative installations. "You make a museum with fifty masterpieces,

not with five hundred," he wrote, and you display those fifty masterpieces with flair.[53] Twenty years later he could still complain: "Our museums remain ineffective very largely because the arrangement of their collections inevitably dulls the interest they are supposed to arouse. Everything is shown; almost nothing is displayed. . . . No effort is made to focus attention."[54] By that time, however, as we saw in chapter 3, much had already been done to answer his complaints; both of his suggested remedies—period decor and focused emphasis on masterpieces—had entered mainstream art museums. Such was the success of the Macy's-Met collaboration that from 1929 the museum hosted a series of exhibitions entitled The Architect and the Industrial Arts, in which major designers, including John Wellborn Root, Raymond Hood, Eliel Saarinen, Raymond Loewy, and William Lescaze, created seductive domestic room settings full of the latest in home furnishings (fig. 96).[55] For a while art and design installations at museums and department stores became virtually indistinguishable. After a visit to the Met's 1934 applied arts exhibition, Lewis Mumford complained in the New Yorker that it "hardly differs seriously enough from that of a good department store to warrant the Metropolitan's special efforts."[56]

Owing to such confusion, and to curatorial dislike of simulated environments more generally, designer installations enjoyed only a brief vogue in museums (they of course remain a staple of furniture showrooms). Bach's exhibitions were canceled during World War II, and the Met, like most art museums, never again invested seriously in contemporary design.

The exception to the rule was the Museum of Modern Art, which in the 1930s embraced modern design and set the standard for "showmanship" with respect to high art. A sparse hang in intimate rooms with white walls and focused light has become so ubiquitous that it is hard now to see the showmanship involved. But perhaps it can be best appreciated where least expected, in the 1934 Machine Art exhibition designed by architect and curator Philip Johnson (fig. 97). Johnson's simple but effective move in that installation was to cross Simonson's two forms of showmanship by displaying industrial products and applied arts not in a contextual setting, as at the Met and nearby department stores, but isolated like masterpieces of high art. Ignoring the function and working contexts of ball bearings, boiling flasks, and propellers and stressing instead formal qualities of material, surface, and volume through presentation, lighting, and photography, Johnson transformed utilitarian products of the machine age into seductive ready-made sculptures. One critic said the exhibition proved Johnson to be "our best showman and possibly the world's best." The New York Times said it represented his "high-water mark to date as an exhibition maestro."[57]

From its earliest days MoMA had expressed an interest in contemporary design, yet the design ethos under Barr and Johnson owed more to European modernism than to

97. Installation view of the Machine Art exhibition at the Museum of Modern Art, 1934.
Photo: Digital Image © The Museum of Modern Art/Art Resource, New York.

the everyday concerns dear to Dana or Bach. The Machine Art exhibition, for example, did feature products that could be had in local department stores, but the emphasis was placed on things that had little resonance with middle-class shoppers on Fifth Avenue. The museum bulletin claimed the exhibition served "as a practical guide to the buying public," but how many households needed the ring of ball bearings that graced the catalog cover or the oversized spring voted the most beautiful object by a panel of celebrity judges? The most familiar photograph of the show highlighted objects that had little place in the home (fig. 97). According to *ARTnews*, "[T]he man in the street feels that these things are all very nice, but that the pure joys of functional beauty are for the cerebral aesthete."[58] Notably absent from the exhibition were those contemporary U.S. designers—Loewy, Bel Geddes, Walter Teague, Henry Dreyfuss—whose work had revolutionized product design in everything from trains to telephones.[59] By 1934 their

"streamlined" products could be seen everywhere—from the Met annual show to department stores and city streets—except at MoMA. Having saturated the market, those designers succeeded in realizing Henry Cole's dream of integrating quality design, mass production, and efficient distribution to a broad consumer public. But for the men at MoMA, streamlining's reliance on sensual effect and advertising to sell products and planned obsolescence to endlessly renew consumer desire had cheapened contemporary design and warped public taste. MoMA's mission was to counter the superficial allure of commercial design, and to that end it privileged the structural austerity of European modernism. Where native design had "sold out" by catering to popular tastes, European design retained its integrity, that is to say its distance from the mass market, through kinship with modern architecture and rejection of seductive ornament. Le Corbusier, in his book *The Decorative Art of Today* (1925), dismissed decoration as a form of disguise for poor quality. "Trash is always abundantly decorated," he wrote; by contrast "the luxury object is well made, neat and clean, pure and healthy, and its bareness reveals the quality of its manufacture."[60] The latter appealed to sophisticated tastes, while "decorative objects flood the shelves of the Department Stores; they sell cheaply to shopgirls." For Europeans—and by extension the men at MoMA—streamlining came to be seen as the hallmark of a vulgar, fad-driven society.[61] Perhaps the issue of integrity and betrayal was sharpened by the fact that streamlining's leading advocate, Raymond Loewy, was a French émigré and contemporary of Le Corbusier who had struck it rich in America. In 1949, toward the end of his illustrious career, Loewy appeared on the cover of *Time* magazine surrounded by his products and a caption that read "He streamlines the sales curve," a reference to his own definition of good design as "a beautiful sales curve, shooting upward."

Nowhere was MoMA's rejection of mainstream taste and commercial culture more evident than in the exhibition Art in Our Time, organized to coincide with the 1939 New York World's Fair. As a counterpoint to the enormously popular, streamlined, corporate-sponsored pavilions designed by Loewy, Bel Geddes (fig. 43), and others, Art in Our Time limited its section on design to four single European chairs by Le Corbusier, Mies, Marcel Breuer, and Alvar Aalto (and a futuristic bathroom by Buckminster Fuller).[62]

To be sure, beginning in 1938, under the guidance of John McAndrew, Philip Johnson's successor in the design department, MoMA organized a series of traveling exhibitions of inexpensive useful objects, following the example of John Cotton Dana in Newark. (A price limit per object was first set at $5 and later rose to $100.) Subscribing institutions included colleges, department stores, and local art associations: "[T]he lenders, including retailers, wholesalers and manufacturers, received gratifying requests from all over the country and several wholesalers found enough attendant business in the provinces to establish new retail outlets in other sections of the country."[63] In 1940 MoMA

hosted an exhibition entitled Organic Design in Home Furnishings with the aim of fostering collaboration between designers, merchants, and manufacturers. Department stores, led by Bloomingdale's, sponsored prizes in return for the right to sell the winning designs. Installations simulated domestic environments, in some cases down to picket fences and fake lawns and trees.[64] The Useful Objects shows were canceled in 1948 but briefly reborn with a modified focus between 1950 and 1954 under McAndrew's successor, Edgar Kaufmann Jr., son of the Pittsburgh department store founder (who naturally viewed his emporium as a font of good taste for the consuming public). Kaufmann's Good Design shows, organized in conjunction with the Merchandise Mart in Chicago, also enjoyed success during their brief run. Extensive media advertising promoted the exhibitions; a television game show involving chosen products was even planned. Selected pieces were stocked by department stores with MoMA "Good Design" labels to boost sales.

The design exhibitions struck a chord with middle America, but their emphasis on "shoppers" and improving "the quality of many Christmas gifts," as museum patron A. Conger Goodyear sarcastically put it, was out of step with the increasingly canonical direction of the museum.[65] In 1953 MoMA officially became a collecting institution and abandoned direct involvement in the retail end of design. Thereafter the museum dedicated itself to acquiring objects of the past on the basis of their "quality and historical significance." Those criteria come from the catalog to Arthur Drexler's 1959 exhibition Introduction to Twentieth-Century Design from the Collection of the Museum of Modern Art and were used to justify the exclusion of utilitarian objects—"not because such objects are intrinsically unworthy, but because too often their design is determined by commercial factors irrelevant, or even harmful, to aesthetic quality."[66]

The Blockbuster Era

In museological terms, the 1950s may be viewed as a period of professional consolidation following the populist expansion and experimentation of previous decades. Budgets were under control, the art market flourished, and museums found themselves in the steady hands of curators and directors whose connoisseurial priorities aligned with the interests of their patrons and collectors. Commercial overlaps disappeared, audiences became more elite, and a solemn hush prevailed. But all that began to change in the 1960s and 1970s because of a resurgence of populism and mounting financial challenges. For reasons both ideological and economic, museums turned to marketing and high-profile programming to increase and diversify visitors and raise revenue. Progressive leaders of major urban institutions expanded outreach at the same time that the ranks of middle-class "culture consumers" (to borrow the resonant title of Alvin Toffler's 1964

98. Mona Lisa crowds at the National Gallery, 1963. Photo courtesy
of the National Gallery of Art, Washington, D.C., Gallery Archives.

book) multiplied. In 1963, as a Cold War demonstration of cooperation between "free world" allies (fig. 98), the Louvre sent Leonardo's Mona Lisa to the National Gallery in Washington, an event that drew some two million people. The gallery's director, John Walker, recoiled at the sight of "busloads of tourists" engaged in superficial "cultural sightseeing." These were not the "truly devout" that, in his opinion, justified "the maintenance of public collections."[67] But they underlined the magnetic power of the masterpiece and revealed the potential size of the public for art. The modern "blockbuster" era had begun.

The exhibitions organized by Thomas Hoving at the Met in the late 1960s are often referred to as the first real blockbusters, but it depends on how the term is defined. Cer-

tainly large-scale shows full of masterpieces and accompanied by extensive publicity were nothing new in the 1960s. If size, quality, foreign loans, and publicity are the blockbuster's essential criteria, then the Italian Renaissance exhibition held at London's Royal Academy in 1930, with its star pictures considered by some too fragile to travel and "crowds . . . so great that one couldn't possibly see the pictures," would surely qualify.[68] So, too, would the van Gogh show at MoMA in 1935. "By the time the exhibition opened in November," recalled Russell Lynes, "the press coverage had already made it famous and nearly every suburban housewife knew about van Gogh's ear."[69] Reviews declared the show "superb," "fraught with wonder," "magnificent." To the annoyance of local businesses, a banner advertising the show (among the first of its kind?) hung over the street in front of the museum. "Store windows on Fifth Avenue were filled with ladies' dresses in van Gogh colors, displayed in front of color reproductions of his paintings. His sunflowers bloomed on shower curtains, on scarves, on tablecloths and bathmats and ashtrays." Queues stretched around the block. Trains marked "Van Gogh Special" brought people from as far away as nine hundred miles. Attendance in New York over a two-month period reached 123,339; a further 227,540 people saw the show in San Francisco. The show's success confirmed Philip Youtz's assertion a year earlier at the Madrid museum conference that temporary exhibitions were "agreed to be one of the methods best calculated to attract the general public."[70]

Though a small admission fee was charged for the Van Gogh exhibition, money was not MoMA's motive for organizing it. For Barr what mattered was cultivating a broad public for high art. Similarly for Hoving, at least in his first blockbusters, including Harlem on My Mind, populism and publicity (for himself and the Met) came before profit. If making money has become a fundamental goal of the blockbuster as we know it today, we can trace the origins of the phenomenon to the moment in the late 1960s and early 1970s when rising financial pressures made generating revenue a chief impetus for exhibition planning.

By the 1960s, the income from loyal benefactors, endowments, and local subsidies was no longer sufficient to meet the rising costs of building maintenance, new programs, and staffing in many private museums.[71] State-run museums were insulated from economic change, but those without substantial government subsidies (which includes most museums in the United States) were forced by budget shortfalls to seek new audiences and to entice visitors new and old to give and spend money. Through the 1950s, development offices, capital campaigns, marketing, and membership drives were virtually unheard of in art museums. Admission charges were rare. Gradually, however, recurring deficits forced museums to join universities and hospitals in charging for services, enlarging their circle of generous friends, and pursuing grants and donations. To increase attendance and justify new fees and solicitations, museums had to make them-

selves more appealing, which meant renovating or adding buildings and expanding programs, which in turn entailed additional staff and higher associated costs. The old art museum public wasn't big enough to pay the bills, and new audiences, surrounded by recreational alternatives, required new forms of stimulation to keep them coming back. At the same time grant-awarding agencies wanted tangible results for their investment in the form of healthy visitor numbers.[72] Museums gradually became audience driven, and, as everyone knew, there was no more effective way to attract crowds than the well-advertised blockbuster exhibition.

Because they are dependent on heavy marketing and valuable masterpieces flown in from distant museums, blockbusters are expensive to mount, but their proven popularity has made them attractive to corporations willing to exchange financial support for advertising. To make a profit, museums then charged special admission and created new spending opportunities; and to keep the profits flowing, major exhibitions had to be planned to follow one another with regularity. In short, beginning in the 1970s, blockbusters became many museums' financial salvation. As Jay Gates, director of the Phillips Collection in Washington, observed in 1998 at the height of the blockbuster craze: "It is no longer a revelation to observe that, over the course of the last 30 years, art museums in America have come to be driven, if not dominated, by their major exhibition schedules. Virtually everything that is quantifiable about America's major museums follows the performance of their exhibitions. . . . Attendance, ticket sales, membership, shop revenues, activity in the café, the private use of the building for business or social purposes—all of these things climb or fall in connection with exhibitions."[73]

Because it has always been heavily dependent on private funding, Boston's Museum of Fine Arts offers a particularly good example of creeping commercialism in the art museum. Though we think of it (and others like it) as a "public" institution, it was founded and for much of its history financed by local benefactors. The MFA received no public subsidies until 1966, when the city stepped in to subsidize visits by local schoolchildren.[74] It remains the least subsidized major urban art museum in the United States. Over the years costs regularly exceeded income, but the problem became acute in the 1960s, and a new approach was needed. In 1966 the museum imposed a general admission fee for the first time in fifty years. Further deficits ensued, leading to raised admission fees and internal cutbacks. A Centennial Fund drive, the first of its kind in the museum's history, was launched to pay for a building that would offer new "creature comforts" in the form of an auditorium, added exhibition space, and a better restaurant.[75] The board of trustees was enlarged "to attain a larger number of trustees who would give substantial sums themselves or assume close personal responsibility for . . . fundraising in relation to a permanent Development Department."[76] As important as behind-the-scenes efforts were, then-director Perry Rathbone acknowledged in the

early 1970s that it would take a host of new public initiatives—"exhibitions of international scope, events of record-making popularity, breathtaking acquisitions, lavish publications, programs involving visiting scholars, seminars, and films"—to significantly boost attendance and revenue. The measures were sufficiently novel to warrant a public explanation: "While we believe that such programming is not outside the province of museums, it is no secret that the motivation behind this effort has been, perhaps, less to deepen the experience of our visitors than to broaden the appeal of the museum and thus to increase its income."[77] Half a century earlier Rathbone's recipe might have been justified as "showmanship" aimed at broadening access, but now the goal was raising money. In fiscal year 1971 popular exhibitions of the work of Andrew Wyeth and Cézanne produced record attendance and merchandise sales, but a year later, Rathbone's last as director, with no blockbusters scheduled, the red ink returned. In his seventeen years at the museum, Rathbone witnessed membership grow from two thousand to fifteen thousand and shop revenues increase tenfold from $30,000 to $350,000; annual and corporate appeals had been introduced. Yet owing to inflationary pressures the museum was no closer to financial stability.

Recurring deficits in the mid-1970s forced the MFA to reduce hours and increase admission fees, triggering a significant drop in attendance and revenue. In 1975–76 a new president of trustees, Howard Johnson, was brought in to revitalize the museum.[78] Johnson, a former president of MIT and dean of its business school, initiated another capital campaign, hired a money manager and other managerial staff, and began planning a major physical expansion that would result in I. M. Pei's West Wing (fig. 48). All the while, he realized above all that "the program must also become more attractive to our potential viewers."[79] Confronted with escalating admission charges and membership fees, visitors expected a greater return on their investment. Though averse to the language and practices of for-profit business, the MFA and other museums had no choice but to welcome the marketers, managers, and merchandise and to start treating their visitors as customers.

In 1977–78 a model for the new Pei extension went on display amid a string of popular exhibitions (in the old building) that included Pompeii AD 79, Thracian Gold, Monet Unveiled, Peter Rabbit, Art in Bloom (paintings paired with elaborate flower arrangements), Winslow Homer, and Hiroshige, a list that reveals a marketer's grasp of public taste. Almost half of the 892,000 visitors to the MFA that year lined up to see the Pompeii exhibit (fig. 99) and to buy related posters, T-shirts, mugs, and buttons that read "I survived Pompeii." It was among the first shows at the MFA to offer an audio guide and to receive corporate sponsorship (from Xerox). Retail sales doubled, membership rose, and the restaurant enjoyed a profit for the first time in years. A visiting celebrity—Peter Falk, star of the *Columbo* television show—graced the back cover of the annual report,

99. Front cover of
*Annual Report, Museum
of Fine Arts, Boston,* 1978.

shopping bag in hand. A winning formula had been established, and with the opening
of the Pei wing in 1981, providing space for traveling blockbusters, a much-expanded
shop, and new restaurants, attendance climbed above one million and the museum en-
joyed its first budget surplus ($126,000) in a decade. Further good years followed, cul-
minating in the *annus mirabilis* of 1985, when a Renoir retrospective set a record for ex-
hibition attendance and boosted the museum's surplus to $2.5 million. Thanks to
unprecedented marketing on television and in the print media (paid for by IBM), a mar-
ket survey commissioned by the museum discovered that 83,000 people came to the
MFA for the first time to see the Renoir exhibit and that 3,654 of them became new

members. The annual report stated: "The highly developed ancillary services of the Museum helped make 'Renoir' much more than a simple box-office success and enabled the Museum to restore to the endowment all of the operating deficits taken from it during the seventies."[80]

A downturn in corporate giving in the late 1980s compounded by significant cutbacks in federal aid to the arts during the Reagan administration made it all the more imperative that the MFA follow up the success of Renoir with other popular exhibitions. It had become clearer than ever, at the MFA and elsewhere, that blockbusters made the museum world go round. In 1990, the museum hosted the immensely popular Monet in the 90s: The Series Paintings, which helped to generate another surplus of $2.4 million. "If we could have a Monet exhibition every other year," the president of the trustees wrote, the museum "would have few financial concerns. . . . In the years when these unusual events are not part of the program, the Museum is finding it increasingly difficult to make ends meet."[81] Indeed, the following year further deficits were again projected and staff laid off for the first time in the museum's history. "As we have now learned," he admitted, blockbusters offered a quick fix but they "cannot sustain the future."[82]

From the 1990s a more complex and sophisticated response to financial challenges emerged at the MFA and other museums. Under a new director, Malcolm Rogers, blockbusters became more frequent to avoid down years between major events. The fiscal year 1998–99 witnessed three major impressionist blockbusters in a row: Monet in the 20th Century (569,000 visitors), Mary Cassatt: Modern Woman (230,750), and John Singer Sargent (320,000). In all there were seventeen shows during the year contributing to a total attendance of 1.7 million, a record-high 103,000 memberships, and a reported surplus of $1.9 million. The museum found new ways of exploiting the perennial appeal of impressionism, plumbing its own permanent collection for the exhibition Impressions of Light: The French Landscape from Corot to Monet (2002), which was marketed as a blockbuster with the usual ticketed entry, catalogs, and banners. Beyond impressionism, programming ventured into new areas of popular interest with exhibitions on fashion, jeweled tiaras, celebrity photographs, rock guitars, racing cars, and the clay animation characters Wallace and Gromit.

In addition to exhibitions, Rogers created new departments of marketing and development and visitor services ("whose mandate is to introduce a culture of visitor awareness to the Museum with the goal of exceeding visitor expectations");[83] invited "young people" to attend Friday "singles evenings"; hosted a dog show, business receptions, and corporate-sponsored events; entered lucrative partnerships with the Nagoya Museum in Japan and a casino in Las Vegas; rearranged the permanent collection to better promote the MFA's famous impressionist paintings; introduced tiered levels of membership; raised member fees and admission charges (among the highest in the United States);

expanded ancillary entertainment and culinary offerings; transformed the definition of the museum shop; and cut back on educational services to area colleges and universities that offered prestige but little profit. Rogers was heavily criticized in the art press and national media. "Show Me the Monet," was the title of the *Newsweek* article announcing the MFA's deal with the Bellagio casino resort in Las Vegas, and reporters had little difficulty securing a negative comment on virtually any of his initiatives from peers in the art establishment.[84] Those who criticized him, however, offered no constructive advice on how else to pay the bills at an institution that receives less than a quarter of 1 percent of its annual operating budget from state and federal sources.

Museum Shops

From the late nineteenth century through the 1960s, museum shops were often no more than a desk or corner in the lobby selling a few postcards and scholarly publications (fig. 100). Such materials were educational and offered as a public service. The subject of shops merited only a paragraph in Laurence Coleman's authoritative 1950 treatise on museums, and he was clear about their purpose: "Most small museums do their selling at the information desk, but some large museums have the sales job differentiated to the point of featuring a separate little bookshop. . . . A few badly run museums make the mistake of offering mere souvenirs and other unsuitable stuff; but, properly conducted, the business of selling is useful."[85] One wonders what Coleman would have made of retail operations at today's museums, which frequently extend beyond a large gift shop to include specialized blockbuster shops (fig. 101), satellite outlets in malls and airports, and online/catalog shopping services. The new commercialism is perhaps most conspicuous at shops that accompany blockbuster exhibitions, not infrequently positioned at the exit to the show. At the MFA gift shop accompanying Monet in the 20th Century (1998), for example, visitors were tempted by the following orgy of Monet products: scholarly catalogs and books, videos, posters, framed reproductions, T-shirts and sweatshirts, postcards and pens, Monet watercolor and paint sets, chocolate paint palettes, kaleidoscopes, toys, cosmetic bags, coin purses, desk blotters, napkin holders, address books, personal organizers, water lily boxes, photo frames, stationery sets, note cubes and cards, wrapping paper, pillows, aprons, umbrellas, tote bags, night lights, magnets, calendars, "Monet's Garden Latte Cup and Saucers," tray sets, trivets, soup bowls, cups, pasta dishes, plates, salt and pepper shakers, suncatchers, bottle stoppers, water bottle and cup sets, candle holders, soap, and Christmas tree ornaments. Set above the rest in terms of price was "Claude Monet's Museum Collection," a line of domestic wares labeled "antique reproduction porcelain pieces . . . patterned after Claude Monet's own beautiful, white and yellow collection which he often filled with fresh fruit or flowers

100. Walker Art Center Lobby Book Corner, ca. 1942. Photo: Rolphe Dauphin.
Photo courtesy of the Walker Art Center, Minneapolis.

101. Mary Cassatt exhibition shop, Museum of Fine Arts, Boston, 1999.

from his garden." During a two-month stretch the museum sold fifty thousand post-cards, thirty-four thousand catalogs, and ten thousand posters, not to mention plenty of what Coleman would surely have labeled "unsuitable stuff."[86] The MFA proved what retailers know to be true: "[A]nything Monet sells—anything."[87]

Under U.S. law, museums avoid tax liability if what is sold at their shops is related to their educational mission. But the connection can be tenuous at times. Take, for example, the following label found on a box of Christmas crackers on sale at the MFA: "Our festive crackers are decorated with designs from William Morris patterns housed in the Museum's collection. The breathtaking design work of Morris & Co., catalyst of the Arts and Crafts movement, created some of the world's finest wallpapers and tapestries. . . . Morris' credo was 'Have nothing in your house that you do not know to be useful or believe to be beautiful.'" Flimsy rationales of this sort (which, moreover, represent a travesty of Morris's beliefs) breed cynicism and disparaging comparisons to the shopping mall, but for many museums today commerce is essential. According to Malcolm Rogers, it is "one of the pillars of the success of the museum."[88] In the hope of increasing profitability, in 2002 the MFA became one of the first American museums to turn its retail division into a for-profit company. For its managers, if not also MFA staff, there is no shame in comparisons to a mall. "Museums are the new malls," said a buyer for the new store. "You can eat here, hang out, go to a movie or shop."[89] The atrium of Pei's West Wing (fig. 48), surrounded by potted trees, reflective surfaces, a café, movie posters at the theater box office, and a busy shop, makes analogies to a mall seem entirely appropriate. But does it matter if museums and malls overlap? The public clearly enjoys shopping in the museum; for many the shop has become an integral part of the visit.[90] With the rise of self-contained and attractive shopping precincts (sometimes occupying historic sites such as London's Covent Garden or Boston's Faneuil Hall), shopping has joined museum-going as a leading leisure activity, engine of urban renewal, and reason for travel. According to Jeffrey Inala, co-editor with architect Rem Koolhas of the *Harvard Design School Guide to Shopping* (2001): "We have reached a moment when culture and retailing can no longer be separated."[91] "Our culture is a commodity culture," observes John Fiske, "and it is fruitless to argue against it on the basis that culture and profit are mutually exclusive terms."[92] Koolhas himself is equally at home designing museums and upscale boutiques, notably his Prada store in New York (2001), described by the *New York Times* as a "museum show on indefinite display."[93]

Recurrent warnings (from the elite on the right and left) that commerce will erode the public's regard for museums have yet to be substantiated.[94] Commercialism has penetrated every facet of life in the United States, and it will slowly do the same everywhere. The challenge for museums is to be able to take advantage of commercial opportuni-

ties without sacrificing their rhetorical withdrawal from the everyday world. No one knows, or can agree on, where the line should be drawn. Leaving aside the tchotchkes that have no real relevance to the museum experience, the role of reproductions is itself a source of contention. Museums work hard to defuse the tension between the unique status of their masterpieces and their reproduction by defending the latter as a form of educational outreach. Note in the following statement from the Met store Web site how the museum blurs distinctions between original and reproduction, disinterested scholarship and commerce, in an attempt to sell shopping as central to its mission:

> Visitors to The Met Store often ask how our products are selected and produced. Every product created by the Museum is the result of careful research and expert execution by the Metropolitan's staff of art historians, designers, and master craftspeople, who ensure that each reproduction bears the closest possible fidelity to the original. The Metropolitan's reproduction and publication programs are a source of pride to the Museum, not only because they are executed with a focus on quality and attention to art-historical scholarship, but also because publishing and reproducing our collection is part of the original mission of the Museum, and has been a tradition here for over a century.[95]

Proximity to the original and a pedagogic purpose are what elevate the shop's contents— and the shopper—above the level of kitsch. Reproduction enhances the stature of the original while making it available to everyone, as Andreas Huyssen has noted: "The original artwork has become a device to sell its multiply-reproduced derivatives; reproductability turned into a ploy to auraticize the original after the decay of aura."[96] Referring to the role of reproduction in the tourist's worldview, Dean MacCannell has observed: "It is . . . mechanical reproduction . . . that is most responsible for setting the tourist in motion on his journey to find the true object."[97] Discovery of that object prompts the traveler to secure his or her own authentic ("I was there") reproduction in the form of a photograph, postcard, or other memento. For many, by extension, consumption of the reproduction frames, and is integral to, the experience of the "true object" in museums. Those who look down on museum shops and shoppers are the same people who denigrate mass tourism and the gaping crowds before the *Mona Lisa*. Art world insiders, who are invariably also citizens of the world, claim their own authenticity by distancing themselves from the tour groups and the Monet fridge magnets.

Though I have focused heavily on the Boston Museum of Fine Arts, it is hardly alone. Rising costs, shrinking government subsidies, and an uncertain economy have compelled museums everywhere, big and small, public and private, to behave more like businesses, expand their programs and buildings, and mount crowd-pleasing exhibitions. A small sampling of museums in the United States around the year 2000 reveals activities that would have been unthinkable a generation earlier. At the Brooklyn Museum

visitors were encouraged to "adopt a masterpiece" and join in karaoke evenings between visits to an exhibition of hip-hop culture (Hip-Hop Nation: Roots, Rhymes, and Rage, 2000) and a self-promoting exhibition of the Saatchi collection (Sensation, 1999).[98] A sparkling new entrance by James Polshek drew further attention to the museum. San Francisco's Museum of Modern Art organized an exhibition of athletic sneakers (Design Afoot: Athletic Shoes, 1995–2000), while the Houston Museum of Fine Arts hosted a show of *Star Wars* memorabilia (*Star Wars:* The Magic of Myth, 2001). Visitors to the Monet and Cézanne blockbuster shops at Brooklyn and Philadelphia found everything from soup mixes and olive oil to Rodin-shaped pasta and autographed Cézanne baseballs for sale.[99] The Philadelphia Museum went one step further by packaging the Cézanne show and its products for a home shopping television network. Thanks to admission fees and shop sales connected to the exhibition Van Gogh: Face to Face, the Detroit Institute of Arts saw its miscellaneous income in 2000 rise nearly tenfold over previous years to $9.6 million.[100] Even the Met, despite Montebello's outspoken distaste for commerce and entertainment, boasts a solid record of corporate and retail involvement. "The Business behind Art Knows the Art of Good Business," announced a Met brochure hoping to attract corporate sponsors in the mid-1980s.[101] In 2001 the museum operated thirty-nine stores worldwide, producing over $87 million in revenue.[102]

No museum has gone further to emulate a business model than the Guggenheim under Thomas Krens. With degrees in fine art and financial management, Krens is the venture capitalist of the museum world, leveraging the Guggenheim collection and exporting the Guggenheim brand to new "branch" museums (franchises?) around the world. Since the 1990s he has angered the art world establishment by hosting exhibitions of motorcycles, Armani fashion, and the paintings of Norman Rockwell and doing business with a Las Vegas casino (fig. 94).[103] While other directors quietly oversee the expansion of shops and restaurants, Krens openly embraces business practices and discourse. His by-now famous formula for the successful museum embodies values and language that his mainstream colleagues abhor: "Great collections, great architecture, a great special exhibition, a second exhibition, two shopping opportunities, two eating opportunities, a high-tech interface via the Internet, and economies of scale via a global network."[104] Even more commercial are the terms the Guggenheim's director of corporate relations used to defend its policies: "We are in the entertainment business, and competing against other forms of entertainment out there. We have a Guggenheim brand that has certain equities and properties."[105] Traditional museum people have always loathed Wright's building (as a museum), and its transformation into a seeming showcase for motorcycles and haute couture has only hardened attitudes. The press has reported Krens's triumphs and travails with great interest. Retrenchments at the museum following a downturn in the post-9/11 world economy prompted the following from

Once in a lifetime.

Rembrandt by Himself

Sixty self portraits assembled from all
over the world for the first time ever.

9 June – 5 September
The National Gallery
www.nationalgallery.org.uk

102. Advertisement for the Rembrandt's Self-Portraits exhibition,
National Gallery, London, 1999.

Michael Kimmelman: "You could almost hear the door shut on an era. The age of the go-go Guggenheim was over. . . . Having mimicked the dot.com businesses of the era, the hype about global networking, cutting-edge growth and a new economy, Mr. Krens's dream, like the bubble of the dot.coms, burst. . . . Mr. Krens was right in one sense. Arts institutions are not really different from other businesses, at least not when they act like them. They are just as vulnerable."[106] The Guggenheim empire may decline and fall; even the successful venture in Bilbao may wither over time, but the hard reality that museums are part of the entertainment industry and will need to innovate to survive financially cannot be wished away. As MoMA director Glenn Lowry has acknowledged: "No museum, except maybe the Getty, has an endowment big enough to be free of the marketplace, so all other museums have to retail products, solicit corporations, franchise themselves, seek members."[107]

The economic challenges of the 1970s and 1980s affected small private museums as much as large civic ones. In Boston, inflation and pressing conservation needs awoke the Isabella Stewart Gardner Museum after decades of genteel slumber. Gardner's original endowment no longer covered expenses, the café ran at a loss, the modest shop barely broke even, and the membership program cost more than it earned. The century-old building badly needed climate control. An aging board of trustees had neither the expertise nor the personal resources to solve the problem. In 1987 a new director, Anne Hawley, modernized the museum from top to bottom, reforming and enlarging the board of trustees and initiating financial planning, a capital campaign, development and public relations departments, and dynamic new programs. Only the museum's installation, set in stone by the terms of Gardner's will, remained the same.[108]

Recent cutbacks in government funding have left European museums with little choice but to follow suit. Throughout Europe governments are pressuring museums to earn more of their own keep through increased retail, catering, and corporate sponsorship.[109] The most august of state-run museums have begun to hype blockbusters (fig. 102) and open their doors to commerce. Donor plaques and "naming opportunities" are as commonplace in Europe as they are in the United States. Beneath I. M. Pei's Pyramid at the Louvre, visitors may browse and eat at an American-style shopping mall and food court.[110] Corporate funds paid for the Louvre's new English galleries and *Mona Lisa* room and for the restoration of the Apollo Gallery. In 2007, the Louvre sold its name for $520 million to a new museum rising in Abu Dhabi.[111] Money from a chain of grocery stores and a French couturier paid for the Sainsbury Wing and the Yves Saint Laurent Room at London's National Gallery. The Spanish government hoped 40 percent of the Prado's budget would be covered by corporate donations by 2008.[112] Museums in Italy are be-

ing privatized.[113] And so on. Where once Europeans scoffed at the commercialism of U.S. museums, now they are looking across the Atlantic for ideas and cash, in some cases entering into joint commercial ventures and appealing directly to wealthy North American donors.[114]

Weighing the Costs of Commercialism

Given that special exhibitions, shops, and other amenities are now vital to the success of many museums, what benefits and disadvantages do they bring? On the plus side, new buildings, shops, and restaurants have made the museum a comfortable and lively destination. Neighborhoods and cities have been rejuvenated. High-profile temporary exhibitions have drawn the public to museums in record numbers. Exhibitions of guitars and fashion, though reviled by some, attract new audiences. Blockbusters raise the profile of the institution, locally, nationally, and internationally. In theory at least, exhibitions stimulate new levels of interest in permanent collections. Museums bring the world closer to home and cultivate global understanding. For the scholar and the museum habitué, blockbusters offer rare opportunities to see assembled masterpieces, leading to fresh appreciation of individual careers and historical moments. The revelatory power of great works of art brought together to illustrate a life's work or to support a coherent thesis is beyond dispute. Owing to its sense of occasion, a great exhibition reaffirms the pleasures to be had from viewing beautiful objects in real time and space, and no amount of revisionist thinking or Internet access can diminish that experience. The catalogs and symposia that accompany exhibitions often constitute scholarship of a high order. Blockbusters also help pay for smaller exhibitions that may have less appeal but shed new light on lesser-known corners of the history of art. One museum that balances its exhibition schedule well is the Met in New York. Refusing to charge extra for special shows ("We won't do an exhibition just for the gate," says the director),[115] the Met frees itself and encourages the public to explore a wide range of subjects. The museum does its share of impressionist exhibitions, but it will also organize Tilman Riemenschneider: Master Sculptor of the Late Middle Ages (1999) or Warriors of the Himalayas: Rediscovering the Arms and Armor of Tibet (2006).

As we have seen, there can be no denying the economic benefits of the blockbuster to museums, local cities, and even nation-states. Ever since the King Tut exhibition swept Europe and the United States in the 1970s, museums routinely estimate the contribution exhibitions make to local coffers in the hope of winning city funds and concessions and corporate support. The 613,000 people who saw King Tut when it stopped in New Orleans in 1978 spent an estimated $89 million in the area, generating tax revenues of $4 million. According to the Met the same show drew 1.2 million visitors and pumped

$110 million into the New York economy.[116] The success of the exhibition in Seattle helped persuade the city to build a new museum. And who's to say how much good King Tut did for Egypt in terms of trade, tourism, foreign loans, student exchanges, defense contracts, and international goodwill? A second world tour of ancient Egypt's boy king (Tutankhamen and the Golden Age of the Pharaohs) from 2005 will pay for the refurbishment of Egyptian museums.[117]

On the other hand, in the negative column, delicate works of art risk long-term damage from travel and exposure to varying atmospheric conditions.[118] The *Mona Lisa* was considered by its custodians too fragile to travel in 1963, but it went to Washington anyway; similarly, over seventy years ago the Italian Renaissance blockbuster at the Royal Academy (1930) took place against the better judgment of many museum professionals. Politics drove those exhibitions, and in some cases still does, but today financial considerations and curatorial vanity are primarily what lie behind the continuation of risky international loans. Where once museums lent works of art for scholarly purposes, many now charge significant loan fees or stage traveling shows for money. The constant pressure of organizing new exhibitions has taken curators away from the needed but less glamorous work of researching permanent collections. Museums argue that temporary exhibitions lead visitors to discover the permanent collection, but in most museums the crowds congregate in the exhibition halls or in those parts of the collection popularized by blockbusters. The constant search for corporate sponsorship of exhibitions creates the appearance of museums for hire, eroding public confidence in the independence and integrity of the institution.

Corporate Sponsorship

The most sensitive funding issue of recent years concerns the museum's increased reliance on corporate sponsorship to meet the high costs of staging the exhibitions that draw the crowds and pay the bills. Museums need the large volumes of people that exhibitions attract, and exhibitions require outside funding. Key to many exhibitions' success is effective marketing and publicity, which corporate sponsors are willing to underwrite in exchange for self-promotion. The advantage to sponsors is association with a "clean" and uplifting product—art—and access to an affluent public. Most attention has been paid to sponsorship of exhibitions, but sponsors also step forward to support popular and lucrative museum-based events, such as "singles" nights, free visits, concerts, and fund-raising dinners.

Though sponsorship began in the 1960s as a form of philanthropy, its economic benefits were easily apparent. In 1967 David Rockefeller encouraged fellow business leaders to support the arts in the following terms: "It can provide a company with ex-

tensive publicity and advertising, a brighter public reputation, and an improved corporate image. It can build better customer relations, a readier acceptance of company products, and a superior appraisal of their quality. Promotion of the arts can improve the morale of employees and help attract qualified personnel."[119] Thirty years later, the Smithsonian's secretary, I. Michael Heyman, provided more detailed insights into corporate thinking: "Two of our sponsors made it clear . . . that the value of the Smithsonian to corporations lies in pairing our identity (or 'brand') with that of a corporation ('co-branding'). In corporate eyes, our well-known identity bespeaks 'American,' 'integrity,' 'familiarity,' 'family,' 'history,' 'technology,' 'art' and similar concepts."[120] What corporations value will vary from one museum and exhibition to the next, but clearly "co-branding" makes good business sense and provides a guide to museums seeking support. Many corporations might be willing to associate themselves with the feel-good popularity of a Renoir exhibition, but more obscure shows require more creative solutions. For example, a 1989 Canaletto retrospective at the Met was sponsored by Louis Vuitton, matching a luxury luggage maker with an artist synonymous with the golden age of travel. German Art of the Twentieth Century at London's Royal Academy in 1985 was backed by Lufthansa and Deutsche Bank, two German powerhouses with a strong international profile.

Because sponsors expect good publicity in return for financial support, the fear is that they will interfere with the contents or message of an exhibition in pursuit of the right image. Such concerns, reasonable at any time given the profit motive behind sponsorship, were especially acute during the "culture wars" of the 1980s and 1990s, when censorship was in the air and conservative politicians targeted certain exhibitions to justify reducing government support for the arts, forcing museums into the open arms of corporations.[121] Examples of direct meddling are difficult to find, however (at least they are very hard to see from the outside looking in). It would seem that ideologically driven political coercion (from the left and right) poses a greater threat to a museum's autonomy than profit-oriented businesses. Addressing fears of corporate intervention, Philippe de Montebello remarked: "[T]he only time I have seen curatorial integrity somewhat compromised [at the Met] is when there has been no sponsorship and I've had to ask, 'Which pieces can be dropped from the show?'"[122] Yet even as Montebello denied interference, he revealed that the real problem museums face is an inability to secure sponsorship. Without funding, compromises must be made and whole exhibitions may be canceled. To ensure smooth planning and avoid wasted time and effort, the natural tendency is to favor exhibitions likely to find sponsors; and the tougher the economic climate, the more this will be true. In other words, corporate censorship may not be an issue, but self-censorship from within almost inevitably is. As Hans Haacke put it in the late 1980s:

> It is fair to assume that exhibition proposals that do not fulfill the criteria for corporate sponsorship risk not being considered, and we never hear about them. Certainly, shows that could promote critical awareness, present products of consciousness dialectically and in relation to the social world, or question relations of power have a slim chance of being approved—not only because they are unlikely to attract corporate funding, but also because they could sour relations with potential sponsors for other shows. Consequently self-censorship is having a boom. Without exerting any direct pressure, corporations have effectively gained a veto in museums. . . . Museums are now on the slippery road to becoming public relations agents for the interests of big business and its ideological allies.[123]

It goes without saying that museums in need of revenue program exhibitions that have a good chance of attracting the public, and therefore sponsors. As Haacke suggests, potentially challenging or unpopular exhibitions have difficulty getting off the ground. Controversy is avoided.

What is lost is not only the type of confrontational shows that Haacke had in mind but exhibitions that might expand the public's taste beyond the familiar favorites—impressionism, the Old Masters, and Egyptian treasures. We would surely all agree with James Wood, former director of the Art Institute of Chicago, when he said the goal of a responsible museum should be "to develop critical appreciation where enjoyment and understanding are combined with the self-confidence to exercise an informed personal taste. The goal of such a museum is not a herd of customers but an individualized public which has learned what it *does not,* as well as what it *does* like."[124] But it is precisely this ideal of creating a critically informed, open-minded public that is swept aside when the success of a museum's program is measured by attendance figures and shop revenue. If once upon a time programming was determined on high by curatorial inclinations, in the blockbuster era it is driven as much from the bottom up by marketing surveys and the lowest common denominator. The logic of the bottom line dictates that museums follow—but rarely challenge—public taste. In practice, the public is given little chance to determine "what it *does not,* as well as what it *does* like."

The art historian John House offers a telling story about an exhibition he organized in the mid-1990s. His Landscapes of France (1995) aimed to contextualize the achievement of the impressionists by showing their familiar works alongside contemporary landscapes by once-popular but now-forgotten artists. As first installed at London's Hayward Gallery, impressionist paintings constituted 50 percent of the show; Monet and Pissarro rubbed shoulders with the likes of Luigi Loir and Antoine Chintreuil. But when the exhibition moved to Boston's MFA the title was changed to Impressions of France and the proportion of impressionist paintings increased. What originally had been a revisionist exercise by a leading scholar was repackaged as an impressionist blockbuster. But, as House notes, the MFA knew what it was doing: "Attendance figures—double

the number in Boston, despite less press coverage than in London—suggest what the public wanted."[125]

If challenging or obscure topics are a casualty of blockbuster culture, giving the public what it wants has led museums to cross over the high/low cultural divide in search of new material—jeweled tiaras, racing cars, rap culture—and new publics. Such exhibitions have attracted a broader cross section of the public (whether they return to see other exhibitions or the permanent collection is unclear), and thus have helped to defuse charges of elitism, but they have upset academics and curators who remain faithful to the established canon of high art.[126] For better or worse, and notwithstanding the spread of an evidently less elitist art history, tiaras and racing cars have yet to figure in university curricula. Even left-leaning museum critics, who have long complained about the art museum's exclusive tendencies, share the old guard's distaste for commerce and anything that is too popular with the masses. The "losers" in the blockbuster sweepstakes are those curators and academics whose own interests and scholarship are compromised or marginalized in the pursuit of what will sell.[127] Aspects of the permanent collection currently unpopular with the public will languish in benign neglect, receiving lower priority in acquisition funds and exhibition opportunities. Also suffering are smaller museums that can't pay the fees or lack the clout and collateral to enter the give and take of reciprocal loans that underpin the blockbuster system ("We'll lend you our Monet if you'll let us borrow your Rembrandt next year").[128] Small museums are no less dependent on special exhibitions and marketing to draw the public, but they operate with lower expectations; patronage and publicity will be local, and instead of Monet they must settle for impressionists of the second rank, Maurice Prendergast or Walter Sickert. Finally, professional art critics also are at risk of losing their stature in an environment that treats Norman Rockwell as seriously as Jackson Pollock and banks on familiar subjects that need no introduction.

The drift toward popular showmanship and fund-raising in recent decades has created tensions within museums between directors and trustees and between curators and directors. For most of the twentieth century, directors came from the curatorial ranks and shared a commitment to art and scholarship; neither they nor curators entered the profession looking to spend their days wooing donors and assuaging trustees bent on running a museum like a business. Discreetly cultivating collectors and benefactors is nothing new—curators have always been courtiers of a sort—but hustling for money and monitoring attendance have become priorities at many institutions and overshadow the scholarly and creative aspects of museum work that lured most into the field in the first place. Explaining why she left her position as director of New York's New Museum of Contemporary Art in the late 1990s, Marcia Tucker explained: "To direct an institu-

tion nowadays you have to be an opportunist. You have to use every social situation you get to think about fund raising and social contacts. Sorry, but the cocktail-party conversation is not my preferred mode of thought."[129] Because of the new pressures, curators have less desire or aptitude to become directors, and vacancies at the top have become harder to fill. In large institutions a recent trend finds more directors who have business training or who share power with deputy directors who do.

At the turn of the new millennium, the problem of coercive funding again made the headlines. In 1999 it was revealed that an exhibition at the Brooklyn Museum, Sensation: Young British Artists from the Saatchi Collection, had been financially backed by the collector himself. Because exhibitions at major museums tend to raise the financial value of their contents (at least in the short term) and because Saatchi is well known for speculating in the art market, it seemed at least possible that there was more to his support than a desire to broaden public taste. Equally problematic was the report that Saatchi had had significant involvement in the selection and installation of the artwork.[130] Notwithstanding obvious conflicts of interest, the Brooklyn Museum went forward in the hope that the sensational, provocative content of the exhibition would boost attendance, membership, and revenues. Who could resist a spectacle that, in the words of the museum's advance publicity, "may cause shock, vomiting, confusion, panic, euphoria, and anxiety"?[131] Confirming the postmodern maxim that "any publicity is good publicity," tabloid marketing and controversy generated by Chris Ofili's *The Holy Virgin Mary* (1996), depicting Mary as an African woman covered with elephant dung and pornographic magazine clips, helped turn an exhibition of relatively unknown "young British artists" into a box office success (175,000 attended the show). Ironically the attention generated by the politically motivated outrage of then–New York mayor Rudolph Giuliani stood to further jeopardize public funding for the arts and make private sponsorship all the more inevitable. One year later, the coincidence of an exhibition of Giorgio Armani fashion at the Guggenheim and a $15 million Armani gift to the museum created the appearance of an institution for sale.[132] The museum's denial of any connection between the two did little to satisfy the critics. As at Brooklyn, reports filtered out that Armani had had a say in what pieces to include in the show. Roberta Smith quipped in the *New York Times:* "A few more shows like Armani and it won't matter how many architectural masterpieces the Guggenheim can afford to build [referring to Bilbao]; they will just be rentable exhibition halls."[133]

Shock and indignation erupted in the wake of Sensation. While Giuliani and the Catholic Church fumed over Ofili's black Virgin, art world insiders decried the clear conflict of interest. Though museums frequently display personal collections ("vanity exhibitions," as they are known) in the hope of securing future gifts and the same newspa-

pers that cried foul over Sensation happily review many such shows, the Saatchi case was seen to have overstepped the bounds of propriety.[134] But where precisely is the line to be drawn between ethical and unethical conduct? In 2000, as a result of the Sensation sensation, the AAM issued a set of guidelines to help institutions guard their integrity while "developing and managing support from business."[135] Despite well-meaning and commonsense boilerplate concerning conflict of interest, transparency, and full accountability, the criteria remain vague, and in the end museums are left to draw their own lines. "There are no clear-cut ethical standards about exhibition funding practices. . . . Any search for absolutes will likely lead nowhere or, worse, to standards that don't work," writes András Szántó. "Ethical standards always emerge from an always-shifting consensus. A practice unpardonable in the past may be considered normal today, or tomorrow."[136] For Glenn Lowry, director of MoMA, the museum's unavoidable dependence on the marketplace—on sponsors, shops, and so on—necessarily involves compromise, leaving it "to each institution to make sure that none of it affects the content of the exhibitions or the integrity of the museum."[137] MoMA turned a spotlight on itself by opening its new $850 million building with a special exhibition that, at the very least, let everyone know how important corporate patrons are to the future of the museum. Contemporary Voices: Works from the UBS Art Collection (2005) featured a random, pedagogically unfocused selection of works given or promised to MoMA by the financial services giant.[138] The blue-chip paintings came from the former Paine Webber art collection (which had toured the United States as such less than ten years earlier), assembled under the leadership of former Paine Webber chairman and CEO Donald Marron, a trustee and one-time president and vice chairman of MoMA's board. UBS funded the MoMA exhibition and catalog. In exchange for paintings the museum could not afford to buy on the open market, MoMA offered UBS its imprimatur and publicly acknowledged a loyal servant and benefactor.

In a society unwilling to adequately fund arts organizations, fund-raising is a necessary evil, fraught with potential for abuse and peril for museums guided by high ideals. If critics see little difference between the "arm's-length" support of corporate sponsors and the intervention of an Armani or Saatchi, for those who work in museums what is at stake is their own professional status and control. Fund-raising is a fact of life under capitalism, but when money is offered in exchange for a sponsor's direct involvement in the exhibition, an institution's authority is undermined along with the public's trust. If a corporation is given free rein to execute and promote an exhibition, the museum is reduced to a marketing tool, its standing as independent tastemaker is compromised, and its curators and staff are made redundant. If we accept Montebello's claim that the only time sponsorship compromises an exhibition is when there is none, we might also wonder if the only time a museum rejects sponsorship is when it threatens curatorial

control. The Sensation and Armani shows were dangerous precedents not least because they raised the specter of a market-driven future in which curators would no longer be needed and museums would just be rentable exhibition halls.

■ ■ ■

Much of the discussion around museum funding and the rise of commercialism hinges on untested assumptions about public attitudes. Does the museum-going public care (or notice) who sponsors an exhibition, whether Armani paid for or planned the Guggenheim show, that motorcycles or Norman Rockwell occasionally invade the spaces of high art, or whether a museum shares certain features with an upscale shopping mall? Museums don't include such questions on their exit surveys, but to judge simply by attendance figures and shop revenues, the public—that is to say the mass, blockbuster public on which many museums now depend—evidently has no problem with any of it.[139] Absent a healthy endowment, museums must cater to a broad audience and corporate donors while not alienating their established constituencies (including their staff)—a challenge they have met thus far through diverse programming and amenities, stratified membership levels and benefits, and the simultaneous embrace of financial opportunities and traditional ideals.

As for corporate sponsorship, the art museum is no more or less susceptible to conflicts of interest or distanced from the market than other institutions, including the universities that house the market's sharpest critics. Virtually everything today is sponsored. For the time being, at least, the public appears to be willing to accept corporate support as the price of being entertained and educated. In any case, are the alternatives any better? Originally the Boston MFA rejected local government support to protect the autonomy of its governing board, but to what extent do the interests of a Brahmin elite and the general public converge? The recent "culture wars" and diversity targets for museum admission reveal that state funding can come with stringent conditions of its own. As Gilbert Edelson has remarked, when government funding is provided, "it is almost always followed by a protesting politician."[140] In defense of corporate sponsors it should be noted that just as not all rich people like or use art for social distinction, not all corporations see museum sponsorship as a good investment. If sponsorship of exhibitions and programming were so effective as a public relations tool, there would be much more of it. More than a simple business venture, corporate support of museums must at some level involve a genuine commitment and enthusiasm for the cause.

Beyond conflict of interest and professional integrity, the blurring of lines between art, entertainment, and commerce inside the museum is a test of attitude and ideology. Those who have worked in or long enjoyed the purified high-art museum inevitably resist its passing. On the other hand, the art museum as we know it is itself a fairly re-

cent invention born of conflict with a contrary utilitarian tradition. John Cotton Dana, Philip Youtz, and others bemoaned the rise of the aesthetic museum just as traditionalists today regret its seeming demise. The crucial difference between then and now is that in the 1920s collaboration with business was pursued in an effort to broaden access and improve public taste, but now money is the motive. The merchants and designers had been driven from the temple; now their readmission through the back door threatens the ideal of the museum as a refuge from material concerns. Postmodernists would counter that the autonomy of art no longer carries weight; museums constitute an important source of bourgeois entertainment and escape, but so do travel, eating out, and shopping in an attractive, carefree environment. Museums that fail to offer diverse forms of stimulation risk obsolescence in our hypermodern era.[141] More threatening to the escapist appeal of the museum than shops or cafés are reminders of the complex social world visitors have temporarily chosen to leave behind, which is why exhibitions that "question power relations" and provoke "critical awareness" of issues, including corporate self-interest, hold so little interest for so many museum-goers. As Herbert Muschamp said of the Armani "scandal": "What a bore it is to think about such matters when you're looking at pretty things."[142]

Rather than lessening the allure of museums, is it not possible that blockbusters, concerts, restaurants, and shops have added to it? Be that as it may, we shouldn't exaggerate the demise of the traditional art museum and the suffering of its faithful constituents. For those who care about high art and seek quiet contemplation, much of the old museum still remains. Commercialism is the cost of the peace and beauty that still reigns in the galleries far removed from the shops and restaurants.

There is no document of civilization which is not at the same time a document of barbarism. **Walter Benjamin (ca. 1940)**

6 RESTITUTION AND REPATRIATION

Of all the topics covered in this book, none threatens the utopian aura of the art museum more than restitution and repatriation. Mounting requests for the return of cultural treasures currently housed in European and U.S. museums have brought to light troubling ties to some of the darkest episodes in modern history, including the Holocaust during World War II and the subjugation of indigenous peoples under colonial rule. What these requests suggest is that the selfsame objects that museums promote as transcendent, life-enhancing masterpieces may, in the untold story of their provenance (if not their creation), also confirm Walter Benjamin's dictum that civilization always masks injustices committed in its name. At what cost were these products of human creativity acquired by the museum? Wall labels happily tell us who gave the objects to museums but not how the donors got them or where they originally came from. By calling to mind the unhappy pasts of many treasures and the inequities of power and cultural resources in the world today, the issue of restitution dampens the celebratory spirit of museums.

Behind recent headlines of Nazi plunder, the looting of cultural sites, and Greek demands for the repatriation of the Parthenon (Elgin) Marbles lie deeper philosophical conundrums involving restitution that may be summarized in the following propositions:

1. Museums are dedicated to the preservation and study of works of art, but when those aims involve the removal of an object from its original site or context the integrity and purpose of both object and site are compromised.
2. Museums cannot replace or "explain" an object's past life and highlight its unique aesthetic properties at the same time.
3. Museums must grow or they will die, and no collection can ever be complete, but growth may involve behavior that is viewed, at least by some, as unethical, if not illegal.

4. By displaying objects of other cultures museums further global understanding, but in so doing they deprive those cultures of the right to represent and determine the fate of their own heritage.

5. Pressure on museums to become more inclusive in their definition of art and representation of other cultures ironically negatively affects those cultures by stimulating new markets and incentives for the despoliation of archeological sites and illicit trafficking of artifacts.

Since much of what any museum contains was not made to be displayed there, questions of ownership and propriety may be raised on numerous levels. Who determines what is in the best interests of works of art, and according to what criteria? Does the long-term survival and pedagogic value of an object in a museum justify its removal from its original site and the inevitable loss of aesthetic and ritual significance that derived from context? Do the notional interests of posterity matter more than local customs and memory? How do we adjudicate between the goal of preservation, sacred to all museums, and the sacred rights of individuals and peoples to claim what is theirs by law or tradition? Do requests for the return of artistic treasures hinge solely on legal jurisdiction (if so, whose?), or are there circumstances in which moral, political, and even sentimental factors outweigh the law? Is there, in effect, a "statute of limitations" that invalidates demands for objects acquired long ago under different geopolitical conditions? At what point does refusal to return cultural treasures amount to a repudiation of the civilized values museums claim to uphold? Should rich Western museums somehow compensate, or share their resources with, the resource-poor countries whose cultural property they collect?

More questions could no doubt be added to this list, yet these alone suggest why restitution and repatriation constitute difficult areas of museum governance and international law. Moreover, no two cases are the same, making generalizations impossible. Different museums face different challenges. Older European museums have more problems with the legacy of colonial rule than do museums in the United States, but the latter, in their efforts to catch up with the former, have been more deeply implicated in the postwar acquisition of looted art and artifacts. Art museums have had little involvement in the repatriation of human remains that has plagued museums of natural history and anthropology. Such differences notwithstanding, what complicates the question of cultural property is a universal commitment to the museological ideals of preservation, pedagogy, and plenitude. The fundamental tensions between the museum's mission and restitution demands are revealed in a review of notable cases stretching from the Napoleonic Louvre and Elgin Marbles to recent claims stemming from World War II and looted antiquities.

The Louvre

The story of the rise and fall of the revolutionary and Napoleonic Louvre rehearses essential features of each and every restitution case down to the present: the fantasy of a universal collection that justifies the forced acquisition of public and private collections at home and abroad; the arrogance of one nation convinced of its superior enlightenment removing cultural property from another in the name of preservation, scholarship, and civilization; the use of such disinterested rhetoric to mask political, imperial, and even economic interests; the feebleness of law and treaties in the face of power and greed; and the realization that museumification alters an object's purpose and meaning, and thus the public's relationship to it.

The story of the Louvre's creation is well known by now, but it is worth stressing again in this context that the desire to create the greatest of art museums could be realized only through the forced appropriation of works of art that before 1789 had belonged elsewhere—above church altars, in civic buildings and princely palaces.[1] Nothing on display at the Louvre when it opened in 1793 had been made for a museum—or for the French republic, for that matter. Both the museum and the nation as a sovereign political entity were creations of the Revolution, founded on the ruins of institutions that theretofore had provided all meaningful sustenance for artists. From a revolutionary point of view, however, the museum was an act of creation and sign of progress: the open enjoyment of a nationalized collection of fine art in a liberated royal palace demonstrated the triumph of enlightenment over superstition, the people over the privileged elite, and public education over private pleasure. Symbolic as well as useful, the Louvre Museum became a chief ornament of the newly founded French state. After 1792 and the start of armed aggression against France's enemies, beginning with Belgium and Holland (then the Austrian Netherlands), the spread of republican virtue justified the confiscation of art for the Louvre in conquered lands.[2] The "liberation" of new territory brought foreign institutions under French law; churches in Belgium, like those in any French province, were made to cede their pictures and property to the state; when the Dutch Statholder fled The Hague for England, he was treated like any other émigré and his art was confiscated. If at first confiscation was haphazard and associated with general looting accorded by tradition to a victorious army, from 1794 it became organized and focused on the aggrandizement of the Louvre and other Paris institutions. Well-informed experts sent from France systematically despoiled cities and churches of paintings by Rubens, Van Dyck, and other Old Masters.

The forced seizure of cultural property was cloaked in a heady rhetoric hailing the superior enlightenment, politics, and aesthetic sensibility of the French. Because, it was argued (on the basis of the precedent of ancient Greece), the arts flourished most in a

land of liberty, confiscation abroad was an act not of theft but of liberation and reloca-tion to the only place great art could be truly cultivated and appreciated. According to that logic, the world would one day thank France for its enlightened intervention. In a speech heralding an early shipment of Belgian paintings to the Louvre, the artist Luc Barbier declared: "The fruits of genius are the patrimony of liberty. . . . For too long these masterpieces have been soiled by the gaze of servitude. It is in the bosom of a free people that the legacy of great men must come to rest. . . . The immortal works of Rubens, Van Dyck and the other founders of the Flemish school are no longer on alien soil. . . . [T]hey are today delivered to the home of the arts of genius, the land of liberty and equal-ity, the French Republic."[3] The steady stream of treasures from the Low Countries fu-eled visions of Paris becoming an unrivaled hub of learning and the Louvre a museum to end all museums. In a tract of 1794, the politician Boissy d'Anglas envisaged Paris as "the asylum of all human knowledge . . . the capital of the arts, the school of the uni-verse."[4] For revolutionaries there was no contradiction between this utopian dream and the violence required to make it come true; the end justified the means. With the Nether-lands under French control, acquisitive eyes looked south to Italy and its supreme trea-sures. "Certainly, if our victorious armies penetrate into Italy," wrote Abbé Grégoire, "the removal of the Apollo Belvedere and the Farnese Hercules would be the most bril-liant conquest."[5] Two years later the French army duly invaded Italy under the command of Napoleon Bonaparte and set about appropriating the most famous works of art on the Italian peninsula.

By all accounts Napoleon cared little for the finer points of art, but he was well aware of its propaganda value. He knew the worth of his official painters, Jacques-Louis David and Baron Gros, and he understood the universal esteem in which the masterpieces of antiquity and the Renaissance were held. As a student of history, he knew as well that it was expected of him as successor to the leaders of ancient Rome to treat cultural prop-erty as trophies of war. The Arch of Titus in Rome with its bas relief recording the loot-ing of Jerusalem in 70 CE was a direct inspiration for Napoleon's Arc du Carrousel, which throughout his reign served as a pedestal for the famous bronze horses of San Marco, taken from Venice in 1797.

Napoleon differed from the emperors he sought to emulate in two fundamental re-spects, however: first, he sought to legitimate confiscation of art through treaty agree-ments; and second, he took not for himself but for public institutions in France and the benefit of the French people. Beginning with armistice agreements signed in Parma and Modena in May 1796, the looting that had taken place earlier north of the Alps was replaced by the stipulated surrender of a precise number of artworks: twenty objects from Parma, Modena, and Venice, respectively, a hundred from the Papal States, and so forth. The numbers seemed reasonable, a measured sum rather than arbitrary plun-

der. Private collections were left untouched (though other forms of pressure were used to acquire desirable privately owned objects, like the Venus de Medici and the Borghese Warrior). Successor to the Romans, Napoleon was equally a child of the Enlightenment and was keen to give his actions the semblance of rational conduct. In his memoirs he noted with pride that his use of treaties to acquire art was unprecedented.[6] He made a conspicuous show of distinguishing between acquisition by treaty and unlicensed looting: two days before signing the Armistice of Bologna (June 23, 1796), which compelled the pope to cede one hundred works of art to France, Napoleon had a soldier shot in front of his troops for stealing a chalice from a church.[7]

For those conquered by Napoleon, on the other hand, it made little difference how the art was taken. Italians experienced the appropriation of their famous masterpieces as a form of psychological warfare. Rome, and indeed much of Italy, was already a museum, as the Frenchman Quatremère de Quincy described it in 1796, and the loss of crucial parts of its collection to an upstart museum in Paris was a blow to collective pride, even though Italy had yet to become a unified nation. This is how a newspaper in Milan described the loss of the Apollo Belvedere from the Vatican: "Bonaparte has left the Pope in Rome, but he has taken the Apollo. Certainly the priest is useful to Rome, but Apollo is a god and this god nourishes the city he inhabits every bit as much as the priest, and even more than that priest, is the glory of the city."[8]

Back in Paris the arrival of Napoleon's booty was cause for celebration. The convoys from Italy were paraded through the streets of the capital accompanied by elaborate festivities (fig. 103). A song written to greet the caravan of papal antiquities from Rome in 1798 concluded with a remarkable declaration: "Rome is no more in Rome, It is all in Paris." A banner made for the statues read: "Monuments of Antique Sculpture. Greece gave them up; / Rome lost them; / Their fate has twice changed; / It will not change again."[9] The press, meanwhile, eager to fan the flames of patriotism, identified the acquisition of great works of art as fitting recompense for the loss of French life on the battlefield. "It is not slaves, or even kings that [France] wants chained to the chariot of victory," wrote a leading newspaper. "[I]t is the glorious remains of art that she wants to adorn her triumphs."[10] Further military campaigns in Germany and Spain yielded many more treasures for Paris. At the Louvre, the director Dominique Vivant-Denon became the emperor of the museum world, guiding new acquisitions and the building of the greatest art collection the world had known. Cementing the Louvre's identity as a public monument and propaganda tool, the Grand Gallery was used for important ceremonial events, including Napoleon's second marriage to Marie-Louise of Austria in 1810 (fig. 104).

Precisely because the museum had become an important imperial symbol, the allies demanded its dissolution following Napoleon's defeat in 1815. Though just a year earlier,

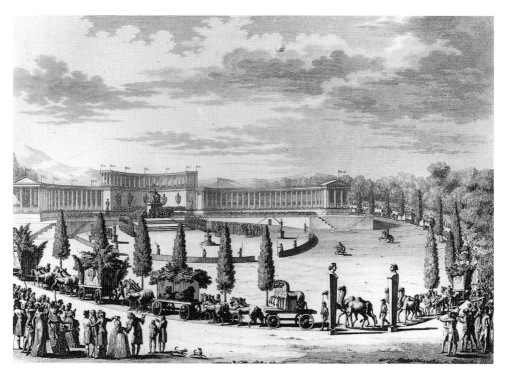

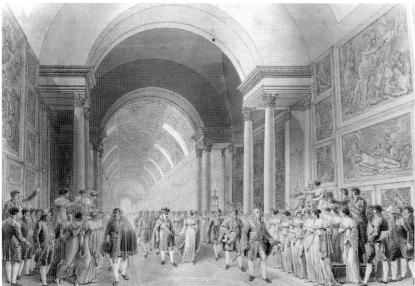

103. Pierre-Gabriel Berthault, *Triumphal Entry of the Monuments of the Arts and Sciences,* 1798. Engraving. Photo courtesy of the Courtauld Institute of Art, London.

104. Benjamin Zix, *The Marriage Procession of Napoleon and Marie-Louise through the Grand Gallery of the Louvre,* 1810. Pen and ink, wash, 40 × 60 cm. Photo: Réunion des Musées Nationaux/Art Resource, New York.

following the emperor's abdication and first exile on Elba, the allies had decided to leave the Louvre intact as a gift to the new Bourbon king, the renewed aggression of the Hundred Days culminating in Napoleon's surrender at Waterloo caused a swift change of heart. Following his victory, the duke of Wellington wrote with respect to the museum: "[T]he circumstances are now entirely different."[11] In his opinion the French had betrayed the trust and generosity of Europe, and justice required the return of works of art "to the countries from which, contrary to the practice of civilized warfare, they had been torn during the disastrous period of the French Revolution and the tyranny of Buonaparte." Besides, he added, French feelings on the subject were clouded by "national vanity," and it was "desirable . . . that the people of France, if they do not already feel that Europe is too strong for them, should be made sensible of it. . . . The day of retribution must come."

By confiscating art from churches and palaces across Europe and making it a source of patriotic pride at the Louvre, the French accelerated a sense of national heritage in the lands they had invaded and made restitution inevitable. "The same feelings which induce the people of France to wish to retain the pictures and statues of other nations," noted Wellington, "would naturally induce other nations to wish, now that success is on their side, that the property should be returned to their rightful owners."[12] The repatriation of Napoleon's booty fueled a museum boom in early-nineteenth-century Europe as emerging nation-states sought to emulate the Louvre's example at home. The allies that pursued restitution were among the first to build museums in its image, in many cases full of art reclaimed from the Louvre but *not* returned to its original location. As mentioned in chapter 1, in the early decades of the nineteenth century new museums opened all across Europe, in Rome, Milan, Amsterdam, Antwerp, Berlin, Munich, London, Madrid, and beyond. The Prussians were the first to retrieve their pictures from Paris. Explaining his motive, the Prussian king wrote to Vivant Denon: "[N]ational honor and the interest I take in the progress of the arts in my States, compel me to request the return of what was taken by force of arms."[13] Schinkel's influential new museum in Berlin (see chapter 2) broke ground in 1823. Rubens's *Martyrdom of St. Peter* from Cologne was the first picture to be taken down and sent home.[14] The city celebrated its return on October 15, 1815, the anniversary of Napoleon's defeat at Leipzig (1813), with a procession, fireworks, and music (fig. 105). Similarly, the convoy of paintings returning to Belgium in 1815 traversed the country in a triumphal procession that mirrored earlier parades of Napoleonic loot. In each town church bells, fireworks, and cannon salutes greeted the convoy; one newspaper said that it "offered a triumphal and majestic air and seemed to announce that the Belgians had once more become a nation."[15] The arrival in Antwerp of "this precious heritage," "fruit of the genius of our ancestors . . . which since the fifteenth century has been the glory of our country,

105. *Return to Cologne of Rubens' "Martyrdom of Saint Peter" in 1815, 1837.*
Lithograph (detail). Photo: Rheinisches Bildarchiv Koln.

our city, and our academy," was the occasion of an elaborate public festival. The procession terminated at the museum, which was decorated with a triumphal arch surmounted by a portrait of Rubens, "patriarch of our school."[16] Justice had demanded restitution; the return of those treasures warranted a museum fit for their display as national heritage.

Within months of Waterloo the Louvre had been reduced to what one British visitor described as a "wilderness of frames."[17] Defiant to the end, Denon continued to insist that the allies lacked "the eyes with which to see [true art]" and that France would prove in time, "by the superiority of its arts, that those masterpieces belonged here more than anywhere else."[18] But Denon's blustery rhetoric offered little consolation as convoys ferried the looted treasures out of Paris. Before long he stepped down from the Louvre, his triumphant achievement undone. Though defeated, Denon had in fact done much to frustrate the work of restitution and to uphold the glory of French museums. Thanks in large part to his efforts, a good deal of what was taken by Napoleon remained on French soil. Of the 506 paintings removed from Italy, 248 may still be found in French museums and churches.[19] Numerous masterpieces of Italian painting, including Veronese's *Marriage at Cana* (from Venice), Titian's *Christ Crowned with Thorns* (from Milan), Tintoretto's *Paradise* (from Verona), and Giotto's *Saint Francis* (from Florence), continue to hang prominently in the Louvre. Of the many dozens of paintings by Rubens taken from Belgium and Germany, at least two important works—the *Saint Gregory* in the Greno-

ble museum (taken from Antwerp) and the *Adoration of the Magi* now in Lyon (taken from Munich)—escaped restitution.

Why was so much left behind? For the allies the problem was twofold. On the one hand, especially in the Netherlands, the Louvre's agents left no lists of what they had taken. Local inventories made after the event—in some cases as late as 1815, some twenty years later—were incomplete and lacking in detail. Returning a famous painting like Rubens's *Descent from the Cross* to its home in Antwerp Cathedral was straightforward enough, but identifying lesser works of art (not to mention decorative arts, coins and medals, books, etc.) and matching them with their original owners presented a much greater challenge. In addition, many paintings sent to Paris had subsequently been redirected to churches and newly created provincial museums, and retrieving those works proved difficult. Even if their whereabouts were known, provincial officials had no desire to cooperate and allied troops were not on hand to provide motivation. Some private collectors lacked the means to gather what had been dispatched to the Louvre; most of the Albani collection from Rome, for example, ended up being auctioned in Paris and went to Prince Ludwig's newly built Glyptothek in Munich.[20]

The Louvre's acquisition policies remained a source of contention long after 1815. Well into the twentieth century the French continued to maintain that Napoleon's acquisitions were legitimated by treaty and reclaimed illegally by force.[21] The allies, meanwhile, insisted the reverse was true; they viewed Napoleon's art as "loot" and his treaties as a ruse that merely veiled "crimes under a less ignominious name," as Henry Milton put it.[22] Outstanding claims went unresolved, but they were not forgotten, as subsequent conflicts revealed. Memories of Napoleonic looting were revived during and after World War I, and in the 1940s the Nazis drafted detailed lists of German art the French had never returned, aiming to bring it home to stock Hitler's equally megalomaniac museum at Linz.[23] At the start of the twenty-first century the parties seem finally to have put the matter behind them, leaving unanswered the intriguing questions of whether French ownership of unreturned art would survive a legal challenge today, where a case, if someone wanted to press it, could be tried, and who would constitute the jury.

A crucial turning point in the cyclical plundering of art in times of war occurred when, after Waterloo, the allies refrained from retributive pillage and took from the Louvre only what the French had taken from others. Rejecting Napoleon's appeal to Roman precedent as absurd and anachronistic, the allies pursued restitution with self-conscious restraint in an effort to establish a new and civilized standard of international conduct with respect to cultural property.[24] The agent for the Netherlands, for example, pressed his country's claims with "the greatest correctness . . . to prove to France that the orders from [the Dutch king] bind us to moderation and decency." He had the list of what he removed from the Louvre notarized on the spot to prevent criticism of "an operation

that the right of peoples and justice had long demanded."[25] Since Britain had not been conquered and therefore had nothing to reclaim, the French could only attribute British involvement in repatriation to a desire to enrich London's museums at the expense of the Louvre; but there was no such plan. To quell rumors to that effect, the British not only offered their allies diplomatic and logistical help in repatriating their art but paid for the return of the pope's treasures. British travelers were taken aback by the arrogance and self-righteousness of Frenchmen they encountered at the Louvre. The Scottish miniature painter Andrew Robertson recounted a heated argument with the painter Baron Gros, who had fought with Napoleon in Italy and gone on to paint great propaganda pictures on his behalf. With "the Italian pictures going fast," Robertson recalled, Gros fumed like a "volcano," swearing that "France was the garden and cradle of the arts—the only place where these things belong" and that "a time of vengeance would come."[26] Robertson responded that if vengeance was appropriate then the allies "would be justified in taking everything away," French treasures included, but that such an action would only compound the bad example set by France and encourage future armies "to carry off works of art at every change of success which would end in their ruin." Blinded by defeat and amour propre, the French were unable to see the logical and moral flaws in their position. "A Frenchman sees no further than his own interests," concluded Robertson. Another visitor remarked: "That France was never able to take anything from England, and that consequently our General [Wellington] can have nothing to remove is so obvious an answer for an Englishman to make that it requires the exertion of all his good breeding to resist the temptation."[27] The British did not leave Paris empty-handed, however. They conspicuously overpaid (35,000 pounds, equal to the sum paid to Lord Elgin for his marbles) to secure Antonio Canova's overblown portrait of Napoleon as the Roman god of war. Wellington accepted the statue as a gift and installed it in the foyer of his London townhouse (Apsley House), where it remains to this day.

Though confident that right was on their side, visitors from the allied countries were not above feeling regret at the sight of the once-mighty museum stripped of its glittering prizes. The English painter Thomas Lawrence captured the ambivalence of many when he confessed: "[M]uch as we ought to reprobate the injustice by which the greater part of [the gallery's contents] were obtained, we cannot but regret the end of such a collection of works of art."[28] The response of Lawrence and others to the dismantling of the Louvre underscores the tensions that continue to inform debates about repatriation. On the one hand, visitors came to the Louvre in droves and marveled at the sight of so many masterpieces assembled under one roof. Having previously faced long and difficult journeys to often remote places to view noted works *in situ*, they welcomed the convenience of a central museum and applauded its accessibility to a broad public. Arriving in Paris in the summer of 1815, Henry Milton confessed that he would not "have

taken the trouble to visit France had it not been for this collection" and the likelihood that its treasures would soon be scattered, "never again to be seen except by the rich and idle few."[29] Even those sent to repatriate national property felt a twinge of remorse in the execution of their duty. The German Jacob Grimm (author of the fairy tales) wrote to his brother in 1815: "On a personal level, it bothers me to have to reclaim these works of art; there is something unclean about coming to sniff around and disturbing an established order."[30] On the other hand, everyone was conscious of the means used to form the collection and the ugly nationalism it had been made to serve. Grimm conceded that his "bad conscience" evaporated as soon as he pondered the purpose of his mission.

As a trophy of conquest, the Louvre naturally provoked foreign indignation, but the encounter with so many canonical art objects in a strange new venue also gave rise to an argument for restitution—and against museums—that was based on the aesthetic and historical dependence of works of art on the settings for which they had been designed. Though works of art had changed locations frequently over the centuries and many church altarpieces had found their way into private collections (the king of Poland's purchase of Raphael's *Sistine Madonna* from an Italian convent in 1753 was but a celebrated instance of a broader trend), the vast scale of dislocations occasioned by the Revolution and the Napoleonic Wars sparked heightened reflection on the role of place in the reception of art. Laments about the negative effects of decontextualization were widespread among early visitors to the Louvre. For those familiar with the Louvre's contents before the Revolution, the *absence* of an original context was as visible as the works of art themselves. Museum-goers today give little thought to the past lives of objects they come to see (and museums rarely encourage thoughts in that direction), but at Napoleon's Louvre visitors could scarcely look at the paintings and sculptures without thinking of where they had been just a few years earlier. For some the sensation induced melancholy and nostalgia for the vanished pleasures of the Grand Tour, curtailed by the war. "The finest emotions and associations of thought which these works suggested in their original seats, became dissolved and dissipated by their transportation," wrote John Scott. "The statue that warmed and inspired the soul in Rome is chiefly the prompter of regrets and misgivings when placed in a gallery of the Tuileries. The enthusiasm it excited in its primitive situation was of the highest poetical and moral kind; but this is chilled when we find it surrounded by French academicians and connoisseurs taking notes and snuff."[31] For others, such as the German philosopher August Wilhelm Schlegel, it prompted deeper meditations on the condition of art.[32]

The most sustained and provocative criticism of the Louvre appeared in Quatremère de Quincy's *Letters to Miranda on the Displacement of Monuments of Art from Italy* (1796). Published at the height of Napoleon's Italian campaign, *Letters to Miranda* presented a

complex and courageous rejection of French policy. On a political level, Quatremère observed that the subjugation of peoples and confiscation of their patrimony was "completely subversive of the spirit of liberty" championed by the French republic. On a philosophical level, the appropriation of cultural property defied the sense of common purpose achieved by the Enlightenment. "The arts and sciences belong to all of Europe, and are no longer the exclusive property of one nation," he declared. "It is towards the maintenance and expansion of this community that all thoughts, all efforts of politics and philosophy must be directed."[33] Finally Quatremère argued that the creation of a central museum in Paris, rather than advancing the arts or knowledge of antiquity, would have the opposite effect. By removing works of art from the setting and purpose for which they were intended, the museum denatured those objects and greatly reduced their power of example. Historical understanding suffered, and the objects themselves were reduced to free-floating commodities subject to the vicissitudes of the market and the detached gaze of the connoisseur. In short, by transferring works of art to a museum, "one strips them, in the name of conservation, of all the useful connections that once gave them value."[34] In his view, the museumification of art was tantamount to an act of vandalism.

Quatremère was particularly upset about the damage French confiscations had done to the integrity of Rome, viewed by all enlightened Europeans as inviolable common ground. Rome itself was a museum, he argued, whose coherence depended on the preservation of everything exactly as it was: "The true museum of Rome that I refer to is made up . . . of statues, colossi, temples, obelisks, triumphal columns, baths, circuses, amphitheaters, triumphal arches, tombs, stuccoes, frescoes, bas-reliefs, inscriptions, ornamental fragments, construction materials, furniture, utensils, etc. but it is equally composed of places, sites, mountains, quarries, ancient roads, the location of ruined villas, geographical relationships, the ties that bind together all objects, memories, local traditions, surviving customs, the parallels and connections that can only be made in the place itself."[35] Removing parts of Rome's rich context impaired both the site and the objects and lowered the French to the level of a philistine "who tears pages from a book just for the illustrations."

Quatremère turned with equal vehemence on the other art museum of revolutionary Paris, Alexandre Lenoir's Museum of French Monuments (fig. 77). Though the museum had provided asylum to religious art and tomb monuments during the heated days of the Terror, the return of calm in the mid-1790s led Quatremère (and others) to call for its dissolution in the interests of aesthetics, history, and propriety: "Let us pretend no longer that works of art can be preserved in these repositories of ignorance and barbarism. Yes, you have transported the physical matter, but have you also brought that train of sensations, tender and profound, melancholic, sublime, and touching, that enveloped them? Have you transported the interest and charm that they drew from their

location, from the religious atmosphere that surrounded them, from that sacred aura that added to their luster? . . . All these objects have lost their effect in losing their purpose."[36] Beacons of enlightenment or repositories of ignorance and barbarism? For Lenoir and his supporters, the Museum of French Monuments was an invaluable public repository of national history and heritage; he had spared its contents from destruction and had compensated for lost environments with sympathetic period settings composed of authentic architectural elements and stained glass. The museum played a pioneering role in the rediscovery of medieval art and history in the early nineteenth century. For Quatremère and the critics, on the other hand, the museum's continued existence was little better than the iconoclasm that had brought it into being; no amount of scholarship generated by the museum could compensate for the loss of aura sustained by its orphaned contents. On one side, preservation, education, and the display of national heritage; on the other, the integrity of monuments and sites and the rituals of church and families: the arguments for and against the Museum of French Monuments anticipate current disputes involving sacred objects and public museums. Interestingly, in a final effort to avoid restitution, which became unavoidable following the restoration of the monarchy in 1815, Lenoir suggested that his museum become a sacred as well as a secular site; staffed by a priest and a curator, the museum could alternately serve different purposes and constituencies. Lenoir was ignored, but his idea foreshadows recent attempts to accommodate spiritual functions within public art museums.[37]

If Quatremère and John Scott hoped that war's end would revive the prerevolutionary art world they were sorely disappointed, for the dissolution of the Louvre was the beginning, not the end, of the first museum boom. The French Revolution and Napoleonic Wars hastened the emergence of European nationalism, and the Louvre solidified the identification of art as national patrimony. Quatremère's *Letters to Miranda* no doubt aided the return of Vatican treasures when republished in 1815, but his broader argument about the importance of context fell on deaf ears in the rush to imitate the Louvre. The proper context for objects identified as national heritage in modern Europe would henceforth be a central museum in a national or regional center.

The Elgin Marbles

As we have seen, the British had no works of art to reclaim from the Louvre and supported allied restitution efforts with a view to achieving French capitulation and European stability. But the French were not entirely wrong to suspect British motives in the humbling of their museum. Politics may have prevented the taking of spoils, but that did not stop British visitors from fantasizing about what might have been. Even as the British assisted in the return of the Vatican marbles, Henry Milton could not help pon-

106. British officers of the Benin punitive expedition with the bronzes and ivories taken from the royal compound, Benin City, 1897. © The Trustees of The British Museum.

dering how greatly "the grandeur and dignity of the nation would be increased by the possession of these matchless statues."[38] He realized, however, that the price of following Napoleon's example was too great: "I fear we could not obtain them without risking what is infinitely beyond even their worth, our public integrity and good faith." Everyone now wanted a museum to enhance "the grandeur and dignity of the nation," but how to create one without sacrificing "public integrity and good faith" and violating the national property of others? Milton offered one solution: the market. "May we not wish that England with clear and perfect honor could buy the whole?" he wondered aloud in the Louvre. Whatever could be acquired through purchase in an open market would secure "clear and perfect honor"—and this perception continued to hold sway until very recently. The discovery and auction of the Aegina Marbles just a few years earlier (1812), bought by Prince Ludwig of Bavaria for his Glyptothek in Munich against heavy competition from the British and French, provided a model of what was to come.[39]

A second route to museum expansion was colonialism. If appropriating art through force or coercion was no longer acceptable on the Continent, similar strategies pursued in non-European territories posed no threat to a nation's "public integrity and good faith." The rules of "civilized warfare," including prohibitions on the looting of cultural property, did not apply to aggression against "uncivilized" peoples. The British thought nothing of confiscating the Benin Bronzes in Africa in the late 1890s in retaliation for local revolts against foreign occupation (fig. 106), yet similar actions by Napoleon in Italy warranted the strongest condemnation.

Napoleon's enemies scoffed at French claims of political and moral superiority used to justify confiscation of art in conquered lands, but the entire colonial enterprise relied on precisely the same ideology. Throughout the modern era museum expansion in Europe and the United States mirrored colonial rivalries and the struggle for geopolitical domination.

Such is the broad context for the acquisition of the Elgin Marbles (fig. 107). If not for the Louvre and the fierce international competition it triggered, there might be no "Elgin Marbles." This is not to blame the Louvre and excuse the British Museum, where the sculptures from the Parthenon went on display in 1816, but to suggest that the case of Lord Elgin and his marbles represents only the most notorious instance of a mass migration of monuments and works of art brought about by national ambitions played out through museums in post-Napoleonic Europe. Simply put, national vanity, greed, and expansionism in the nineteenth and early twentieth centuries lie behind the collecting activity of Europe's oldest and greatest museums. The extraordinary fame of the Parthenon sculptures and the well-publicized demands for their return have made

them a cause célèbre, but countless other works of art were acquired under circumstances that were no different in kind.

What are the Elgin Marbles, and how were they acquired by the British Museum? The story has been well documented and needs only a brief summary here.[40] The name "Elgin Marbles" refers to a large group of sculptures taken from the Parthenon in Athens between 1801 and 1812 by the Scottish nobleman Thomas Bruce, seventh earl of Elgin. The Parthenon,

107. The Elgin Marbles on display at the British Museum, 2006.

built as a temple of Athena on the Acropolis between 447 and 432 BCE, is considered the defining masterpiece of ancient Greek architecture. Similarly, the sculptural program—comprising a 525-foot bas-relief frieze representing the Panathenaic procession, ninety-two metopes depicting historical and mythical battle scenes in high relief, and pediment sculptures in the round representing various gods—constitutes the magnum opus of Phidias, the most renowned of ancient artists. Of the sculpture that had survived early vandalism, a massive explosion in 1687 (when the temple was used as a powder magazine by the Ottoman Turks), and the ravages of time, Elgin removed just under half of the frieze (approximately 247 feet), fifteen metopes, and seventeen pediment sculptures. After perilous journeys and prolonged negotiations, the marbles were bought in 1816 by the British government and deposited in the British Museum in London, where they still reside, for the past half-century in handsome galleries paid for by the art dealer Joseph Duveen.

Elgin found himself in a position to acquire the sculptures by virtue of his position as British ambassador (1799–1803) to the Sublime Porte of the Ottoman Empire, of which Greece had been a dominion for centuries. His motive for removing the marbles was primarily patriotic. Recognizing the artistic importance of the sculptures, he wanted to secure them for Britain and the benefit of British artists. At first he thought only of making accurate studies and casts for academies back home, but a sudden turn of events provided the opportunity to do more. In 1798 Napoleon invaded Egypt with the aim of extending his empire and blocking British trade routes to India. Because Egypt was also nominally part of the Ottoman Empire, the French became enemies and the British allies of the Turks. A succession of British victories beginning with Lord Nelson's destruction of the French fleet at the Battle of the Nile in 1798 culminated in French capitulation three years later and put Elgin in a position to leverage Turkish gratitude. "Nothing was refused which was asked," the British government later noted of that moment in Anglo-Ottoman affairs,[41] and in 1801 Elgin asked for and received written permission not just to draw and model the Parthenon but also to dig on the site and to carry off "any pieces of stone with inscriptions and figures."[42] No mention was made of removing sculptures still attached to the building, but permission to go that one important step further was subsequently given by local officials in Athens.

Following his arrival in Constantinople, with Napoleon's looting of Italy fresh in mind, Elgin made it part of his diplomatic mission to counter French designs on ancient art in the eastern Mediterranean. Determined to gain the upper hand in this as yet under-explored hub of the ancient world, he shifted his attention from making drawings and casts to outmaneuvering the French for original works of art. At one point he dreamed of carting off the entire Erectheion and quipped: "Bonaparte has not got such a thing from all his thefts in Italy."[43] Following the formula that had worked so well in Europe,

Napoleon's army in Egypt was accompanied by a team of artists and scientists in pursuit of knowledge and acquisitions for the Paris museums. The seemingly disinterested pursuit of knowledge cloaked monumental collecting interests. Among their finds was the famous Rosetta Stone, which soon provided the key to deciphering Egyptian hieroglyphs.[44] In the aftermath of the French defeat in 1801, the British took the precious fragment and sent it to London to become a prize possession of the British Museum. The British had every reason to believe that the French had their eyes on the Parthenon. Before the Revolution, the French ambassador to the Porte, Comte Choiseul-Gouffier, used his influence to acquire a significant number of Greek sculptures for himself, including a metope and a section of the frieze from the Parthenon. "Take all you can," Gouffier wrote to his agent Fauvel in Athens. "Do not neglect any opportunity to pillage anything that is pillageable in Athens and its territory. Spare neither the dead nor the living."[45] When Gouffier emigrated to Russia to escape the Revolution, his collection was confiscated for the Louvre. Napoleon personally insisted that the Parthenon metope be put on display in the museum. Through bad luck and timing, Lord Elgin was imprisoned by the French on his way home from Constantinople; he later claimed he could have gained his release at any time had he been willing to hand over his marbles. If the British government had not bought Elgin's collection, the French, among others, were waiting to do so.

Another connection linking the Elgin Marbles to the Louvre and the politics of national museum building comes in the person of William Richard Hamilton (1779–1859).[46] As attaché and private secretary to Lord Elgin in Constantinople, Hamilton was instrumental in negotiating the French surrender in Egypt and acquiring the Elgin Marbles for Britain. It was Hamilton who took possession of the Rosetta Stone and dispatched it to London. Subsequently promoted to undersecretary of state for foreign affairs, he was involved in the European peace process in 1815 and used his influence to repatriate allied art. He was especially helpful in the repatriation of papal treasures, which was supervised by his friend Canova, and for his efforts he was painted into a fresco in the Vatican commemorating their return. In Hamilton's mind the dismantling of Napoleon's Louvre and the British Museum's acquisition of the Elgin Marbles, for which he lobbied long and hard behind the scenes, were related. From Paris he wrote to Elgin just months before Parliament decided to buy the sculptures in 1816: "I flatter myself that [the restitution of allied art] must contribute materially to enhance the value of your collection."[47] Vivant-Denon, who despised Hamilton and held him responsible above all others for "the entire destruction of the Louvre,"[48] also made the connection and pointed to Britain's hypocrisy. In the midst of a heated conversation in which Hamilton defended the British Museum by saying its contents had "the advantage of belonging to us whereas the objects in [the Louvre] belong to those who reclaim them," Denon retorted that the London museum owed its new-

found stature to the shameful "degradation of Athenian monuments, perpetrated by a man holding public office and sanctioned by national purchase."[49]

Eager to claim high moral ground and to distance Elgin's actions from French plunder, the British government held a special inquiry into the acquisition of the marbles. As if responding to Denon, Parliament sought to ascertain whether the sculptures had been acquired legitimately and what value they had, both financially and as "public property." Following testimony from a variety of witnesses, a parliamentary committee determined that the terms of Elgin's original permit (firman) had been exceeded but that since Ottoman authorities had never objected to the removal or export of the marbles, even though "the work of taking down and removing was going on for months, and even years, and was conducted in the most public manner,"[50] nothing improper had occurred. Moreover, far from complaining, the "Turks showed a total indifference and apathy as to the preservation of these remains." The report concluded that Elgin might have received favors because of who he was but that he had acted "in a character entirely distinct from his official situation." And because he had purchased the sculptures with his own money he was entitled to treat the collection as personal property and to sell it to the nation. Patriotism rather than profit was his motive, and to reinforce that perception the government paid Elgin less than half of what it had cost him to bring the sculptures to London.

As for the aesthetic and scholarly value of the marbles, the critical reception was overwhelmingly favorable. With a few curmudgeonly exceptions, connoisseurs and artists summoned by the House of Commons from across Europe agreed that they were "the finest models and the most exquisite monuments of antiquity." As documented work by the greatest of Greek sculptors, the marbles revolutionized the history of ancient art by allowing the differences between Greek and Roman art to be apprehended for the first time.[51] Canova repaid Hamilton's assistance with the pope's treasures by supporting the purchase and expressing his "high obligation" to Elgin "for having brought these memorable and stupendous sculptures into our neighborhood."[52] Elgin paid for Europe's foremost antiquarian, E. Q. Visconti, former curator of antiquities at the Vatican and Musée Napoléon, to visit London and deliver his stamp of approval. Others needed no incentive to express their satisfaction. Britain's chief enthusiast was the artist Benjamin Robert Haydon, who prophesied the collection's drawing power in the British Museum: "Pilgrims from the remotest corners of the earth will visit their shrine, and be purified by their beauty."[53]

Transcending national pride, a collective belief in the superiority of, and common descent from, Greek civilization caused all Europeans to feel grateful that the shining masterpiece of Greek art had been rescued from oblivion. Because the Elgin Marbles (and all other sculptures discovered in Greece) were seen as part of Europe's heritage, their

retrieval from the barbarian Turk could itself be considered an act of repatriation. Once installed in Europe's museums, Greek art, as the embodiment of ancient Greek virtues, would inspire improvements in the modern world. Even the staunch museum critic Quatremère de Quincy had nothing but praise for Lord Elgin's salvage operation. Aware that his support might seem inconsistent with his earlier opposition to Napoleon's plundering of Rome, he defended his position with an appeal to morality, conservation, and scholarship, anticipating some of the talking points in recent debates over cultural property. Quatremère maintained that whereas Napoleon had taken art against the will of the Italians, Elgin acquired his collection legitimately from the Ottoman rulers "in gratitude for English help."[54] Where Napoleon was guilty of exercising "the barbarous right to plunder," Elgin acted with "ardent and enlightened zeal."[55] In Rome monuments were protected and valued, but in Athens the Parthenon and its sculptures were subjected to "the shipwrecks of time, the ravages of war, and the barbarity of the Turks."[56] Turning on its head his earlier identification of museums as mausoleums of art, he said that the Acropolis had become "in a sense their tomb" and the British Museum their salvation. Brushing aside the value of understanding the sculptures *in situ,* Quatremère welcomed the opportunity to view them "close at hand," as if you were "in the sculptor's yard or studio."[57] He closed his apologia with an endorsement that has sustained the status quo at the British Museum—and encyclopedic museums more generally—ever since: "Containing the largest number of original pieces of Greek sculpture from its best period, [the museum] should henceforth place itself at the head of all collections where science and the history of art seek to find classic models and genuine material for the sound assessment of taste."[58]

The steady eastward expansion of collecting, tourism, and taste across the Mediterranean in the nineteenth century greatly enlarged Europe's museums and left Elgin's critics in the minority. It took a celebrity of Lord Byron's stature to give the plight of the Parthenon lasting purchase in European thought. A romantic philhellene, Byron fought and died for the cause of Greek independence in the 1820s, and his crusade on behalf of the Parthenon is almost as well known today as his poetry. Early in his epic *Childe Harold's Pilgrimage* (1812), Byron had his protagonist visit Greece and, like contemporary English travelers to the Louvre, voice sadness mixed with anger at the sight of the Parthenon despoiled.[59] He combined principled outrage against the removal of the marbles with scarcely veiled hostility toward Elgin as a Scot (despite, or because of, Byron's own Scottish ancestry on his mother's side) and a willful conflation of ancient and modern Greece. Most important, however, was Byron's identification of the Parthenon with the emerging modern Greek nation and the sculptures—"the last poor plunder from a bleeding land"—with the destiny of the people. Thanks in part to Byron's public feud with Elgin, the Parthenon and its sculptures became synonymous with Greece.

Since winning its independence from the Ottoman Empire in 1828, Greece has yearned to see the sculptures returned to the Acropolis. And in Britain, Byron's romantic heirs have continued to lend sympathetic support. Traveling in Greece soon after Elgin, Byron's friend John Cam Hobhouse recalled an encounter with a "learned Greek" who told him: "You English are carrying off the works of the Greeks our forefathers; preserve them well; Greeks will come and re-demand them."[60] The Greeks made sporadic pleas for their return over the years, but it was not until 1983, two years after Greece joined the European Community, that a formal request was submitted. Press conferences at the time by the Greek minister of culture, Melina Mercouri, echoed earlier Byronic appeals to national symbolism and sentiment: "This is our history, this is our soul. . . . You must understand us. You must love us. We have fought with you in the second war. Give them back and we will be proud of you. Give them back and they will be in good hands. . . . They are the symbol and the blood and the soul of the Greek people. . . . We have fought and died for the Parthenon and the Acropolis."[61] This and subsequent requests were rejected, yet over time the tide of public opinion, within Britain and elsewhere, among politicians and the lay public, has gradually turned in favor of the Greek position.

As Mercouri's statement makes clear, the argument for repatriating the Elgin Marbles is emotional and depends on the iconic value of monuments for the nation's self-image. A legal case against Elgin—claiming in effect that Britain acquired the sculptures illegitimately and should therefore give them back—is less than compelling. "The argument that [the sculptures] were illegally or immorally taken does not survive careful examination," according to the legal scholar John Henry Merryman. "The Greeks do not have a strong legal or moral case against Elgin."[62] As Merryman (among others) has demonstrated, Elgin acquired the sculptures openly with the permission of the ruling authorities; that Greece subsequently won its independence from the Ottoman Empire does not render Elgin's deeds illegal. Objections that Elgin took unfair advantage of his ambassadorial post hold little water given that diplomatic channels were routinely used to buy and transport art across national borders in early modern Europe. Elgin's collection was in turn bought for the British Museum with the backing of Parliament following a thorough public inquiry. Regardless of how Elgin acquired his collection, no court of law would take on a case that was two hundred years old. Apart from a cleaning mishap in the 1930s (of a sort that all museums have been guilty of at some point in their past), the sculptures have been well cared for and displayed by the British Museum. The claim that restitution would reunite the sculptures with the Parthenon—the basis of a recent Greek position on restitution—is misleading, since corrosive air pollution in Athens prohibits their display outdoors.[63] The closest they will ever get to their original setting is a modern, climate-controlled museum nearby. In terms of conser-

vation, quality of display, and public access it would be hard to argue that the marbles would be better off in Athens—though the argument that they are better off in London makes no sense either.

In the absence of persuasive legal or rational arguments for restitution, the Greeks' best hope for the return of the sculptures lies in the perception that it is simply the right thing to do. Whatever the circumstances under which they were acquired and no matter how well they have been looked after in London, they belong in Greece, alongside the great building for which they were made. There is something uniquely compelling about a people deprived of its memory and heritage, and there can be no denying the strength of Greek attachment to the Parthenon. As Ernest Gellner has written, "[M]odern man is not loyal to a monarch or a land or a faith . . . but to a culture,"[64] and cultural heritage in the modern nation-state is deeply tied to national monuments, shrines, and symbols. To the extent that the Parthenon has become the icon of Greece, the presence of the Parthenon sculptures on foreign soil is an open wound to national pride.

On the other hand, it can be argued that the Parthenon sculptures have been part of the British Museum for so long that they are now part of Britain's heritage. At any rate, they are part of the museum's history and among its greatest attractions. The return of the sculptures to Greece would diminish the museum's stature, and perhaps also its attendance and revenue (though the museum is free, the Parthenon galleries make an attractive venue for profitable corporate parties, and postcard sales are perennially brisk). Because museum directors tend to be judged by what they *add* to their museums, no director wants to be remembered for giving them back. But as much as the loss of those famous sculptures would hurt, perhaps more worrisome still for the British Museum is the prospect that giving in to Greek demands would unleash other restitution claims. As a former director of the museum warned: "[I]f once a group of objects were returned, then there would be a continual and increasing demand for return from all over the world. . . . This is a bandwagon which could result in wholesale destruction for the sake of narrow nationalism."[65]

It is often said that the Elgin Marbles represent a special case, but this is illogical as well as insensitive to others whose cultural heritage has also been the target of the world's great museums. The Parthenon may be "special" in the sense that it resonates deeply within Western culture and has received extraordinary media attention, but who is to say it is more important to the Greeks than any other monument or object is to the memory and identity of another people? How do we rank the Greek request against requests of other nations for the return of cultural treasures held by foreign museums? The Nigerian government, for example, has formally requested the return of the Benin Bronzes, a set of superbly cast, sixteenth-century brass plaques and other objects seized by the British army in 1897 and currently a cornerstone of the new African galleries in the

108. The Benin Bronzes on display at the British Museum, 2006.

British Museum (fig. 108).[66] Egypt describes the Rosetta Stone as "the icon of our Egyptian identity" and has asked for its return.[67] If the Elgin Marbles go home, it will surely be not because they are demonstrably more important to Greece than the Benin Bronzes are to Nigeria or the Rosetta Stone is to Egypt but because the Parthenon and Greece are closer to the hearts and minds of Western publics. Nonetheless, if and when the sculptures go back, other restitution demands will be harder to deny; and if the museum then concedes to further requests, where will restitution end?

The Domino Effect

It is easy to vilify the British Museum as a last bastion of colonial arrogance in a postcolonial age, but many other museums are in a similar predicament. The great encyclopedic museums in the West collectively bear witness to the spread of colonial rule

across the globe, and in their reluctance to confront their pasts they now seem out of step with recent political developments. As the anthropologist Thurstan Shaw noted some time ago: "Whereas political self-determination [for former colonies] has been conceded, its logical concomitant in the realm of cultural property is still strongly resisted by the former colonial masters. We claim righteousness for having given such countries their independence, and for giving many of them financial aid, yet we cling to their cultural property as if the conditions of colonial times still obtained. These countries want their own cultural property to contribute to their own process of growing to national maturity. The territories have been handed back to the inhabitants, but many of their treasures have not."[68] The global ties that bind us closer together in networks of economic and cultural exchange are gradually compelling nations and museums to reckon with the heritage claims of peoples it was once easy to ignore. With requests for the repatriation of cultural treasures on the rise, the problem for museums will extend beyond a handful of outstanding icons to include ethical questions about the acquisition and treatment of much larger categories of objects.

Proponents of repatriation dismiss fears of a domino effect by pointing to cases that have been resolved without triggering copycat claims. There is the case of the Icelandic manuscripts returned from Denmark in 1971, for example, and the broadly successful repatriation of Native American material prompted by the passage of the Native American Graves Protection Repatriation Act (NAGPRA) in 1990.[69] But neither constitutes a good model for art museums. More generally, the isolated success stories one can point to suggest that museums find it easier to do the right thing when the objects in question are of secondary importance to their collections. For example, in the late 1990s the Glasgow Museum repatriated a Ghost Dance Shirt taken (it was claimed) from the corpse of a dead Sioux warrior at the Battle of Wounded Knee a century earlier. The museum's director said of its return: "It's all about values and ethics. A shirt that was ripped off the body of a dead Sioux had no business in our collection. We no longer have the shirt, but the story of its return is now part of Glasgow's history, a memory of an act of generosity."[70] Arguably the garment was not vital to the Scottish museum in the way that the Elgin Marbles are to the British Museum, and its connection to a fallen soldier puts it in the category of sacred objects that command universal respect. In the United States, NAGPRA has been hailed a great success, but the act primarily covers human remains and objects of ritual and sacred value; museums that have no qualms about returning bones they never display may be more reluctant to part with a beautiful Mimbres pot or painted buffalo hide. To some extent at least, ethical commitments would seem to be contingent on the display value of the objects concerned.

If "values and ethics" are indeed the guiding criteria, how much difference is there between a Sioux shirt and the Benin Bronzes, taken in anger by a colonizing military

force? Awkward questions surround works of art in every well-established museum, though the discretion of wall labels and interpretive materials regarding provenance and terms of acquisition limits ethical reflection in most visitors. The label accompanying a beautiful torso of an Indian fertility goddess *(yakshi)* at Boston's MFA (fig. 109), for example, doesn't say how or when it was separated from the gateway of the Great Stupa at Sanchi, an important monument that attracts thousands of visitors each year; nor does it disclose how it passed into the hands of Denman Waldo Ross before he gave it to the museum in 1929. Perhaps the facts are unknown, but in any case the museum regards such questions as irrelevant to the visitor. Displayed at eye level with its (purposefully?) truncated limbs and prominent female features, the *yakshi* is treated more like an Indian Venus de Milo than a desecrated Buddhist icon from a key pilgrimage site. How would our impression of the MFA's magnificent Japanese collection (fig. 81) change if a wall panel included the following correspondence between two of the museum's early benefactors? "Already people here are saying that my collection must be kept here in Japan for the Japanese," wrote Ernest Fenollosa to Edward Morse from Tokyo in 1884 (two years after Japan's first museum opened in Tokyo). "I have bought a number of the very greatest treasures secretly. The Japanese as yet don't know that I have them. I wish I could see them all safely housed forever in the Boston art museum. And yet, if the Emperor or the Mombusho should want to buy my collection, wouldn't it be my duty to humanity, all things considered, to let them have it?"[71] Did Fenellosa ever offer those treasures to the emperor, or are they now the pride of the MFA's collection? Standing in Harvard's Sackler Museum before a kneeling Bodhisattva from the Magao Caves (no. 328) at Dunhuang, visitors have no way of knowing that the Chinese consider the piece stolen (during the Harvard expedition of 1923–24) and that a placard to that effect appears (in English and Chinese) in the cave where the statue once stood.[72] What are a museum's ethical obligations to such objects, or to the places from which they come?

If we add to the long list of objects acquired by Western museums under dubious circumstances an even longer list of things acquired legally but on terms that today would be considered unacceptable, it becomes clear why museums would rather avoid the issue of restitution altogether. If the Elgin Marbles go home, then why not also the so-called Elliot Marbles,

109. Torso of a fertility goddess *(yakshi)* from the Great Stupa at Sanchi (25 BC–AD 25), on display at the Museum of Fine Arts, Boston.

sculptures removed from Amaravathi in southern India in the mid–nineteenth century and sent to London by Sir Walter Elliot? Or the Assyrian treasures from Khorsabad, Nimrud, and Ninevah (in what is now Iraq), acquired for the British Museum with the permission of the Ottoman Empire in the 1840s and 1850s? Or the Pergamon Altar, that masterpiece of Hellenistic sculpture acquired by the Germans in 1882, also from the Ottoman sultan, in an attempt to put the Berlin museum on a par with its counterpart in London?[73] Though it was excavated by the Germans and legitimately bought for twenty thousand marks, the modern Turks, within whose borders ancient Pergamon now lies, want it back. What of the Cesnola treasures—some thirty-five thousand objects in all—spirited out of Cyprus, then also part of the Ottoman Empire, after 1872 to become the cornerstone of the Met's classical collection? Like Elgin, Cesnola used his position as U.S. consul to Cyprus to collect and pursue excavations that were criticized for their voracity and indifference to scholarly interests (he claimed to have excavated over sixty thousand tombs!). In the words of one contemporary, Cyprus was treated as a "mine to be exploited in all haste for objects to collect or sell. The excavations were brutal and destructive. . . . [A]ll was sacrificed to the quest for loot."[74] Labels in the new installation of the Cesnola collection in New York acknowledge some problems with Cesnola's scholarship but nowhere mention that he used subterfuge and bribes to circumvent an 1871 ban on the export of antiquities from Cyprus. At the opening ceremony for the new galleries in April 2000, the president of Cyprus, Glafcos Clerides, when pressed by a Cypriot journalist about the collection's extralegal acquisition, noted ominously: "At this stage the government does not intend to ask for the return of the antiquities but it will wait to see the outcome of Greece's attempt to repatriate the Elgin Marbles before it decides what to do, since the Cesnola collection was exported from Cyprus during Ottoman rule, just like the Elgin Marbles."[75]

Would Egypt today agree to the system of partage that allowed foreign archeologists in decades past to walk off with boatloads of precious antiquities?[76] Should we sanction the power of superior wealth and expertise to obtain another country's heritage? It may well be true that without foreign help many (more) Egyptian sites would have fallen prey to tomb robbers or remained undiscovered, but now that Egypt, like Greece, is capable of protecting its patrimony, should more of what was excavated and exported a century ago now go back? And the same questions could be asked of European heritage in the form of architectural fragments, period interiors, stained glass, paintings, sculpture, and decorative arts acquired by wealthy North American collectors during the unstable years of the early twentieth century. The Berlin Museum director Wilhelm von Bode described the flow of art across the Atlantic as "the greatest transplantation of art-works the world has known since the Roman plundering of Grecian art and the rape of churches and museums of Europe whereby Napoleon enriched the Louvre."[77] A review of the 1945

Boston exhibition Art of the Middle Ages labeled its contents as "the rarest loot that has ever been stripped from houses of worship and redistributed in the westward course of collecting."[78] The collecting equivalent of Manifest Destiny was justified in the United States by the utopian purpose of the public museum, dedicated to the eventual triumph of secular humanism, universal knowledge, and democracy over Old World ignorance and superstition. The standard rhetoric argues that even the most voracious collectors of the Gilded Age (J. P. Morgan, Henry Clay Frick, Isabella Stewart Gardner, etc.) ultimately collected not for themselves but to make great art available to a broad public.[79]

Lists of disputed and suspiciously acquired objects are all too easy to compile. But short of returning *everything* collected under circumstances that today would be considered offensive or illegal, what options do museums have? They could post labels admitting to past transgressions, as James Clifford has suggested, but that would deflate their utopian mission and no doubt upset fee-paying visitors.[80] Another way out is through negotiated loans and exchanges. In exchange for the return of disputed objects, museums could borrow things of similar interest. This was the outcome of the negotiated settlement between the Italian government and the Met in New York in 2006, hailed as a victory by both sides. The Italians got back works of art they had long insisted had been illicitly excavated and exported, while the Met saved face in receiving long-term loans of comparable material. The delicate question of ownership might also be addressed through branch museums in other countries—the "British Museum, Cairo," perhaps, or the "Met in Nicosia." Both ideas have been suggested by the Greeks to resolve the impasse over the Parthenon sculptures.[81] Solutions of this sort are consistent with the growing use of international cultural diplomacy by governments and object sharing by museums looking to make better use of their collections and satisfy the public's thirst for novelty. Increased collaboration, whether for political or economic reasons, may change the definition and use of permanent collections.

Finally, countries could choose not to pursue the course of repatriation and opt instead to allow foreign museum holdings abroad to enhance their cultural stature on the world stage. Long ago Japan used art and culture in the context of international expositions to impress the West, and it continues to support the refurbishment of museum displays of Japanese art in Europe and the United States. Governments and sponsors from the Islamic world are beginning to use a similar strategy. Welcoming a gift of $9.7 million in 2004 from a Saudi donor to create a spectacular new Islamic gallery at London's Victoria and Albert Museum, the museum's director said it would combat "negative attitudes" in the West.[82] Other developing nations—Egypt, China, and Turkey, among others—have used traveling exhibitions to improve their international profile. While leaving the door open to a future restitution request, the president of Cyprus nevertheless heralded the new Cesnola galleries at the Met in 2000 by saying: "[A]ntiquities and our civilization are

an ambassador of Cyprus abroad and this exhibition will make Cyprus known not only on a cultural but also on a tourist level."[83] Though able to sympathize with the dispossessed, Kwame Anthony Appiah also believes sharing makes more sense in the long run. "Were I advising a poor community pressing for the return of many ritual objects," he writes, "I might urge it to consider whether leaving some of them to be respectfully displayed in other countries might not be part of its contribution to the cosmopolitan enterprise of cross-cultural understanding as well as a way to ensure their survival for later generations."[84] This means not that nothing should be repatriated but that global distribution is important. "I actually want museums in Europe to be able to show the riches of the society they plundered in the years when my grandfather [in Ghana] was a young man."[85]

Nazi Loot and the Rape of the Developing World

On the morning of November 9, 1997, readers of the Sunday *Boston Globe* awoke to a shocking headline: "Murky Histories: Suspicious Pasts Cloud Some Local Artworks of the Fogg, MFA." An arresting two-page spread, complete with color illustrations, suggested that prominent works by Monet, Cézanne, Degas, Van Gogh, and Picasso might have been appropriated by the Nazis from victims of the Holocaust during World War II. In the months that followed, further claims and revelations cast a shadow over virtually every museum that had acquired works of art just before or during the war. Indeed everyone in the art world was implicated, including dealers, auction houses, and private collectors as well as curators. Suddenly, looted Nazi art was on everyone's mind. A spate of articles and books revealed the staggering scale of looting across Nazi-occupied Europe: between 1933 and 1945 an estimated six hundred thousand works of art were appropriated or stolen or went missing. The World Jewish Congress reported that in France alone the Nazis seized roughly one hundred thousand art objects, more than half of which had never been returned to their owners or heirs.[86] The facts had been known to a handful of scholars for some time, but the great majority of art lovers in the United States and Europe had no inkling that their beloved local museums were associated in any way with the unequivocal evil of the Third Reich. Museum professionals were themselves caught off guard by the revelations, not least because distinguished men and women from their ranks had been centrally involved in Allied efforts to undo Nazi looting after the war's end. From the United States, James Rorimer, Otto Wittman, Thomas Carr Howe, Edith Stanton, and others of the Monuments, Fine Arts, and Archives section of the military who went on to become leaders in the postwar museum world had devoted themselves selflessly to repatriating countless works of art that had been lost and stolen during the German occupation of Europe.[87]

Moving to counter the damaging publicity, in June 1998, at the same time that the U.S. State Department convened the Conference on Holocaust-Era Assets and President Clinton appointed a presidential advisory panel on the matter, the Association of Art Museum Directors (AAMD) issued a report on "the spoliation of art during the Nazi/World War II era (1933–1945)" that included the following resolutions:

- AAMD recognizes and deplores the unlawful confiscation of art that constituted one of the many horrors of the Holocaust and World War II.
- American museums are proud of the role they, and members of their staffs, played during and after World War II, assisting with the preservation and restitution of hundreds of thousands of works of art through the U.S. Military's Monuments, Fine Arts and Archives section.
- AAMD reaffirms the commitment of its members to weigh, promptly, and thoroughly, claims of title to specific works in their collections.
- AAMD urges the prompt creation of mechanisms to coordinate full access to all documentation concerning this spoliation of art, especially newly available information. To this end, the AAMD encourages the creation of databases by third parties, essential to research in this area, which will aid the identification of any works of art which were unlawfully confiscated and which of these were restituted.[88]

The AAMD recommended that museums undertake provenance research on their own collections and post the findings on the Web; that every effort be made to contact living heirs where works of art were found to have been channeled through Nazi hands; and that future gifts and purchases be carefully screened beforehand. Confident in his organization's resolve, Philippe de Montebello declared: "America's museums place themselves squarely on record as committed to acting swiftly and proactively to conduct the necessary research that will enable us to learn as much as possible about the history of works of art for which full ownership records have not been available." Nevertheless some outsiders wondered if the guidelines were anything more than "a public relations effort to make the museums appear godly."[89]

The AAMD's new policies were soon put to the test when, in November 1998, a tainted Monet—*Nymphéas* (Water Lilies) of 1904—was discovered in the midst of the major retrospective at Boston's MFA, Monet in the 20th Century. For museum skeptics, the details and timing of the discovery could not have been more opportune. On the eve of an international conference on Holocaust-era assets sponsored by the U.S. government, here was a pretty painting by the world's most beloved and overexposed artist taking part in a massively advertised, record-setting blockbuster show despite a documented Nazi past. Shortly after the exhibition opened, the painting's provenance was revealed and disseminated by the press. It turned out that before the war the Monet had belonged to a leading French dealer, Paul Rosenberg, a friend of Picasso and Matisse and pur-

veyor to the world's leading collectors on both sides of the Atlantic.[90] Following the German invasion of France in 1940, Rosenberg, a Jew, fled to the United States and his collection was confiscated by the Nazis. The *Nymphéas* entered the loot-laden collection of the Nazi foreign minister, Joachim von Ribbentrop. After the war it was returned to France and held by the state together with two thousand other paintings whose prewar ownership was then unclear. Years passed and no claim was made. Housed initially at the Jeu de Paume, the painting was transferred in 1975 to the Musée des Beaux-Arts in provincial Caen. Publicly displayed and well known to Monet scholars, *Water Lilies* was frequently on loan to traveling exhibitions before its inclusion in Monet and the 20th Century. It was spotted in the Boston show by Jonathan Petropoulos, an art historian who had included a photograph of it, obtained from the von Ribbentrop archives, in his book *Art as Politics in the Third Reich* (1996). Once the picture's past had been revealed, the MFA rewrote the wall label and issued a public statement. With the help of the Art Loss Register in London, and armed with a prewar photograph and documents, the descendants of Paul Rosenberg laid claim to their long "lost" painting.[91]

The story of Monet's *Nymphéas* ended well, but it left troubling questions in its wake. Given the fame of Paul Rosenberg's prewar collection, and the relative ease with which the painting's past was uncovered by Petropoulos, why hadn't its rightful owners been found sooner? The obvious conclusion is that no one had tried to find them and that the matter of provenance and ownership had never been a priority for the many scholars and curators who had studied and handled the painting after World War II. Nor, it would seem, had the French government made an active effort to identify the painting's owner despite its assertion (backed by the MFA) that the work had long been publicly exhibited for precisely that reason.[92] The painting's presence in the Boston exhibition was an embarrassment to the museum in light of the June 1998 AAMD commitment, signed by the MFA's director, not to "borrow works of art known to have been illegally confiscated during the Nazi/World War II era and not restituted." The museum may reasonably claim that no one knew the Monet had been "illegally confiscated" during the war, yet it could have complied with another AAMD recommendation that in case of orphaned objects museums "should acknowledge the history of the work of art on labels and publications."[93] The museum did this only after pressure from the press and the World Jewish Congress.

Also disturbing was the implication that if a painting of such stature could so easily escape detection then many lesser works were unlikely ever to be reclaimed. The Rosenberg case proved to be straightforward because the family had proof that the painting was in its possession before the war and had been looted by the Nazis rather than given away or bought legitimately by a collector. As a leading dealer, Rosenberg kept careful records, and his collection was very well known. But none of that is true of the great

majority of art objects displaced and stolen during the war. Families were destroyed and dispersed, documents and memories were lost. Few today could muster the documentary evidence the Rosenberg heirs had at hand. And even where evidence of prewar ownership exists, bringing claims invariably entails complex and expensive litigation and obstacles along the way. Current owners, perhaps embarrassed, out of pocket, and attached to objects they bought in good faith, have disputed evidence and used the courts to block restitution.[94] On the bright side, organizations like the Art Loss Register and the World Jewish Congress have helped families with claims, and museums have committed themselves to a thorough review of their collections. Some museums have dedicated staff to provenance research, and in cases where internal research has uncovered evidence of illegal confiscation or suspicious wartime transactions they have followed the AAMD recommendation and made their findings public.[95] Most museums have Web pages devoted to that purpose, and the American Association of Museums acts as a central clearinghouse for shared information. We can be sure that much more attention is now paid to provenance when museums acquire or borrow works of art. Museums evidently want to do the right thing and certainly want to avoid being accused of not doing enough. Even auction houses undertake provenance research to guard against unknowingly dealing in works that passed through Nazi hands.[96]

Despite much progress, problems remain.[97] The Washington Conference on Holocaust-Era Assets in 1998 prompted other nations to take action, but no umbrella organization came into being to ensure any consistency in response, methods, or standards of provenance research, or procedure for restitution. Every country has its own laws and operates independently of others, greatly complicating international restitution claims. Even within countries local practices may vary. In Germany itself, for example, a decentralized system of government leaves local museums autonomous and unaccountable to outside authority. In 1999 the Federal Republic of Germany pledged to return Nazi loot found in public institutions, but it had no means of forcing the compliance of local museums. Nor did it offer to fund research. Six years after the Berlin Declaration, only 166 of the 3,350 public museums in Germany had contributed findings to the central Internet database created to link lost objects with their owners.[98] Some German museums have gone out of their way to satisfy claims, while others have buried their heads in the sand. In the end, says Willi Korte, who has researched plundered art on behalf of museums and Nazi victims, "The whole thing is based on political commitment and goodwill. If you want to return art, you can find a way to do it. If you don't want to do it, you can find ways not to do it. You can randomly pick the legal arguments that suit you."[99] With respect to art seized or sold under duress during the Nazi era, we may never know how much was lost, but we can be certain that not all of it will find its way back to where it belongs.

While the allied restitution efforts of the postwar years were laudable, it should be noted that the work was limited to Western Europe. We still know little about what happened in Nazi-controlled Eastern Europe during and after the war. The Russians have only begun to disclose the extent of Soviet looting in Germany at the end of the war—estimated at 2.5 million works of art, books, and archives, including much that the Nazis had confiscated from victims of the Holocaust.[100] Moreover, they continue to view the loot as legitimate compensation for the suffering of their people during the war and so far have no shown interest in negotiating its return. The focus on Europe also obscures what happened in Asia during World War II.[101] How much attention is paid to the provenance of Asian art bought and sold and acquired by museums since the 1940s? The provenance research carried out by museums in the United States and Europe is concerned primarily, if not exclusively, with paintings, which constituted only a fraction of what was plundered. Once a museum has reviewed its paintings, will research then extend to prints and drawings, furniture and the decorative arts? Less valuable, less publicized, and often not unique (having been made in multiples), objects classified in the "lower" categories of art are harder to trace and will probably never receive the same attention. Provenance research is time consuming and complicated, requiring archival and language skills as well as art historical training. At some museums research was initially carried out by temporary staff funded by outside grants, but those grants evaporated, and it falls largely to curators to do the work on top of more rewarding tasks, such as the acquisition of new objects and the planning and execution of exhibitions. No matter who does the work, what happens when press and public interest subsides? A decade after Nazi loot was the stuff of headlines, it has retreated to the back pages of the specialist art magazines. Recently the director of Amsterdam's Rijksmuseum drew a distinction between Dutch paintings stolen by Napoleon and still in the Louvre and more recent restitution claims: "We see [Napoleon's booty] as history and are not going to claim them back from the Louvre," but at the same time "we would not now dream of buying illegally exported antiquities or ethnographic objects, or of not returning a painting to a rightful Jewish owner."[102] But at what point will theft from a Holocaust victim in World War II become "history" and no longer subject to action?

We might also ask why it took so long for the issue of Nazi-era restitution to emerge. The answer is complex. First, not until the 1980s did many wartime archives open for the first time, bringing to light long-buried questions about missing Jewish assets and those who had profited from them. Second, the last Holocaust survivors, after rebuilding shattered lives in new homes, were aging and wanted to right a lingering wrong before it was too late. Third, new sensitivity to forms of institutional oppression stemming from social activism of the 1960s and 1970s forced a broader reconsideration of museums' obligations to peoples whose objects they collect and whose cultures they

represent; the passage of NAGPRA in 1990 and Greek demands for the Elgin Marbles coincided with, and no doubt intensified, interest in half-forgotten claims left over from the war. Fourth, given the altruism and thoroughness of postwar restitution efforts, museums may well have assumed that the problem had been dealt with long ago. Not only did the men and women involved undertake their duties with skill and dedication, but they had vehemently opposed American efforts to bring the cream of Berlin's museum holdings to Washington for "safekeeping" on grounds that such a move threatened to make the United States seem "no less culpable" to "candid eyes" than the Nazis. The so-called Wiesbaden Manifesto, signed by twenty-four officers of Monuments, Fine Arts, and Archives (and later endorsed by one hundred museum officials), concluded: "We wish to state that from our knowledge, no historical grievance will rankle so long, or be the cause of so much justified bitterness, as the removal, for any reason, of a part of the heritage of any nation, even if that heritage may be interpreted as a prize of war."[103] But notwithstanding the integrity of the officers of Monuments, Fine Arts, and Archives and their European colleagues, the flourishing art market of the postwar years gave museums—especially in the cash-rich and art-poor United States—irresistible opportunities to expand their collections, and it would be naive to imagine that temptation did not on occasion lead museums to ignore ethical concerns when rare masterpieces presented themselves for acquisition.

One day the same may be said of works of art acquired from developing countries in Asia, Africa, and Latin America over the last few decades. As the supply of canonical Western art dries up, collectors and museums have turned their attention to new frontiers, notably contemporary art, previously marginalized art traditions, and newly "discovered" antiquities. Concomitantly a revisionist expansion of the art historical canon has sparked public demand for greater multicultural representation in our museums, ironically encouraging the material deprivation of cultures that revisionists aim to support and study. Students in the West have benefited from the inability of underresourced nations to guard their own heritage. Virtually all nations have laws protecting their cultural patrimony and outlawing the illegal excavation and export of artifacts, laws that received widespread international backing in the form of the UNESCO Convention on the Means of Prohibiting and Preventing the Illicit Import, Export and Transfer of Ownership of Cultural Property, adopted in 1970. But, as in the drugs or arms trade, where there is foreign demand and the financial rewards of illicit activity dwarf the incomes of honest farmers, police, and customs officials, laws are ignored and easily infringed. All over the developing world the destruction of archeological sites and cultural heritage, fed by market desires in the developed world, carries on at an alarming rate despite local prohibitions and international agreements. This is how John Hess assessed the situation at the time of the UNESCO Convention: "After World War II, . . . the spec-

tacular boom in art prices and in the collection of primitive and ancient artifacts [has] given rise to pillage on an industrial scale. Thousands of peasants eke out their livelihood from it; hundreds of dealers and corrupt officials make fortunes from it. The passionate and underpaid devotees of archaeology watch aghast while the history of antiquity disintegrates before their eyes. . . . Every American museum that collects ancient art is, or was until recently, a knowing receiver of stolen goods."[104]

Western museums publicly oppose illicit trafficking of cultural property, of course, and since 1970 laws against it have become stricter, yet the looting continues. One archeologist has estimated that as much as 80 to 90 percent of the material on the antiquities market at the turn of the new millennium was illicit.[105] At the root of the problem are unscrupulous dealers and collectors, and hardly a month passes without news of smuggled treasures reaching the West. In 2003, for example, rare and beautiful artifacts from a little-known Mesopotamian settlement began appearing for sale in London and Paris; they had been systematically looted by villagers two years earlier under the noses of helpless officials from Iran's Ministry of Culture.[106] When the police finally halted the looting, much of the site had been destroyed; thousands of objects were confiscated from locals, but countless others had already been spirited out of Iran. The final tally of artifacts stolen from the Baghdad museum during the U.S.-led invasion in 2003 stands at close to fifteen thousand, two-thirds of which are still missing.[107] Of the items recovered, over a quarter were found abroad. Such well-publicized cases are the exception. More common is the looting that takes place out of the public eye and goes unreported: it typically involves an unguarded site or newly discovered tomb that is plundered under the cloak of dark and a network of middlemen and dealers who smuggle the found objects to a primary art market (London, New York, Hong Kong) via countries with lax custom controls (notably Switzerland), where they are given a false provenance and sold to a private collector.[108] In contrast to documented art objects stolen from museums or collectors, newly excavated objects often have no paper trail, making spurious provenances easy to concoct and hard to disprove. Museums steer well clear of the former, but, until recently at least, they operated with looser standards with respect to the latter. "It was common through the 1980s and 90s," the *New York Times* reported, "for museums to buy ancient art that had no known provenance."[109] In the late 1990s, just when museums were publicly committing themselves to Nazi-era provenance research, they were quietly working with art dealers to prevent a tightening of regulations on the antiquities trade.[110]

Late in 2005, in a new attempt to stem the flow of illegally excavated and exported antiquities across its borders, Italy attacked the problem at the buyers' end, charging the Getty Museum with conspiring with dealers to acquire millions of dollars' worth of looted antiquities, and asking the Met and other U.S. museums to return antiquities

that it claimed were illegally exported from the country.[111] The case sent shockwaves through the American museum community and may halt (at least temporarily) the acquisition of undocumented objects. Chastened by the publicity, Met director Philippe de Montebello remarked: "Before the purchase of any antiquity, rigorous due diligence is conducted, and there is no question that far fewer pieces in the future will meet our criteria."[112] But we should not imagine that the looting will stop; collectors need things to collect, and museums need to grow. The rewards for dealers and looters are great and the chances of getting caught are not great enough, especially in archeologically rich, cash-poor countries lacking the resources to protect their heritage or stage sophisticated legal proceedings. The Italian case was unusual for a number of reasons. First, the quality of evidence—particularly photographs of the objects in question fresh from the ground and still encrusted with dirt—was especially good, and only "incontrovertible evidence" could compel American museums to act. Second, Italy, as a major European nation, has the resources—legal, financial, archeological, and media—to take on those museums in a way that developing nations (as yet) do not. And third, U.S. museums need the goodwill of the Italian authorities to ensure future cooperation on the loans that are so vital to their exhibition programs. The Italian Renaissance is still central to the Western canon, and major blockbusters (e.g., Fra Angelico at the Met [2005] or Bellini, Giorgione, Titian and the Renaissance of Venetian Painting at Washington's National Gallery [2006]) depend on the goodwill of the Italians.

Compounding the problem for countries in the developing world is the fact that we in the West care less about the loss of their heritage than we do about the fate of the Parthenon or art looted by the Nazis. Whether because looting archeological sites seems like a victimless crime or because we hold anonymous artifacts produced by unfamiliar cultures in lower esteem, museums are held to a higher standard of ethical conduct when it comes to Western art. Even archeological material from Western Europe gets more attention than its equivalent from other parts of the world; witness the Getty trial in Rome. As He Shuzhong, head of Cultural Heritage Watch in Beijing, noted: "Can you imagine a Renoir suddenly appearing on the international market without any history of where it came from? It's outrageous that nobody gives Asian art the same scrutiny."[113] And the same is true for African and Latin American art. A recent, fleeting controversy serves as an example. Late in 1997, in a commendable bid to show an expanded range of art, the Boston MFA inaugurated a new display of artifacts from Africa, Mesoamerica, and Oceania that instantly drew fire from the governments of Guatemala and Mali for including objects they claimed had been illicitly exported to the United States.[114] Both claims involved typical ambiguities. The Malian artifacts evidently lacked documented provenance but are believed by archeologists to have been looted and smuggled out of the country after the enactment of strict export bans in 1969. As for the Gua-

temalan objects, the MFA rejected calls for their restitution, arguing that even though it was clear they had left Guatemala in violation of local export laws in the late 1970s and early 1980s they had entered the United States legally, *before* the U.S. Congress endorsed the 1970 UNESCO convention on illicit trafficking of cultural property in 1983 (the Convention on Cultural Property Implementation Act). But while the MFA is legally entitled to keep the art in question, is it morally defensible to do so? Certainly the Guatemalan vice minister for culture didn't think so, stating that the museum was not "reputable" because "it does not respect the cultural heritage of our country or our laws against looting. . . . We cannot call them a museum because that is a term of honor. Their collectors buy looted pieces and then they accept them. A real museum with ethics would not accept looted goods."[115]

The disputed objects had been given to the museum by prominent collectors who were also trustees, so it was harder for the museum to give them back—or decline the gifts in the first place—even if it had wanted to. As a former director of the MFA admitted: "Often the biggest problem the museum director faces is . . . the collecting activity of his or her board members, especially if those people occasionally present the museum with an object. You cook your own goose very quickly if you tell a museum member or board member you will not accept their gifts on quasi-legal and ethical grounds."[116] In much the same way that museums regard corporate sponsorship and possible conflicts of interest as a necessary evil, a softening of ethical standards with respect to gifts from key donors is seemingly tolerated as the price of growth.

If public sympathy made the return of Nazi loot an international priority that no one could ignore, visitors to the MFA exhibition of African, Oceanic, and pre-Columbian art at the time of the miniscandal in 1997 were unmoved by protests from the Malian and Guatemalan governments. "Most greeted the art with enthusiasm, and the controversy surrounding it with simple, so-what shrugs," remarked a local reporter.[117] The more thoughtful among the crowd echoed the standard salvage/preservation/access argument made by museums themselves. "They ought to stay here and people ought to see them," said one. "I think it's sad that they were not able to protect their own culture. We certainly wouldn't want them destroyed in a revolution. . . . They're fabulous items that should be preserved in a museum." Another defended the good museums do in preserving and representing other cultures for the benefit of many, "and, for that reason, the end justifies the means." A third resorted to another stock rebuttal of the repatriation debate: "If the art of all these different counties were sent back to those countries, this museum would be empty—except for American art. I think that Egyptian art, that Greek art, and that Mayan art all belong to the people of the world."

■ ■ ■

New acquisitions are the lifeblood of museums. The quest for wondrous objects, novelty, and completeness has driven museums and motivated their publics from the beginning; along the way the interests of preservation, education, and delight have been admirably served. Once Napoleon made those ideals the concern of the state and dedicated its powers to their fulfillment, museums have represented both the best and the worst aspects of advanced societies, for much of the good they do has come at the expense of dispossessed cultures and peoples. As accumulative, forward-looking institutions, museums are understandably reluctant to confront the unsavory circumstances surrounding the acquisition of many of their treasures. Restitution fundamentally compromises any museum's mission. Because museums are a source of national pride and tourist revenue, governments are likewise reluctant to see them weakened. But for the same reasons and perhaps to a greater extent, museums and governments in once-subjugated countries press for the return of their heritage. Where a given object is better off is a matter of opinion, and in the end the issue of restitution and repatriation boils down to precisely that. Objects go home when public opinion says they should.[118] The battle for public opinion will continue to rage in the years to come.

CONCLUSION: BEYOND BILBAO

This book began with a desire to better understand the conflicts of opinion that characterize public debate about art museums and their place in society. To that end, each chapter attempted to put key issues in historical perspective. Two things should be clear after reading this book. First, the issues facing museums today are not new, and some of them are as old as the museum itself. As we have seen, shifting circumstances cause certain issues to gain greater urgency at different times. Opinions will also vary, and postmodernism has heightened debate by arguing that truths are contingent and that things once taken for granted are susceptible to revision. The latter position has itself been contested by proponents of traditional values. In the face of controversies and divergent views, James Cuno and fellow contributors to *Whose Muse?* insist that the public's trust in museums depends on a broad-based reaffirmation of first principles, or "truths," beginning with the primacy of art objects whose authenticity is beyond doubt. Other more recent priorities, they claim, such as audience building, diversity, community activism, and expansion (through new buildings or branches), are secondary, if not contrary, to a museum's proper mission. Cuno and his colleagues are right to focus on the good museums do; criticism too easily overlooks their remarkable success over the past two centuries. But at the same time, assumptions should not be made too quickly about what the public trusts museums to do or who constitutes the museum's public. The "truth" about a painting by Rembrandt can extend beyond its attribution to include questions of provenance and function (who owned the painting in the past, and how was it used and valued at different times?) and the circumstances of its acquisition by the museum (did it pass through Nazi hands during World War II?). Should minority populations trust a museum that privileges Rembrandt, or one whose outreach efforts

are only token programs? At a time when some museums are eliminating admission fees, should we trust others that say they have no choice but to raise their prices?

Nor should reaffirmation of traditional values blur recognition that different institutions face different challenges. An old museum full of mainstream Western art will look to the future differently from a community-based museum of African Diaspora culture or a start-up institute of contemporary art. The mainstream museum may have problems with restitution or outdated environmental controls, the diasporic museum may need to build a collection, and the contemporary museum may want to put itself on the map with a splashy building. All three may be financially insecure, but they will approach the challenge of fund-raising in different ways.

Whatever the source or motive, criticism that sparks reflection and debate is good for any institution. The last twenty years or so have witnessed a remarkable invigoration of museum culture and discourse. What can we expect in the years to come?

A decade after the opening of the new Guggenheim in Bilbao, the building boom continues. In New York City alone in 2006 more than sixty arts institutions were undergoing or had recently completed architectural renovations or new construction at a cost of some $3 billion.[1] Skeptics continue to warn (and in some cases wish) against expansion, worrying that the market cannot sustain an infinitely expanding cultural sector, but there can be no denying that museums and allied cultural venues are now central to the mushrooming global tourist industry as well as local community development. High culture has become an engine of urban renewal throughout the West. Expansion can be justified, in other words, both economically and politically—an extremely potent mix. On the level of psychology and emotion, beautiful museums offer a safe and seductive environment and are attractive as such. Disagreements will continue about what constitutes a beautiful or effective museum, but that architecture is central to the museum experience cannot be in doubt. Because the psychic, emotional value of our environment and the spaces we inhabit is vague and understudied, it is too easily underestimated. Those who argue for greater access to museums have trouble articulating why access matters. We lack compelling language to justify the social value of art.

A stunning space is part of what museum-goers pay to enjoy, but, as consultant Adrian Ellis states, "[A] splendid building is only part of the equation. The other part is the quality of the programming and the resources [that institutions] can bring to bear on the programming."[2] A general rule of thumb for art museums holds that the greater the collection (a museum's chief asset) and endowment, the less need for alluring architecture, shops, and cafés. However, special exhibitions, retail, and restaurants have become so much a part of the mainstream museum experience that those few museums that do without them now seem perverse and unnecessarily ascetic. Museums that trumpet their permanent collections struggle to find effective means of stimulating higher

visitation. One emerging strategy is to make permanent collections seem less permanent and more like temporary exhibitions through rearrangement and focused thematic shows.[3] Creative "showmanship" of this sort (to revive a term popular in the 1920s) may raise the hackles of conservative critics and curators, but a static collection makes for a static public, which many museums neither want nor can afford.

Indeed, audience cultivation and analysis constitute a likely area of future growth as museums seek out previously untapped segments of the population, such as hard-to-reach teenagers (fig. 110).[4] Expanding the museum-going public, whether for ideological or economic reasons, will continue to be a widely shared goal of most institutions, and the challenge will be to balance the allocation of resources and programming in such a way that no one feels short-changed. At the same time, a powerful new trend in the field is the spread of "niche" museums targeting communities underserved by mainstream institutions. Whether those museums can survive financially by appealing to narrow interests remains to be seen. As if in response to the embrace of cultural difference at smaller institutions, mainstream museums have aggressively laid claim to the center on the strength of a universal humanist mission that in theory includes all and is rooted in the primacy of objects regardless of who comes to see them.

At the heart of the British Museum, Norman Foster's Great Court (2000; fig. 111) models for the rest of the world the new claim of a transcendent global embrace. Opened at

the start of a new millennium, the domed courtyard unites visitors from disparate lands with elemental sculptures from the ancient civilizations of Egypt, Rome, India, Assyria, Europe (Celts), and Oceania (Easter Island). In the middle of the court is the old Reading Room, transformed into a modern information center and library "focusing on the world cultures represented in the British Museum."[5] From under the ethereal dome, access is given to galleries of Egyptian sculpture, ethnographic collections (allowing visitors to see "the works of recent non-western societies . . . in their proper context among other world cultures"), and the King's Library, home to an exhibition about the museum's history that reinforces the timeless message of Tennyson's lines inscribed in the floor of the court: "and let thy feet / millenniums hence / be set in the midst of knowledge."

110. "Dude, Where's My Museum?" *Museum News* 84 (September–October, 2005).

111. Norman Foster, Great Court, British Museum, 2000.

112. The Euphronios Krater on display at the Metropolitan Museum of Art, New York, 2006.

The claim to transcendent relevance has also been mobilized to defuse mounting restitution claims, the most combustible issue facing encyclopedic museums. Even as the crisis of Nazi loot subsides a decade after the international initiatives of the late 1990s, other demands arise to keep the issue of restitution in the foreground. In 2005, Italian authorities went public with damning evidence that many classical antiquities prominently displayed in North American museums, including the Getty, Met, and Boston MFA, had been illegally excavated and exported. Media reports showed Getty curator Marion True bundled into court in sunglasses like a mobster.[6] Rather than endure a prolonged and embarrassing court case, one museum after another negotiated settlements behind closed doors. In exchange for returning looted artifacts—foremost among them, the famed Euphronios Krater (fig. 112) acquired by the Metropolitan Museum in 1972—the Italians offered long-term loans of similar material.[7] The Italians hope the publicity will dampen enthusiasm for undocumented antiquities among the world's wealthy museums; the latter, meanwhile, admit to no wrongdoing and reaffirm the ideals set forth in the Declaration on the Importance and Value of Universal Museums (2002)

(see Appendix). Countering the parochial interests that motivate repatriation claims, the declaration insists that "museums serve not just the citizens of one nation but the people of every nation."

What do museum professionals beyond Europe and North America make of the declaration? For George Abungu, former director of the National Museums of Kenya, the Declaration on Universal Museums "is a way of refusing to engage in dialogue around the issue of repatriation."[8] Abungu himself does not believe in mass repatriation, but he does want "dialogue between museums, and between museums and communities affected by issues of repatriation, in order to reach amicable solutions." Fellow African Kwame Appiah sides with the universal position, so long as meaningful dialogue is part of the equation between rich and poor museums. Using the British Museum as an example, he writes: "However self-serving it may seem, the British museum's claim to be a repository of the heritage not of Britain but of the world seems to me exactly right. Part of the obligation, though, will be to make those collections ever more widely available not just in London but elsewhere, through traveling collections, through publications, and through the World Wide Web."[9]

Thinking of his native Ghana, Appiah says: "I'd rather that we negotiated as restitution not just the major objects of significance for our history, but a decent collection of art from around the world."[10] The problem with cosmopolitanism, so far at least, is that it works only in one direction—toward the already bountiful museums of the West. While museums in Europe and the United States promote the benefits of universality for their own citizens and affluent tourists, what becomes of the museums and the populations they serve in the rest of the world? As George Abungu noted, the signatories of the declaration all hail from rich Western museums, heightening suspicions that what motivated the document was not so much a genuine desire to share as a fear of losing hold of their fabulous collections. What realistic chance does Mali or Guatemala have of either repatriating its own patrimony or borrowing Western art from New York and London? Putting aside legitimate security concerns at museums in the developing world, we still seem years away from seeing Rembrandts and Rothkos from Amsterdam and New York in an Accra museum. At the same time, are universal museums in the West doing all they can to promote the sort of cross-cultural dialogue that Abungu and Appiah have in mind? Who gets to take part in that dialogue and to what end? Making the world's museums truly cosmopolitan would be a noble (utopian?) goal for the global twenty-first century.

APPENDIX DECLARATION ON THE IMPORTANCE AND VALUE OF UNIVERSAL MUSEUMS (2002)

The international museum community shares the conviction that illegal traffic in archaeological, artistic, and ethnic objects must be firmly discouraged. We should, however, recognize that objects acquired in earlier times must be viewed in the light of different sensitivities and values, reflective of that earlier era. The objects and monumental works that were installed decades and even centuries ago in museums throughout Europe and America were acquired under conditions that are not comparable with current ones. Over time, objects so acquired—whether by purchase, gift, or partage—have become part of the museums that have cared for them, and by extension part of the heritage of the nations which house them. Today we are especially sensitive to the subject of a work's original context, but we should not lose sight of the fact that museums too provide a valid and valuable context for objects that were long ago displaced from their original source. The universal admiration for ancient civilizations would not be so deeply established today were it not for the influence exercised by the artifacts of these cultures, widely available to an international public in major museums. Indeed, the sculpture of classical Greece, to take but one example, is an excellent illustration of this point and of the importance of public collecting. The centuries-long history of appreciation of Greek art began in antiquity, was renewed in Renaissance Italy, and subsequently spread through the rest of Europe and to the Americas. Its accession into the collections of public museums throughout the world marked the significance of Greek sculpture for mankind as a whole and its enduring value for the contemporary world. Moreover, the distinctly Greek aesthetic of these works appears all the more strongly as the result of their being seen and studied in direct proximity to products of other great civ-

ilizations. Calls to repatriate objects that have belonged to museum collections for many years have become an important issue for museums. Although each case has to be judged individually, we should acknowledge that museums serve not just the citizens of one nation but the people of every nation. Museums are agents in the development of culture, whose mission is to foster knowledge by a continuous process of reinterpretation. Each object contributes to that process. To narrow the focus of museums whose collections are diverse and multifaceted would therefore be a disservice to all visitors.

Signed by the Directors of: The Art Institute of Chicago; Bavarian State Museum, Munich (Alte Pinakothek, Neue Pinakothek); State Museums, Berlin; Cleveland Museum of Art; J. Paul Getty Museum, Los Angeles; Solomon R. Guggenheim Museum, New York; Los Angeles County Museum of Art; Louvre Museum, Paris; The Metropolitan Museum of Art, New York; The Museum of Fine Arts, Boston; The Museum of Modern Art, New York; Opificio delle Pietre Dure, Florence; Philadelphia Museum of Art; Prado Museum, Madrid; Rijksmuseum, Amsterdam; State Hermitage Museum, St. Petersburg; Thyssen-Bornemisza Museum, Madrid; Whitney Museum of American Art, New York; The British Museum, London.

NOTES

All translations are my own unless otherwise noted.

Introduction

1. See, for example, Maxwell L. Anderson, "Defining Success in Art Museums," *Art Museum Network News,* October 2004, www.amnnews.com/view_10_2004.jsp (accessed October 29, 2006); "Art Museums Look Inward," *Harvard University Gazette,* January 17, 2002, www.philaculture.org/advo/announce.htm (accessed October 29, 2006). Even if such claims are exaggerated, they feed public perceptions of success and growth.

2. Judith H. Dobrzynski, "They're Building a Lot More Than Their Collections," *New York Times,* April 21, 1999, E13.

3. On China's new museums, see Elizabeth Casale, "China's New Cultural Revolution," *Platform* 4 (October 2004), www.aeaconsulting.com/site/platformv4i1a.html (accessed October 29, 2006).

4. James Cuno, "The Object of Art Museums," in *Whose Muse? Art Museums and the Public Trust,* ed. James Cuno (Princeton: Princeton University Press, 2004), 50, 52. In addition to Cuno's piece, there are essays by Philippe de Montebello, Glenn Lowry, Neil MacGregor, John Walsh, and James Wood.

5. Ibid., 73.

6. Kwame Anthony Appiah, *Cosmopolitanism: Ethics in a World of Strangers* (New York: W. W. Norton, 2006), and "Whose Culture Is It?" *New York Review of Books* 53 (February 9, 2006), www.nybooks.com/articles/18682 (accessed October 2006).

7. The conference in question, "The Institutions of Culture: The Museum," was held at Harvard's Center for European Studies and resulted in a landmark book of critique edited by the conference organizers, Daniel J. Sherman and Irit Rogoff, *Museum Culture: Histories, Discourses, Spectacles* (Minneapolis: University of Minnesota Press, 1994).

8. On Japan's first museum, see Alice Y. Tseng, "Styling Japan: The Case of Josiah Conder and the Museum at Ueno, Tokyo," *Journal of the Society of Architectural Historians* 63 (December 2004): 472–97. On Zimbabwe, see Dawson Munjeri, "Refocusing or Reorientation? The

Exhibit or the Populace: Zimbabwe on the Threshold," in *Exhibiting Cultures: The Poetics and Politics of Museum Display,* ed. Ivan Karp and Steven D. Lavine (Washington, DC: Smithsonian Institution Press, 1991), 444–56. Two recent books, Moira Simpson's *Making Representations: Museums in the Post-Colonial Era* (New York: Routledge, 1996) and Christine F. Kreps's *Liberating Culture: Cross-Cultural Perspectives on Museums, Curation, and Heritage Preservation* (New York: Routledge, 2003), argue against a Western-centric view of museums and for the liberation of indigenous cultures from Western hegemony.

9. M. A. Shakur, *Museum Studies* (Peshawar: Museum Association of Pakistan, 1953), v.

10. Ian Fisher, "Museum Pillage Described as Devastating but Not Total," *New York Times,* April 17, 2003. On international efforts to rebuild the museum, see "International Efforts to Help Iraqi Curators Save Looted Collections," *Art Newspaper,* June 2003, 6.

11. Kreps, *Liberating Culture,* 5.

12. Danielle Rice, "Museums: Theory, Practice, and Illusion," in *Art and Its Publics: Museum Studies at the Millennium,* ed. Andrew McClellan (Oxford: Blackwell, 2003), 78.

13. On the museum as tomb, see Theodor Adorno, "Valéry Proust Museum," in *Prisms,* trans. Samuel Weber and Shierry Weber (London: Spearman, 1967), 173–85; and Douglas Crimp, *On the Museum's Ruins* (Cambridge, MA: MIT Press, 1993); also see Llewellyn Negrin, "On the Museum's Ruins: A Critical Reappraisal," *Theory, Culture, and Society* 10 (February 1993): 97–125.

14. Philip Fisher, *Making and Effacing Art: Modern American Art in a Culture of Museums* (New York: Oxford University Press, 1991), 17; also see Ivan Gaskell, *Vermeer's Wager: Speculations on Art History, Theory and Art Museums* (London: Reaktion Books, 2000) and "Sacred to Profane and Back Again," in McClellan, *Art and Its Publics,* 149–62; and David Carrier, *Museum Skepticism: A History of the Display of Art in Public Galleries* (Durham: Duke University Press, 2006).

15. On this point, see Nick Prior, "Having One's Tate and Eating It: Transformations of the Museum in the Hypermodern Era," in McClellan, *Art and Its Publics,* 51–74.

16. Andreas Huyssen, "Escape from Amnesia: The Museum as Mass Medium," in *Twilight Memories: Marking Time in a Culture of Amnesia* (New York: Routledge, 1995), 17.

17. Paul Tillich, "Critique and Justification of Utopia," in *Utopias and Utopian Thought,* ed. Frank Manuel (Boston: Beacon Press, 1965), 296. The literature on utopias is vast. A good place to start (with an excellent bibliography) is *Utopia: The Search for the Ideal Society in the Western World,* ed. Roland Schaer, Gregory Claeys, and Lyman Tower Sargent (New York: Oxford University Press, 2000); see also Krishan Kumar, *Utopianism* (Minneapolis: University of Minnesota Press, 1991).

18. Georges Bataille, *Rethinking Architecture,* trans. Paul Hegarty (New York: Routledge, 1997), 23.

19. Appiah, *Cosmopolitanism.*

20. Andreas Huyssen, "Memories of Utopia," in *Twilight Memories,* 85–101. Huyssen is responding to Jean Baudrillard's *Simulacres et simulation* (Paris: Galilée, 1981).

21. On recent patterns of "Web visitation," see Carol Vogel, "3 Out of 4 Visitors to the Met Never Make It to the Front Door," *New York Times,* March 29, 2006, E18.

22. Quoted in *The Foucault Reader,* ed. Paul Rabinow (New York: Pantheon Books, 1984), 6.

23. Ibid., 46.

24. On Wilson's work in museums, see Maurice Berger, *Fred Wilson: Objects and Installations, 1979–2000* (Baltimore: Center for Art and Visual Culture, University of Maryland, Baltimore

County, 2001); and Lisa G. Corrin, ed., *Mining the Museum: An Installation* (New York: New Press, 1994). Tony Bennett offers thoughts on the intersection of theory and practice in "Putting Policy into Cultural Studies," in *Cultural Studies,* ed. Lawrence Grossberg, Cary Nelson, and Paula Treicher (New York: Routledge, 1992), 23–37.

25. Tony Bennett, "The Political Rationality of the Museum," *Continuum* 3 (1990): 44.

26. Berger, *Fred Wilson,* 34.

27. Huyssen, "Memories of Utopia," 90.

28. James Clifford, *The Predicament of Culture: Twentieth-Century Ethnography, Literature, and Art* (Cambridge, MA: Harvard University Press, 1988), 15–16; also 118–19, 145.

Chapter 1. Ideals and Mission

The epigraph is from Walter Benjamin, *The Arcades Project,* trans. Howard Eiland and Kevin McLaughlin (Cambridge, MA: Belknap Press, 1999), 406.

1. "The British Museum," 2003, www.thebritishmuseum.ac.uk/world/world.html (accessed January 1, 2006).

2. National Gallery of Art, "Mission Statement," 2006, www.nga.gov/xio/mission.htm (accessed October 29, 2006).

3. Quoted in "Taiwan Science and Technology Institutions: National Palace Museum," www.nsc.gov.tw/dept/belgium/e_web.htm (accessed October 29, 2006).

4. Peter Klaus Schuster, "The Treasures of World Culture in the Public Museum," *ICOM News,* no. 1 (2004): 4.

5. Johann Valentin Andreae, *Christianopolis,* trans. E. H. Thompson (Dordrecht: Kluwer Academic Publishers, 1999), 203, 210, 212.

6. Sir Francis Bacon, *Essays, Advancement of Learning, New Atlantis* (Franklin Center, PA: Franklin Library, 1982), 372, 382. For a nicely illustrated history of utopian schemes, see Roland Schaer, Gregory Claeys, and Lyman Tower Sargent, eds., *Utopia: The Search for the Ideal Society in the Western World* (New York: Oxford University Press, 2000).

7. *Francis Bacon: A Critical Edition of the Major Works,* ed. Brian Vickers (Oxford: Oxford University Press, 1996), 55.

8. Samuel Quicchelberg, *Inscriptiones vel tituli theatri amplissimi* (Munich: Adam Berg, 1565), examined in context by Eva Schulz, "Notes on the History of Collecting and of Museums in the Light of Selected Literature of the Sixteenth to Eighteenth Century," *Journal of the History of Collections* 2 (1990): 205–18; Lorraine Daston and Katherine Park, *Wonders and the Order of Nature, 1150–1750* (New York: Zone Books, 1998). On early modern collecting, also see the essential work of Krzysztof Pomian, *Collectors and Curiosities: Paris and Venice, 1500–1800,* trans. E. Wiles-Portier (Cambridge: Polity Press, 1990); Oliver Impey and Arthur MacGregor, eds., *The Origins of Museums: The Cabinet of Curiosities in Sixteenth- and Seventeenth-Century Europe* (Oxford: Oxford University Press, 1985); and Paula Findlen, *Possessing Nature: Museums, Collecting, and Scientific Culture in Early Modern Italy* (Berkeley: University of California Press, 1994).

9. The influence of Bacon's text on early modern institutions is well documented; see, for example, Arthur MacGregor, "'A Magazin of All Manner of Inventions': Museums in the Quest for 'Solomon's House' in Seventeenth-Century England," *Journal of the History of Collections* 1 (1989): 207–12; and Debora J. Meijers, "The Kunstkamera of Tsar Peter the Great (St. Petersburg 1718–34):

King Solomon's House or Repository of the Four Continents?" in *The Architecture of the Museum,* ed. Michaela Giebelhausen (New York: Manchester University Press, 2003), 17–31.

10. Andreae, *Christianopolis,* 203.

11. For a good selection of ancient references to the museum, see Edward A. Parsons, *The Alexandrian Library* (New York: Elsevier Press, 1952), 98–102. For more recent discussion of the *mouseion* and its influence, see Paula Young Lee, "The Musaeum of Alexandria and the Formation of the Muséum in Eighteenth-Century France," *Art Bulletin* 79 (1997): 385–412; and Daniel Heller-Roazen, "Tradition's Destruction: On the Library of Alexandria," *October* 100 (Spring 2002): 133–53.

12. See Marcia Hall, ed., *Raphael's School of Athens* (New York: Cambridge University Press, 1997), especially Ralph E. Lieberman, "The Architectural Background," 64–84.

13. Bronislaw Baczko, *Utopian Lights: The Evolution of the Idea of Social Progress,* trans. J. L. Greenberg (New York: Paragon, 1989), 319–20.

14. [Louis-Sebastien Mercier], *L'an deux mille quatre cent quarante: Rêve s'il en fût jamais,* 3 vols. ([Paris], 1786), 2:25–26.

15. Mercier's account of the Louvre built on others of his day, including Diderot's brief entry on the Louvre in the *Encyclopédie* ([1765], 9:706–7) and Maille Dussausoy, *Le citoyen désintéressé, ou diverses idées patriotiques, concernant quelques établissements utiles à la ville de Paris* (1767), 140ff. On late-eighteenth-century utopianism, see Frank E. Manuel and Fritzie P. Manuel, *Utopian Thought in the Western World* (Cambridge, MA: Belknap Press, 1979), 461ff.

16. Armand-Guy Kersaint, *Discours sur les monuments publics* (Paris: P. Didot ainé, 1792), 1, 39. Kersaint and Mercier were contemporaries and fellow Girondins in the early years of the Revolution.

17. Marquis de Condorcet, "Fragment sur l'Atlantide," in *Oeuvres de Condorcet,* ed. A. Condorcet O'Connor and M. F. Arago (Paris: Didot, 1847), 6:597–600.

18. J.-L. David, *Rapport . . . sur la fête de la Réunion républicaine du 10 août* (Paris: Imprimerie Nationale, 1793), 4.

19. Quoted in Andrew McClellan, *Inventing the Louvre: Art, Politics, and the Origins of the Modern Museum in Eighteenth-Century Paris* (New York: Cambridge University Press, 1994), 94. On the political functions of the Louvre and early museums, also see Carol Duncan, *Civilizing Rituals: Inside Public Art Museums* (New York: Routledge, 1995).

20. See Dominique Poulot, *Musée, nation, patrimoine, 1789–1815* (Paris: Gallimard, 1997).

21. Friedrich Schiller, *On the Aesthetic Education of Man,* trans. Reginald Snell (New Haven: Yale University Press, 1954), 87 (letter 18). Interpreting Schiller, James Sheehan writes: "The experience of beauty liberates us without alienating us from the physical world in which we must live. Art and life do not become one; instead, art teaches us how to live in freedom and harmony." James Sheehan, *Museums in the German Art World: From the End of the Old Regime to the Rise of Modernism* (New York: Oxford University Press, 2000), 45. Sheehan provides an excellent history of German museums.

22. William Hazlitt, "Picture Galleries in England," in *The Collected Works of William Hazlitt,* ed. A. R. Walker and Arnold Glover (London: J. M. Dent, 1903), 9:7. See also Colin Trodd, "Culture, Class, City: The National Gallery, London and the Spaces of Education, 1822–57," in *Art Apart: Art Institutions and Ideology across England and North America,* ed. Marcia Pointon (New

York: Manchester University Press, 1994), 42. The eighteenth-century art dealer Edme Gersaint recommended collecting as an ideal form of recreation for the man "accablé d'affaires." *Catalogue raisonné . . . de feu M. Quentin de Lorangère* (Paris: Jacques Barois, 1744), 1.

23. Quoted in Christopher Whitehead, *The Public Art Museum in Nineteenth Century Britain: The Development of the National Gallery* (Aldershot: Ashgate, 2005), 5. Also see Brandon Taylor, *Art for the Nation: Exhibitions and the London Public, 1747–2001* (Manchester: Manchester University Press, 1999).

24. *Punch,* July 8, 1843, 22.

25. Charles Kingsley, *His Letters and Memories of His Life,* ed. Fanny Kingsley, 2 vols. (London: Macmillan, 1890), 1:129.

26. Sir Henry Cole, *Fifty Years of Public Work,* 2 vols. (London: George Bell, 1884), 2:368.

27. Numerous historians and critics have made good use of Foucault's work in their analysis of museums; see, for example, Duncan, *Civilizing Rituals;* Eilean Hooper-Greenhill, *Museums and the Shaping of Knowledge* (New York: Routledge, 1992); Douglas Crimp, *On the Museum's Ruins* (Cambridge, MA: MIT Press, 1993); and Thomas A. Markus, *Buildings and Power: Freedom and Control in the Origin of Modern Building Types* (New York: Routledge, 1993).

28. *The Works of John Ruskin,* ed. E. T. Cook and A. Wedderburn, 39 vols. (London: George Allen, 1907–8), 34:247; also 30:53, where Ruskin recommends museums for their ability to improve the "laboring multitude."

29. Cole, *Fifty Years of Public Work,* 1:356. Thomas Greenwood agreed that "the order and evident science . . . in which [museum collections] are grouped and arranged" would inspire respect in the workingman for the principle of order in society at large; Thomas Greenwood, *Museums and Art Galleries* (London: Simkin, Marshall, 1888), 8, 26. On the value of order in Victorian museums, see Tony Bennett, *The Birth of the Museum: History, Theory, Politics* (New York: Routledge, 1995) and *Pasts beyond Memory: Evolution, Museums, Colonialism* (New York: Routledge, 2004).

30. Quoted in Trodd, "Culture, Class, City," 38. A French commentator wrote in 1872: "Museums are by no means a simple luxury. The sight of portraits of humanity's benefactors and soldiers who have contributed to the defense and glory of the homeland will inspire respect and admiration in the masses and ignite in them sentiments of goodness and patriotism." C. Le Coeur, *Considérations sur les musées de province* (Paris: Vignancourt, 1872), 17.

31. General Luigi P. di Cesnola, *An Address on the Practical Value of the American Art Museum* (Troy, NY: Stowell Printing House, 1887), 17.

32. Edward Bradbury, "A Visit to Ruskin's Museum," *Magazine of Art* 3 (1879–80): 57. On Ruskin's museum, see Edward T. Cook, *Studies in Ruskin* (London: George Allen, 1891), 141–61; Catherine W. Morley, *John Ruskin, Late Work, 1870–1890: The Museum and Guild of St. George: An Educational Experiment* (New York: Garland, 1984); and Susan P. Casteras, "The Germ of a Museum, Arranged First for 'Workers in Iron': Ruskin's Museological Theories and the Curating of the Saint George's Museum," in *John Ruskin and the Victorian Eye,* ed. Susan Phelps and Anthony Lacy Gully (New York: Abrams, 1993), 184–209.

33. Bradbury, "Visit to Ruskin's Museum," 58; and William C. Ward, "Saint George's Museum, Sheffield," *Art Journal* 21 (1882): 242. Mention should also be made of the Art Treasures Exhibition held in Manchester in 1857, the same year South Kensington opened. Six-

teen thousand works of art, many borrowed from landed families, entertained 1,300,000 people over four months in a glass and steel structure resembling the Grand Gallery of the Louvre, demonstrating once more that even the humblest segments of society could draw pleasure and inspiration from a public art exhibition. And nowhere was inspiration more needed than Manchester, capital of the industrial North, a smoke-covered "foul drain" from which "the greatest stream of human industry flows out to fertilize the world," according to Alexis de Tocqueville, who visited the booming mill town in 1835. Quoted in Suzanne Fagence Cooper, "Art Treasures Exhibition, Manchester 1857," *Magazine Antiques* 159 (June 2001): 926–33; and Francis Haskell, *The Ephemeral Museum: Old Master Paintings and the Rise of the Art Exhibition* (New Haven: Yale University Press, 2000).

34. Matthew Arnold, *Culture and Anarchy* (New Haven: Yale University Press, 1994), 30, 32, 34, 47.

35. For the history of the South Kensington Museum, see Anthony Burton, *Vision and Accident: The Story of the Victoria and Albert Museum* (London: Victoria and Albert Museum, 1999); Taylor, *Art for the Nation*, ch. 3; and Bennett, *Birth of the Museum*.

36. Cole, *Fifty Years of Public Work*, 2:346.

37. Ibid., 2:345; in a lecture at the École centrale d'architecture in Paris in 1867, he described museums as "une espèce de monument socialiste, où le niveau est le même pour tous" (2:302).

38. Greenwood, *Museums and Art Galleries*, 173.

39. On the spread of applied arts museums in Europe and the United States, see Michael Conforti, "The Idealist Enterprise and the Applied Arts," in *A Grand Design: The Art of the Victoria and Albert Museum* (New York: Abrams, 1997), 22–47.

40. Quoted in Burton, *Vision and Accident*, 127ff.

41. Greenwood, *Museums and Art Galleries*, 249ff.

42. Quoted in Rossella Froissart, "Les collections du Musée des arts décoratifs de Paris: Modèles de savoir technique ou objets d'art," in *La jeunesse des musées: Les musées de France au XIXe siècle*, ed. Chantal Georgel (Paris: Réunion des Musées Nationaux, 1994), 84.

43. See Steven Conn, *Museums and American Intellectual Life, 1876–1926* (Chicago: University of Chicago Press, 1998), chs. 1–3.

44. On Wells and the museum, see Lars Gustafsson, "The Present as the Museum of the Future," in *Utopian Vision, Technological Innovation, and Poetic Imagination*, ed. Klaus L. Berghahn and Reinhold Grimm (Heidelberg: Carl Winter Universitäts, 1990); and Nicole Pohl, "'Passionless Reformers': The Museum and the City in Utopia," in Giebelhausen, *Architecture of the Museum*, 137–39.

45. Quoted in Sigfried Giedion, *Space, Time and Architecture*, 5th ed. (Cambridge, MA: Harvard University Press, 1967), 251.

46. Arnold, *Culture and Anarchy*, 128, 106.

47. Julius Meier-Graefe, "The Mediums of Art, Past and Present," in *Art in Theory, 1900–2000: An Anthology of Changing Ideas*, ed. Charles Harrison and Paul Wood (Malden, MA: Blackwell, 2003), 57, 55.

48. Ibid., 56. Meier-Graefe here echoed earlier critics of art's commodification, notably Quatremère de Quincy; see Daniel J. Sherman, "Quatremère/Benjamin/Marx: Art Museums, Aura, and Commodity Fetishism," in *Museum Culture: Histories, Discourses, Spectacles*, ed. Daniel J. Sherman and Irit Rogoff (Minneapolis: University of Minnesota Press, 1994), 123–43.

49. Henry James, *The American Scene* (1904; reprint, New York: Horizon, 1967), 192. On the American market, see Flaminia Gennari Santori, *The Melancholy of Masterpieces: Old Master Painting in America, 1900–1914* (Milan: 5 Continents, 2003).

50. See Anne Higonnet's *At Home with Art: A History of Personal Collection Museums, 1848–1940* (Pittsburgh, PA: Periscope Publications, 2007).

51. On late-nineteenth-century museum developments in the United States, see Conn, *Museums and American Intellectual Life*. Matthew Arnold, among others, had remarked on the lack of culture in the United States; see his "A Word about America," *Nineteenth Century* 11 (May 1882): 680–96, and also Benjamin Ives Gilman, *Museum Ideals of Purpose and Method* (Boston: Boston Museum of Fine Arts, 1923), 69–73.

52. Walter Smith, writing in *Household Taste,* quoted in John Cawelti, "America on Display: The World's Fairs of 1876, 1893, 1993," in *The Age of Industrialism in America,* ed. F. C. Jaher (New York: Free Press, 1968), 319.

53. Cesnola, *Address,* 10.

54. Quoted by Dennis B. Downey, *A Season of Renewal: The Columbian Exposition and Victorian America* (Westport, CT: Praeger, 2002), 1.

55. See Conn, *Museums and American Intellectual Life,* ch. 6.

56. Quoted in Calvin Tomkins, *Merchants and Masterpieces: The Story of the Metropolitan Museum of Art* (New York: Dutton, 1970), 107.

57. Gilman, *Museum Ideals,* 69. On the development of nineteenth-century American art museums, see Alan Wallach, *Exhibiting Contradiction: Essays on the Art Museum in the United States* (Amherst: University of Massachusetts Press, 1998). For more on the "battle of the casts," see Walter Muir Whitehill, *Museum of Fine Arts, Boston: A Centennial History,* 2 vols. (Cambridge, MA: Belknap Press, 1970).

58. Gilman, *Museum Ideals,* 94. For the spread of art appreciation in the United States, see Rossiter Howard, "Changing Ideals of the Art Museum," *Scribner's Magazine,* January 1922, 125–28.

59. [Benjamin Gilman], "The Copley Square Museum," *Bulletin of the Museum of Fine Arts, Boston* 7 (1909): 19.

60. Andrew Carnegie, "The Best Use of Wealth," in *Miscellaneous Writings of Andrew Carnegie,* ed. Burton J. Hendrick, 2 vols. (Garden City, NY: Doubleday, Doran, 1933), 2:210.

61. John Cotton Dana, *A Plan for a New Museum* (Woodstock, VT: Elm Tree Press, 1920), 16, and *The New Museum* (Woodstock, VT: Elm Tree Press, 1917), 32. An important article by Paul DiMaggio examines Dana's insights with respect to Boston's Museum of Fine Arts, "Cultural Entrepreneurship in Nineteenth-Century Boston: The Creation of an Organizational Base for High Culture in America," in *Media, Culture, and Society: A Critical Reader,* ed. Richard Collins et al. (Beverly Hills, CA: Sage Publications, 1986), 194–211.

62. John Cotton Dana, *The Gloom of the Museum* (Woodstock, VT: Elm Tree Press, 1917), 6, 8.

63. Gilman, *Museum Ideals,* 95.

64. Dana, *New Museum,* 14.

65. Ibid., 20, 21–22.

66. On Dana, see *John Cotton Dana, 1856–1929* (Newark: Newark Public Library, 1930); and Holger Cahill, "John Cotton Dana and the Newark Museum," in *A Museum in Action* (Newark: Newark Museum, 1944). For a brief but worthy reappraisal of Dana's work, see

Stephen E. Weil, *Making Museums Matter* (Washington, DC: Smithsonian Institution Press, 2002), 188–92.

67. Gilman, *Museum Ideals*, 6–7.

68. Ralph Adams Cram, *The Ministry of Art* (Boston: Houghton Mifflin, 1914), 83.

69. Charles L. Hutchinson, "The Democracy of Art," *American Magazine of Art* 7 (August 1916): 399.

70. Mrs. Schuyler van Rensselaer, "The Art Museum and the Public," *North American Review* 205 (January 1917): 81.

71. Ibid., 90.

72. Roger Fry, "An Essay in Aesthetics," in Harrison and Wood, *Art in Theory*, 80.

73. Ernest Fenollosa, *Epochs of Chinese and Japanese Art* (New York: Stokes and Heinemann, 1912), 1:xxiv. Quoted in Carrier, *Museum Skepticism*, 128.

74. Cram, *Ministry of Art*, 96.

75. Gilman, *Museum Ideals*, 72.

76. Reprinted in Elizabeth Simpson, ed., *The Spoils of War* (New York: Harry N. Abrams, 1997), 279. Drafted in 1907, the convention entered in force in 1910.

77. Paul Clemen, ed., *Protection of Art during War* (Leipzig: E. A. Seemann, 1919), 1.

78. Arsène Alexandre, *Les monuments français détruits par l'Allemagne* (Paris: Berger-Levrault, 1918), 23, 1.

79. Ibid., 5.

80. Ibid., 31–32.

81. Focillon's phrase is from League of Nations, Committee on Intellectual Co-operation, *Minutes of the Twelfth Session, 1930* (Dijon: Darantière, 1930), 99. A year earlier a committee member said the congress "served to show that, local divergences notwithstanding, the art of nations had a common source. If one wanted to prove how deeply rooted were the League's ideas, it was in the province of the popular arts that an illustration would be found." *Minutes of the Eleventh Session, 1929,* 33.

82. E. Foundoukidis, describing Destrée's beliefs, in "L'oeuvre internationale de Jules Destrée dans le domaine des arts," *Mouseion* 33–34 (1936): 11. Foundoukidis was Destrée's secretary at the Museums Office.

83. Ibid., 11.

84. Ibid., 9.

85. Paul Otlet, "Mundaneum 1929," in Le Corbusier and Pierre Jeanneret, *Oeuvre complète de 1910–1929,* ed. Willy Boesiger and Oscar Stonorov, 4th ed. (Erlenbach: Éditions d'architecture, 1946), 190.

86. Ibid., 192.

87. DeWitt H. Parker, *The Analysis of Art* (New Haven: Yale University Press, 1926), 180–81.

88. In a radio broadcast in June 1941, during the worst of the bombing, Hess remarked: "I remember being told during the Spanish conflict how when Barcelona was undergoing its most agonizing moment of aerial bombardment, that outside the Concert Hall there was a queue that stretched almost to the end of the street. People felt then as people today in Britain feel now, that music with its wealth of spiritual beauty could still all the turmoil, all the hatred, all the sorrow of modern warfare." Quoted in Marian C. McKenna, *Myra Hess: A Portrait* (London: Hamish Hamilton, 1976), 150–51.

89. Kenneth Clark, *The Other Half: A Self-Portrait* (London: John Murray, 1977), 28. He also wrote: "I believe that many Londoners who remember the first year of the war will agree that the National Gallery concerts were amongst the few rewarding intervals in their daily lives" (29).

90. Letter to the editor, *Yorkshire Post,* March 16, 1940; in National Gallery Archives HF 1940/5.

91. Charles Wheeler, R.A., to *Times (London),* January 3, 1942, quoted in Neil MacGregor, "A Pentecost in Trafalgar Square," in *Whose Muse? Art Museums and the Public Trust,* ed. James Cuno (Princeton: Princeton University Press, 2004), 43.

92. Kenneth Clark to Martin Davies, February 5, 1942, National Gallery Archives, NG 16/59.4. Attendance at the thirty-one exhibitions between 1942 and 1945 averaged just under twenty-two thousand people.

93. On the Guggenheim Museum, see Neil Levine, *The Architecture of Frank Lloyd Wright* (Princeton: Princeton University Press, 1996), 299–363.

94. Ibid., 315, 335.

95. Roberta F. Alford, "Popular Teaching in Art Museums," *Museum News* 23 (February 1, 1946): 6.

96. Archibald MacLeish, "Museums and World Peace," *Museum News* 23 (June 1, 1946): 6–7 (emphasis in original).

97. Ibid.

98. "Educational Activities," *Bulletin of the Minneapolis Institute of Arts* 38 (January 1, 1949): 10.

99. See John Szarkowski, "The Family of Man," in *The Museum of Modern Art at Mid-century: At Home and Abroad,* ed. John Elderfield, Studies in Modern Art 4 (New York: Museum of Modern Art, 1994), 12–37; Christopher Phillips, "The Judgment Seat of Photography," *October* 22 (Fall 1982): 27–63.

100. Edward Steichen, *The Family of Man,* 30th Anniversary Edition (New York: Museum of Modern Art, 1997), 5. The text was by Carl Sandberg.

101. Ibid., 3.

102. Quoted in Mary Anne Staniszewski, *The Power of Display: A History of the Exhibition Installations at the Museum of Modern Art* (Cambridge, MA: MIT Press, 1998), 250.

103. André Malraux, *Museum without Walls,* trans. S. Gilbert and F. Price (New York: Doubleday, 1967), 220, 162.

104. Guggenheim Museum, "The Guggenheim Museum Celebrates Fortieth Anniversary of the Landmark Frank Lloyd Wright Building," September 21, 1999, www.guggenheim.org/press_releases/release_60.html (accessed May 1, 2006).

105. Serge Guilbaut, *How New York Stole the Idea of Modern Art: Abstract Expressionism, Freedom, and the Cold War,* trans. Arthur Goldhammer (Chicago: University of Chicago Press, 1983). Also see Kirk Varnedoe, "The Evolving Torpedo: Changing Ideas of the Collection of Painting and Sculpture of the Museum of Modern Art," in *The Museum of Modern Art at Mid-century: Continuity and Change,* Studies in Modern Art 5 (New York: Museum of Modern Art, 1995), 12–73.

106. Walter Pach, *The Art Museum in America: Its History and Purpose* (New York: Pantheon, 1948), 210. On the suppression of language in abstract art, see W. J. T. Mitchell, "*Ut Pictura Theoria:* Abstract Painting and Language," in *Picture Theory* (Chicago: University of Chicago Press, 1994), 213–39; also Benjamin H. D. Buchloh, "From Faktura to Factography," in *October: The First Decade, 1976–1986,* ed. Annette Michelson et al. (Cambridge, MA: MIT Press, 1987), 77–113.

107. Sybil Gordon Kantor, *Alfred H. Barr, Jr. and the Intellectual Origins of the Museum of Modern Art* (Cambridge, MA: MIT Press, 2002), 317–18.

108. William Rubin, "When Museums Overpower Their Own Art," *New York Times*, April 12, 1987, H31.

109. Francis Henry Taylor, "The Undying Life in a Work of Art," *New York Times Book Review*, November 22, 1953, 1, 43.

110. Roland Barthes, *Mythologies,* trans. Annette Lavers (New York: Hill and Wang, 1972), 101. Barthes's essays were written between 1954 and 1956 and were first published in 1957.

111. Ibid.

112. Pierre Bourdieu and Alain Darbel, *The Love of Art: European Art Museums and Their Public,* trans. C. Beattie and N. Merriman (Cambridge: Polity Press, 1991). On Bourdieu and French cultural politics leading to the creation of the Pompidou Center, see Rebecca DeRoo, *The Museum Establishment and Contemporary Art: The Politics of Artistic Display in France after 1968* (New York: Cambridge University Press, 2006).

113. Mitchell, *Picture Theory,* 217, 241–79.

114. See Francis Frascina, *Art, Politics and Dissent: Aspects of the Art Left in Sixties America* (New York: Manchester University Press, 1999), ch. 3.

115. See Brian Wallis, ed., *Hans Haacke: Unfinished Business* (Cambridge, MA: MIT Press, 1986). In response to Haacke's question, 25,566 visitors said yes and 11,563 said no.

116. Quoted in Frascina, *Art, Politics and Dissent,* 112.

117. Thomas P. F. Hoving, "Branch Out!" *Museum News* 47 (September 1968): 15–16; on the 1960s, see also Neil Harris, "A Historical Perspective on Museum Advocacy," in *Cultural Excursions: Marketing Appetites and Cultural Tastes in Modern America* (Chicago: University of Chicago Press, 1990).

118. Thomas Hoving, untitled introduction to issue, *Metropolitan Museum of Art Bulletin* 27 (January 1969): 243.

119. Ibid.

120. Thomas Hoving, preface to *Harlem on My Mind,* ed. Allon Schoener (New York: New Press, 1995). Also see Michael Kimmelman, "Culture and Race: Still on America's Mind," *New York Times*, November 19, 1995; and Steven C. Dubin, *Displays of Power: Controversy in the American Museum from the Enola Gay to Sensation* (New York: New York University Press, 1999), 18–63.

121. Katharine Kuh, "What's an Art Museum For?" *Saturday Review,* February 22, 1969, 58–59.

122. A. Zachs et al., "Public Attitudes toward Modern Art," *Museum* 22 (1969): 144. These findings echoed an earlier survey by Theodore Low in the 1940s that found a marked public preference for art appreciation over "art and daily living" in educational programming at the Met. Theodore Low, *The Museum as Social Instrument* (New York: Metropolitan Museum of Art, 1942), 24–30.

123. Hoving, preface to Schoener, *Harlem on My Mind.*

124. Allon Schoener, "Introduction to the New Edition," in Schoener, *Harlem on My Mind.*

125. Hoving, untitled introduction, 244.

126. Thomas Hoving, "Report of the Director," *Metropolitan Museum of Art Bulletin* 27 (October 1968): 55, 61.

127. Grace Glueck, "The Total Involvement of Thomas Hoving," *New York Times Magazine,* December 8, 1968, 45.

128. Sherman E. Lee, "The Art Museum in Today's Society," *Dayton Art Institute Bulletin* 27 (March 1969): 6.

129. John Walker, *Self-Portrait with Donors* (Boston: Little, Brown, 1974), xiv.

130. Grace Glueck, "The Guggenheim Cancels Haacke's Show," *New York Times,* April 7, 1971, 52 (my thanks to Gina Fraone for this reference). On the piece in question, "Shapolsky et al. Manhattan Real Estate Holdings, a Real-Time Social System, as of May 1, 1971," see Wallis, *Hans Haacke,* 92–97.

131. Quoted in Milton Esterow, "The Future of American Museums," *ARTnews* 74 (January 1975): 34.

132. George Heard Hamilton, "Education and Scholarship in the American Museum," in *On Understanding Art Museums,* ed. Sherman Lee (Englewood Cliffs, NJ: Prentice Hall, 1975), 113. Also see Grace Glueck, "The Ivory Tower versus the Discotheque," *Art in America* 59 (May–June 1971): 80–85. On the "effacement" of art's meanings in the museum, see Philip Fisher, *Making and Effacing Art: Modern American Art in a Culture of Museums* (New York: Oxford University Press, 1991), esp. ch. 6.

133. Otto Wittmann, *Art Values in a Changing Society* (Toledo, OH: Toledo Museum of Art, 1974), 18–19.

134. Jean-Hubert Martin, *Magiciens de la Terre* (Paris: Centre Pompidou, 1989). All quotations come from the catalog's preface, 8–9.

135. Homi K. Bhabha, "Double Visions," in *Grasping the World: The Idea of the Museum,* ed. Donald Preziosi and Claire Farago (Burlington, VT: Ashgate, 2004), 240–41.

136. J. Carter Brown, *Rings, Five Passions in World Art* (New York: Harry N. Abrams, 1996), 17.

137. Ibid. 15, 19.

138. "Vision for the New de Young," www.thinker.org/deyoung/newdeyoung/index.html (accessed February 2000). According to the architects' statement on the same Web site, entitled "Building the People's Museum," the building would itself manifest "the distinctiveness of different cultures" while revealing "the hidden kinship between divergent cultural forms."

139. Herbert Muschamp, "An Iraqi-Born Woman Wins Pritzker Architecture Award," *New York Times,* March 22, 2004, B1.

140. Herbert Muschamp, "An Architect at the Service of a Cosmopolitan Ideal," *New York Times,* March 22, 2004, B4.

141. Christina A. Kreps, *Liberating Culture: Cross-cultural Perspectives on Museums, Curation and Heritage Preservation* (New York: Routledge, 2003), 9–10.

142. Ellen Lochrane Hirzy, *Excellence and Equity: Education and the Public Dimension of Museums* (Washington, DC: American Association of Museums, 1992), 6, 8. Weil notes that this tract was endorsed by the governing board of the AAM and that an earlier AAM publication, *Museums for a New Century* (1984), declared education to be the museum's "primary" purpose; see *Making Museums Matter,* 32–33. It is worth noting that art museums were conspicuously underrepresented on the task force that produced *Excellence and Equity* and, more generally, that art museum curators and directors are scarce at AAM and other professional museum conferences.

143. Quoted in Janet Tassel, "Reverence for the Object: Art Museums in a Changed World," *Harvard Magazine,* September–October 2002, 49.

144. Philippe de Montebello, "Art Museums, Inspiring Public Trust," in Cuno, *Whose Muse?* 166.

145. *Here and Now,* WBUR, National Public Radio, September 25, 2001.

146. Ibid.

147. Philippe de Montebello, "Open Letter from the Metropolitan Museum of Art Family to Your Family," www.metmuseum.org/news/metmuseum_openletter.html (accessed October 3, 2001).

148. Malcolm Rogers, Boston Museum of Fine Arts, "Free Admission," www.mfa.org/pressroom /news/freeadmission.html (accessed October 3, 2001).

149. Metropolitan Museum of Art, "September 11: Curators' Choices," press release, September 11, 2002, www.metmuseum.org/September_11/curators_choices.html (accessed October 2002); see also press release of September 6, 2002.

150. Quoted in Tom Mullaney, "A Director Whose Eye Is Focused on Change," *New York Times,* March 29, 2006, E4.

151. Kwame Anthony Appiah, *Cosmopolitanism: Ethics in a World of Strangers* (New York: W. W. Norton, 2006), xix, 78.

152. Ibid., 126, 85. The work of an earlier "cosmopolitan" philosopher, Ananda K. Coomaraswamy, is worth remembering. Quoting Aristotle, Coomaraswamy reminds us that "[t]he general end of art is man." "What Is the Use of Art, Anyway?" (1937), in Coomaraswamy, *Christian and Oriental Philosophy of Art* (New York: Dover, 1956), 96.

153. Milo C. Beach, "Look to Museums to Bridge the Gap between Cultures," *Wall Street Journal,* May 15, 2003, D8. A year later an article in the *New York Times* noted the upsurge in exhibitions of Islamic art in the West whose purpose was to "bridge the cultural divide." The benefits were threefold: "[T]he Islamic world would feel that its heritage was admired in countries that increasingly link Islam with terrorism; Westerners could look beyond today's turmoil to recognize one of the world's great civilizations; and alienated Muslim youths in Europe could identify with the glories of their Islamic roots." Alan Riding, "Islamic Art as a Mediator for Cultures in Confrontation," *New York Times,* April 6, 2004, B1; also see Holland Carter, "What Does Islam Look Like?" *New York Times,* February 26, 2006, sec. 2, 1, 36.

154. Quoted in John Tagliabue, "Louvre Gets $20 Million for New Islamic Wing," *New York Times,* July 28, 2005, E1. Prince Alwaleed Bin Talal Bin Abdulaziz AlSaud also hopes the new Islamic wing "will assist in the true understanding of the true meaning of Islam, a religion of humanity, forgiveness and acceptance of other cultures." *New York Times,* August 3, 2005, A13. In 2006 a new Islamic wing, funded by another Saudi, Mohammed Jameel, opened at London's Victoria and Albert Museum. Alan Riding's review of it concluded: "The Prophet [Muhammad] himself is quoted as saying: 'God is beautiful, and he loves beauty.' In these ugly times, this too may be worth remembering." *New York Times,* August 9, 2006, E3.

155. *New York Times,* August 3, 2005.

156. Quoted in Alan Riding, "London Sees Political Force in Global Art," *New York Times,* August 4, 2005, B3.

157. Quoted in Alan Riding, "Imperialist? Moi? Not This French Museum," *New York Times,* June 22, 2006, B1, B8.

158. "Abu Dhabi and French Governments in Historic Cultural Accord," http://www.ameinfo

.com/112754.html. See also Alan Riding, "The Louvre's Art: Priceless. The Louvre's Name: Expensive," *New York Times*, March 7, 2007, B1.

Chapter 2. Architecture

In the epigraphs, Karl Friedrich Schinkel and Gustav Waagen's *Uber das Aufgaben der Berliner Galerie* (1828) is quoted in D. Watkin and T. Mellinghof, *German Architecture and the Classical Ideal* (Cambridge, MA: MIT Press, 1987), 99; Renzo Piano is quoted in Leah Garchik, "Shrugging Off Celebrity Mantle, Sort Of," *San Francisco Chronicle*, July 15, 2002.

1. See *ARTnews* 97 (Summer 1998): 76.

2. Herbert Muschamp, "Culture's Power Houses," *New York Times*, April 21, 1999, E6.

3. For the Guggenheim's impact on Bilbao, see "The Museo Guggenheim Bilbao: The Art of Titanium," www.bilbao-city.net (accessed June 2002); Maria V. Gomez, "Reflective Images: The Case of Urban Regeneration in Glasgow and Bilbao," *International Journal of Urban and Regional Research* 22 (March 1998): 106–21; Beatriz Plaza, "The Guggenheim-Bilbao Museum Effect: A Reply to Maria V. Gomez," *International Journal of Urban and Regional Research* 23 (September 1999): 589–92; Marjorie Rauen, "Reflections on the Space That Flows: The Guggenheim Museum Bilbao," *Journal of Arts Management, Law and Society* 30 (Winter 2001): 283–300.

4. Blake Eskin, "The Incredible Growing Art Museum," *ARTnews* 100 (October 2001): 138. On the "Bilbao effect," see Benjamin Forgey, "Beyond Bilbao: Revisiting a Special Effect," *Washington Post*, October 20, 2002.

5. Roberta Smith, "Memo to Art Museums: Don't Give Up on the Art," *New York Times*, December 3, 2000, quoted in James Cuno, "Against the Discursive Museum," in *The Discursive Museum*, ed. Peter Noever (Vienna: Hatje Cantz, 2001), 51.

6. Jed Perl, "Welcome to the Funhouse: Tate Modern and the Crisis of the Museum," *New Republic*, June 19, 2000, 31.

7. Christopher Knight, "When the Museum Becomes an Event," *Los Angeles Times*, May 28, 2000.

8. Michael Kimmelman, "All Too Often, the Art Itself Gets Lost in the Blueprints," *New York Times*, April 21, 1999, E7.

9. Marcin Fabianski, "Iconography of the Architecture of Ideal *Musaea* in the Fifteenth to Eighteenth Centuries," *Journal of the History of Collections* 2 (1990): 95–134.

10. Lewis Mumford, "Utopia, the City and the Machine," in *Utopias and Utopian Thought*, ed. Frank Manuel (Boston: Beacon Press, 1965), 14; also Krishan Kumar, *Utopianism* (Minneapolis: University of Minnesota Press, 1991), 12–16; Helen Rosenau, *The Ideal City in Its Architectural Evolution* (Boston: Book and Art Shop, 1959); Ruth Eaton, *Ideal Cities: Utopianism and the (Un)Built Environment* (London: Thames and Hudson, 2001).

11. Lewis Mumford, *The City in History* (Harmondsworth: Penguin, 1975), 693.

12. See Marcia Hall, ed., *Raphael's School of Athens* (New York: Cambridge University Press, 1997), especially Ralph E. Lieberman, "The Architectural Background," 64–84.

13. [Louis-Sebastien Mercier], *L'an deux mille quatre cent quarante: Rêve s'il en fût jamais*, 3 vols. ([Paris], 1786), 2:25–26.

14. On Boullée, see J.-M. Pérouse de Montclos, *Etienne-Louis Boullée (1728–1799): Theoretician of Revolutionary Architecture*, trans. J. Emmons (New York: George Braziller, 1974); Helen Rosenau, *Boullée and Visionary Architecture* (London: Academy Editions, 1976); *Les architects de la liberté, 1789–1799*, exhib. cat. (Paris: École Nationale Supérieure des Beaux-Arts, 1989).

Other influences were no doubt also in play in the late eighteenth century. In 1742 Count Francesco Algarotti proposed a similar museum design of four wings punctuated by cupolas and Corinthian porticos to Augustus III of Saxony. Michelangelo Simonetti's Pio-Clementino Museum at the Vatican had opened in 1773 with its own imposing rotunda and dignified galleries. In the end the question of influence is less important than the establishment by the third quarter of the eighteenth century of a standard vocabulary for public buildings devoted to knowledge and the arts comprising a complex central plan, vaulted galleries, and domed rotundas.

15. J.-N.-L. Durand, *Précis of the Lectures on Architecture (1802–5)* (Los Angeles: Getty Center, 2000), 159–61. Durand conflates museums, libraries, and academies and alludes to their function as sites of scholarly discourse. On Durand, see Werner Szambien, *Jean-Nicolas-Louis Durand, 1760–1834* (Paris: Picard, 1984).

16. Etienne-Louis Boullée, "Architecture, Essai on Art," in Rosenau, *Boullée*, 90. On character, see also Nicolas Camus de Mazières, *The Genius of Architecture; or, The Analogy of That Art with Our Sensations* (1780), trans. D. Britt, with an introduction by Robin Middleton (Santa Monica, CA: Getty Center, 1992); and Sylvia Lavin, *Quatremère de Quincy and the Invention of a Modern Language of Architecture* (Cambridge, MA: MIT Press, 1992).

17. Léon Dufourny, quoted in *Les architects de la liberté*, 331.

18. Rosenau, *Boullée*, 107.

19. Ibid., 104.

20. Charles-Axel Guillaumot, *Mémoire sur la manière d'éclairer le galerie du Louvre* (Paris, 1797), 4.

21. Ibid., 21–22.

22. Ibid., 24.

23. Thomas Jessop, *Journal d'un voyage à Paris en Septembre–Octobre 1820* (Paris, 1928), 28. A range of responses to the Louvre are discussed by Dominique Poulot, *"Surveiller et s'instuire": La Révolution française et l'intelligence de l'héritage historique* (Oxford: Voltaire Foundation, 1996), 417ff.

24. Anonymous review of William Shepherd, *Paris in 1802 and in 1814*, in the *Edinburgh Review*, September 1814, 470.

25. John Scott, *A Visit to Paris in 1814* (London: Longman, 1815), 251–52.

26. François-Xavier de Burtin, *Traité théoretique et pratique des connaissances qui sont nécessaires à tout amateur de tableaux*, 2 vols. (Brussels: L'auteur, 1808), 1:15.

27. Quoted in Michael Snodin, ed., *Karl Friedrich Schinkel: A Universal Man* (New Haven: Yale University Press, 1991), 132. On "liminality" and museums, see Carol Duncan, *Civilizing Rituals: Inside Public Art Museums* (New York: Routledge, 1995), ch. 1.

28. Quoted in Douglas Crimp, *On the Museum's Ruins* (Cambridge, MA: MIT Press, 1993), 300. For Hirt's design, see Volker Plagemann, *Das deutsche Kunstmuseum, 1790–1870* (Munich: Prestel-Verlag, 1967), 38–42. On the dispute between Hirt and Schinkel, see Steven Moyano, "Quality vs. History: Schinkel's Altes Museum and Prussian Arts Policy," *Art Bulletin* 72 (December 1990): 585–608, and James J. Sheehan, *Museums in the German Art World: From the End of the Old Regime to the Rise of Modernism* (New York: Oxford University Press, 2000), 70–81.

29. Schinkel and Waagen, *Uber das Aufgaben der Berliner Galerie*, quoted in Watkin and Mellinghof, *German Architecture and the Classical Ideal*, 99.

30. See Eve Blau, *Ruskinian Gothic: The Architecture of Deane and Woodward, 1845–61* (Princeton: Princeton University Press, 1982).

31. See John Physick, *The Victoria and Albert Museum: The History of the Building* (Oxford: Phaidon, 1982).

32. J. Randolph Coolidge Jr., "The Architectural Scheme," *Bulletin of the Museum of Fine Arts, Boston* 5 (June 1907): 41. On the design and the moral influence of the Beaux Arts museum in America, see Ingrid A. Steffensen-Bruce, *Marble Palaces, Temples of Art: Art Museums, Architecture and American Culture, 1890–1930* (Lewisburg, PA: Bucknell University Press, 1998).

33. Quoted in Steffensen-Bruce, *Marble Palaces*, 120.

34. Ibid., 73; also 141.

35. Museum of Fine Arts, Boston, *Communications to the Trustees* (Boston: Museum of Fine Arts, 1904), 84.

36. Coolidge, "Architectural Scheme," 41; Arthur Fairbanks, untitled piece, *Bulletin of the Museum of Fine Arts, Boston* 7 (December 1909): 44.

37. Walter Muir Whitehill, *Museum of Fine Arts, Boston: A Centennial History*, 2 vols. (Cambridge, MA: Belknap Press, 1970), 1:227.

38. Richard F. Bach, "The Field Museum of Natural History, Chicago, Illinois," *Architectural Record* 56 (July 1924): 1–15.

39. Richard F. Bach, "The Fogg Museum of Art, Harvard University," *Architectural Record* 61 (June 1927): 465–77; Meyric R. Rogers, "Modern Museum Design as Illuminated by the New Fogg Museum, Harvard University," *Architectural Forum* 47 (December 1927): 601–8; and Kathryn Brush, *Vastly More Than Brick and Mortar: Reinventing the Fogg Art Museum in the 1920s* (New Haven: Yale University Press, 2003) .

40. Bach, "Fogg Museum of Art," 469.

41. Philip N. Youtz, "Museum Equipment, Exhibition Rooms, and Sections Open to the Public," in League of Nations, International Museums Office, "International Study Conference on the Architecture and Equipment of Art Museums, Madrid, 1934," typescript, Fine Arts Library, Harvard University, 2–17.

42. Philip Youtz, "Museums among Public Services," *Museum News* 11 (September 15, 1933): 7.

43. Philip Youtz, "Museum Architecture," *Museum News* 15 (December 1, 1937): 10.

44. Ibid., 12.

45. Paul Cret, "L'architecture des musées en tant que plastique," *Mouseion* 25–26 (1934): 7–16; also see John H. Markham, "Le plan et la conception architecturale des musées," *Mouseion* 29–30 (1935): 7–22. On Cret and his place between the Enlightenment and the modernism of Wright and Kahn, see Richard A. Etlin, *Symbolic Space: French Enlightenment Architecture and Its Legacy* (Chicago: University of Chicago Press, 1994), ch. 3.

46. Fiske Kimball, "The Modern Museum of Art," *Architectural Record* 66 (December 1929): 558–80, and "Planning the Art Museum," *Architectural Record* 66 (December 1929): 582–90.

47. William Lescaze, "A Modern Housing for a Museum," *Parnassus* 6 (November 1937): 14. The architect Clarence Stein agreed that architecture must not "steal the show." Clarence Stein, "Making Museums Function," *Architectural Forum* 56 (June 1932): 609–16.

48. Lescaze, "Modern Housing," 14.

49. John Coolidge, *Patrons and Architects: Designing Art Museums in the Twentieth Century* (Fort Worth, TX: Amon Carter Museum, 1989), 81.

50. Ibid., 81–85. Also see Talbot F. Hamlin, "Modern Display for Works of Art," *Pencil Points* 20 (September 1939): 615.

51. For the Guggenheim, see Neil Levine, *The Architecture of Frank Lloyd Wright* (Princeton: Princeton University Press, 1996), 299–363.

52. Peter Blake, "The Guggenheim: Museum or Monument," *Architectural Forum* 111 (December 1959): 92.

53. Coolidge, *Patrons and Architects*, 45.

54. Quoted in Blake, "Guggenheim," 93.

55. Quoted in Levine, *Frank Lloyd Wright*, 348.

56. Ibid., 335.

57. Henry-Russell Hitchcock, "Museums in the Modern World," *Architectural Review* 86 (September 1939): 148.

58. Coolidge, *Patrons and Architects*, 81.

59. Mies van der Rohe, "Museum for a Small City," *Architectural Forum* 78 (May 1943): 84.

60. Blake, "Guggenheim," 89. Blake used Mies's design as a model for his own projected museum for Jackson Pollock; see Victoria Newhouse, *Towards a New Museum* (New York: Monacelli Press, 1998), 130–32.

61. William Rubin, "When Museums Overpower Their Own Art," *New York Times*, April 12, 1987, H31.

62. Coolidge, *Patrons and Architects*, 74. Also see Gabriela Wachter, ed., *Mies van der Rohe's New National Gallery in Berlin* (Berlin: Vice Versa, 1995).

63. Quoted in Paul Goldberger, "What Should a Museum Building Be?" *ARTnews* 74 (October 1975): 35. In a paper presented at the 2006 College Art Association conference in Boston ("From the Romanesque Church to the Modern Museum: Displaying the Sacred Structures of Pierre Soulages's Abstract Paintings"), Marcia Brennen showed that as director of the Houston MFA in the 1960s J. J. Sweeney suspended paintings by Pierre Soulages from the ceiling in the manner recommended earlier by Mies.

64. Goldberger, "What Should a Museum Building Be?" 38.

65. Ibid., 37.

66. "Centre Pompidou, Paris," *Architectural Review* 161 (May 1977): 272. Also see Newhouse, *Towards a New Museum*, 193–98.

67. Quoted in Elizabeth C. Baker, "Beaubourg Preview," *Art in America* 65 (January–February 1977): 100.

68. Jean Baudrillard, "The Beaubourg-Effect: Implosion and Deterrence," trans. R. Krauss and A. Michelson, *October* 20 (Spring 1982): 7.

69. B. S. M., "Darling of the Architectural Avant-Garde for US Designs Museum," *Art Newspaper*, November 2000, 18.

70. Quoted in Mary Louise Schumacher, "Museums Move with a Splash to Center Stage," *Milwaukee Journal Sentinel*, September 23, 2000.

71. Paul Goldberger, "Art Houses," *New Yorker*, November 5, 2001, 98.

72. In addition to articles referenced above, see also Franklin W. Robinson, "No More Buildings!" *Museum News* 81 (November–December 2002): 28–29; Cuno, "Against the Discursive Museum"; Jeffrey Hogrefe, "Lost Art: Has Architecture Become the Museum's Worst Enemy?" *Metropolis*, December 1999, 71–74; and Hilton Kramer, "Critic's Notebook: Growing Pains," *Art*

and Antiques 25 (November 2002): 130–31. As early as 1986, Philippe de Montebello observed: "In order to retain or gain new audiences, museums are building highly visible, dramatic symbolic centers in imitation of the great European cathedrals. . . . It's an indication that the appreciation of art as a personal experience is being lost." Quoted in Andrea Oppenheimer Dean, "Showcases for Architecture," *Architecture* 75 (January 1986): 30.

73. Douglas Davis, *The Museum Transformed: Design and Culture in the Post-Pompidou Age* (New York: Abbeville, 1990), 124.

74. For a recent appreciation, appropriately contrasted with Calatrava's Quadracci Pavilion at Milwaukee, see Goldberger, "Art Houses," 98–100.

75. Quoted in the *New York Times,* November 7, 2004, sec. 2, 21.

76. Nicolai Ouroussoff, "Even More Modern," *New York Times,* September 12, 2004, 97.

77. Backlash may produce a similar mismatch in the choice of the minimalist Tokyo firm Sanaa to build the new Louvre II in Lens, a declining provincial city like Bilbao. Significantly, Sanaa's design for the new Louvre was praised by the former French culture minister, Jack Lang, a keen supporter of Pei's Pyramid and Mitterrand's ambitious projects in the 1980s, as an "an anti-Guggenheim." Claire Downey, "Louvre Annex to Open in Lens, France," *Architectural Record* 193 (September 2005): 36.

78. Michael Kimmelman, "The Greatest Generation," *New York Times Magazine,* April 6, 2003, 76. For a survey of the loft type, see Helen Searing, "The Brillo Box in the Warehouse: Museums of Contemporary Art and Industrial Conversions," in *The Andy Warhol Museum* (New York: Distributed Art Publishers, 1994), 39–65.

79. Quoted in Julie V. Iovine, "A New Broom Sweeps a Meier Design Clean," *New York Times,* May 23, 2002, E5. Richard Meier clearly believes his museums achieve the proper balance between art and architecture: "The primary intention of our museum architecture is to encourage the discovery of aesthetic and cultural values and to foster a contemplative appreciation for the museum's collection through its own spatial experience. We believe that art objects should be displayed in surroundings that have strong spatial definition, but at the same time, create a place in which art is enhanced rather than overwhelmed." Richard Meier, *Building for Art* (Basel: Birkhauser, 1990), 96.

80. J. E. Kaufman, "Whitney Announces Major Expansion—Again," *Art Newspaper,* July–August 2004, 10. Also see Nicolai Ouroussoff, "Whitney's New Plan: A Respectful Approach," *New York Times,* November 9, 2004, B1.

81. On Kahn, see Patricia Cummings Loud, *The Art Museums of Louis I. Kahn* (Durham: Duke University Press, 1989); and Coolidge, *Patrons and Architects,* 27ff. On Kahn and Cret, see Etlin, *Symbolic Spaces.*

82. Louis Kahn, "Monumentality," in *New Architecture and City Planning,* ed. Paul Zucker (New York: Philosophical Library, 1944), 577–88, quoted in Loud, *Art Museums,* 48.

83. Charles Saumarez-Smith, "Architecture and the Museum," *Journal of Design History* 8 (1995): 255.

84. Goldberger, "Art Houses," 99.

85. Herbert Muschamp, "The Miracle in Bilbao," *New York Times Magazine,* September 7, 1997, 57; Peter Plagens, "Another Tale of Two Cities," *Newsweek,* November 3, 1997, 82.

86. Quoted in Edmund P. Pillsbury, "The New Sackler Museum at Harvard," *Burlington Magazine* 128 (January 1986): 64.

87. Douglas Crimp, "The Postmodern Museum," in *On the Museum's Ruins*, 282–325.

88. These quotations come from two articles on Stirling: Robert Campbell's "Putting a Wry Face on Adversity," *Architecture* 75 (January 1986): 48, 50, and Martin Fisher's "Cultural Centering," *Architectural Record* 172 (September 1984): 146.

Chapter 3. Collecting, Classification, and Display

Epigraphs are from George Brown Goode, "Museum History and Museums of History," paper read before the American Historical Association in December 1888, quoted in Benjamin Ives Gilman, *Museum Ideals of Purpose and Method* (Boston: Boston Museum of Fine Arts, 1923), 77, and from Gilman, *Museum Ideals*, 77.

1. See Lisa G. Corrin, ed., *Mining the Museum: An Installation by Fred Wilson* (New York: New Press, 1994); and Maurice Berger, *Fred Wilson: Objects and Installations, 1979–2000* (New York: Distributed Art Publishers, 2001).

2. Patterson Sims, *The Museum: Mixed Metaphors* (Seattle: Seattle Art Museum, 1993).

3. Ibid., 29.

4. Michel Foucault, *The Order of Things: An Archaeology of the Human Sciences* (New York: Pantheon Books, 1971), xv, originally published as *Les mots et les choses: Une archéologie des sciences humaines* (Paris: Gallimard, 1966).

5. On theories of collecting, see John Elsner and Roger Cardinal, eds., *The Cultures of Collecting* (London: Reaktion Books, 1994); and Susan Stewart, *On Longing* (Durham: Duke University Press, 1993). An extreme psychoanalytic view of collecting is offered by Werner Muensterberger, *Collecting: An Unruly Passion* (Princeton: Princeton University Press, 1994).

6. For Jean de la Bruyère on collecting, see his *Characters* (1688), ch. 13: "Of Fashion." On Flaubert's tale of Bouvard and Pécuchet, see Eugenio Donato, "The Museum's Furnace: Notes toward a Contextual Reading of *Bouvard and Pécuchet*," in *Textual Strategies: Perspectives in Post-Structuralist Criticism*, ed. Josue V. Harari (Ithaca: Cornell University Press, 1979), 213–38. According to Donato, Bouvard and Pécuchet's collection underlines the "fiction" of representational coherence that sustains all museums: "The set of objects the Museum displays is sustained only by the fiction that they somehow constitute a coherent representational universe.... Such a fiction is the result of an uncritical belief in the notion that order and classifying, that is to say, the spatial juxtaposition of fragments, can produce a representational understanding of the world. Should the fiction disappear, there is nothing left of the *Museum* but 'bric-a-brac,' a heap of meaningless and valueless fragments of objects" (223).

7. Rosamond Wolff Purcell and Stephen Jay Gould, *Illuminations: A Bestiary* (New York: Norton, 1986), 14.

8. James Clifford, *The Predicament of Culture: Twentieth-Century Ethnography, Literature, and Art* (Cambridge, MA: Harvard University Press, 1988), 219.

9. Daniel Costello, "Museum Envy," *Wall Street Journal*, January 14, 2000, W12.

10. Quoted in Carol Vogel, "The Met Makes Its Biggest Purchase Ever," *New York Times*, November 10, 2004, B7. Elsewhere in the article Montebello described the acquisition as "one of the highest points"of his twenty-seven years as director. For a reverential "background" piece on the Duccio, see Calvin Tomkins, "The Missing Madonna," *New Yorker*, July 11 and 18, 2005, 42–49.

11. John Walker's illustrated guide *National Gallery of Art, Washington* (New York: Abrams,

1984) begins its chronological survey of attributed masterpieces with a Duccio panel from the *Maestà* (1308–11) and ends with Jackson Pollock's *Number 1 (Lavender Mist)* of 1950.

12. Carol Duncan and Alan Wallach, "The Universal Survey Museum," *Art History* 3 (December 1980): 448–69. Duncan develops these ideas further in her book *Civilizing Rituals: Inside Public Art Museums* (New York: Routledge, 1995).

13. Quoted in Eugenio Donato, "Museum's Furnace," 222.

14. The literature on this topic is immense, but the indispensable works include Oliver Impey and Arthur MacGregor, eds., *The Origins of Museums: The Cabinet of Curiosities in Sixteenth- and Seventeenth-Century Europe* (Oxford: Oxford University Press, 1985); Krzysztof Pomian, *Collectors and Curiosities: Paris and Venice, 1500–1800,* trans. E. Wiles-Portier (Cambridge: Polity Press, 1990); Paula Findlen, *Possessing Nature: Museums, Collecting, and Scientific Culture in Early Modern Italy* (Berkeley: University of California Press, 1994); and Lorraine Daston and Katherine Park, *Wonders and the Order of Nature* (New York: Zone Books, 1998).

15. Daston and Park, *Wonders,* 272. Stephen Bann's excellent study of John Bargrave reveals the contingency of seventeenth-century curiosity cabinets; see *Under the Sign: John Bargrave as Collector, Traveler, and Witness* (Ann Arbor: University of Michigan Press, 1994).

16. Daston and Park, *Wonders,* 272; also see Pomian, *Collectors and Curiosities,* 45.

17. Quoted in Stephen Greenblatt, *Marvelous Possessions: The Wonder of the New World* (Chicago: University of Chicago Press, 1991), 20. On the dangers of wonder unmodified, also see Daston and Park, *Wonders,* 11–14, 110–23.

18. Impey and MacGregor, *Origins of Museums,* 14.

19. Findlen, *Possessing Nature,* 95.

20. Ibid., 390.

21. See Stephen Bann, "The Return to Curiosity: Shifting Paradigms in Contemporary Museum Display," in *Art and Its Publics: Museum Studies at the Millennium,* ed. Andrew McClellan (Oxford: Blackwell, 2003), 97–115.

22. On the early museums of Vienna, see Debora Meijers, *Kunst als natuur: De Hapsburgse schilderijengalerie in Wene omstreeks 1780* (Amsterdam: sua, 1991); also Germain Bazin, *The Museum Age,* trans. Jane van Nuis Cahill (New York: Universe, 1967), 158–59. On the arrangement of picture collections more generally, see Colin B. Bailey, "Conventions of the Eighteenth-Century *Cabinet de Tableaux:* Blondel d'Azincourt's *La première idée de la curiosité,*" *Art Bulletin* 69 (1987): 431–46.

23. See ch. 1 of Andrew McClellan, *Inventing the Louvre: Art, Politics, and the Origins of the Modern Museum in Eighteenth-Century Paris* (New York: Cambridge University Press, 1994).

24. André Félibien, *Entretiens sur les vies et sur les ouvrages des plus excellens peintres,* 2 vols. (Paris: P. Le Petit, 1666–88), 2:3.

25. *Lettre de M. le Chevalier de Tincourt à Madame la Marquise de *** sur les tableaux et dessins du cabinet du roi* (Paris, 1751), 7, 22. For a full discussion of the Luxembourg Gallery, see McClellan, *Inventing the Louvre,* ch. 1.

26. See Carol Gibson-Wood, *Studies in the Theory of Connoisseurship from Vasari to Morelli* (New York: Garland, 1988), 35 and passim.

27. C. F. Neickel[ius], *Museographia oder Anleitung zum rechten Begriff und nutzlicher Anlegung der Museorum oder Raritaten Kammern* (Leipzig: Hubert, 1727), 4. Similar priorities inform Jonathan Richardson's *An Account of Some of the Statues . . . and Paintings in Italy* (1722).

28. L.-J.-M. Daubenton, *Histoire naturelle, générale et particulière avec le description du cabinet du roi* (Paris: Imprimerie royale, 1749–), 3:1.

29. J.-B.-P. Lebrun, *Observations sur le Muséum national* (Paris: Charon, 1793), 15.

30. For the arrangement of early modern print collections, see the essays by Peter Parshall and Antony Griffiths, based on their M. Victor Leventritt Lectures, 7 and 8 April 1993, Print Collecting in Sixteenth and Eighteenth Century Europe, *Bulletin of the Harvard University Art Museums* 2 (Summer 1994).

31. Nicolas de Pigage, *La Galerie Electorale de Dusseldorf* (Basel: C. de Mechel, 1778); on eighteenth-century German collections, see James J. Sheehan, *Museums in the German Art World: From the End of the Old Regime to the Rise of Modernism* (New York: Oxford University Press, 2000).

32. Quoted and translated in Sheehan, *Museums,* 40.

33. Casimir Varon, *Rapport du conservatoire du muséum* (1794), quoted in McClellan, *Inventing the Louvre,* 113.

34. Ludwig I of Bavaria, *Briefweschel zwischen Ludwig I. von Bayern und Georg von Dillis,* ed. R. Messerer (Munich: Beck, 1966), xvii.

35. Quoted in Sheehan, *Museums,* 76. On the arrangement dispute at the Altes Museum, also see Steven Moyano, "Quality vs. History: Schinkel's Altes Museum and Prussian Arts Policy," *Art Bulletin* 57 (December 1990): 585–608, and Christoph Martin Vogtherr, "Zwischen Norm und Kunstgeschichte: Wilhelm von Humboldts Denskschrift von 1829 zur Hängung in der Berliner Gemäldgalerie," *Jahrbuch der Berliner Museen* 34 (1992): 53–64.

36. Karl Friedrich Schinkel and Gustav Waagen, *Uber die Aufgaben der Berliner Galerie,* quoted in D. Watkin and T. Mellinghoff, *German Architecture and the Classical Ideal* (Cambridge, MA: MIT Press, 1987), 99. On the dispute between Schinkel, Waagen, and Hirt, see Sheehan, *Museums,* and Vogtherr, "Zwischen Norm und Kunstgeschichte."

37. "Thoughts on the New Building for the National Gallery," *Art Journal,* May 1, 1853, 121–25, quoted in Giles Waterfield, *Palaces of Art: Art Galleries in Britain, 1790–1990* (London: Dulwich Picture Gallery, 1991), 56. Waterfield provides an incisive account of display strategies in Britain during the nineteenth and twentieth centuries.

38. Waterfield, *Palaces of Art,* 145.

39. Quoted in Sheehan, *Museums,* 145.

40. "Horrors of Museum Trotting," *Atlantic Monthly,* December 1929, 855–57; also see 768–73.

41. For a beautifully illustrated historical survey of display strategies, see Victoria Newhouse, *Art and the Power of Placement* (New York: Monacelli Press, 2005).

42. The idea was suggested as early as 1864 by J. Edward Gray, Keeper of Zoology at the British Museum, "Address to Section D," *Report of the British Association for the Advancement of Science* 34 (1864): 76.

43. On German museum reform of the 1880s, see Alexis Joachimides, *Die Museumsreformbewegung in Deutschland und die Entstehung des modernen Museums 1880–1940* (Dresden: Verlag der Kunst, 2001); also Sheehan, *Museums,* ch. 4.

44. Frank Jewett Mather, "Two Theories of Museum Policy," *Nation,* December 28, 1905, 518.

45. Arthur Fairbanks, untitled piece, *Bulletin of the Museum of Fine Arts, Boston* 7 (December 1909): 44.

46. "Museums," *Burlington Magazine* 13 (September 1908): 322; Frank J. Mather, "Art in America," *Burlington Magazine* 9 (April 1906): 62.

47. Charles G. Loring, "A Trend in Museum Design," *Architectural Forum* 47 (December 1927): 579.

48. F. Schmidt-Degener, "General Principles regarding the Enhancement of Works of Art," in League of Nations, International Museums Office, "International Study Conference on the Architecture and Equipment of Art Museums, Madrid, 1934," typescript, Fine Arts Library, Harvard University, 17. Interestingly, Schmidt-Degener wondered "whether the modern tendency towards restraint and severity is not . . . a fashion which we are following unconsciously." Also see reports in P. d'Espezel and G. Hilaire, eds., *Musées* (Paris: Cahiers de la République des Lettres, des Sciences, et des Arts, n.d.), and early issues of the journal *Mouseion,* for example, J. Jaujard, "Les principes muséographiques de la réorganisation du Louvre," *Mouseion* 31–32 (1935): 7–22.

49. Blake-More Godwin, "Le Toledo Museum of Art," *Mouseion* 29–30 (1935): 1.

50. Arthur Melton, *Problems of Installation in Museums of Art* (Washington, DC: American Association of Museums, 1935), 2 and passim.

51. *Exposition Internationale de 1937. Musées et expositions. Section 1: Muséographie* (Paris: Denoël, 1937), 18–19. The organizers included Henri Focillon, Paul Vitry, Georges-Henri Rivière, René Huyghe, Paul Valéry, and Germain Bazin.

52. Brian O'Doherty, *Inside the White Cube: The Ideology of the Gallery Space* (San Francisco: Lapis Press, 1986), 14.

53. Clarence Stein, "The Art Museum of Tomorrow," *Architectural Record* 67 (January 1930): 5–12; Lee Simonson, "Skyscrapers for Art Museums," *American Mercury,* August 1927, 399–404; for a one-story variation, see Auguste Perret, "Le musée moderne," *Mouseion* 3 (1929): 225–35.

54. Luc Benoist, *Musées et muséologie* (Paris: Presses Universitaires de France, 1960), 120–21.

55. Joshua C. Taylor, "The Art Museum in the United States," in *On Understanding Art Museums,* ed. Sherman E. Lee (Englewood Cliffs, NJ: Prentice-Hall, 1975), 45.

56. Paul Ortwin Rave, quoted in Wilhelm Treue, *Art Plunder: The Fate of Works of Art in War and Unrest,* trans. B. Creighton (New York: John Day, 1961), 233–34. Also see Stephanie Barron et al., *"Degenerate Art": The Fate of the Avant-Garde in Nazi Germany* (Los Angeles: Los Angeles County Museum of Art, 1991).

57. Theodore Schmit, "Les musées de l'Union des Républiques Socialites Soviétiques," in d'Espezel and Hilaire, *Musées,* 206–21; also *Exposition Internationale de 1937,* 20. On Soviet museum practice, see Adam Jolles, "Stalin's Talking Museums," *Oxford Art Journal* 28 (2005): 429–55.

58. George Harold Edgell, "Policies in Acquisition," *Art in America* 34 (October 1946): 179–82. Decades earlier, Joseph Breck, director of the new Minneapolis museum then under construction, said of its acquisition policy that "it should strive even more rigorously [than before] to acquire the best and only the best." "The Minneapolis Institute of Arts: Its Purpose and Its Collections," *Bulletin of the Minneapolis Institute of Arts* 3 (October 1914): 118.

59. Quoted in Carol Vogel, "Surprises and Big Sales at London Art Auctions," *New York Times,* June 27, 2005, B7.

60. For the Seager system, see F. Hurst Seager, "The Lighting of Picture Galleries and Museums," *Journal of the Royal Institute of British Architects* 20 (November 1912): 43–54. Paul Cret, in his article "Theories of Museum Planning," in *Paul Philippe Cret: Architect and Teacher,* ed. Theo B. White (Philadelphia: Art Alliance Press, 1973), 78, quotes museum people who disliked the Seager system; also see Laurence V. Coleman, *The Museum in America* (Washington,

DC: American Association of Museums, 1937), 207. For a good overview of lighting issues, see Michael Compton, "The Architecture of Daylight," in Waterfield, *Palaces of Art,* 37–47; for a 1930s perspective, see *Exposition Internationale . . . 1937,* 22–23.

61. See Geoffrey N. Swinney, "Gas Lighting in British Museums and Galleries," *Journal of Museum Management and Curatorship* 18 (June 1999): 113–43.

62. Among those who preferred natural light were Eric Maclagen, "Museum Planning," *Journal of the Royal Institute of British Architects* 38 (June 6, 1931): 534; Kenneth Clark, "Ideal Picture Galleries," *Museums Journal* 45 (November 1945): 132; Fiske Kimball, "Planning the Art Museum," *Architectural Record* 66 (December 1929): 582–90; and William Valentiner, "The Museum of Tomorrow," in *New Architecture and City Planning: A Symposium,* ed. Paul Zucker (New York: Philosophical Library, 1944), 660. Articles in *Mouseion* and other journals in the late 1920s and 1930s chart the increased use of artificial light in museums, especially in northern Europe and the United States.

63. See Garry Thomson, *The Museum Environment* (London: Butterworths, 1978).

64. Lee Simonson, "Museum Showmanship," *Architectural Forum* 56 (June 1932): 534.

65. Quoted in Helen Searing, *New American Art Museums* (New York: Whitney Museum of American Art, 1982), 112.

66. On Lenoir and his museum, see McClellan, *Inventing the Louvre,* ch. 5, and Francis Haskell, *History and Its Images* (New Haven: Yale University Press, 1993), ch. 9.

67. On this movement in France, see Dominique Poulot, *Musée, nation, patrimoine, 1789–1815* (Paris: Gallimard, 1997).

68. Emile Deschamps, quoted in translation in Stephen Bann, *The Clothing of Clio: A Study of the Representation of History in Nineteenth-Century Britain and France* (Cambridge: Cambridge University Press, 1984), 82.

69. See Joachimides, *Die Museumsreformbewegung,* 53ff. On Bode, see also Thomas W. Gaehtgens, *Die Berliner Museuminsel in Deutschen Kaiserreich* (Munich: Deutscher Kunstverlag, 1992); and Malcolm Baker, "Bode and Museum Display: The Arrangement of the Kaiser-Friedrich Museum and the South Kensington Response," *Jahrbuch der Berliner Museen* Suppl., 38 (1996): 143–53.

70. On Valentiner, see Margaret Sterne, *The Passionate Eye: The Life of William R. Valentiner* (Detroit: Wayne State University Press, 1980); and Jeffrey Abt, *A Museum of the Verge: A Socioeconomic History of the Detroit Institute of Arts* (Detroit: Wayne State Press, 2001); on his work in New York, see William Valentiner, "The Arrangement," *Metropolitan Museum of Art Bulletin* 5 (March 1910). A curious manifestation of the German vogue for period settings occurred in eastern France during World War I. Following the bombing of Saint-Quentin, the Germans salvaged the contents of the Musée Lécuyer, including important pastels by Maurice de Saint-Quentin, and transferred them to Maubeuge, where, as proof of their solicitude for endangered French art, they reinstalled the collection following Bode's modern principles. See Baron Frh. von Hadeln, *Das Museum au Pauvre Diable zu Maubeuge: Ausstellung der aus St. Quentin und Umgebung geretteten Kunstwerke* (Stuttgart: Julius Hoffmann, 1918).

71. Fiske Kimball, "The Art Museum—Ideals and Progress," in *Fairmount Park Art Association, 65th Annual Report* (Philadelphia, 1937), 17–18; see also Fiske Kimball, "The Modern Museum of Art," *Architectural Record* 66 (December 1929): 559–80.

72. Quoted in Elizabeth Grossman, *The Civic Architecture of Paul Cret* (New York: Cambridge

University Press, 1996), 124. The term *personal collection museum* comes from Anne Higonnet, whose forthcoming book promises to be the definitive study of the subject.

73. "Visitors to Pennsylvania Museum Express Preference for Period Rooms," *ARTnews* 28 (December 7, 1929): 9. Forty-four percent preferred period rooms, against 32 percent for paintings. Also see F. Kimball, "Musée d'art de Pennsylvanie: Statistique des visiteurs d'après leur profession," *Mouseion* 4 (1930): 32–43.

74. Loring, "Trend in Museum Design," 579.

75. Thomas Munro, "The Place of Aesthetics in the Art Museum," *College Art Journal* 6 (Spring 1947): 183. For an example of the problematic "authenticity" of period rooms, see John Harris, "A Cautionary Tale of Two 'Period' Rooms," *Apollo* 142 (July 1995): 56–57.

76. Arthur W. Melton, "Studies of Installation at the Pennsylvania Museum of Art," *Museum News* 10 (January 15, 1933): 6.

77. Sir Eric Maclagen, "Different Methods of Presenting Collections," in League of Nations, "International Study Conference," 20–21. See also Maclagen, "Museum Planning," 529: "[A]ll forms of architectural decoration are . . . quite definitely detrimental" to the display of art. He calls period rooms "the worst mistake of all" (530) and labels Valentiner's efforts at Detroit a failure.

78. Henri Verne, "Faut-il brûler le Louvre?" in d'Espezel and Hilaire, *Musées*, 268.

79. Clark, "Ideal Picture Galleries," 31.

80. Coleman, *Museum in America*, 199. Ambivalence toward period interiors in the 1930s is reflected in the official catalog of the Cloisters, which opened in 1938 and was composed of medieval buildings brought from France: "Prominence has been given the exhibits by making the architectural setting unobtrusive. Though the backgrounds are medieval in style, the simplest precedents have been followed for the modern work so as not to detract from original elements." James J. Rorimer, *The Cloisters: The Building and the Collection of Medieval Art* (New York: Metropolitan Museum, 1938), xxx.

81. See Michael Brawne, *The New Museum: Architecture and Display* (London: Architectural Press, 1965), 32.

82. Fairbanks, untitled piece, 44. Also see Walter Muir Whitehill, *Museum of Fine Arts, Boston: A Centennial History*, 2 vols. (Cambridge, MA: Belknap Press, 1970), 240ff.

83. Ananda K. Coomaraswamy, "Why Exhibit Works of Art?" (1941), in *Christian and Oriental Philosophy of Art* (New York: Dover, 1956).

84. Frederic H. Douglas and René d'Harnoncourt, *Indian Art of the United States* (New York: Museum of Modern Art, 1941), 11.

85. Quoted in Mary Anne Staniszewski, *The Power of Display: A History of the Exhibition Installations at the Museum of Modern Art* (Cambridge, MA: MIT Press, 1998), 94, which offers a good account of the exhibition (84–98).

86. Susan Vogel, "Bringing African Art to the Metropolitan Museum," *African Arts* 15 (February 1982): 40.

87. Susan Vogel and Francine N'Diaye, *African Masterpieces from the Musée de l'Homme* (New York: Harry N. Abrams: 1985), 11. For an excellent overview of the challenges of assimilating African art into Western museums, see Christa Clarke, "From Theory to Practice: Exhibiting African Art in the Twenty-First Century," in McClellan, *Art and Its Publics*, 165–84. Also see the essays in Dominique Taffin, ed., *Du musée colonial au musée des cultures du monde* (Paris: Maisonneuve et Larose/Musée National des Arts d'Afrique et d'Océanie, 2000).

88. Tom Phillips, ed., *Africa: The Art of a Continent* (New York: Prestel, 1995), 11.

89. Quoted in Clifford, *Predicament of Culture,* 203 (emphasis mine).

90. Ibid., 200.

91. Susan Vogel, "Always True to the Object, in Our Fashion," in *Exhibiting Cultures: The Poetics and Politics of Museum Display,* ed. Ivan Karp and Steven D. Lavine (Washington, DC: Smithsonian Institution Press, 1991), 192–93.

92. Susan Mullin Vogel, *Baule: African Art/Western Eyes* (New Haven: Yale University Press, 1997), 80, and "Objets africains dans les musées d'art: Évolution d'un paradoxe," in Taffin, *Du musée colonial,* 219–24; also see Holland Cotter's review of the exhibition, "Beyond Beauty, Art That Takes Action," *New York Times,* September 28, 1997.

93. Susan Mullin Vogel, "History of a Museum, with Theory," in *Exhibition-ism: Museums and African Art,* ed. Mary Nooter Roberts and Susan Vogel (New York: Museum for African Art, 1994), 94.

94. Frank Jewett Mather, "Atmosphere versus Art," *Atlantic Monthly,* August 1930, 171–77.

95. Mark O'Neill, director of the Glasgow Museum, discusses the impressionist and other exhibitions in his article "The Good Enough Visitor," in *Museums, Society, Inequality,* ed. Richard Sandell (New York: Routledge, 2002), 24–40.

96. Quoted by Andrea Kupfer Schneider, *Creating the Musée d'Orsay: The Politics of Culture in France* (University Park: Pennsylvania State University Press, 1998), 78. Also see Patricia Mainardi, "Postmodern History at the Musée d'Orsay," *October* 41 (Summer 1987): 31–51.

97. Stephen Greenblatt, "Resonance and Wonder," in Karp and Lavine, *Exhibiting Cultures,* 54.

98. Clifford, *Predicament of Culture,* 191, 195. Also see Clarke, "From Theory to Practice," 168–69, and Jean-Hubert Martin, "La modernité comme obstacle à une appreciation égalitaire des cultures," in Taffin, *Du musée colonial,* 149–62.

99. On the acquisition of African art for Western collections, see Sally Price, *Primitive Art in Civilized Places* (Chicago: University of Chicago Press, 1989).

100. Clifford, *Predicament of Culture,* 190.

101. An interesting early "experimental" exhibition, involving labels written by various people from different points of view, was The Label Show: Contemporary Art and the Museum, organized by Trevor Fairbrother at the Boston MFA in 1994. Two years later, a follow-up show, Labeltalk 1996, was organized by the Williams College Museum of Art.

102. Neil MacGregor, "The Purpose of the Enlightenment Museum," *Art Newspaper,* January 2004, 22.

103. Quoted in Josie Appleton, "Museums Need More Confidence in the Power of Their Collections," *Art Newspaper,* June 2004, 24. Appleton cites further examples of "relevant" programming at UK museums.

104. Nicholas Serota, *Experience or Interpretation: The Dilemma of Museums of Modern Art* (New York: Thames and Hudson, 1996), 55.

105. "The Tates: Structures and Themes," *Burlington Magazine* 142 (August 2000): 480. Also see Giles Waterfield, "Tate Britain: A Plaything for the Staff?" *Art Newspaper,* May 2000. For a defense of the new hang at Tate Britain, see "Chronology Undone," *Art Newspaper,* March 2000, 21.

106. See Mignon Nixon's remarks in "Round Table: Tate Modern," *October* 98 (Fall 2001): 7.

107. Quoted in Eleanor Heartney, "Chronology Dethroned," *Art in America* 89 (May 2001): 63.

108. David Sylvester, "Mayhem at Millbank," *London Review of Books,* May 18, 2000, 20. Philip

Fisher has argued separately for the essential historicity of modern art in *Making and Effacing Art: Modern American Art in a Culture of Museums* (New York: Oxford University Press, 1991).

109. John Elderfield et al., *Modern Starts: People, Places, Things* (New York: Museum of Modern Art, 1999), 9.

110. Peter Schjeldahl, "The Reinvention of MOMA," *New Yorker,* January 17, 2000, 84. Echoing reviews of the Tate, Schjeldahl called the show an instance of "millennial narcissism."

111. Jed Perl, "Welcome to the Funhouse," *New Republic,* 35–36.

112. John Elderfield, ed., *Imagining the Future of the Museum of Modern Art* (New York: Museum of Modern Art, 1998), 242.

113. Ibid., 278. Taniguchi's (albeit limited) embrace of openness contrasts with the modernist commitment to narrative voiced in Edward Larrabee Barnes's program for the Dallas Art Museum (1984): "There must be a sense of entrance, or logical sequence, of climax and return. . . . The museum is an architectural composition involving time—the measured unfolding of the collection in quiet, supportive space." Quoted in Searing, *New American Art Museums,* 89.

114. Elderfield, *Imagining the Future,* 32–33. For Varnedoe's views on the collection, and modernism, also see his "Evolving Torpedo: Changing Ideas of the Collection of Painting and Sculpture of the Museum of Modern Art," in John Elderfield, et al., *The Museum of Modern Art at Mid-Century: Continuity and Change* (New York: Museum of Modern Art; distributed by Abrams, 1995), and his *Fine Disregard: What Makes Modern Art Modern* (New York: Abrams, 1990).

115. Elderfield, *Imagining the Future,* 31.

116. On the Benin Bronzes, see Annie E. Coombes, *Reinventing Africa: Museums, Material Culture and Popular Imagination* (New Haven: Yale University Press, 1994), 7–28. For the Horniman display, see Ruth B. Phillips, "Where Is 'Africa'? Re-viewing Art and Artifact in the Age of Globalization," in *Grasping the World: The Idea of the Museum,* ed. Donald Preziosi and Claire Farago (Burlington, VT: Ashgate, 2004), 758–74.

117. Holland Cotter, "America the Contradictory," *New York Times,* June 30, 2006, B25.

118. Tony Bennett, "The Political Rationality of the Museum," *Continuum* 3 (1990): 50–51. Bennett cites these museums as evidence of heightened reflection on "the processes of showing who takes part in those processes and their consequences for the relations they establish between the museum and the visitor." Elsewhere, small ethnic and regional museums, each of them rich with local color, offer alternative stories and identities; see, for example, Joseph Berger, "Ethnic Museums Abounding," *New York Times,* July 4, 2003; on the Ecomuseum in France, see Dominique Poulot, "Identity as Self-Discovery: The Ecomuseum in France," in *Museum Culture: Histories, Discourses, Spectacles,* ed. Daniel J. Sherman and Irit Rogoff (Minneapolis: University of Minnesota Press, 1994), 66–84.

119. James Clifford, "Four Northwest Coast Museums: Travel Reflections," in Karp and Lavine, *Exhibiting Cultures,* 215, and "Looking Several Ways: Anthropology and Native Heritage in Alaska," *Current Anthropology* 45 (February 2004): 5–30. Also see the remarkable exhibition ExitCongoMuseum, organized by Boris Wastiau at the Royal Museum for Central Africa in Tervuren in 2000.

120. Information about the NMAI is taken from their Web site, www.nmai.si.edu, under "Visitor Information," "About NMAI," 2006 (accessed November 14, 2006).

121. A session at the 2005 American Association of Museums Annual Meeting, "Community Curatorship: The National Museum of the American Indian (NMAI) and Natives Peoples

Working Collaboratively," featured tribal representatives from the Yakama Nation (Washington State), Saint-Laurent Metis (Manitoba, Canada), and the Native American community of Chicago discussing their work at the museum.

122. Edward Rothstein, "Who Should Tell History: The Tribes or the Museums?" *New York Times,* December 21, 2004, B1.

Chapter 4. The Public

1. Stephen E. Weil, *Making Museums Matter* (Washington, DC: Smithsonian Institution Press, 2002), 28–52.

2. Quoted in Janet Tassel, "Reverence for the Object: Art Museums in a Changed World," *Harvard Magazine,* September–October 2002, 57.

3. See Krzysztof Pomian, *Collectors and Curiosities: Paris and Venice, 1500–1800,* trans. E. Wiles-Portier (Cambridge: Polity Press, 1990), especially the essay "Between the Visible and the Invisible," and Hans Belting, *Likeness and Presence: A History of the Image before the Era of Art* (Chicago: University of Chicago Press, 1993).

4. On art appreciation and social distinction in Britain, see John Barrell, *The Political Theory of Painting from Reynolds to Hazlitt* (New Haven: Yale University Press, 1986); and Iain Pears, *The Discovery of Painting: The Growth of Interest in the Arts in England, 1680–1768* (New Haven: Yale University Press, 1988).

5. Kant, quoted in Nick Prior, *Museums and Modernity: Art Galleries and the Making of Modern Culture* (New York: Berg, 2002), 27.

6. See Andrew McClellan, "Watteau's Dealer: Gersaint and the Marketing of Art in Eighteenth-Century Paris," *Art Bulletin* 78 (September 1996): 439–53.

7. Quoted in Thomas Crow, *Painters and Public Life in Eighteenth-Century Paris* (New Haven: Yale University Press, 1985), 10.

8. See John Goodman, "Altar against Altar: The Colisée, Vauxhall Utopianism and Symbolic Politics in Paris (1769–77)," *Art History* 15 (1992): 434–69; and Richard D. Altick, *The Shows of London* (Cambridge, MA: Belknap Press, 1978).

9. On early modern European museums, see Edouard Pommier, ed., *Les musées en Europe à la veille de l'ouverture du Louvre* (Paris: Klincksieck, 1995); also Germain Bazin, *The Museum Age,* trans. Jane van Nuis Cahill (New York: Universe Books, 1967). James J. Sheehan, *Museums in the German Art World: From the End of the Old Regime to the Rise of Modernism* (New York: Oxford University Press, 2000), is very good on the art museum public in Germany.

10. William Shepherd, *Paris in 1802 and 1814* (London: Longman, 1814), 52; and W. E. Frye, *After Waterloo: Reminiscences of European Travel, 1815–1819,* ed. Salomon Reinach (London: W. Heinemann, 1908), 62–66.

11. Andrew McClellan, *Inventing the Louvre: Art, Politics, and the Origins of the Modern Museum in Eighteenth-Century Paris* (New York: Cambridge University Press, 1994), 8–12. A good survey of nineteenth-century visitors and cartoons is provided by Luce Abélès, "Roman, musée," and Dominique Poulot, "Le musée et ses visiteurs," in Chantal Georgel, *La jeunesse des musées: Les musées de France au XIXe siècle* (Paris: Réunion des Musées Nationaux, 1994), 316–31 and 332–51, respectively; for Britain, see Frances Borzello, *Civilizing Caliban: The Misuse of Art, 1875–1980* (New York: Routledge, 1987).

12. A British parliamentary report on London's National Gallery in 1836 recommended that

the paintings be divided into schools and carry labels including name, dates, and information about teachers and pupils: "This ready (though limited) information is important to those whose time is much absorbed by mental or bodily labor." Quoted in Brandon Taylor, *Art for the Nation: Exhibitions and the London Public, 1747–2001* (Manchester: Manchester University Press, 1999), 47.

13. [Carl Christian Berkheim], *Lettres sur Paris* (Heidelberg: Mohr, 1809), 353.

14. Quoted in Francis Henry Taylor, *The Taste of Angels* (Boston: Little, Brown, 1948), 542.

15. Henry Milton, *Letters on the Fine Arts Written from Paris in the Year 1815* (London: Longman, 1816), 2, 9.

16. John Scott, *A Visit to Paris in 1814* (London: Longman, 1815), 42.

17. Ibid., 57.

18. Sir John Dean Paul, *Journal of a Party of Pleasure to Paris in the Month of August, 1802* (London: Cadell and Davies, 1802).

19. Milton, *Letters on the Fine Arts*, 28.

20. For an interesting survey of living artists' responses to museums, see Michael Kimmelman, *Portraits: Talking with Artists at the Met, the Modern, the Louvre and Elsewhere* (New York: Modern Library, 1999).

21. Dr. G. F. Waagen, "Thoughts on the New Building to Be Erected for the National Gallery of England," *Art Journal* 5 (May 1, 1853): 123. On the museum as utilitarian institution, see Tony Bennett, *The Birth of the Museum: History, Theory, Politics* (New York: Routledge, 1995).

22. Quoted in Louise Purbrick, "The South Kensington Museum," in *Art Apart: Art Institutions and Ideology across England and North America*, ed. Marcia Pointon (New York: Manchester University Press, 1994), 77. On attitudes toward the public in nineteenth-century Britain, see Taylor, *Art for the Nation*, chs. 2 and 3.

23. Matthew Arnold, *Culture and Anarchy* (New Haven: Yale University Press, 1994).

24. Quoted in Borzello, *Civilizing Caliban*, 109.

25. Quoted in Charlotte Klonk, "Mounting Vision: Charles Eastlake and the National Gallery of London," *Art Bulletin* 82 (June 2000): 331.

26. Quoted in Neil MacGregor, "A Pentecost in Trafalgar Square," in *Whose Muse? Art Museums and the Public Trust*, ed. James Cuno (Princeton: Princeton University Press, 2004), 42.

27. Borzello, *Civilizing Caliban*, 42–44.

28. Quoted in Seth Koven, "The Whitechapel Picture Exhibition and the Politics of Seeing," in *Museum Culture: Histories, Discourses, Spectacles*, ed. Daniel J. Sherman and Irit Rogoff (Minneapolis: University of Minnesota Press, 1994), 34.

29. Borzello, *Civilizing Caliban*, 33, 51ff.

30. Henrietta O. Barnett, "Women as Philanthropists," in *The Woman Question in Europe*, ed. Theodore Stanton (New York: G. P. Putnam, 1884), 124–25. See also her "Pictures for the People," in Rev. Canon S. A. Barnett and Henrietta Barnett, *Practicable Socialism*, 2nd ed. (London: Longmans, 1894).

31. Sir Henry Cole, *Fifty Years of Public Work*, 2 vols. (London: George Bell, 1884), 2:346.

32. Ibid., 2:302; in a lecture at the École centrale d'architecture in Paris in 1867, Cole described museums as "une espèce de monument socialiste, où le niveau est le même pour tous."

33. *The Works of John Ruskin*, ed. E. T. Cook and A. Wedderburn, 39 vols. (London: George

Allen, 1907–8) 34:250. Echoing Ruskin, a National Gallery report of 1886 said the museum should avoid becoming, "especially on cold and wintry nights, the resort of a class of persons whose presence would be most undesirable." Quoted in Borzello, *Civilizing Caliban,* 42.

34. On Waagen and the Berlin Museum, see Carmen Stonge, "Making Private Collections Public: Gustav Friedrich Waagen and the Royal Museum in Berlin," *Journal of the History of Collections* 10 (1998): 61–74; and Sheehan, *Museums.*

35. Bennett, *Birth of the Museum,* 98 and passim. Codes of behavior were also put in place in France; see Daniel J. Sherman, *Worthy Monuments: Art Museums and the Politics of Culture in Nineteenth-Century France* (Cambridge, MA: Harvard University Press, 1989).

36. Arnold, *Culture and Anarchy,* 48.

37. Ibid., 128.

38. Ibid., 90.

39. Ibid., 106–8.

40. Ibid., 29–30.

41. Cole, *Fifty Years of Public Work,* 2:293.

42. Barnett, "Pictures for the People," 185; also see Thomas Greenwood, *Museums and Art Galleries* (London: Simkin, Marshall, 1888), 173–74.

43. Quoted in Borzello, *Civilizing Caliban,* 118.

44. Greenwood, *Museums and Art Galleries,* 11.

45. William Stanley Jevons, "The Use and Abuse of Museums," in *Methods of Social Reform* (London: Macmillan, 1883), 60.

46. Greenwood, *Museums and Art Galleries,* 182.

47. Ibid., 7–8.

48. See Alexis Joachimedes, *Die Museumsreformbewegung in Deutschland und die Entstehung des modernen Museums, 1880–1940* (Dresden: Verlag der Kunst, 2001).

49. Quoted in Sheehan, *Museums,* 163.

50. [Benjamin Ives Gilman], "The Copley Square Museum," *Bulletin of the Museum of Fine Arts, Boston* 7 (April 1909): 19.

51. Arthur Fairbanks, untitled piece, *Bulletin of the Museum of Fine Arts, Boston* 7 (December 1909): 44.

52. Benjamin Ives Gilman, *Museum Ideals of Purpose and Method* (Boston: Boston Museum of Fine Arts, 1923), 68, 303; also "Guides or Docents in Museums," *Proceedings of the American Association of Museums* 7 (June 1913): 64–65.

53. *Museum of Fine Arts, Boston, Forty-first Annual Report for the Year 1916* (Boston: Metcalf, 1917). Also see [Gilman], "Copley Square Museum," 18, and "Sunday Docent Service," *Bulletin of the Museum of Fine Arts, Boston* 8 (August 1910): 28, for references to the diversity of the public. The docent service was first offered in 1895, two years after Gilman joined the museum.

54. Quoted in "Children's Parties at the Museum," *Bulletin of the Museum of Fine Arts, Boston* 9 (August 1911): 40. On children in museums, also see Anna Curtis Chandler, "School Children and the Art Museum," *American Magazine of Art* 15 (October 1924): 508–13.

55. [Gilman], "Copley Square Museum," 18.

56. See Calvin Tomkins, *Merchants and Masterpieces: The Story of the Metropolitan Museum of Art* (New York: Dutton, 1970), 118ff.

57. Toledo Art Museum, *The Museum Educates* (Toledo, OH: Toledo Art Museum, 1935), n.p.

58. Charles R. Morey, "Research and Art Museums," *Museum News* 12 (September 15, 1934): 7.

59. Paul J. Sachs, "An Address to the Trustees," *Bulletin of the Museum of Modern Art* 6 (July 1939): 11, reproduced as "Why Is a Museum of Art," *Architectural Forum* 71 (September 1939): 198.

60. Ibid., 12.

61. John Cotton Dana, *The Gloom of the Museum* (Woodstock, VT: Elm Tree Press, 1917), 23. For Gilman scholarship was a secondary function of the museum; see Gilman, *Museum Ideals,* 95–97, 108.

62. Theodore L. Low, *The Museum as Social Instrument* (New York: Metropolitan Museum of Art, 1942), 9; see also his *The Educational Philosophy and Practice of Art Museums,* 10, 88–90.

63. Ibid., 17.

64. Ibid., 9.

65. S. Dillon Ripley, *The Sacred Grove: Essays on Museums* (Washington, DC: Smithsonian Institution Press, 1969), 73.

66. Low, *Educational Philosophy,* 190.

67. Morey, "Research and Art Museums," 7. No doubt with rival Harvard in mind, Morey said that graduate art history programs "should not be asked, at the risk of compromising their objective of pure scholarship, to undertake as well the vocational training of museum workers."

68. Francis Henry Taylor, *Babel's Tower: The Dilemma of the Modern Museum* (New York: Columbia University Press, 1945), 22–23, 51.

69. Low, *Museum as Social Instrument,* 11.

70. Philip Youtz, "The Sixty-ninth Street Branch Museum of the Pennsylvania Museum of Art," *Museum News* 10 (December 15, 1932): 6–7. On branch museums, also see Paul M. Rea, *The Museum and the Community* (Lancaster, PA: Science Press, 1932); and "Chicago Institute Opens Its First Branch," *Museum News* 13 (January 1, 1936): 1.

71. "The New Director Now Takes Over Brooklyn Museum," *ARTnews* 32 (April 21, 1934): 3.

72. Philip Youtz, "Museums among Public Services," *Museum News* 11 (September 15, 1933): 8.

73. Victor d'Amico, "The Museum of Art in Education," *Art Education Today* 7 (1941), 51, quoted in Low, *Educational Philosophy,* 80.

74. Philip Youtz, "The Social Science Approach to Art in Adult Education," *Museum News* 8 (October 15, 1930): 10.

75. Philip Youtz, "Museumitis," *Journal of Adult Education* 6 (1934): 387, 391, and "Museums among Public Services," 7–9.

76. Toledo Art Museum, *The Museum Educates,* not paginated. For Gilman's influence, at least in the United States, one has only to survey museum bulletins from the 1920s and 1930s, such as those of Wadsworth Atheneum, Hartford, the Art Institute of Chicago, and the Philadelphia Museum of Art. As early as 1910, the Met had adopted Gilman's aims, saying the purpose of its docent programs was not to impart facts and history but to "fire enthusiasm" through "appreciation." "Expert Guidance to the Museum," *Metropolitan Museum of Art Bulletin* 5 (September 1910): 201–7; also see Rossiter Howard, "Changing Ideals of the Art Museum," *Scribner's Magazine* 71 (January 1922): 125–28. An excellent history of museum education is provided by Terry Zeller, "The Historical and Philosophical Foundations of Art Museum Education," in *Museum Education: History, Theory, and Practice,* ed. N. Berry and S. Mayer (Reston, VA: Art Education Association, 1989), 10–89.

77. See Mary Anne Staniszewski, *The Power of Display: A History of the Exhibition Installations at the Museum of Modern Art* (Cambridge, MA: MIT Press, 1998), 81 and passim.

78. Gilman, *Museum Ideals,* 109.

79. Ibid., 342–43.

80. Arthur Melton, *Problems of Installation in Museums of Art* (Washington, DC: American Association of Museums, 1935), 11.

81. T. R. Adam, *The Civic Value of Museums* (New York: American Association for Adult Education, 1937), 25.

82. *The Visual Arts: A Report Sponsored by the Darlington Hall Trustees;* published on behalf of the Arts Enquiry by PEP (Political and Economic Planning) (Oxford: Oxford University Press, 1946), 149. The report especially recommended gallery-based lectures.

83. Sir Kenneth Clark, "Ideal Picture Galleries," *Museums Journal* 45 (November 1945): 133. Twenty years earlier, in a testy rebuttal of Gilman's beliefs, William Ivins had argued to the contrary that most museum visitors "don't have ecstasies and . . . do ask questions, where, when, why, how, and how much—all of which imply interest *about* art but not *in* art." William M. Ivins, "Of Museums," *The Arts* 3 (January 1923): 32. Though Ivins wrote several still useful books on the print medium while serving as the Met's curator of prints, his wider views on education did not prevail.

84. John Coolidge, *Some Problems of American Art Museums* (Boston: Club of Odd Volumes, 1953), 12, 19.

85. James R. Johnson and Adele Z. Silver, *The Educational Program of the Cleveland Museum of Art* (Cleveland, OH: Cleveland Museum of Art, 1971), 26.

86. Quoted in Anthony Burton, *Vision and Accident: The Story of the Victoria and Albert Museum* (London: Victoria and Albert Museum, 1999), 179.

87. Eric Maclagen, "Museums and the Public," *Museums Journal* 36 (August 1936): 182.

88. John Walker, *Self-Portrait with Donors* (Boston: Little, Brown, 1974), 51–52.

89. See Brian O'Doherty, *Inside the White Cube: The Ideology of the Gallery Space* (San Francisco: Lapis Press, 1986), 42.

90. On labor union views on museums, see Mark Starr, "Museums and the Labor Unions," *Museum News* 26 (January 1, 1949): 7–8. Starr was educational director of the International Ladies' Garment Workers' Union in New York.

91. *Visual Arts,* 145.

92. Low, *Museum as Social Instrument,* 24–30. An intriguing survey conducted by Low at the Met in the early 1940s found that a clear majority of visitors (just under 50 percent) favored aesthetic appreciation over "art and daily living" (5 percent), a social theme developed for its appeal to the less well educated.

93. Pierre Bourdieu and Alain Darbel, *The Love of Art: European Art Museums and Their Public,* trans. C. Beattie and N. Merriman (Cambridge: Polity Press, 1991), 67, originally published as *L'amour de l'art, les musées d'art européens et leur public,* 2nd ed. (Paris: Editions de minuit, 1966); also see Pierre Bourdieu's *Distinction: A Social Critique of the Judgement of Taste,* trans. R. Nice (Cambridge, MA: Harvard University Press, 1984), and *The Field of Cultural Production* (Cambridge: Polity Press, 1993).

94. Bourdieu and Darbel, *Love of Art,* 67.

95. Ibid., 112.

96. See Rebecca J. DeRoo, *The Museum Establishment and Contemporary Art: The Politics of Artistic Display in France after 1968* (New York: Cambridge University Press, 2006), ch. 2.

97. "New York Annual Meeting: Going to Meet the Issues," *Museum News* 49 (September 1970): 18. Among the resolutions proposed by some AAM delegates was a more organized effort to address the problems of "racism, sexism, repression and war" and to increase opportunities for women, minorities, and "other oppressed people."

98. Ibid., 19.

99. See Dominique Poulot, "Identity as Self-Discovery: The Ecomuseum in France," in Sherman and Rogoff, *Museum Culture,* 66–84.

100. I. Michael Heyman, "A New Day Begun," *Smithsonian Magazine,* August 1999, www.smithsonianmag.si.edu/smithsonian/issues99/aug99/heyman_aug99.html (accessed November 14, 2006).

101. Emily Dennis Harvey and Bernard Friedberg, eds., *A Museum for the People* (New York: Arno Press, 1971), 28.

102. Quoted in ibid. On Anacostia, also see Caryl Marsh, "A Neighborhood Museum That Works," *Museum News* 47 (October 1968): 11–16; John Kinard, "To Meet the Needs of Today's Audience," *Museum News* 50 (May 1972): 15–16; and Emily Dennis, "Seminar on Neighborhood Museums," *Museum News* 48 (January 1970): 13–18.

103. Ripley, *Sacred Grove,* 105.

104. Ibid., 73.

105. Quoted in Harvey and Friedberg, *Museum for the People,* 3–4.

106. Quoted in ibid., x.

107. James Johnson Sweeney, "The Artist and the Museum in Mass Society," in *Culture for the Millions? Mass Media in Modern Society,* ed. Norman Jacobs (Boston: Beacon Press, 1961), 95.

108. Walker, *Self-Portrait with Donors,* xiv.

109. Ibid., 28.

110. Sherman Lee, "The Art Museum in Today's Society," *Dayton Art Institute Bulletin* 27 (March 1969), quoted in Zeller, "Historical and Philosophical Foundations," 31.

111. Grace Glueck, "The Ivory Tower versus the Discotheque," *Art in America* 59 (May–June 1971): 80–85.

112. American Association of Museums, *Museums for a New Century* (Washington, DC: American Association of Museums, 1984), 19, 60, 104.

113. Quoted in Harvey and Friedberg, *Museum for the People,* 6–7.

114. Quotes taken from book advertisements in *AAM Bookstore,* Spring/Summer 2006, 6.

115. Martin Bailey, "We'll Have Ways of Making Muslims Like Rubens Nudes," *Art Newspaper,* July–August 2000, 10.

116. See Sandy Nairne, "Final Report and Recommendations of the National Museum Directors' Conference on Cultural Diversity," March 2006, www.nationalmuseums.org.uk/images/publications/cultural_diversity_final_report.prf (accessed July 2006). For a response to diversity goals, see Josie Appleton, "Art for Inclusion's Sake," April 7, 2004, www.spiked-online.com/Articles/0000000CA4BC.htm (accessed July 2006).

117. As early as 1932 Philip Youtz noted that a steady bill of "temporary exhibitions" would "undoubtedly stimulate attendance." "Sixty-ninth Street Branch," 6. On Hoving's role in creat-

ing the blockbuster boom in the 1970s, see Michael Conforti, "Hoving's Legacy Reconsidered," *Art in America* 74 (June 1986): 19–23.

118. Franz Schulze described the Pei wing as "a temple of cultural democracy" in "A Temple of Cultural Democracy," *ARTnews* 80 (November 1981): 132.

119. Margaret Mead, "Museums in a Media-Saturated World," *Museum News* 49 (September 1970): 23–26.

120. Rudolph Morris, "Leisure Time and the Museum," *Museum News* 41 (December 1962): 17–18.

121. Alan Wallach, "Class Rites in the Age of the Blockbuster," *Harvard Design Magazine* 11 (Summer 2000): 48–54; see also Gary O. Larson, *American Canvas* (Washington, DC: National Endowment for the Arts, 1997).

122. Robert Coles, "The Art Museum and the Pressures of Society," in *On Understanding Art Museums,* ed. Sherman Lee (Englewood Cliffs, NJ: Prentice Hall, 1975), 185–202.

123. Quoted in Roberta Smith, "Should Museums Always Be Free?" *New York Times,* July 13, 2006, A19.

124. From 2003 on, the Cincinnati Art Museum offered free admission, thanks to a gift from the Lois and Richard Rosenthal Foundation. See Jim Knippenburg, "Art Museum 'Free' Policy Begins Today," *Cincinnati Enquirer,* May 17, 2003. My thanks to Sarah Moser for this information and for interviewing museum staff who told her that attendance rose by 25 percent in the first year following the new policy.

125. See Smith, "Should Museums Always Be Free?" A19. Smith lists many U.S. museums that no longer charge, or have never charged, for admission, including St. Louis, Minneapolis, Dayton, Cleveland, Toledo, Des Moines, Virginia, and the Nelson-Atkins in Kansas City.

126. Jonathan Mahler, "High Culture Hits the Strip," *Talk,* May 2001, 84–85. On Krens, see also Michael Kimmelman, "The Globe Straddler of the Art World," *New York Times,* April 19, 1998; and Peter Plagens, "In a Spiral," *Newsweek,* May 20, 1996.

127. Malcolm Rogers, "Popular and Accessible Does Not Equal Stupid," *Art Newspaper,* November 2004, 20; also Geoff Edgers, "MFA's Monets: Dicey Deal?" *Boston Globe,* January 25, 2004.

128. James Cuno, "Art Museums Should Get Back to Basics," *Boston Globe,* October 26, 2000, and "In the Crossfire of the Culture Wars: The Art Museum in Crisis," Occasional Papers, Harvard University Art Museum, no. 3, 1995, www.artmuseums.harvard.edu/professional/occpapers3 .html (accessed November 19, 2006); Philippe de Montebello, "Musings on Museums," *CAA News,* March–April 1997; Calvin Tomkins, "The Importance of Being Elitist," *New Yorker,* November 24, 1997. "Hip vs. Stately: The Tao of Two Museums," *New York Times,* February 20, 2000, opposed Krens and Montebello much as Hoving and Lee had been opposed thirty years earlier.

129. James Delingpole, "Ouch! Is This the Direction Our Museums Have to Go?" *Times* (London), March 18, 2006, 25.

130. Adam Gopnik, "The Death of an Audience," *New Yorker,* October 5, 1992; Jed Perl, "Welcome to the Funhouse," *New Republic,* June 19, 2000.

131. James Cuno, "Against the Discursive Museum," in *The Discursive Museum,* ed. Peter Noever (Vienna: Hatje Cantz, 2001), 52.

132. James Cuno, "The Object of Art Museums," in Cuno, *Whose Muse?* 57.

133. Ibid., 59.

134. Coolidge, *Some Problems*, 18. Francis Henry Taylor at the Met had similar misgivings in the early 1950s; see Tomkins, *Merchants and Masterpieces*, 324. On the need to visually stimulate museum visitors, also see Nelson Goodman, *Of Mind and Other Matters* (Cambridge, MA: Harvard University Press, 1984), 179, and Ivan Gaskell, *Vermeer's Wager: Speculations on Art History, Theory and Art Museums* (London: Reaktion Books, 2000).

135. VTS was designed by cognitive psychologist Abigail Houston and museum educator Philip Yenawine. For an introduction to how it works, see "What Is VTS?" 2001, www.vue.org/whatisvts .html (accessed July 2006).

136. Bryan Robertson, "The Museum and the Democratic Fallacy," in *Museums in Crisis*, ed. Brian O'Doherty (New York: Braziller, 1972), 79.

137. R. L. Duffus, *The American Renaissance* (New York: Knopf, 1928), 239.

138. Adam, *Civic Value of Museums*, 54: "[T]he difficulties faced by museums in attaining educational objectives spring principally from the lack of educational support by outside organizations."

139. See, for example, Beth B. Schneider, *A Place for All People* (Houston, TX: Museum of Fine Arts, 1998), which documents an extraordinary outreach program funded by a host of institutional grants. The American Association of Museums' *Museums for a New Century* (1984), 57, noted that most of the outreach efforts described in *Museums: Their New Audiences* of 1972 no longer existed. Youtz's Sixty-ninth Street Branch Museum closed in 1932 when Carnegie funding was withdrawn; twice, in the 1920s and again in the 1960s, plans to create branch museums of the Met in New York fell through for lack of donors. For the earlier scheme, see W. Howe, *A History of the Metropolitan Museum*, 2 vols. (New York: Columbia University Press, 1946), 2:203.

140. John H. Falk, "Visitors: Who Does, Who Doesn't and Why," *Museum News* 81 (March–April 1998): 38ff.

141. Cuno, "In the Crossfire," 3.

142. AAM, *Museums for a New Century*, 55.

143. Vera L. Zolberg, "Tensions of Mission in American Art Museums," in *Nonprofit Enterprise in the Arts*, ed. Paul Dimaggio (New York: Oxford University Press, 1986), 185.

144. "Final Report and Recommendations," passim.

145. On the recent diversification of San Francisco museums, see Edward Rothstein, "Anecdotal Evidence of Homesick Mankind," *New York Times*, July 20, 2006, B1.

Chapter 5. Commercialism

Epigraphs are from Benjamin Ives Gilman, *Museum Ideals of Purpose and Method* (Boston: Boston Museum of Fine Arts, 1923), 388, and Philip Johnson, quoted in Andrea Oppenheimer Dean, "Showcases for Architecture," *Architecture* 75 (January 1986): 28.

1. Judith H. Dobrzynski, "Glory Days for the Art Museum," *New York Times*, October 5, 1997, sec. 2, 1.

2. Douglas Martin, "This Isn't Your Father's Art Museum: Brooklyn's Got Monet, but Also Karaoke, Poetry and Disco," *New York Times*, October 27, 1997. A further selection of headlines from the late 1990s includes "The Hot Place to Party: Museums" (*Boston Globe*, August 21, 1997); "Art(?) to Go: Museum Shops Broaden Wares, at a Profit" (*New York Times*, December 10, 1997); and "Impressionists Sure Move the Merchandise" (*New York Times*, April 21, 1999).

3. Ellen Hoffman, "Painting a New Picture," *USAir Magazine,* May 1996, 52ff.

4. Roberta Smith, "Memo to Art Museums: Don't Give Up on Art," *New York Times,* December 3, 2000, sec. 2, 1.

5. Michael Kimmelman, "Museums in a Quandary: Where Are the Ideals?" *New York Times,* August 26, 2001, sec. 2, 1. It should be noted that journalists had raised a similar alarm a good deal earlier; see, for example, Mark Lilla, "The Great Museum Muddle," *New Republic,* April 8, 1985, 25–30, which begins: "Never has the American art museum been so popular, never has it been so confused." Also see Thatcher Freund, "Art and Money: How New England's Greatest Museum Saved Its Life by Mortgaging Its Soul," *New England Monthly,* October 1987, 49ff.

6. Michael Kimmelman, "What Price Love?" *New York Times,* July 17, 2005, sec. 2, 1.

7. Glenn D. Lowry, "A Deontological Approach to Art Museums and the Public Trust," in *Whose Muse? Art Museums and the Public Trust,* ed. James Cuno (Princeton: Princeton University Press, 2004), 146–47.

8. Philippe de Montebello, "Art Museums, Inspiring Public Trust," in Cuno, *Art Museums,* 161.

9. Sir Joshua Reynolds, *Discourses on Art,* ed. Robert R. Wark (New Haven: Yale University Press, 1975), 13. Also see David H. Solkin, *Painting for Money: The Visual Arts and the Public Sphere in Eighteenth-Century England* (New Haven: Yale University Press, 1993); and Annie Becq, "Creation, Aesthetics, Market: Origins of the Modern Concept of Art," in *Eighteenth-Century Aesthetics and the Construction of Art,* ed. Paul Mattick (New York: Cambridge University Press, 1993), 240–54.

10. Quoted in Nikolaus Pevsner, *Academies of Art Past and Present* (1940; reprint, New York: Da Capo Press, 1973), 153.

11. A museum of modern French art was established at Versailles in 1797, a forerunner to the better-known Luxembourg Museum, which opened in Paris in 1818. A Sèvres museum opened in 1800, as did the Musée des arts et métiers.

12. On these exhibitions, see Patricia Mainardi, *Art and Politics of the Second Empire: The Universal Expositions of 1855 and 1867* (New Haven: Yale University Press, 1987), ch. 2; and Paul Greenhalgh, *Ephemeral Vistas: The Expositions Universelles, Great Exhibitions and Worlds Fairs, 1851–1939* (Manchester: Manchester University Press, 1988), 3–6.

13. Quoted in Dominique Poulot, *Musée, nation, patrimoine, 1789–1815* (Paris: Gallimard, 1997), 195.

14. Sir John Deal Paul, *Journal of a Party of Pleasure to Paris in the Month of August, 1802* (London: Cadell and Davies, 1802), 39.

15. On the Chalcographie, see George D. McKee, "Collection publique et droit de reproduction: Les origines de la Chalcographie du Louvre, 1794–1797," *Revue de l'Art* 98 (1992): 54–65; and Françoise Viatte, "La Chalcographie du Louvre d'hier à aujourd'hui," *Nouvelles de l'Estampe,* nos. 148-49 (October 1996): 43–44.

16. For museums and photography, see Pierre-Lin Renié, "Braun *versus* Goupil et quelques autres histoires: La photographie au musée du Louvre au XIXe siècle," in *État des lieux* (Bordeaux: Musée Goupil, 1999), 97–152; Anthony J. Hamber, *"A Higher Branch of Art": Photographing the Fine Arts in England, 1839–1880* (Amsterdam: Gordon and Breach, 1996); and Ivan Gaskell, *Vermeer's Wager: Speculations on Art History, Theory and Art Museums* (London: Reaktion Books, 2000), ch. 7.

17. On Berlin, see Steven Moyano, "Quality vs. History: Schinkel's Altes Museum and Prussian Arts Policy," *Art Bulletin* 57 (December 1990): 585–608; on Britain, see Anthony Burton,

Vision and Accident: The Story of the Victoria and Albert Museum (London: Victoria and Albe Museum, 1999); and on France, see J.-B. Pujoulx, *Paris à la fin du XVIIIe siècle* (Paris: Brigii Mathé, 1801), 259ff.

18. Quoted in Louise Purbrick, "The South Kensington Museum: The Building of the House of Henry Cole," in *Art Apart: Art Institutions and Ideology across England and North America,* ed. Marcia R. Pointon (Manchester: Manchester University Press, 1994), 70.

19. Quoted in Greenhalgh, *Ephemeral Vistas,* 33.

20. Horace Greeley, *Art and Industry as Represented in the Exhibition at the Crystal Palace, New York 1853–4* (New York: Redfield, 1853), xix.

21. A good overview of arts and crafts museums in Europe is provided by Michael Conforti, "Les musées des arts appliqués et l'histoire de l'art," in *Histoire de l'histoire de l'art, XVIIIe et XIXe siècles* (Paris: La documentation française/Musée du Louvre, 1997), 329–47.

22. Founding Charter of 1870, quoted in R. Craig Miller, *Modern Design in the Metropolitan Museum, 1890–1990* (New York: Metropolitan Museum and Abrams, 1990), 1. Also see Michael Conforti, "The Idealist Enterprise and the Applied Arts," in *A Grand Design: The Art of the Victoria and Albert Museum* (New York: Abrams, 1997).

23. General Luigi P. di Cesnola, *An Address on the Practical Value of the American Museum* (Troy, NY: Stowell Printing House, 1887), 10.

24. See Gillian Naylor, *The Arts and Crafts Movement* (London: Studio Vista, 1971); and Burton, *Vision and Accident.*

25. Greenwood, *Museums and Art Galleries,* 256. See Jeffrey A. Auerbach, *The Great Exhibition of 1851: A Nation on Display* (New Haven: Yale University Press, 1999), 21.

26. Quoted in Greenwood, *Museums and Art Galleries,* 257.

27. Quoted in ibid., 32. On the "antimodernism" of the Arts and Crafts movement in America, see T. J. Jackson Lears, *No Place of Grace: Antimodernism and the Transformation of American Culture, 1880–1920* (Chicago: University of Chicago Press, 1981).

28. On the Columbian Exposition and efforts to counter the commercial image of Chicago, see Neil Harris et al., *Grand Illusions: Chicago's World's Fair of 1893* (Chicago: Chicago Historical Society, 1993), esp. 60–63.

29. *Masterpieces of Art: Exhibition at the New York World's Fair 1939* (New York: Art News, 1939), 5.

30. Gilman, *Museum Ideals,* 62–72, 92–97. Gilman documents the failure of the South Kensington method in a report to his museum's trustees, Museum of Fine Arts, Boston, *Communications to the Trustees* (Boston: Museum of Fine Arts, 1904), 49ff.

31. Gilman, *Museum Ideals,* 384.

32. Ibid., 388.

33. Ibid., 381; also Benjamin Ives Gilman, "Museum Publicity," *American Magazine of Art* 8 (February 1917): 145–47.

34. Justus Brinckmann, director of the Hamburg Museum, quoted in Charles Richards, *Industrial Art and the Museum* (New York: Macmillan, 1927), 22.

35. Richards, *Industrial Art,* 53, also 55–56.

36. Quoted in Robert W. Rydell, *All the World's a Fair: Visions of Empire at American International Expositions, 1876–1916* (Chicago: University of Chicago Press, 1984), 45.

37. John Cotton Dana, *The Gloom of the Museum* (Woodstock, VT: Elm Tree Press, 1917), 22.

ʼ ᴐana, *A Plan for a New Museum* (Woodstock, VT: Elm Tree Press, 1920), 30–31.
 ᴐpkin, "Art: Three Aisles Over," *Outlook and Independent* 156 (November 26,
 ɼ]he department stores of the land have given themselves over to the trading of
 ⸝ecause this is a stimulus to business."
 ⸝ I. Strauss, "The Architecture of Merchandising," *Architectural Forum* 58 (May 1933):
 the interaction of New York stores and museums, see William Leach, *Land of Desire:
 ᴐnts, Power, and the Rise of a New American Culture* (New York: Vintage, 1993), 164–73.
 ᴐerlin, see Charlotte Klonk, "From Shop Windows to Gallery Rooms in Early Twentieth-
 ᴐntury Berlin," *Art History* 28 (September 2005): 468–95.

41. Carlos E. Cummings, "East Is East and West Is West: Some Observations on the World's
Fair of 1939 by One Whose Main Interest Is in Museums," *Bulletin of the Buffalo Society of Nat-
ural Sciences* 20 (1940): 11, 348.

42. See Frederick Kiesler, *Contemporary Art Applied to the Store and Its Displays* (New York:
Brentano's, 1930); also Leach, *Land of Desire*, 303ff.

43. See Florence Levy, "The Service of the Museum to the Community," *American Magazine
of Art* 15 (November 1924): 583; also R. L. Duffus, *The American Renaissance* (New York: Knopf,
1928), 228ff.

44. "The New Director Now Takes Over Brooklyn Museum," *Art News* 32 (April 21, 1934): 5.

45. Dana, *Gloom of the Museum*, 23. Also see John Cotton Dana, *Should Museums Be Useful?*
(Newark: Newark Museum, 1927), 5.

46. John Cotton Dana, "In a Changing World Should Museums Change?" in *Papers and Re-
ports Read at the Twenty-first Annual Meeting of the American Association of Museums* (Washing-
ton, DC: American Association of Museums, 1926), 20.

47. Richard F. Bach, "The Museum as a Laboratory," *Metropolitan Museum of Art Bulletin* 14
(1919): 3; also Richard F. Bach's *Museums and the Industrialized World* (New York: Metropolitan
Museum of Art, 1926) and *Museum Service to the Art Industries* (New York: Metropolitan Mu-
seum of Art, 1927).

48. Quoted in Leach, *Land of Desire*, 314; also see 170–73.

49. Robert de Forest, quoted in Popkin, "Art," 502. Also see Richards, *Industrial Art*, 60, which
recommended store windows as a source of inspiration for museums: "The museums cannot
set up House Beautiful within their walls, but they can present models of fine arrangement of
superlatively beautiful things that will stand as permanent lessons in good taste."

50. W. Howe, *A History of the Metropolitan Museum*, 2 vols. (New York: Columbia University
Press, 1946), 138.

51. Leach, *Land of Desire*, 314.

52. Robert W. de Forest, *Art in Merchandise: Notes on the Relationship of Stores and Museums*
(New York: Metropolitan Museum of Art, 1928), 5.

53. Lee Simonson, "The Land of Sunday Afternoon," *New Republic*, November 21, 1914, 22–23.

54. Lee Simonson, "Museum Showmanship," *Architectural Forum* 56 (June 1932): 533.

55. On these exhibitions, see Kristina Wilson, "Style and Lifestyle in the Machine Age: The
Modernist Period Rooms of 'The Architect and the Industrial Arts,'" *Visual Resources* 21 (Sep-
tember 2005): 245–61.

56. Quoted in Miller, *Modern Design*, 28. Miller provides a good account of the history of mod-
ern design at the Met.

57. Quoted in Russell Lynes, *Good Old Modern: An Intimate Portrait of the Museum of Modern Art* (New York: Atheneum, 1973), 91–92. Also see Mary Anne Staniszewski, *The Power of Display: A History of the Exhibition Installations at the Museum of Modern Art* (Cambridge, MA: MIT Press, 1998), 158.

58. "Platonic Precepts," *ARTnews* 32 (April 28, 1934): 10. On MoMA's interaction with department stores and the industrial arts, see A. Joan Saab, *For the Millions: American Art and Culture between the Wars* (Philadelphia: University of Pennsylvania Press, 2004), ch. 3.

59. See Donald J. Bush, *The Streamlined Decade* (New York: George Braziller, 1975); Jeffrey L. Meikle, *Twentieth-Century Limited: Industrial Design in America, 1925–1939* (Philadelphia: Temple University Press, 2001); Jonathan M. Woodman, *Twentieth-Century Design* (New York: Oxford University Press, 1997); and Richard Guy Wilson et al., *The Machine Age in America, 1918–1941* (New York: Brooklyn Museum of Art/Abrams, 2001).

60. Le Corbusier, *The Decorative Art of Today*, trans. James I. Dunnett (Cambridge, MA: MIT Press, 1987), 87.

61. See Nigel Whiteley, "Toward a Throw-away Culture: Consumerism, 'Style Obsolescence' and Cultural Theory in the 1950s and 1960s," *Oxford Art Journal* 10 (1987): 9.

62. *Art in Our Time* (New York: Museum of Modern Art, 1939), 332–34. By comparison, approximately four hundred paintings, sculptures, prints, and photographs were shown. Architecture and film were also well represented. A more comprehensive survey of contemporary design is provided by Sheldon Cheney and Martha Candler Cheney, *Art and the Machine: An Account of Industrial Design in 20th-Century America* (New York: Whittlesey House, 1936).

63. Elodie Courter, "Notes on the Exhibition of Useful Objects," in *Organic Design in Home Furnishings*, ed. Eliot Noyes (New York: Museum of Modern Art, 1941), 3. Streamlined objects were omitted.

64. Ibid.; also see Staniszewski, *Power of Display*, 167.

65. Goodyear is quoted in Lynes, *Good Old Modern*, 180. On the end of the design shows, see Terence Riley and Edward Eigan, "Between the Museum and the Marketplace: Selling Good Design," in John Szarkowski et al., *The Museum of Modern Art at Mid-Century: At Home and Abroad* (New York: Museum of Modern Art; distributed by Abrams, 1994).

66. Arthur Drexler and Greta Daniel, *Introduction to Twentieth-Century Design from the Collection of the Museum of Modern Art* (New York: Museum of Modern Art, 1959), 4.

67. John Walker, *Self-Portrait with Donors* (Boston: Little, Brown, 1974), 67.

68. Kenneth Clark, *Another Part of the Wood: A Self-Portrait* (London: John Murray, 1974), 183.

69. Lynes, *Good Old Modern*, 134–35. The exhibition reviews quoted here come from Lynes.

70. Philip Youtz, "Exhibition Rooms," in League of Nations, International Museums Office, "International Study Conference on the Architecture and Equipment of Art Museums, Madrid, 1934," typescript, Fine Arts Library, Harvard University, 8. Youtz recognized that the permanent collection, "even one filled with masterpieces, soon ceases to draw local visitors, but a well arranged exhibition of lesser work, which is new, will always bring an interested public."

71. For an overview of funding patterns in U.S. museums after 1960, see Victoria D. Alexander, *Museums and Money: The Impact of Funding on Exhibitions, Scholarship, and Management* (Bloomington: Indiana University Press, 1996).

72. In a 1972 article entitled "The Beleaguered Director," Thomas Leavitt writes: "As the country-club tone of the museum disappeared, private funds became harder to solicit and we had to

build a case for public tax support from cities, counties, states, and finally the federal government. And virtually all of these funds from public sources were conditional upon our performing additional services for the public. These additional services in turn required more staff and facilities and therefore higher expenses and often bigger deficits." In *Museums in Crisis*, ed. Brian O'Doherty (New York: Braziller, 1972), 95.

73. "Letter from the Director," *Phillips Collection News*, November–December 1998, 2.

74. Perry T. Rathbone, "Influence of Private Patrons: The Art Museum as an Example," in *The Arts and Public Policy in the United States*, ed. W. McNeil Lowry (Englewood Cliffs, NJ: Prentice-Hall, 1984), 45. In 1960 Rathbone, when asked by a journalist to name the biggest problem facing the art museum, replied: "[T]he simple answer, of course, was money" (131).

75. Walter Muir Whitehill, *Museum of Fine Arts, Boston: A Centennial History*, 2 vols. (Cambridge, MA: Belknap Press, 1970), 2:824ff.; and *The Museum Year: 1971–72. The Ninety-sixth Annual Report of the Museum of Fine Arts, Boston* (Boston: Museum of Fine Arts, 1972), 8.

76. Whitehill, *Museum of Fine Arts*, 2:842.

77. *The Museum Year: 1970–71. The Ninety-fifth Annual Report of the Museum of Fine Arts, Boston* (Boston: Museum of Fine Arts, 1971), 7.

78. This information is drawn from the museum's annual reports for these years; also see Freund, "Art and Money."

79. *The Museum Year: 1975–76. The One Hundredth Annual Report of the Museum of Fine Arts, Boston* (Boston: Museum of Fine Arts, 1976), 6. The incursion of business practices into museums is the featured subject of *Museum News* 57 (January–February and July–August 1979); also see Alexander, *Museums and Money*.

80. *The Museum Year: 1985–86. The One Hundred Tenth Annual Report of the Museum of Fine Arts, Boston* (Boston: Museum of Fine Arts, 1986), 5. Also see Christopher Bowden, "Marketing a Rediscovery: Renoir at the Boston MFA," *Museum News* 64 (August 1986): 40–45.

81. *The Museum Year: 1989–90. The One Hundred Fourteenth Annual Report of the Museum of Fine Arts, Boston* (Boston: Museum of Fine Arts, 1990), 5.

82. *The Museum Year: 1990–91. The One Hundred Fifteenth Annual Report of the Museum of Fine Arts, Boston* (Boston: Museum of Fine Arts, 1991), 7.

83. *Museum of Fine Arts Boston: Annual Report 1996* (Boston: Museum of Fine Arts, 1996), 5.

84. Steve Friess and Peter Plagens, "Show Me the Monet," *Newsweek*, January 26, 2004, 60–61. On the Las Vegas deal, also see Geoff Edgers, "MFA's Monets: Dicey Deal?" *Boston Globe*, January 25, 2004, A1; and "Casino Loan Earns Boston Unwelcome Attention," *Art Newspaper*, July–August 2004, 11.

85. Laurence Vail Coleman, *Museum Buildings*, vol. 1 (Washington, DC: American Association of Museums, 1950), 125.

86. Julie Connolly, "Impressionists Sure Move the Merchandise," *New York Times*, April 21, 1999.

87. Rob Kemery, CEO of The Museum Co., quoted in Kerry Wood, "Rich with History," *Giftware Business*, September 2001, 23.

88. Maureen Dezell, "Retail, Once the Star of the MFA, Struggles," *Boston Globe*, September 15, 2000, D11.

89. Quoted in Judith Rosen, "MFA's Art and Commerce," *Publishers Weekly*, January 27, 2003, 119.

90. See Stefan Toepler and Volker Kirchberg, "Museums, Merchandising and Nonprofit Commercialization," August 2005, www.nationalcne.org/papers/museum.htm (accessed November 14, 2006). Toepler and Kirchberg demonstrate that even though shop profits at major American museums remained flat through the 1990s and contributed only minimally to operating budgets, museums invest in shops anyway because they help draw visitors who spend money on various fees and services. They suggest furthermore that the public now expects museums to have shops, forcing those that did not have or need retail operations to create them; also see Dezell, "Retail, Once the Star."

91. Quoted in Ruth La Ferla, "Travel to Exotic Places and Buy, Buy, Buy," *New York Times,* August 12, 2001, sec. 9, 2. La Ferla interviewed one young visitor to New York who, pressed for time and with mild regret, chose Bloomingdale's over the Met.

92. John Fiske, *Reading the Popular* (New York: Routledge, 1989), 4.

93. Herbert Muschamp, "Forget the Shoes, Prada's New Store Stocks Ideas," *New York Times,* December 16, 2001, sec. 2, 1, 6.

94. See, for example, Paul DiMaggio, "When the 'Profit' Is Quality," *Museum News* 63 (June 1985): 28ff.

95. "Behind the Scenes of the Met Store," www.metmuseum.org/store /st_behind.asp/ FromPage/catBehindTheScenes, 2002-6 (accessed November 14, 2006). In a keynote address to the AAM in 2002, the journalist Susan Stamberg complained that a shop at the end of an exhibition "erases the artistic encounter," to which Beverly Barsook, executive director of the Museum Store Association, responded that shops "can actually enhance visitors' experiences," "extend their museum encounter," and therefore reinforce the "institution's mission." *Museum News* 81 (November–December 2002): 7. Another store manager wrote: "Millions of visitors pass through museum stores each year and are grateful for the chance to extend their knowledge and appreciation of what the museum offers." *Museum News* 81 (September–October 2002): 67.

96. Andreas Huyssen, "Escape from Amnesia: The Museum as Mass Medium," in *Twilight Memories: Marking Time in a Culture of Amnesia* (New York: Routledge, 1995), 24. Huyssen is of course referring back to Walter Benjamin's famous essay concerning reproduction and the death of aura, "The Work of Art in the Age of Mechanical Reproduction," in *Illuminations,* ed. Hannah Arendt (New York: Schocken Books, 1969), 217–51.

97. Dean MacCannell, *The Tourist: A New Theory of the Leisure Class* (New York: Schocken Books, 1976), 45. Also see Jonathan Culler, "The Semiotics of Tourism," in *Framing the Sign: Criticism and Its Institutions* (Norman: University of Oklahoma Press, 1988), 153–67.

98. On Brooklyn, see Martin, "This Isn't Your Father's Art Museum"; Roberta Smith, "Hip-Hop as a Raw Hybrid," *New York Times,* September 22, 2000; and Susan Kirschbaum, "Dinner, Dancing and, Oh Yes, Art," *New York Times,* March 14, 1999.

99. Judith Dobrzynski, "Art(?) to Go: Museum Shops Broaden Wares, at a Profit," *New York Times,* October 10, 1997, A1; also see Gail Gregg, "From *Bathers* to Beach Towels: Museums Expand Retailing Operation," *ARTnews* 96 (April 1997): 120–22.

100. Joy Hakanson Colby, "How the DIA Rode out Money Woes," *Detroit News,* January 22, 2002.

101. Quoted in Brian Wallis, "The Art of Big Business," *Art in America* 74 (June 1986): 28.

102. Rem Koolhas et al., *Harvard Design School Guide to Shopping* (Cologne: Taschen, 2001), 144.

103. At first Krens had doubts about Las Vegas, but the sight of lines outside Steve Wynn's Gallery of Fine Art at the Bellagio resort changed his mind. "You walked into the gallery, and there was total silence. Everyone was on the audio machines, listening to Steve Wynn's tour, which was intelligent and accessible. And I thought to myself, 'What is wrong with this picture except my own attitude?'" Quoted in Celestine Bohlen, "Guggenheim and Hermitage to Marry in Las Vegas," *New York Times,* October 20, 2000, A18. Also see Jonathan Mahler, "High Culture Hits the Strip," *Talk Magazine,* May 2001, 83ff.; and Sze Tsung Leong, " . . . And Then There Was Shopping," in *Harvard Design School Guide to Shopping,* ed. Rem Koolhas et al. (New York: Taschen, 2001), 144. The main exhibition hall of the Guggenheim Las Vegas, designed by Rem Koolhas, closed in 2003; the smaller Guggenheim Hermitage at the Venetian is still in business.

104. Quoted in "Hip vs. Stately: The Tao of Two Museums," *New York Times,* February 20, 2000, sec. 2, 50. On Krens and his philosophy, also see Paul Werner, *Museum, Inc.: Inside the Global Art World* (Chicago: Prickly Paradigm Press, 2005); and Hans Haacke, "The Guggenheim Museum: A Business Plan," in *Learning from the Bilbao Guggenheim,* ed. Anna Guasch and Joseba Zuleika, Conference Papers No. 2 (Reno: University of Nevada, Reno, Center for Basque Studies, 2005), 113–23.

105. Quoted in Kirschbaum, "Dinner, Dancing," sec. 9, 6.

106. Michael Kimmelman, "An Era Ends for the Guggenheim," *New York Times,* December 6, 2002, E39. The popular press has long taken an unusual interest in Krens and his museums; see, for example, Peter Plagens, "In a Spiral," *Newsweek,* May 20, 1996, 68–70; Vicky Ward, "A House Divided," *Vanity Fair,* August 2005, 128ff.

107. Quoted in *New York Times,* May 19, 1996. In 2005 the Getty announced it would begin soliciting private funds to support its operations. *New York Times,* August 16, 2005, B1.

108. Anne Hawley, "Dances with Trustees: How One Museum Reinvented Its Board and Rediscovered Itself," *Museum News* 77 (January–February 1998): 40ff.

109. See, for example, Sarah King, "French Museums' Budget Woes," *Art in America* 86 (January 1998): 27; Martin Bailey, "Finance and Culture: UK Museums," *Art Newspaper,* December 1999, 13. Also see Gaskell, *Vermeer's Wager,* ch. 8.

110. Lianne McTavish, "Shopping in the Museum? Consumer Spaces and the Redefinition of the Louvre," *Cultural Studies* 12 (1998): 168–92.

111. Alan Riding, "The Louvre's Art: Priceless. The Louvre's Name: Expensive," *New York Times,* March 7, 2007, B1.

112. Alan Riding, "European Museums Open Door to Corporate Donors," *New York Times,* November 13, 2004, A22.

113. Melinda Henneberger, "Italy Plans to Have Private Sector Run Museums," *New York Times,* December 3, 2001, E1; Eric Sylvers, "10 Years Later, Italy Assesses Change in How Its Fabled Museums Are Run," *New York Times,* January 1, 2004, E5.

114. See Brook Mason, "Museums Enter the Art and Culture Industry Market," *Art Newspaper,* June 2000, 10, on the Internet partnership between MoMA and Tate Modern; and "How the Brits Woo the US Donors," *Art Newspaper,* September 2000, 13. These initiatives mark a radical departure from practices in Europe as little as twenty years ago; see Bruno S. Frey and Werner W. Pommerehne, "An Economic Analysis of the Museum," in *Economic Policy for the Arts,* ed. W. S. Hendon et al. (Cambridge, MA: Abt Books, 1980), 250–60.

115. Quoted in Judith Dobrzynski, "Passing on the Pain at the Met," *New York Times,* April 14, 1999, B4.

116. James Gasser, "Why Cities Need Museums," *Museum News* 57 (May–June 1979): 26; Alexander, *Museums and Money,* 71.

117. See Julia Beizer et al., "Marketing the King: Tut 2 and the New Blockbuster," *Museum News* 85 (November–December 2005): 37–43; and Robin Pogrebin and Sharon Waxman, "King Tut, Set for 2nd U.S. Tour, Has New Decree: Money Rules," *New York Times,* December 2, 2004, A1, C13.

118. In his last book, the late Francis Haskell argued against the exhibition craze on these grounds. "It is . . . greatly to be desired that some . . . sense of responsibility for the irreparable and precious should be restored," he wrote. *The Ephemeral Museum: Old Master Paintings and the Rise of the Art Exhibition* (New Haven: Yale University Press, 2000), 145. Yet shortly before his death he was himself involved in a large loan exhibition of Italian Baroque paintings, The Genius of Rome (Royal Academy, 2001), dedicated to his memory. Also see the editorial "To Lend or Not to Lend?" in *Burlington Magazine* 147 (November 2005): 721.

119. Quoted in Mark W. Rectanus, *Culture Incorporated: Museums, Artists, and Corporate Sponsorships* (Minneapolis: University of Minnesota Press, 2002), 26. Promotional literature sent to businesses by the Boston MFA in 2002 reveals that little has changed: "Corporate sponsors . . . build brand awareness, demonstrate their commitment to the arts, and affiliate themselves with a world-renowned cultural institution." Sponsorship is described as a "blend of philanthropy and cost-effective marketing."

120. Quoted in ibid., 25.

121. On museums and the "culture wars," see Steven C. Dubin, *Displays of Power: Controversy in the American Museum from the Enola Gay to Sensation* (New York: NYU Press, 1999).

122. Quoted in Michael Kimmelman, "Does It Really Matter Who Sponsors a Show?" *New York Times,* May 19, 1996, H33. Also see Rathbone, "Influence of Private Patrons," 138–39.

123. Hans Haacke, "Museums, Managers of Consciousness," in *Unfinished Business* (Cambridge: MIT Press, 1988), 71; on Haacke, also see Wallis, "Art of Big Business," 28–32.

124. Quoted in Martin Feldstein, ed., *The Economics of Art Museums* (Chicago: University of Chicago Press, 1991), 57; also see James Wood, "Citizens or Consumers: Today's Art Museum and Its Public," in *Museums and the Price of Success,* ed. Truus Gubbels and Annemoon van Hemel (Amsterdam: Boekman Foundation, 1993).

125. John House, "Possibilities for a Revisionist Blockbuster: *Landscapes/Impressions of France,*" in *The Two Art Histories: The Museum and the University,* ed. Charles W. Haxthausen (New Haven: Yale University Press, 2002), 159–60.

126. Malcolm Rogers defends popularizing exhibitions on grounds of access in "Popular and Accessible Does Not Equal Stupid," *Art Newspaper,* November 2004, 20.

127. Scholars were identified some time ago as the losers in the turn toward popular appeal; see Germain Bazin, "Musées d'hier et d'aujourd'hui," *Musées et Collections Publiques de France* 168 (1985): 7–10; Grace Glueck, "The Ivory Tower versus the Discotheque," *Art in America* 59 (May–June 1971): 85; and S. Dillon Ripley, *The Sacred Grove: Essays on Museums* (Washington, DC: Smithsonian Institution Press, 1969), 73.

128. On the bartering behind a blockbuster, see Terry Pristin, "The Art behind the Art Show:

Wheeling and Dealing to Get Monet to Brooklyn," *New York Times,* October 2, 1997; also see de Montebello on this topic in Cuno, *Whose Muse?* 163–65.

129. Quoted in Deborah Solomon, "As Art Museums Thrive, Their Directors Decamp," *New York Times,* August 2, 1998, 35; also see Grace Glueck, "The Job Description Reads, 'Do It All,'" *New York Times,* April 21, 1999, E:10–11; Marjorie Schwarzer, "Turnover at the Top: Are Directors Burning Out?" *Museum News* 81 (May–June 2002): 43ff.; "Where Are the Museum Directors?" *ARTnews* 104 (Summer 2005): 72; Jacob Russell, "Art Museums Debate Skills for Top Post," *Wall Street Journal,* August 18, 2005, B1; and the profiles of directors, curators, and trustees by Thomas W. Leavitt, Edward F. Fry, and Grace Glueck in O'Doherty, *Museums in Crisis.*

130. See James Cuno, "'Sensation' and the Ethics of Funding Exhibitions," in *Unsettling "Sensation": Arts-Policy Lessons from the Brooklyn Museum of Art Controversy,* ed. Lawrence Rothfield (New Brunswick: Rutgers University Press, 2001). This collection includes much good discussion about museum funding.

131. Quoted in Rothfield, *Unsettling "Sensation,"* 2.

132. Eleanor Heartney, "Annals of Sponsorship I: The Guggenheim's New Clothes," *Art in America* 89 (2001): 61–63; Herbert Muschamp, "Armani at the Guggenheim: Where Ego Sashays in Style," *New York Times,* October 20, 2000, sec. 2, 1, 38.

133. Quoted in Cuno, *Whose Muse?* 16. The issue of curatorial control seems vital in this case. A few years later the Met largely escaped criticism when it mounted a show of Chanel fashion sponsored by the House of Chanel. The difference? The Met rejected the input of Chanel designer Karl Lagerfeld and made that point clear to the public: "While the sponsorship of the exhibition is the House of Chanel, the curatorial responsibilities were exercised exclusively by the [curators]. At no point did Karl Lagerfeld express any interest in directing or controlling the curatorial concept or substance of the exhibition." Harold Koda, "Chanel at the Met," *New York Times,* May 11, 2005.

134. See Gilbert S. Edelson, "Some Sensational Reflections," in Rothfield, *Unsettling "Sensation."* Also see Judith H. Dobrzynski, "Private Collections Routine at Museums," *New York Times,* October 1, 1999, B6; Geoff Edgers, "Furor Ahoy: MFA Exhibit of Koch's Collections Stirs Questions over Choices, Motives," *Boston Globe,* August 30, 2005, A1; and Ken Johnson, "Mixed Blessing: The Highs, Lows, and Limits of Modernism—and Private Collections," *Boston Globe,* December 29, 2006, D4.

135. See American Association of Museums, "Guidelines for Museums in Developing and Managing of Business Support," November 2001, www.aam-us.org/museumresources/ethics/bus_support.cfm (accessed November 14, 2006). Also see David Barstow, "After 'Sensation' Furor, Museum Group Adopts Guidelines on Sponsors," *New York Times,* August 3, 2000, E1, 3.

136. András Szántó, "Don't Shoot the Messenger: Why the Art World and the Press Don't Get Along," in Rothfield, *Unsettling "Sensation,"* 194.

137. Quoted in Kimmelman, "Does It Really Matter?" H33.

138. See Roberta Smith, "Corporate Taste in Art, and the Art of Donation," *New York Times,* February 14, 2005, B35.

139. An interesting exhibition curated by Sarah Hyde at the Courtauld Gallery in London entitled The Value of Art (1999) tested the seeming incompatibility between financial and aesthetic value by displaying a wide variety of art objects with their current market estimates. The

show provoked predictable outrage among traditional art world types while appealing to the public's fascination with the worth of things. Also see the review by Natasha Walter, "It's Art, but Is It Worth It?" *Independent,* Monday Review, July 5, 1999, 5.

140. Gilbert S. Edelson, "Some Sensational Reflections," in Rothfield, *Unsettling "Sensation,"* 178.

141. See Nick Prior, "Having One's Tate and Eating It: Transformations of the Museum in the Hypermodern Era," in *Art and Its Public: Museum Studies at the Millennium,* ed. Andrew Mc-Clellan (Oxford: Blackwell, 2003), 51–76.

142. Muschamp, "Armani at the Guggenheim," 38.

Chapter 6. Restitution and Reparation

For the epigraph's quote from Walter Benjamin's "Theses on the Philosophy of History," see *Illuminations,* ed. Hannah Arendt (New York: Schocken Books, 1969), 256.

1. Andrew McClellan, *Inventing the Louvre: Art, Politics, and the Origins of the Modern Museum in Eighteenth-Century Paris* (New York: Cambridge University Press, 1994); also Cecil Gould, *Trophy of Conquest: The Musée Napoléon and the Creation of the Louvre* (London: Faber and Faber, 1965).

2. On Belgium, see Charles Piot, *Rapport à Mr. le Ministre de l'Intérieur sur les tableaux enlevés à la Belgique en 1794 et restitués en 1815* (Brussels: E. Guyot, 1883).

3. *Le Moniteur Universelle,* September 24, 1794; reprint, ed. A. Ray (Paris: Au Bureau Central, 1840–), vol. 22 (1847): 26–27.

4. F.-A. de Boissy d'Anglas, *Quelques idées sur les arts* (Paris: Imprimerie Nationale, 1794), 164.

5. Quoted in Gould, *Trophy of Conquest,* 41.

6. Ibid., 45. On Napoleon's confiscations, also see F. H. Taylor, *The Taste of Angels* (Boston: Little, Brown, 1948), 542–64; Charles Saunier, *Les conquêtes artistiques de le Révolution et de l'Empire* (Paris: Renouard, 1902); Dorothy Mackay Quynn, "The Art Confiscations of the Napoleonic Wars," *American Historical Review* 50 (April 1945): 437–60; M.-L. Blumer, "La Commission pour la recherche des objets de sciences et arts en Italie, 1796–1797," in *La Révolution Française* 87 (1934): 62–88, 124–50, 222–59.

7. *Correspondance de Napoléon Ier,* 32 vols. (Paris: Imprimérie Impériale, 1858–69), 1:516, 527–29.

8. *Corrière de Milano,* July 5, 1797, quoted in Eugène Müntz, "Les annexions de collections d'art ou de bibliothèques et leur rôle dans les relations internationals. Principalement pendant la Révolution française," *Revue d'histoire diplomatique* 9 (1896): 481–508.

9. See McClellan, *Inventing the Louvre,* 121–23; and Patricia Mainardi, "Assuring the Empire of the Future: The 1798 Fête de la Liberté," *Art Journal* 48 (Summer 1989): 155–63.

10. *Moniteur Universelle,* June 6, 1796, quoted in Blumer, "La Commission," 63.

11. Wellington to Viscount Castlereagh, September 23, 1815, *The Dispatches of Field Marshall the Duke of Wellington . . . from 1799 to 1815,* ed. Lieutenant Colonel Gurwood (London: John Murray, 1838), 12:644–46. At the same time Lord Liverpool observed: "It is most desirable to remove [the museum's contents] if possible from France as whilst in that country they must necessarily have the effect of keeping up the remembrance of their former conquests and of cherishing the military spirit and vanity of the nation." Quoted in Taylor, *Taste of Angels,* 572; also see Gould, *Trophy of Conquest,* ch. 7.

12. Gurwood, *Dispatches*, 645.

13. Quoted in Saunier, *Les conqûetes artistiques*, 111.

14. See Benedicte Savoy, "'Le naufrage de toute une époque': Regards allémands sur les restitutions de 1814–1815," in *Dominique-Vivant Denon: L'oeil de Napoléon* (Paris: Réunion des Musées Nationaux, 1999), 258–67.

15. Quoted in Piot, *Rapport*, 351.

16. Ibid., 363, 341–42.

17. Henry Milton, *Letters on the Fine Arts, Written from Paris in the Year 1815* (London: Longman, 1816), 92.

18. Quoted in Saunier, *Les conqûetes artistiques*, 99.

19. M.-L. Blumer, "Catalogue des peintures transportées d'Italie en France de 1796 à 1814," *Bulletin de la Société de l'Histoire de l'Art Français*, 1936, 244–348.

20. See Francis Haskell and Nicholas Penny, *Taste and the Antique* (New Haven: Yale University Press, 1981), 115–16.

21. See Louis Hautecoeur, *Catalogue des peintures*, vol. 2, *École italienne et école espagnole* (Paris: Musées nationaux, 1926), 11–12. Hautecoeur describes the confiscations as an indemnity for the army's "effort" and "blood" and as a "singularly idealistic" policy.

22. Milton, *Letters on the Fine Arts*, iii. Also see W. D. Fellowes, *Paris during the Interesting Month of July 1815* (London: Gale and Fenner, 1815), 109: "At the Musée Napoléon are to be seen the rarest specimens of art, collected into one focus by robbery and plunder! Let the French nation call it whatever they please!"

23. See Hector Feliciano, *The Lost Museum: The Nazi Conspiracy to Steal the World's Greatest Art*, trans. Tim Bent and Hector Feliciano (New York: Basic Books, 1997), ch. 2.

24. British visitors found Napoleon's resort to ancient example insolent and absurd. The Reverend John Eustace, for example, said that "[t]o sanction or even excuse such lawless rapacity by the conduct of the Romans is too absurd." *Letter from Paris to George Petre, Esq.* (London: J. Mawman, 1814), 48.

25. Quoted in Piot, *Rapport*, 311–12.

26. Quoted in Taylor, *Taste of Angels*, 579.

27. Milton, *Letters on the Fine Arts*, 116. Also see Piot, *Rapport*, 66.

28. Quoted in Lavinia Stainton, "English Visitors to the Musée Napoléon," in *Essays Presented to Professor Johannes Wilde on His Sixtieth Birthday by the Staff and Past and Present Students of the Courtauld Institute of Art*, 2 vols., typescript, 1951, Courtauld Institute of Art, London, 2:163.

29. Milton, *Letters on the Fine Arts*, 2, 9.

30. Quoted in *Dominique-Vivant Denon*, 264.

31. John Scott, *A Visit to Paris in 1814* (London: Longman, 1815), 248.

32. Friedrich von Schlegel, *The Aesthetic and Miscellaneous Works of Friedrich von Schlegel*, trans. E. J. Millington (London: H. G. Bohn, 1849), 102–3.

33. A.-C. Quatremère de Quincy, *Lettres à Miranda sur le déplacement des monuments de l'art de l'Italie (1796)*, ed. Edouard Pommier (Paris: Macula, 1989), 88. Pommier offers a fine contextual analysis of this important text. On Quatremère's art criticism and politics during the Revolution, see A. D. Potts, "Political Attitudes and the Rise of Historicism in Art Theory," *Art History* 1 (1978): 191–213.

34. Quoted in Dominique Poulot, *Musée, nation, patrimoine, 1789–1815* (Paris: Gallimard, 1997),

278; also see Daniel J. Sherman, "Quatremère/Benjamin/Marx: Art Museums, Aura, and Commodity Fetishism," in *Museum Culture: Histories, Discourses, Spectacles,* ed. Daniel J. Sherman and Irit Rogoff (Minneapolis: University of Minnesota Press, 1994), 123–43.

35. Quatremère de Quincy, *Lettres à Miranda,* 102. Quatremère spoke on behalf of Rome "comme membre de cette république générale des arts et des sciences, et non comme habitant de telle ou telle nation" (89). On the "republic" to which he refers, see Dena Goodman, *The Republic of Letters: A Cultural History of the French Enlightenment* (Ithaca: Cornell University Press, 1994).

36. Quoted in McClellan, *Inventing the Louvre,* 195.

37. See Ivan Gaskell, "Sacred to Profane and Back Again," in *Art and Its Publics: Museum Studies at the Millennium,* ed. Andrew McClellan (Oxford: Blackwell, 2003), 149–62.

38. Milton, *Letters on the Fine Arts,* 4.

39. On the Aegina Marbles, see William St. Clair, *Lord Elgin and the Marbles* (New York: Oxford University Press, 1998), 201–4.

40. The best general accounts of the Elgin episode are provided by St. Clair, *Lord Elgin,* and Jeanette Greenfield, *The Return of Cultural Treasures,* 2nd ed. (New York: Cambridge University Press, 1996), 42–90; but other sources cited below should also be consulted.

41. *Report from the Select Committee of the House of Commons on the Earl of Elgin's Collection of Sculptured Marbles* [1816], reproduced in E. J. Burrow, *The Elgin Marbles* (London: John Duncan, 1837), 139.

42. Quoted in John Henry Merryman, *Thinking about the Elgin Marbles: Critical Essays on Cultural Property, Art and Law* (The Hague: Kluwer, 2000), 38; also see St. Clair, *Lord Elgin,* 337–41.

43. Quoted in Christopher Hitchens, *The Elgin Marbles: Should They Be Returned to Greece?* (London: Chatto and Windus, 1987), 44.

44. Katharine Eustace, *Canova: Ideal Heads* (Oxford: Ashmoleon Museum, 1997), 107–9.

45. Quoted (and translated) in St. Clair, *Lord Elgin,* 63.

46. For a concise account of Hamilton's career, see Eustace, *Canova.*

47. Quoted in Hitchens, *Elgin Marbles,* 56.

48. Saunier, *Les conquêtes artistiques,* 135.

49. Ibid., 138.

50. Quoted in Burrow, *Elgin Marbles,* 140. Also see Jacob Rothenberg, *Descensus ad Terram: The Acquisition and Reception of the Elgin Marbles* (New York: Garland, 1977); and Hitchens, *Elgin Marbles,* for a fuller account of the proceedings.

51. In due course, many canonical ancient sculptures, including the Apollo Belvedere and others taken from the Vatican by Napoleon, were recognized as Roman copies rather than Greek originals and gradually lost their preeminent standing to the Parthenon sculptures; see Haskell and Penny, *Taste and the Antique.* By 1821, in an appreciation of the Venus de Milo, lately discovered on the island of Melos and bought for the Louvre by the French ambassador to Constantinople, Quatremère recognized that his beloved Italy was in reality "a kind of secondary market for Greek works of art." A.-C. Quatremère de Quincy, *Sur la statue antique de Vénus* (Paris: Debure Frères, 1821), 7.

52. Ennio Quirino Visconti, *A Letter from the Chevalier Antonio Canova and Two Memoirs . . . on the Sculptures in the Collection of the Earl of Elgin* (London: John Murray, 1816), xxii. On the reception of the marbles, also see Rochelle Gurstein, "The Elgin Marbles, Romanticism and the Waning of 'Ideal Beauty,'" *Daedalus* 131 (Fall 2002): 88–100.

53. Benjamin Robert Haydon, *The Judgment of Connoisseurs upon . . . the Elgin Marbles* (London, 1816), 17.

54. A.-C. Quatremère de Quincy, *Lettres sur l'enlèvement des ouvrages d'art antique à Athènes et à Rome* (Paris: Adrien Le Clerc, 1836), ix–xi.

55. Ibid., 2, xv.

56. Ibid., 28.

57. Ibid., 49. Visconti defended their display in a museum by claiming, "It was usual . . . to exhibit to the public, for close inspection, the statues which were intended to be placed at a certain height." *Letter,* 10.

58. Quatremère de Quincy, *Lettres sur l'enlèvement,* 170.

59. Hitchens, *Elgin Marbles,* summarizes Byron's case against Elgin.

60. Ibid., 65. Hitchens, himself a strong advocate of repatriation, documents a significant history of support for the marbles' return. For an overview of the recent literature on the controversy, see Mary Beard, "Plunder Blunder," *Times Literary Supplement,* June 12, 1998, 5–6.

61. Quoted in Merryman, *Thinking about the Elgin Marbles,* 25

62. Ibid., 62, 50.

63. For the current Greek position, which disavows nationalistic motives and insists on restoring the integrity of the Parthenon, see Hellenic Ministry of Culture, "The Official Greek Position on the Restitution of the Parthenon Marbles to Athens, 1995–2001," www.culture.gr/6/68/682/e68202.html (accessed November 14, 2006).

64. Ernest Gellner, *Nations and Nationalism* (Oxford: Blackwell, 1983), 36.

65. Sir David Wilson, quoted in Sharon Sullivan, "Repatriation," *Getty Conservation Institute Newsletter* 14 (Fall 1999): 20.

66. On the Benin episode, see Anne E. Coombes, *Reinventing Africa: Museums, Material Culture and Popular Imagination* (New Haven: Yale University Press, 1994), ch. 1 and passim; also Martin Bailey, "British Museum Sold Benin Bronzes," *Art Newspaper,* April 2002, 1, 5.

67. Dr. Zahi Hawass, director of Egypt's Supreme Council of Antiquities, quoted in Martin Bailey, "The Rosetta Stone Will Stay in London, Say Trustees," *Art Newspaper,* September 2003, 13. Hawass also wants the return of the bust of Nefertiti from Berlin's Egyptian Museum, the statue of Hatshepsut from the Met, and the obelisk from the Place de la Concorde in Paris.

68. Thurstan Shaw, "Restitution of Cultural Property," *Museum* 149 (1986): 46.

69. Jeanette Greenfield points to Denmark's return of Icelandic manuscripts as "the outstanding example of a major state-to-state return of cultural property . . . an unusually civilized and rational act in the face of all the common, legal, political and historic arguments against return." *Return of Cultural Treasures,* 311; also 12–41.

70. Quoted in Maev Kennedy, "A Lesson in Lost Property," *Guardian,* October 30, 1999, www.guardian.co.uk/parthenon/article/0,,195562,00.html (accessed November 14, 2006).

71. Ernest Fenollosa to Edward Morse, quoted in Walter Muir Whitehill, *Museum of Fine Arts, Boston: A Centennial History,* 2 vols. (Cambridge, MA: Belknap Press, 1970), 1:113.

72. My thanks to Ikumi Kaminishi for this information. A 1906 article in the *Burlington Magazine* stated: "If Japan and China have not yet their Lord Elgin, the sort of enterprise, at least, which brought that great figure to the fore is at length awake, and the great sculpture of China, if not that of Japan, lies ready to his hand obscurely buried in the ruins of Lo-yang." The MFA's Fenellosa and William Bigelow were likened to Elgin's associates, William Hamil-

ton and Mazo. Paul Chalfin, "Japanese Art in Boston," *Burlington Magazine* 8 (1906): 220 (Kraus Reprint, 1968).

73. Stephen Kinzer, "Seeing Pergamon Whole," *New York Times*, September 14, 1997, sec. 2, 29.

74. George Perrot, "L'île de Cypre, son rôle dans l'histoire," *Revue des Deux Mondes*, May 15, 1879, 374. France and Britain were interested in his collection, but it went to New York and the fledgling Metropolitan Museum in 1879, the year Cesnola became the museum's first director.

75. "Cypriot Antiquities at the Metropolitan," August 2000, www.pio.gov.cy/cyprus_today /may_aug2000/page31.htm (accessed February 2004). For more on the Cesnola collection, see Tomkins, *Merchants and Masterpieces*, 44ff.; Karl E. Meyer, *The Plundered Past: The Story of the Illegal International Traffic in Works of Art* (New York: Atheneum, 1977), 68–69; Karl E. Meyer, "Met Goes to the Closet, Gets Out Its Skeletons and Tells the Stories," *New York Times*, April 15, 2000; Vassos Karageorghis et al., *Ancient Art from Cyprus: The Cesnola Collection in the Metropolitan Museum of Art* (New York: Metropolitan Museum, 2000). Ottoman attempts to regulate the flow of antiquities during this era are discussed in Wendy M. K. Shaw, *Possessors and Possessed: Museums, Archaeology, and the Visualization of History in the Late Ottoman Empire* (Berkeley: University of California Press, 2003). My thanks to Lindsay Commons for her help on this topic.

76. For the early history of excavation and archaeology in Egypt, see Donald Malcolm Reid, *Whose Pharaohs? Archaeology, Museums, and Egyptian National Identity from Napoleon to World War I* (Berkeley: University of California Press, 2002).

77. Quoted in Esther Singleton, *Old World Masters: New World Collections* (New York: Macmillan, 1929), ix–x.

78. W. G. Dooley, "Middle Ages," *Boston Evening Transcript*, February 17, 1945, 6.

79. Anne Higonnet offers intelligent insights on this process in her essay "Museum Sight," in McClellan, *Art and Its Publics*, 133–47.

80. James Clifford, *The Predicament of Culture: Twentieth-Century Ethnography, Literature, and Art* (Cambridge, MA: Harvard University Press, 1988), 229: "Ideally the history of its own collection and display should be a visible aspect of any exhibition." Such a strategy was tried in a remarkable temporary exhibition, ExitCongoMuseum (2000), held at the Musée Royal de l'Afrique Central in Tervuren, Belgium; see its catalog, Boris Wastiau, *ExitCongoMuseum* (Tervuren: Royal Museum for Central Africa, 2000), and the review of the show by Marie-Thérèse Brincard in *African Arts* 34 (December 22, 2001).

81. Hellenic Ministry of Culture, "Official Greek Position": "The proposal is that a long-term loan be agreed between the British Museum and the New Acropolis Museum. . . . More specifically, the proposal envisions the exhibition of the Parthenon's sculptures, in the large hall of the New Acropolis Museum, coming together as a joint project of the New Acropolis Museum and the British Museum. In exchange for this co-operation, the Greek Government assumes the responsibility of organising important temporary exhibitions of Greek antiquities on the grounds of the British Museum. These temporary exhibitions, through extensive media coverage, will continually generate international public interest."

82. Mark Jones, quoted in Alan Riding, "Islamic Art as a Mediator for Cultures in Confrontation," *New York Times*, April 6, 2004, B5.

83. "Cypriot Antiquities."

84. Kwame Anthony Appiah, *Cosmopolitanism: Ethics in a World of Strangers* (New York: Norton, 2006), 132.

85. Ibid., 133.

86. The standard texts on Nazi looting are Feliciano, *Lost Museum,* and Lynn H. Nicholas, *The Rape of Europa: The Fate of Europe's Treasures in the Third Reich and the Second World War* (New York: Knopf, 1994). The Canadian Jewish Congress operates a very useful Web site on Nazi loot; see Canadian Jewish Congress Charities Committee, "Nazi-Looted Art," www.cjccc.ca. A remarkable recent book gives a sense of the scale of looting by focusing just on Vienna: Sophie Lille, *Was einmal war: Handbuch der enteigneten Kunstsammlungen Wiens* (Vienna: Czernin, 2003).

87. On Allied restitution efforts, see Elizabeth Simpson, ed., *The Spoils of War* (New York: Abrams, 1997), as well as the memoirs of Thomas Carr Howe, *Salt Mines and Castles: The Discovery and Restitution of Looted European Art* (New York: Bobbs-Merrill, 1946); James Rorimer, *Survival: The Salvage and Protection of Art in War* (New York: Abelard, 1950); James Cuno, "The Fogg Art Museum and the Spoils of War," in *Shop Talk: Studies in Honor of Seymour Slive* (Cambridge, MA: Harvard Art Museums, 1995), 59–63; and Wojciech Kowalski, *Art Treasures and War: A Study on the Restitution of Looted Cultural Property* (Leicester: Institute of Art and Law, 1998), 38ff.

88. American Association of Museums, *Museum Policy and Procedures for Nazi-Era Issues* (Washington, DC: American Association of Museums, 2001), 90. Further information about the task force appeared on the AAMD Web site.

89. Both quotations appear in Walter V. Robinson, "170 Museums to Review Collections for Stolen Art," *Boston Globe,* June 5, 1998, A23.

90. See Feliciano, *Lost Museum,* ch. 5.

91. My information on this episode comes from articles in the *Boston Globe* on November 28 and 30 and December 1, 2, and 19, 1998, as well as David d'Arcy, "French Relent over War Loot," *Art Newspaper,* June 1999, and the MFA's flier, "Claude Monet's *Water Lilies* (1904) and the Restitution of Art after World War II," distributed at the exhibition Monet and the 20th Century. After some resistance, the French government agreed to return the Monet to the Rosenberg family in April 1999.

92. The MFA wall label in the Monet exhibition (and accompanying flier) declared that the painting had been exhibited "in order to facilitate its identification," a claim rejected as disingenuous by the World Jewish Congress; see Walter V. Robinson, "Doubts Raised on Monet Plaque," *Boston Globe,* December 19, 1998. In another article Robinson states: "When the painting was repatriated after the war, French officials failed to learn its connection to Rosenberg, even though the French government's own 1947 list of missing artworks lists the painting, notes Rosenberg's ownership, and even cites dimensions that are identical to the Monet in Boston. Despite those clues, the painting was eventually shunted off to Caen." Walter V. Robinson, "Family Cites Nazi Records in Claim to Monet," *Boston Globe,* December 2, 1998, A14.

93. American Association of Museums, *Museum Policy and Procedures,* 92, 91.

94. Two cases from the late 1990s involving the Goudstikker collection in Amsterdam and a pair of Egon Schiele paintings from the Leopold Foundation in Vienna were closely followed by the press and illustrate the enormous challenges facing heirs seeking restitution; for the former, see *New York Times,* January 12, 1998, and March 27, 1998; for the latter, see *New York Times,* December 24, 1997, January 1, 10, and 29, 1998; March 7, 1998; and April 16, 1998, as well as the *Boston Globe,* January 9, March 5, and September 11, 1998.

95. See Celestine Bohlen, "Museums Accept Stronger Role in Search for Looted Art," *New York Times,* November 30, 2000, B1. A casual survey of Web sites worldwide suggests that only

a very small percentage of the hundreds of objects initially viewed as suspect have turned out to be problematic.

96. See Isabel von Klitzing, "1938–1948—the Dangerous Years: How We Check Art for Tainted Provenance," *Art Newspaper,* July–August 2004, 28. The Art Loss Register monitors the market and cooperates with at least some major auction firms.

97. See Randy Kennedy, "Museums' Research on Looting Seen to Lag," *New York Times,* July 25, 2006, B1.

98. Marilyn Henry, "Restitution: Broken Promises," *ARTnews* 104 (March 2005): 100–111.

99. Ibid., 102.

100. See Konstantin Akinsha and Grigorii Kozlov, *Beautiful Loot: The Soviet Plunder of Europe's Art Treasures* (New York: Random House, 1995); and Steven Lee Myers, "In Moscow, a Proud Display of Spoils of War," *New York Times,* May 17, 2005. For the exhibition of German loot, see *Hidden Treasures Revealed: Impressionist Masterpieces and Other Important French Paintings Preserved by the State Hermitage Museum, St. Petersburg* (New York: Abrams, 1995). The catalog's introduction sidesteps questions of restitution and nowhere acknowledges the circumstances under which many objects from private Jewish collections were acquired by the Germans before being confiscated by the Soviet Trophy Brigades.

101. See Sterling Seagrave and Peggy Seagrave, *Gold Warriors: America's Secret Recovery of Yamashita's Gold* (London: Verso, 2003), reviewed in *Art Newspaper,* January 2004, 31.

102. Quoted in Martin Bailey, "We Serve All Cultures, Say the Big, Global Museums," *Art Newspaper,* January 2003, 6.

103. Quoted in Walter I. Farmer, "Custody and Controversy at the Wiesbaden Collecting Point," in Simpson, *Spoils of War,* 133. Farmer also quotes the supporting document issued by American museum officials. Also see Charles L. Kuhn, "German Paintings in the National Gallery: A Protest," *College Art Journal* 5 (January 1946): 78–79; and Howe, *Salt Mines and Castles,* 304–11.

104. John L. Hess, *The Grand Acquisitors* (Boston: Houghton Mifflin, 1974), 134–35. A revealing account of the post-UNESCO art world, with an excellent bibliography, is provided in Meyer, *Plundered Past.*

105. See Hannah Beech, "Stealing Beauty," *Time,* October 27, 2003. In 1972 a curator at the Cleveland Museum told a reporter that 95 percent of ancient art in the United States had been smuggled in: "Unless you're naïve or not very bright you'd have to know that much ancient art is stolen." Quoted in Meyer, *Plundered Past,* 123.

106. Edek Osser, "London and Paris Markets Flooded with Looted Iranian Antiquities," *Art Newspaper,* January 2004, 9.

107. For a full account of the Iraq Museum, see Matthew Bogdanos, "The Casualties of War: The Truth about the Iraq Museum," *American Journal of Archaeology* 109 (July 2005): 477–526.

108. For a recent well-documented case, see Barry Meier and Martin Gottlieb, "An Illicit Journey out of Egypt, Only a Few Questions Asked," *New York Times,* February 23, 2004.

109. Hugh Eakin, "An Odyssey in Antiquities Ends in Questions at the Getty Museum," *New York Times,* October 15, 2005, A33.

110. Walter V. Robinson, "Museums' Stance on Nazi Loot Belies Their Role in a Key Case," *Boston Globe,* February 13, 1998. The AAMD joined with the Association of Dealers in Ancient, Oriental and Primitive Art to appeal a federal court decision that upheld U.S. Customs' seizure

of a gold platter smuggled out of Italy. The then-president of the National Association of Dealers in Ancient, Oriental and Primitive Art was later convicted of trafficking in looted art.

111. See Eakin, "Odyssey in Antiquities"; Elisabetta Povoledo, "Prosecutors Bet Big on Antiquities Trial in Italy," *New York Times,* November 16, 2005, B1, B7; Hugh Eakin, "Museums under Fire on Ancient Artifacts," *New York Times,* November 17, 2005, B1, B8; Geoff Edgers, "Italian Authorities Said to Have Evidence of Looted Works at MFA," *Boston Globe,* November 1, 2005, C1, C5.

112. Elisabetta Povoledo, "The Met May Settle with Italy," *New York Times,* November 24, 2005, E6. Montebello said the Met would cooperate with Italian authorities but that Italy would have to provide "incontrovertible evidence" that the pieces had been illegally exported: "If we are convinced by the evidence, we will take appropriate action" (E1). The Met settled with the Italian government in February 2006, agreeing to return the Euphronios Krater and other objects in exchange for an array of Etrurian artifacts; see the *New York Times,* February 3, 2006, A1; February 21, 2006, B2; and March 15, 2006, B2.

113. Quoted in Beech, "Stealing Beauty."

114. See Walter V. Robinson, "Mali Presses for Museum Artifacts," *Boston Globe,* December 6, 1997. For a strong statement on the damage done by looting in Mali, see R. J. McIntosh and S. K. McIntosh, "Dilettantism and Plunder: Illicit Traffic in Ancient Malian Art," *Museum* 149 (1986): 49–57.

115. Quoted in Walter V. Robinson, "MFA Won't Relinquish Guatemalan Artifacts," *Boston Globe,* July 9, 1998, A1.

116. Alan Shestack, "The Museum and Cultural Property: The Transformation of Institutional Ethics," in *The Ethics of Collecting: Whose Culture? Whose Property?* ed. Phyllis Mauch Messenger (Albuquerque: University of New Mexico Press, 1999), 98. Also see Lorenz Homberger and Christine Stelzig, "Contrary to the Temptation! An Appeal for a New Dialogue among Museums and Collectors, Scholars, and Dealers," *African Arts* 34 (Summer 2006): 1, 4, 6, 83.

117. Thomas Farragher, "Some Museumgoers Miss Reason for Debate," *Boston Globe,* December 6, 1997, A1.

118. Greenfield, *Return of Cultural Treasures,* points to Denmark's return of Icelandic manuscripts as "the outstanding example of a major state-to-state return of cultural property . . . an unusually civilized and rational act in the face of all the common, legal, political and historic arguments against return" (311) but seems hopeful that other examples will follow. Another exceptional case worth noting is Thomas K. Seligman, "The Murals of Teotihuacán: A Case Study of Negotiated Restitution," in Messenger, *Ethics of Collecting,* 73–90. Seligman tells of an important series of pre-Columbian wall paintings from Mexico left to the Fine Arts Museums of San Francisco by a local collector. Though entitled by U.S. law to keep the murals, the museum decided restitution was the proper course. In conclusion, Seligman wrote: "I am convinced that ethical considerations are much more important than legal ones."

Conclusion

1. Mokoto Rich, "Build Your Dream, Hold Your Breath," *New York Times,* August 6, 2006, sec. 2, 1, 22.

2. Ibid., 22.

3. Alan Riding, "Art Arranged: Shock of the New, Comfort of the Old," *New York Times,* July 22, 2006, B19.

4. Deborah F. Schwartz, "Dude, Where's My Museum? Inviting Teens to Transform Museums," *Museum News* 84 (September–October 2005): 36–41.

5. This and the following quotation are from "The Great Court" at the museum's Web site: www.thebritishmuseum.ac.uk/greatcourt/read.html (accessed July 2006). The museum celebrated its 250th anniversary in 2003 with an exhibition, The Museum of the Mind: Art and Memory in World Cultures, highlighting its "incomparable collection of humanly created artifacts covering all times and places . . . displayed . . . in a single building accessible free to visitors seven days a week." John Mack, *The Museum of the Mind: Art and Memory in World Cultures* (London: British Museum, 2003), 8.

6. Elisabetta Povoledo, "Former Curator in Courtroom As Her Trial Begins in Rome," *New York Times,* November 17, 2006, B8.

7. See, for example, Randy Kennedy and Hugh Eakin, "Met Chief, Unbowed, Defends Museum's Role," *New York Times,* February 28, 2006, B1; Hugh Eakin, "Getty Museum Agrees to Return Two Antiquities to Greece," *New York Times,* July 11, 2006, B1.

8. See "Universal Museums," *ICOM News* 57, no. 1 (2004), http://icom.museum/universal.html (accessed November 14, 2006), where other responses to the declaration may be found. Also see Mark O'Neill, "Enlightenment Museums: Universal or Merely Global," *Museum and Society* 2 (November 2004): 190–202.

9. Kwame Anthony Appiah, *Cosmopolitanism: Ethics in a World of Strangers* (New York: Norton, 2006), 130.

10. Ibid., 133.

ILLUSTRATIONS

INDEX

Page numbers given in *italics* indicate illustrations or material contained in their captions. Titles of artworks can be located under the artist.

Designer: Nola Burger Text: 9.75 / 14.5 Scala Display: Berthold City
Compositor: Integrated Composition Systems Indexer: Kevin B. Millham Printer and Binder: Friesens